sexual order gender
expression

⌐ intersectionality of
 queerness w/ race

Work!

queer kinship
 networks

vamp (vampire)
 ↓
 glamour

"natural" and "real"
were racialized
 categories in the era
 (1970s?)

Duke University Press Durham and London 2019

A Queer History
of Modeling

ELSPETH H. BROWN

Printed in the United States of America on acid-free paper ∞
Designed by Courtney Leigh Baker
Typeset in Garamond Premier Pro by Westchester Publishing Services

Library of Congress Cataloging-in-Publication Data
Names: Brown, Elspeth H., [date] author.
Title: Work! : a queer history of modeling / Elspeth H. Brown.
Other titles: Queer history of modeling
Description: Durham : Duke University Press, 2019. | Includes
 bibliographical references and index.
Identifiers: LCCN 2018041289 (print) | LCCN 2018060227 (ebook)
 ISBN 9781478002147 (ebook)
 ISBN 9781478000266 (hardcover : alk. paper)
 ISBN 9781478000334 (pbk. : alk. paper)
Subjects: LCSH: Photography of women—Social aspects—
 United States. | Fashion photography—United States—
 History—20th century. | Commercial photography—United
 States—History—20th century. | Models (Persons)—United
 States. | Women in popular culture—United States—History—
 20th century. | Femininity in popular culture—United States—
 History—20th century. | Sex in advertising—United States—
 History—20th century. | Queer theory.
Classification: LCC TR681.W6 (ebook) | LCC TR681.W6 B76 2019
 (print) | DDC 779/.24—dc23
LC record available at https://lccn.loc.gov/2018041289

Duke University Press gratefully acknowledges the Social Sciences
and Humanities Research Council of Canada, which provided funds
toward the publication of this book.

Cover art: Donyale Luna, February 8, 1965. Photograph by Richard
Avedon. © The Richard Avedon Foundation

For Asa

CONTENTS

Writing books is a far less solitary activity than it might seem. Archival research, for example, is not possible without the work of archivists who helped me with various collections. In particular, I would like to thank the archivists at the Schomburg Center for Research in Black Culture and the Billy Rose Theatre Division, New York Public Library; the archivists at the Beinecke Rare Book and Manuscript Library, Yale University, the University of Pennsylvania Archives, and the American Philosophical Society, Philadelphia. In addition, warm thanks to Fath Davis Ruffins, Susan Strange, and Wendy Shay at the Archives Center, National Museum of American History, Smithsonian Institution; Katherine Ott and Peter Liebhold at NMAH, who have supported my work at NMAH since I was a graduate student; April Calahan at the Fashion Institute of Technology; fellow scholar Katrin Koeppert, who helped me with Steward papers at Beinecke Library; Erin Harris of the Avedon Foundation; Shawn Waldon of Condé Nast; Lynn Eaton, archivist at Duke University's John W. Hartman Center for Sales, Advertising, and Marketing History; Andi Gustafson and Chelsey Weathers, former PhD students and interns at the Harry Ransom Center, University of Texas, Austin; Barbara Cohen-Stratyner, the New York Public Library for the Performing Arts; and Deborah Martin Kao, Michelle Lamuniere, and Holly Markovitz at Harvard's Fogg Museum.

I have been very fortunate to benefit from research funding from several sources for this project, in addition to the support I have received from the University of Toronto. I benefited from early fellowship support from the American Council of Learned Societies, the Kluge Center at the Library of Congress, and the Social Science and Humanities Research Council of Canada. Research grants from the American Philosophical Society and the John W. Hartman Center for Sales, Advertising, and Marketing History at Duke University made travel to these collections possible.

I am indebted to research assistants, graduate students, and postdoctoral fellows who have helped me, immeasurably, at every stage of this project. Many thanks to Alex Bozikovic, Matt Crowley, Simon Fisher, Holly Karibo, Ananda Korchynski, Liviya Mendelsohn, Saj Soomal, Shyama Talukdar, Jaipreet Virdi, and Kate Witwicki. I have benefited immensely from conversations with former graduate students and postdocs, especially Daniel Guadagnolo, Nick Matte, Cait McKinney, and Marlis Schweitzer, from whose own scholarship I continue to learn. I want to especially thank Daniel Guadagnolo, who has worked with me on this project for many years, and has single-handedly navigated all the image permissions and art acquisitions for publication. Working with him on this project has made an overwhelming and sometimes lonely task seem fun, queer, and possible.

I have had the opportunity to present some of this research over the years, and would like to thank the many scholarly audiences that provided excellent questions and feedback along the way: Brown University; Emory University; Hamilton College; Harvard University; Humboldt University; Kluge Center, Library of Congress; Newberry Library, Chicago; Ryerson University; Stanford University; University of Manitoba; University of Maryland, Institute of Historical Studies; University of Michigan; University of Southern Maine; University of Toronto; University of Wisconsin, Madison; Schulich School of Business, and the Department of History, Western University; Yale University; York University; and several scholarly meetings for the American Historical Association, the American Sociological Association, the American Studies Association, the Berkshire Conference on the History of Women, the Organization of American Historians, and the Social Science History Association.

Toronto has been a wonderful intellectual home for this project's genesis and completion. I especially appreciate the support I have received from friends and colleagues at the University of Toronto, particularly Ritu Birla, Jill Caskey, Michelle Murphy, and John Ricco. I am especially grateful to Eva-Lynn Jagoe for her friendship and commitment to crafting a full life that involves writing as a creative process, and I feel fortunate that Imre Szeman is now part of this world. While director for the Centre for the Study of the United States, I benefited from numerous conversations with visiting scholars about their own research and my own. I have learned a great deal from my students, both undergraduate and graduate, in my years at the University of Toronto. In the greater Toronto area, I have relied on my network of friends and scholars who have created an intellectual, affective, and sometimes material home for me. Marta Braun welcomed me to Toronto, and with Ed Epstein provided us our first place to stay; she has been an anchor ever since. Marc Stein was always available to talk shop regarding

US LGBTQ+ history, and Jorge Olivares has always been generous in his patience with these endless, arcane conversations. My fellow volunteers at the Canadian Lesbian and Gay Archives (recently renamed the ArQuives: Canada's LGBTQ+ Library and Archives), especially Dennis Findlay, have made CLGA a home away from home for the past five years. The members of the Toronto Photography Seminar, including Sarah Parsons and Deepali Dewan, have been an interdisciplinary haven for me; I would like to thank Thy Phu, in particular, whose intellectual companionship in photography studies has been a profound gift.

I am grateful to the many other friends and colleagues, not based in Toronto, who supported me in myriad ways as I worked on this project. In the history and sociology of fashion, many thanks to Joanne Entwistle, Caroline Evans, Ashley Mears, and Elizabeth Wissinger, whose work has helped make a scholarly conversation about the history of the modeling industry. My year at Miami University in 2005–6 was sustained through the support and friendship of Peggy Shaeffer and her wonderful family. I continue to rely on friends and colleagues from my graduate school years at Yale, including Cathy Gudis, Marina Moskowitz, Jeff Hardwick, Lori Rotskoff, Nancy Cott, Alan Trachtenberg, Jean-Christophe Agnew, and Laura Wexler. My colleagues in the LGBTQ+ Oral History Digital Collaboratory, especially K. J. Rawson, Elise Chenier, Sara Davidmann, and Aaron Devor, have sustained this research in more ways than they know. Many thanks to scholars and friends who have supported my work and provided feedback over the years, including Lisa Cartwright, Ann Cvetkovich, Julien Cayla, Jay Cook, Erika Doss, John Kramer, Daniel McCusker, Joanne Meyerowitz, David Serlin, Shawn Michelle Smith, Susan Stryker, Elizabeth Wolfson, and Detlev Zwick. I am especially grateful to scholars whose intersectional critiques of the history of capitalism have shaped my queer approach, including Michael Denning, Finn Enke, Nan Enstad, Brenna Greer, Charlie McGovern, Bethany Moreton, and Kathy Peiss. I would especially like to thank Nan, who has been reading and writing on my behalf for years. Nan and David Serlin provided crucial feedback on the manuscript, and I am deeply indebted to both of them.

My editor at Duke University Press, Ken Wissoker, has been endlessly supportive of queer work in multiple senses of the word, including this project: I owe him my profound thanks. Many thanks as well to Joshua Tranen, Sara Leone, Jade Brooks and Olivia Polk at Duke University Press, whose energy, enthusiasm, and skills have been immeasurably helpful. My family of origin, especially my sister Meghan, as well as Maceo, Susan, Peter, Rennie, Meg, and Alex, has always been there for me. Finally, my deep thanks and love to my son Asa and to Art, who have sustained me every day with their love, humor, and creative energies.

Caroline Jones saw a marketing opportunity. It was late 1969, and soul style had migrated from black African artists such as Miriam Makeba to American musicians and activists such as Nina Simone.[1] Jones, a black advertising pioneer who had risen from secretary to creative director at J. Walter Thompson, had recently joined Zebra Associates, a firm founded in 1969 as the first fully integrated advertising firm with black executives.[2] In this context of heightened black visibility, Jones pitched a proposal to Clairol, the leading company in the US hair care industry. Zebra Associates' focus was on the growing black consumer market (23 million people, worth $30 billion in 1969), and Jones's pitch to Clairol emphasized how the company could position itself as the first major mass market manufacturer to develop hair care products designed specifically for black consumers, particularly black women.[3] The proposal includes a two-page history of black hair care in which Jones described black women's daily struggle with hot combing, pressing, and curling. This grueling ordeal was compounded by the fact that, in Jones's words, no one cared: no large manufacturer had ever developed a specialized product for black hair care. Clairol could be that company, Jones argued, by developing two product lines: one for straightened and pressed hair, and one for natural hair, including the Afro—an emerging, contemporary style that signaled, as she explained to the white Clairol executives reading her proposal, both "black pride" and "heritage identity."[4] But, as Jones was careful to explain, the newer natural hairstyles still required a full line of products, beyond simple shampoos and conditioners, to maintain.[5]

Jones's marketing pitch, and the advertising scripts that accompanied it, emphasized the centrality of emotion in identifying, understanding, and appealing to black consumers. In describing black women's hair histories, Jones refers to their experiences of hair straightening as painful, anxious, and unpleasant; Clairol's new line would, she argued, instill pride, confidence, and trust, replacing disappointment with dependability and reliability. In the classic narrative

form of twentieth-century advertising, Jones describes the negative affects of consumer modernity while offering the company—in this case, Clairol—as the consumer's friend, someone who would be at their side as advocate and champion, capable of instilling new, positive affective states.[6] The centrality of emotion in selling Clairol's new hair care line is clear in the advertising copy. A four-color ad copy for the new line, Born Beautiful, from 1970 begins with an emphasis on how freedom feels: "Freedom is wearing a silk scarf around your neck, instead of your head. . . . Freedom is riding in a convertible blowing the horn instead of your hair . . . freedom is going swimming with out a cap."[7] Here, Jones—an experienced copywriter—draws on over a half century of advertising strategy in tying consumer products to the loftier ideals of contemporaneous social movements; in this case, as Jones fully intended, the copy's reference to freedom is also a reference to the global black freedom movement, of which hair was a key signifier.[8]

But product lines and their advertisers need a further element in animating viewers' emotional lives while situating their brand as the solution to consumers' needs. The product needs a model: a living person who can imbue the product, whether shampoo or chenille, with the affective qualities offered by the copy. In the case of Born Beautiful, one of Clairol's models was Tracey Gayle Norman (fig. I.1). Norman was one of the early 1970s' more successful models: she had been "discovered" by photographer Irving Penn, who booked her for a shoot with Italian *Vogue* at $1,500 a day, and who introduced her to agency director Zoltan Rendessy, a gay Hungarian refugee who opened his own modeling agency in 1970.[9] Zoli specialized in nonconventional models, including black models such as Pat Cleveland, and he quickly signed Norman. Clairol was one of Norman's most loyal clients, and her contract with them lasted six years.

Clairol loved Norman's hair color, and the company developed a product to match it: Dark Auburn (box 512). During the period Norman modeled for Clairol, Dark Auburn was one of the company's strongest-selling products in the Born Beautiful line, the African American hair care products category that Clairol had developed in the wake of Caroline Jones's successful sales pitch. In figure I.1, a color head shot of Norman dominates a Clairol one-step shampoo, conditioner, and hair color product box. Norman's subdued makeup and softly coifed hair connote the "natural" beauty, elegance, and black respectability central to the product's marketing campaign, as Clairol softened black nationalism's radical critique for implied middle-class consumer audiences through the rhetoric of hair. However, despite her success—Norman also did catalogue work and had contracts with Ultra Sheen Cosmetics—Norman's modeling

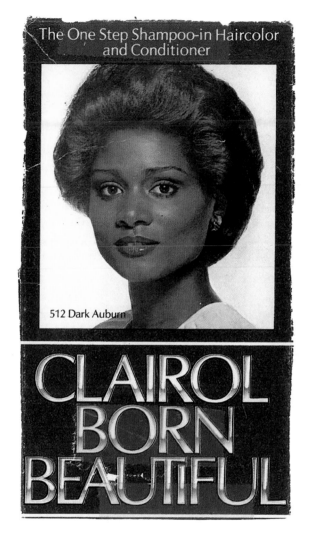

FIG. 1.1 Tracey Norman, model, in Born Beautiful hair color product packaging (Clairol), c. 1975. Courtesy of Tracey Norman.

career abruptly ended during a holiday shoot for *Essence* magazine. While Norman was focused on her work with the photographer, she became aware that hair stylist André Douglas's assistant and the *Essence* fashion and beauty editor Susan Taylor were deep in conversation. Norman lost her concentration as the set became suffused with what she described as a negative energy. She worried that her world, in her words, "would come crashing down."[10]

Norman had grown up in Newark, New Jersey, as a young gay man. By her teenage years, Norman was taking feminizing hormones and was immersed in Harlem's gay ball house culture, where she also learned to walk the runway, a training central to her later success as a model. This world, so memorably

documented by filmmaker Jennie Livingston in her award-winning documentary *Paris Is Burning* (1991), emerged in the 1960s as black and Latino gay men and trans women developed their own culture of fashion fabulousness that was independent of the mostly white gay balls that had been part of New York's gay scene since the 1930s.[11] While on this *Essence* photography shoot, Douglas's assistant recognized Norman as someone he had known as a boy in Newark, and outed Norman to Susan Taylor as trans, to use the contemporary term.[12] The photographs from that shoot were never published, and Zoli and Clairol dropped her contract: Norman's US modeling work evaporated.[13] Like so many black models before her, Norman moved to Paris, where she eventually found work as a showroom model for Balenciaga.

The Jones-Clairol-Norman collaboration illustrates many of this book's central themes. While Norman's story as the US industry's first known trans model is unique, the central role she played in lending her elegance and beauty to a consumer product is not. Today, models are a ubiquitous figure in twentieth-century commercial and popular culture. But this has not always been the case: their emerging centrality to strategies of capitalist enticement has a history that began in the early twentieth century. In the transition to a consumer economy in the early twentieth century, the production of desire became central to the sale of goods. Cultural and business historians ranging from Jackson Lears to Davarian Baldwin have charted the US transition to what William Leach has memorably termed the "land of desire" in the early twentieth century, identifying the cultural intermediaries—photographers, art directors, beauty entrepreneurs, and advertising executives—who brokered manufacturers' pursuit of expanding markets.[14] There has been less research, however, on the new forms of labor that emerged in the US transition to a mass production economy, an economy that relied as much on distribution and consumption of goods as on their manufacture.[15] The work of copy editors, show window dressers, and art directors were forms of labor that required the production of specific emotional states in their viewers, commercialized feelings that were a necessary prelude to sales. The shift to a mass production economy in the late nineteenth and early twentieth centuries necessitated the elaboration of new forms of labor required to expand existing markets and build new ones.

This book explores one aspect of affective labor new to the early twentieth century but now seemingly ubiquitous: the work of the commercial model. Modeling is the quintessential occupation of a modern consumer economy, in which goods and services are bought and sold through the medium of advertising and marketing; its history in the United States is deeply imbricated with the maturation of these industries in the wake of World War I. Models, whether

performing live or through representational distance, as in photographic modeling, produce sales through the affective labor of posing for the lens, or appearing with commodities in a real-time setting. Through the medium of their bodies, models coproduce public feelings whose dominant meanings are shaped by a commercial "common sense" naturalized by the other cultural intermediaries of modern consumer culture: photographers, art directors, fashion editors, apparel merchandisers, fashion show producers, and other marketing professionals. Models do the work of representation in capitalism's dream worlds.

Sexuality is central to the powerful, affective mix through which models enliven material goods. Ever since the first mannequins, or "living models," immigrated to New York from London in 1909, US merchandisers have relied on corporeal display—and its photographic representation—to stage and activate consumer desire. The modeling profession emerged around the time that merchandisers and psychologists began to sell not the product itself but the ineffable, affective benefit that the product promised, whether romance, sexual appeal, glamour, or, simply, pleasure. Sales unfold within an affective circuit linking producer, model, and consumer: as one commercial photographer bluntly noted of the model's labor in 1930, "She sells the stuff by making it desirable."[16] Modeling is a form of labor in which the models and other cultural brokers transform subjective aspects of modern selfhood—gesture, appearance, and presence—into immaterial goods, adding surplus value to manufactured products that are then purchased by wholesale buyers or retail consumers. As we saw with Tracey Gayle Norman's work with Clairol, commercial modeling often carries with it a sense of the beautiful to spark consumer desire, a gendered understanding of the beautiful that, in the context of heteronormative, unequal relations between men and women, is often implicitly sexual as well—even if not always erotic. Gender, race, and sex become woven together in both representation and performance, as the model produces a form of managed, de-erotized, public sexuality. What is the nature of this form of public sexuality, and what is its history? This book seeks to answer this question through exploring the role of models and photography in the production of a managed, de-eroticized sexuality in the public sphere.

Historically, the display of the human body in a commercial field has carried with it a challenge to bourgeois values—values that have sought to separate the market from sites of intimacy usually associated with the private sphere. The model is a human contact zone that brings together commercial transactions, the feminized body, and a discourse of desire, desire for commodities and often for the model as well. It is for this reason that female models were seen in the early twentieth century as types of "public women," or prostitutes, for

their occupation tied the display of the female form to a commercial exchange. Models' use of their bodies to wear or accompany commodities for sale in the marketplace brought together two types of problematic, and historically intertwined, ways of seeing: the gaze of solicitation (in which the body and its services represented the goods for sale) and the (related) gaze of erotic, often aestheticized appreciation. This association between modeling and sex work was a major problem for twentieth-century merchandisers, as they needed to protect their brand identities from the illicit and immoral connotations of the public woman. Although merchandisers needed emotion, including desire, to sell goods, at the same time, they needed to cordon off their goods from the potentially explosive, immoral connotations of the model's public display of the body. How would merchandisers and models produce a sexualized affect in relationship to the commodity form, while at the same time protecting the brand from what the implied bourgeois purchasers would find distasteful, sexually inappropriate, or morally objectionable? This was the challenge facing the modeling industry at its birth in the early twentieth century.

This challenge of containing, channeling, and directing the model's sexuality in relationship to the brand is one that affected white models and models of color in different ways. As I show throughout this book, the history of racism and the body meant that the historical meanings of leasing one's body to the photographer, art director, or couture designer varied for black and white models. The racial meanings of a pale, long-limbed beauty gliding across a couture salon in Edwardian New York or a black trans woman modeling for Clairol in the early 1970s were shaped by a much longer history of racial, sexual, and gendered meanings concerning the body on public display. These racialized and gendered histories continued to shape the meanings of black and white modeling throughout the twentieth century and, indeed, into our own time. The weight of this historical burden, however, has fallen unevenly on the shoulders of black models, whose history I explore with a particular focus throughout the book.

Managing Sexuality in the Modern Marketplace

This book situates the development of modeling in relationship to the history of sexuality. This is not a history of sexual object choices, nor the history of sexual categories, nor even the history of sexual communities or identities. Although my work is deeply indebted to scholarship in the history of sexuality in these areas, in this project I historicize the relationship between sexuality and the market not in terms of prostitution but of an under-researched terrain:

a zone of commodified sexual appeal that has emerged as a central aspect of modern marketing.[17] *Work! A Queer History of Modeling* traces the emergence of a modern, commercialized sexuality that is relational in nature: indebted to the market and to the circulation of emotions among bodies, this type of modern sexuality depends on the movement of desire, glances, and goods across identities, sexual practices, and geographies. This is the sexuality of the "It" girl and the "X" factor: a modern, commercialized form of sexualized appeal that demands categorization even as it eludes it.

Models sell commodities by using their bodies to produce commercialized affect in relationship to specific goods. The vehicle through which these elusive promises are made is the model's performance of a new form of sexuality, one specific to the emerging mass culture industries of the early twentieth century and elaborated on in subsequent years. The various models discussed in this book—photographic models, stage models, cloak models, and fashion models—all played a central role in producing a zone of public discourse that linked gender, class, and racial meanings to commodity forms, and in which sexuality became inextricably linked to the marketing and sale of goods. The public understanding of the various versions of modeling outlined here suggests a larger story about the efforts of cultural brokers to both draw on and contain the implicitly explosive sexuality of bodies on public display.

Work! A Queer History of Modeling charts how models, photographers, agents, and advertisers solved the problem posed by the model's untoward erotic appeal through the production of a new type of managed, commercialized sexuality. I show how over the course of the twentieth century, models, photographers, couturiers, agents, and other cultural brokers distanced the work of the model from the problematic sexualities suggested by nineteenth-century public women, particularly prostitutes—to use the contemporaneous term for sex workers. Merchandisers developed a new discourse of commercial attraction that channeled and contained the model's sexual appeal in a manner familiar to twentieth-century culture industries organized around the commodified display of the female body. The merchandizing of sexual appeal was a racial project as well, as definitions of female beauty articulated on the stage, the catwalk, and the magazine page reflected and constructed a definition of "American" beauty that was both white and Anglo-Saxon. The containment of the white female model's sexuality implicitly established nonwhite models as the sexualized, racialized "other" through which white models' otherwise explosive sexual appeal was sanitized and cleaned up for new consumer audiences. This sanitized version of sexuality, so central to modern consumer culture, has a history densely interwoven with the modeling industry: pleasurable to view,

yet curiously nonerotic, this manufactured appeal calls out to the viewer yet remains nonetheless inaccessible.

In his work on the Victorian barmaid, the historian Peter Bailey very usefully suggests a name for the oddly passionless version of modern sexual appeal: parasexuality.[18] The term combines two otherwise discrete meanings, both of which rely on distance. First, there is the prefix meaning of "almost" or "beside," as in "paralegal" or "paramedic." However, one also finds the definition of "para-" as prevention against, as a prophylactic—as in "parachute." The term suggests a "sexuality that is deployed but contained, carefully channeled rather than fully discharged"; as Bailey argues, it's the sexuality of "everything but."[19] In historical terms, this is the sexuality of the pinup, the beefcake, the chorus girl—and the model, I would argue. Like these modern types, models inhabit a zone of enhanced public visibility; they are available to the scrutinizing gaze while eluding its implied denouement—that is, sex. The implied sexuality of the model, the film star, or the pinup is contained, as Bailey has discussed in relationship to the barmaid, through distance.[20] Material or representational obstacles between the bearer of parasexuality and the audience, such as the catwalk or the magazine page, work to protect the magical property that bears a close relationship to (and is sometimes synonymous with) glamour; at the same time, the distance heightens the desire for the elusive object—close yet so far. The complex dance between corporeal display, public visibility, and the cordon sanitaire of the runway, the stage, or the printed page constitutes a type of managed sexuality that has proved central to the accelerated circulation of commodities in advanced capitalist societies.

This production of managed sexuality has been the model's chief contribution to the mass merchandizing of goods since the first third of the twentieth century. All of the models discussed in this book produced and performed varying versions of corporeal display that were historically overdetermined by dominant understandings concerning the meaning of unattached women displaying their bodies, in public, in commercialized settings. At the beginning stages of this process of rendering female corporeal display safe for the commodification of goods within a landscape of emerging mass consumer culture in the early twentieth century, the model was indisputably seen as a sexually problematic figure, kinswoman to the prostitute, the actress, and the bohemian (implicitly French) artist's model. At the later stages of this shift from public woman to girl next door, however, by the World War II era, the model had been recast as a glamorous yet nonthreatening icon of modern beauty: her sexuality had been tamed, channeled, packaged, and racialized as a key ingredient of commercial marketing.

Analytically, *Work! A Queer History of Modeling* brings together three scholarly fields that are not usually in conversation with one another: queer theory, affect studies, and the history of capitalism. This book is a queer history of the modeling industry in a few different senses of the word. One is the old-fashioned meaning, from the seventeenth century up through the early twentieth: queer as in out of alignment, odd, or strange. Using this earlier use of "queer" as peculiar or odd, the book does not follow a normative narrative history. I explore both fashion modeling and print modeling, crossing the boundaries between editorial (high-end fashion) and commercial work, which I explore here mostly through print advertising for consumer goods such as cigarettes, toothpaste, and wigs. Also, in my analysis of fashion modeling, I sidestep the approach favored in the few popular histories of the field, which usually cover the same famous models, from (for example) interwar models Lee Miller and Muriel Maxwell to midcentury models Lisa Fonssagrives, Dovima, and Dorian Leigh and her sister Suzy Parker—and then from the 1960s' Twiggy to Veruschka and beyond.[21] Although the book does includes some discussion of well-known models and photographers, in general terms I follow a more heterodox approach, one that investigates the histories of those who occupied a nonnormative relationship to an industry that has, historically, been one of the most conservative in relationship to race, gender, and sexual difference.

Second, this book is a queer history in the spirit of scholars such as Cathy Cohen, who have taken an intersectional approach in their critique of early queer theory's investment in whiteness, while bringing together race and sexuality in arguing for a definition of "queer" that creates an oppositional space in relation to dominant norms.[22] Over the course of this book, I pursue an analytic focus on sexuality in the public sphere that foregrounds race alongside other vectors of difference; the nonnormative in relationship to the modeling industry as a whole offers a more nuanced portrait of its history than one organized solely along sexual minority identity.

That said, my book also includes a partial history of sexual and gender minorities within the industry. There is surprisingly little research on the queer history of either modeling or the fashion industry as a whole, although the Fashion Institute of Technology's exhibition, and later book, of 2013 is a promising intervention.[23] Queer is, among other things, a historical term that emerged in the early twentieth century to connote homosexuality as a specific expression of the term's older meaning as odd, bent, or peculiar.[24] In the interwar years, "queer" was a derogatory term for gay men who performed a highly

visible, flamboyant effeminacy, and some of the historical figures I discuss in this book were certainly queer in this sense—Baron Adolph de Meyer is one example.

A third meaning of "queer," emerging in the 1990s and still in place today, is as an umbrella term that references nonnormative sexuality but that critiques stable identity formations such as "gay," "lesbian," "straight," and so on. This understanding, though somewhat presentist, describes the sexual histories and allegiances of still other figures in this book, such as George Platt Lynes, for whom the word "gay" seems both inaccurate and presentist for other reasons. Viewed historically, the term "queer" emerged in public discourse during the McCarthy era, and while some homophile activists distanced themselves from the term, others—such as Lincoln Kirstein—privately self-identified as queer in order to distinguish their complicated sexuality from homophile respectability. At times, in the absence of historical evidence regarding how historical actors would have described their own sexuality, I sometimes use the word "queer" as shorthand for the sexually nonnormative; my hope is that context will allow the reader to understand the moments in which I deploy this otherwise presentist usage. It is worth stating that our current vocabulary remains inadequate to the task of understanding pre-Stonewall nonnormative sexualities, which historians continue to research and address.

When working with the term "queer" throughout this book, I attend to the post-1990s critique of the term as one that can elide differences in the process of creating a seemingly unifying term. For decades, queers of color have shown how the term "queer" erases intersectionality, particularly regarding race. Gloria Anzaldúa, writing over twenty years ago, argued, "Queer is used as a *false* unifying umbrella which all 'queers' of all races, ethnicities, and classes are shoved under . . . when we seek shelter under it we must not forget that it homogenizes, erases our differences."[25] Susan Stryker argued over ten years ago that "all too often queer remains a code word for 'gay' or 'lesbian,'" with trans experience falling outside a lens that "privileges sexual orientation and sexual identity as the primary means of differing from heteronormativity."[26] I am using this older historiography to make a point: trans and queer of color critique concerning the racial, class, and gender biases of the term "queer" has been around for a very long time. While neither Anzaldúa nor Styker is ready to jettison the term, they warn of how *queer* as an umbrella term can shove trans people and queers of color not under the umbrella but under the bus. Through attention to historical specificity, my use of the term "queer" throughout this project attends to racial and gender difference.

This book has been influenced by scholarship over the past decade in the history of emotions and in affect theory. Feelings, like attention, emerged as important objects of commodification for early twentieth-century merchandisers who had realized, along with the first generation of applied psychologists, that most purchasers were everything but rational when it came to buying goods. By the time psychologist Walter Dill Scott had published his *Theory of Advertising* in 1903, the culture brokers of American capitalism understood that—to quote one contemporary agency—"for every act based upon reasoning we perform twenty acts as a result of our emotions."[27] The merchandiser's job required the production of emotion as the consumer engaged with the commodity or its representation. Historically, the model's appearance in the salon or in the print advertisement staged a site for deep play: through the model's affective labor, in collaboration with the designer, photographer, editor, merchandiser, and other coproducers, commodities become imbricated with an orchestrated "look," or "feel," designed to produce sales. The transformation of consumers' emotions into sales can be understood as a form of commodified public feeling central to consumer capitalism, and in this affective relationship with the possible purchaser, the model becomes commercial feelings' coproducer.

Outside of recent work on what Kathleen Barry has called the "wages of glamour" among flight attendants, historians have been somewhat diffident about exploring the histories of affective labor.[28] We don't know as much as we might wish concerning the history of how gender, sexuality, and race have come together to inform the affective labor circuits of modern culture industries or service work. In other fields, particularly sociology, affect has emerged as a useful analytic category in understanding the immaterial labor of contemporary aesthetic, or creative, economies.[29] The recent historiography on affect, emotion, and feeling is voluminous, and I have written about it elsewhere.[30] For this project, the vein of scholarship that has most shaped my thinking about modeling has been that concerned with political economy and the movement of emotions between bodies, rather than simply the affective potentiality within the individual body. In the wake of Arlie Hochschild's groundbreaking early scholarship on the commodification of feeling in the 1980s, recent work within sociology has turned more to Marx and less to Freud in understanding the economic and political valences of affect as emotions in circulation between bodies, with instrumental effects; an influential example has been Michael Hardt's concept of "affective" and "immaterial labour" in analyzing contemporary creative industries.[31] This sociological literature in affect theory has not always

pursued an intersectional analysis, one that considers race, ethnicity, sexuality, and other vectors of difference while theorizing the affective. An exception is the work of Sara Ahmed, who has theorized not only affect as emotions circulating between bodies but also affect as a racial project.[32] I have turned to Ahmed's work, as well as those scholars working within American Studies' public feelings networks, to bring affect as emotions circulating between bodies, constituting publics, together with the history of racial formation in the United States.

Sociologists have found affect to be a useful analytic approach in making sense of the complexity of modeling, in which the model's immaterial labor does its work in both live, performative settings and also through photographic representation. Elizabeth Wissinger and Joanne Entwistle, in particular, have emphasized the centrality of affective flows within the contemporary modeling industry. In their approach, affect works as an excess of energy and potential that explains how the ineffable and the embodied work together within the industry.[33] As an analytic approach, affect enables scholars to account for energies and potentiality that bridge the catwalk and the magazine page, the designer and the consumer, the photographer and the model. For Wissinger, affect helps us understand the ineffable qualities encapsulated in the joint production of the model's "look," the collective result of the immaterial labor of models, photographers, editors, stylists, and others in producing what sociologist Ashley Mears has called the model's "personality, reputation, on-the-job performance (including how one photographs), and appearance."[34] As a historian, my main goal is to bring this analytic focus on affect into dialogue with historical questions concerning the intersectional history of the body and commercial culture. My contribution to this literature is to both historicize models' collaborative work in producing commercial affect and at the same time take account of how racial difference shapes the varied ways in which models' affective labor has been produced, circulated, and interpreted.

In a somewhat different approach, queer theory has also engaged in the affective turn.[35] Ann Cvetkovich's approach and methodology in an *Archive of Feelings*, as well as her later work, has been especially influential for this project, as she ties questions of the archive—central to the work of historians—to everyday emotions and queer/feminist counterpublics.[36] Cvetkovich, Heather Love, Jack Halberstam, José Esteban Muñoz, and Shane Vogel, among others, have brought queer studies into conversation with both racial formation and affect theory through the key word of "feelings" rather than affect per se.[37] None of this important work, however, analyzes queer feeling through the market. Although my questions are more concerned with the production of

dominant narratives of commercial feeling, this important work in building a vocabulary concerning what Kathleen Stewart has called "everyday affect" has been critical to historicizing the production and circulation of everyday feelings in the public sphere.[38] In this project, I interpret modeling as a constellation of racialized, queer practices performed and communicated across shifting borders of time and place, catwalks and magazine pages.

Affect, as a potentiality and capacity that is both generated by bodies and exceeds them, may seem at first glance to exceed the specifics of a particular social identity. Indeed, one can argue that this is the precise reason for the recent "affective turn" in the humanities and social sciences: affect seems to promise an intensity that confounds the conscious mind, an autonomic remainder that in the view of some affect theorists is also a site of utopian potentiality precisely because of its unmappability. The vein of affect theory that focuses on the individual body's production of the briefly unmappable affective intensity stresses the importance of this brief moment as a site of ethics, creativity, and technologies of the self. Yet while the promise of the affective is in its unscripted nature, it doesn't stay that way for long—in Brian Massumi's interpretation, that unmapped moment is only a half second.[39] In the meantime, marketing directs this affective intensity into a cognitive and corporeal script tied to specific products. The work of the model is to use her body to produce an affective intensity for a potential purchaser; the goal of cultural intermediaries is to harness that affect for the purpose of building niche markets organized for particular, historical, consumer audiences. We saw this with Caroline Jones's marketing plan for Clairol: Born Beautiful's product appeal, scripted through discourses of both freedom and respectability, came to life through model Tracey Norman's affective engagement with both the product and the circumstances in which she was photographed, including the photographer's stage directions, the feel of the studio, and the soundtrack or lack thereof. Working with Sara Ahmed's different definition of affect as racialized emotions that move between bodies, we can see how affect can help us understand how a critical tool seemingly antithetical to social, political, and historical identities has been central to the work of both models and their affective coproducers.

In writing a history of the modeling industry, I contribute to the history of capitalism by investigating how historical formations of queer feeling have been tied to racial formation, the market, and consumer capitalism. In exploring the dystopic aspects of commercialized queer feeling, my work is in conversation with more recent work exploring the relationship between (homo)sexuality and normative practices regarding the markets and their global expansion. In this project, I join a growing number of scholars who approach an analysis of

capitalism through a queer lens. Rosemary Hennessey has asked in her work on sexual identities and the market, for example, how affect and sexual identity have been shaped by the economic structures of capitalism, including wage labor, commodity production, and consumption.[40] This work is in dialogue with a Marxist-inspired gay and lesbian historiography that has tied the emergence of modern sexual identity categories to the history of capitalism.[41] Recent scholarship on sexual minority cultures and capitalism has critiqued the post-9/11 emergence of homonationalism and homonormativity, as well as US hegemony in shaping the circulation of global "gay and lesbian" identities, while still other research has explored the development of the gay and lesbian market in the recent past.[42] Increasingly, scholars are beginning to tie together queer life and capitalist formations in historical perspective, as recent work by David K. Johnson, Phil Tiemeyer, Miriam Frank, and Justin Bengry have shown.[43]

The term "work" in this book's title has dual references. It is a reminder to historians of capitalism that work has always unfolded outside sites of industrial production, and is always gendered and racialized. The process of transforming goods into commodities, or shifting use value into exchange value, has its own labor force, in which models play a key, though unacknowledged, role. Models' affective labor is central to the mysterious process of transforming useful things (clothing, for example) into commodities; through gesture, expression, movement, and pose models create the commodity's surplus value. In this book, I focus on the work involved not in the production of objects but instead in the production of commodities: that is to say, I examine models' work in creating surplus value.

At the same time, "work" is also "werk": the queer, racialized performativity of the sashay, the strut, the stroll, as in RuPaul's low-camp *Supermodel: You Better Work* (1991). This is the work of "work it," as in the model's walk on the runway, or, to reach back still further in time, the streetwalker's seductive display of her wares. This bodily performance of spectacular femininity produces an affective excess that, I suggest throughout this book, offers possibilities for both capitalist dream worlds and for queer worldmaking. Surprisingly, even Marx, in theorizing how capitalism derives value from things, found this transformation to be a mysterious and queer alchemy: as he wrote, the commodity "is a very queer thing, abounding in metaphysical subtleties and theoretical niceties."[44] Of course, Marx used the term "queer" in its nineteenth-century meaning, as in odd, or crooked; indeed, other editions of *Capital* translate Marx's term as "strange." Yet this is the same meaning, of course, that came to define those with nonnormative sexualities. Excessiveness—as an affective, sartorial,

and gestural performance—has signified both the diva and gay femininities throughout most of the twentieth century. Read as an analogue for Marx's surplus, excessiveness—a time-honored marker for camp—is itself a queer thing indeed. "Work," then, as a term, references both the affective labor central to the production of surplus value and, at the same time, the excessiveness of often racialized queer performativity.

Work! A Queer History of Modeling charts the paradox of queerness at the center of capitalist heteronormativity. The model's body has functioned as a transfer point for a series of people and practices in the service of both sales and queer worldmaking. The aesthetic industries, including fashion and design, have historically been one site where gay men and lesbians have found some degree of social tolerance, and where they could build queer worlds while making a living shaping heteronormative cultural production. Black models, designers, and other cultural intermediaries in the parallel, Jim Crow, pre-1970s modeling world have, in their very insistence on black beauty, challenged whitestream aesthetic hegemony. Modeling has historically brought together a network of cultural intermediaries whose practices, gestures, material choices, and aesthetic allegiances have been shadowed and shaped by queer sensibilities. Whether throwing shade, overaccessorizing, or performing affectlessness, the modeling industry has long been a queer haven hiding in plain sight. As José Muñoz reminded us, the longer history of being open to attack has meant that queers have had to transfer knowledge covertly.[45] Queerness has had to exist, historically, in innuendo, fleeting moments, gossip, and gesture—an ephemera of queer performativity that evaporates at the hint of exposure. This cultural history has been shaped not so much by sexual acts as by queer relationality to mainstream cultural objects, images, and affects. As I show, the modeling industry has been, historically, the site of a queer structure of feeling, one that—like all such structures—is also directly tied to the history of the market.

WORK! A QUEER HISTORY of Modeling pursues several narrative threads over the course of five chapters. I chart the history of a new form of sexuality in modern America—a managed, de-eroticized form of sexuality central to modern capitalism. I show how this emerging form of sexual capital is racialized, and how black and white models have had to navigate this sexuality in different ways, and why. In focusing on the contributions of black models and sexual minority photographers, I offer a queer history of the industry that emphasizes the central role of these figures in the history of twentieth-century capitalism. By historicizing models' affective labor, I show how the body's production and

circulation of feeling has been commodified, and made central to how economic value accrues within commercial culture. Finally, I offer an account of how queer and black cultural intermediaries have been central to capitalism; in this way, I provide one account of capitalism's queer history.

In my first chapter, I chart the transition from the artist's model to the commercial model in the first decades of the twentieth century. I explore how transformations in advertising and photography set the stage for an industry-wide shift to working with models for commercial work, providing the foundation for the founding of the first modeling agency, the John Roberts Powers agency, in 1923. During the same years, photographer Baron de Meyer brought a queer, affective aesthetic to his work as Condé Nast's first paid staff photographer, where he transformed the visual discourse of fashion photography. These shifts in commercial photography drove the labor demand for photographic models, whom the public saw as akin to prostitutes and chorus girls, working-class women on the make. Powers and his competitors, Harry Conover and Walter Thornton, cleaned up the model's image, repackaging her otherwise illicit sexual allure as clean Americana. This sanitizing of the model's sexual appeal is part of a larger transformation of female sexuality in the public sphere.

Chapter 2 explores the centrality of models to both US couture and to the American stage, which was a key site for the elaboration of modeling as a form of commercialized gender performance in the World War I years through the 1920s. I focus on the first couturier mannequins in the United States, who emigrated as models for the couturier Lucile (Lady Duff Gordon), and who then became the first Ziegfeld showgirls when Lucile began designing costumes for the *Ziegfeld Follies* and other productions. During a period of intensive cultural borrowing across the color line, this chapter reads the Ziegfeld models/showgirls against the massively popular African American Irvin C. Miller revue, *Brown Skin Models* (1925–55). While the stage models constructed and circulated a commodified version of female sexuality, these performances were racial projects as well; the chapter shows how stage models consolidated contemporary discourses of Anglo-Saxon whiteness as well as negotiated competing claims of New Negro modernity.

Chapter 3 examines the queer production of modern glamour through the work of leading figures of fashion photography from the 1930s through the early 1940s, all of whom knew each other intimately and were connected through a transnational queer kinship network. The photographers include George Platt Lynes, George Hoyningen-Huene, his lover and former model Horst P. Horst, and Cecil Beaton. These photographers, who we would mostly describe as gay today, dominated the production of fashion images for *Vogue, Harper's Bazaar,*

and *Town and Country* in the United States and Europe before World War II. Through a focus on the model Ruth Ford, one of Lynes's favorite models in the late 1930s, I show how this queer kinship network coproduced, with Ford, her "look," thus launching her career in the modeling industry, and later Hollywood. The chapter considers notions of publics and queer counterpublics in the years before Cold War antihomosexual panic, and the transformations in post–World War II fashion photography as Richard Avedon and Irving Penn redefined the field.

As the post–World War II prosperity unfolded, US merchandisers developed an interest in the "Negro market," in the years before the civil rights movement turned its attention to Madison Avenue's color line. Chapter 4 discusses black models who worked for the Brandford (later, Watson) and Grace Del Marco agencies, the first black modeling agencies in the United States. Their work unfolded in the context of an expansion of the black middle class in the early post–World War II years, a growing affluence that made consumer marketing to black audiences more attractive to businesses willing to cross the color line by hiring black models for the first time. At the same time, however, black models worked within the shadow of a deeply entrenched history of racist representation of black bodies in American advertising. This chapter explores the work of these models and agencies in the period before the agencies agreed to book nonwhite models in the late 1960s.

The book's concluding chapter explores the modeling industry through the lens of the long 1970s and the relationship between modeling and some of the social changes wrought by this period of political upheaval. I explore the varied discourses of the natural, the real, and the authentic within the modeling industry between the mid-1960s and the early 1980s, when the rise of the "supermodel" transformed the profession. This was a period of token racial integration in the modeling industry, with nonwhite models such as Kedakai Lipton and Naomi Sims winning lucrative modeling contracts. I examine these models' productions of femininity against the counterarchive of second-wave feminism, whose critiques of sexism shifted in these years from a radical critique of militarism, racism, and capitalism to a cultural feminist celebration of authentic womanhood rooted in biological difference. Cultural feminists criticized the modeling industry and consumerism for producing an artificial, plastic, manufactured version of femininity; in contrast, they emphasized women's biological differences, particularly the capacity to give birth, as the site of nature. I examine the costs of this definition of gender in relationship to the history of transfemininity, including within the modeling industry. The feminist critique of market-inflected femininity as artificial and unnatural

problematically produced a competing set of gender ideals that saw femininity as biologically determined while at the same time underestimating the role of the market in shaping gender.

Models, Photography, and the Racialized History of the Body

focus on models' affective work

Models' affective labor requires their work with the body, the material instrument through which models generate sexuality, desire, and value. In my focus on models' affective work, I offer a contribution to the intersectional history of the body that has been unfolding for some decades, in the wake of the English translation of Michel Foucault's work on biopolitics, as well as the US historiography that this work engendered.[46] As this scholarship has shown, the history of the twentieth-century body is inseparable from the much longer history of the Anglo-American racialized discourse of civilization, a discourse that is tied directly to histories of the body. Since the midnineteenth century, photography has played a central role in lending its rhetoric of empiricism to these racializing projects. As photography pushed out pen-and-ink illustration in commercial and fashion advertising in the early twentieth century, this longer history of racial formation, the body, and photography has come to haunt modeling's visual and corporeal discourses throughout the twentieth century, and indeed to our present day. This pernicious legacy concerning the relationship between racism, visual culture, and the model body has inexorably shaped how twentieth-century consumers, art directors, photographers, and other cultural intermediaries made sense of what they were seeing and feeling in relationship to the model event. This is the racist legacy that black and other nonwhite models have had to confront, negotiate, and disrupt as part of the industry's racialized body politics.

The racial politics of the model body were fully elaborated in the nineteenth century's most ambitious research project concerning human and animal movement, a photographic project that was, quite likely, the first sponsored research project in the history of the modern American university. Between 1884 and 1886, the photographer Eadweard Muybridge sequentially photographed ninety-five human and animal models performing a range of quotidian and exceptional movements, resulting in over 100,000 images and 781 published collotype plates containing more than 20,000 figures of moving men, women, children, animals, and birds. Unfolding at the cusp of when the invention of the halftone printing process allowed the mass printing of photographic images for the first time, thereby enabling the photographic representation of the human body in print advertising, the Muybridge project is, in some ways, the beginning of the

Muybridge

modern modeling industry. While most of Muybridge's human models were male students at the University of Pennsylvania, several of his female models were artist models whom Muybridge paid to demonstrate everyday activities accomplished with grace, poise, and a managed, gendered eroticism—precisely the elements of the parasexuality that later came to dominate the commercial, photographic modeling industry. For example, Muybridge hired artist's model Catherine Aimer for five hours on July 18, 1885, to undress and bathe and pour water over her head, dry herself, step out of the bath, and put on stockings—activities that could be read simultaneously as mundane or pornographic, depending on the context.[47] In September 1885, Muybridge paid artist's model Blanche Epler to walk up and down a short flight of stairs with a water vessel (fig. I,2).[48] The female models, as well as the white male athletic models whom Muybridge also photographed, were meant to represent ideal types: the ideal and the white are linked together in a normative understanding of racial hierarchy.[49]

The history of scientific racism and photography is most clear in Muybridge's work with his male models, especially his photographs of Ben Bailey, a "mulatto" pugilist, and the only nonwhite model he worked with over the course of three years. During their work together, Bailey walked, ascended and descended stairs, struck a blow, and threw a rock for Muybridge's cameras (fig. I.3).[50] Though Muybridge worked with ninety-five human models, it was during his work with Bailey on June 2, 1885, that a key instrument of scientific racism—the anthropometric grid—appears for the first time in American photography. First published in 1869 in the London-based *Journal of the Ethnological Society*, J. H. Lamprey's new grid system promised a means of measuring, photographing, and comparing racialized anatomies in the service of British colonialism.[51] Before this early summer day in 1885, Muybridge had photographed his subjects against a plain background; after this day, however, all were photographed against a five-centimeter grid of white strings, designed to allow racialized comparisons across body types. This technology of visual empiricism arrived in the United States for the first time as part of Muybridge's sponsored research, when he was photographing Ben Bailey; no doubt, the grid appeared through the intervention of his scientific supervisory committee, three of whose members were founders of the American Anthropometry Society, as well as key figures in Anglo-American science's efforts to taxonomize racial difference.[52]

While it may seem that anthropological photographs were a world away from the ways of seeing that captured the artist's model or the fashion model, these technologies and their histories are closely linked. Lamprey's anthropometric

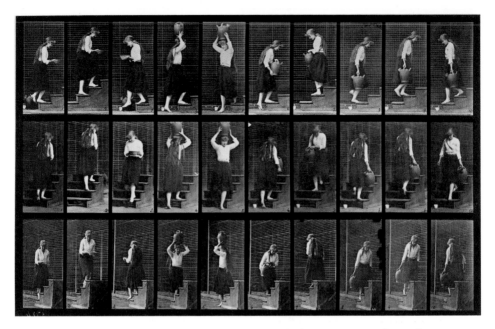

FIG. 1.2 Blanche Epler modeling for Eadweard Muybridge. PL 504, *Ascending and Descending Stairs* (1887), catalog no. 2873, Archives Center, National Museum of American History, Smithsonian Institution, Washington, DC.

grid, a key technique for nineteenth-century race science, emerged from a much longer history of perspectival seeing in the visual arts, and was readily adapted to both aesthetic and scientific ends.[53] Lamprey himself made the linkages between racialization, science, and aesthetics clear when he argued that the vertical silk lines would allow the comparison of height between, for example, a "good academy figure or model of six feet" with "a Malay of four feet eight in height."[54] In this one sentence, Lamprey uses the model to link the discourse of the fine arts with that of European scientific racism. In American photography, Muybridge's multiyear project was both an investigation into comparative racial anatomy—that is, scientific racism—and a project designed for painters, sculptors, and others viewing the body for aesthetic purposes: Muybridge's studies of both human and animal movement would be of value, he claimed, to both "the Scientist and the Artist."[55] These twinned histories of scientific and aesthetic ways of seeing, both of which were imbricated in discourses of racial hierarchy, have continued to haunt the social meanings of the body on display. Racial meanings continue to shape how we understand the model's body, whether in fashion, art, or consumer culture.

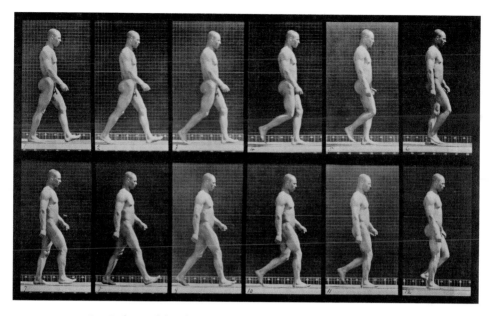

FIG. 1.3 Ben Bailey modeling for Eadweard Muybridge. PL 6, *Walking* (1887), catalog no. 2430, Archives Center, National Museum of American History, Smithsonian Institution, Washington, DC.

Muybridge's work at the University of Pennsylvania exemplifies another historical thread haunting the history of the body within twentieth-century modeling: the intersectional history of whiteness and the exemplary body. The flip side of Anglo-American racial investments in the nonwhite body concerned not the racialized other but the ideals of whiteness. Working with Muybridge's project again—merely as one example to describe the historical imbrication of photography, modeling, the history of the body, and white supremacy—most of the male models in Muybridge's project were white, middle-class, male students whose so-called feeble bodies were just emerging as a site of concern for university administrators.[56] Muybridge's work documenting the ideal male, white body became an important tool for a generation of amateur athletic directors, physiologists, and hygiene experts, who, in the context of the late nineteenth century's xenophobic and racist discourses of civilizational decline, used Muybridge's photographs of male and female models to visualize ideal body types.[57] As Carolyn de la Peña and Christina Cogdell have argued, reformers' investment in the white, ideal body became central to the discourse of eugenics in the US context.[58] Muybridge's photographs of these same male

bodies, exemplifying the energetic rather than the enervated, offered models of ideal whiteness for anxious custodians of white Anglo-Saxon supremacy.

As this brief discussion suggests, Muybridge's work shuttled between discourses of the ideal and the typical model body. This semantic overlap between the ideal and the typical continued into the twentieth century, when the terms "normal" and "normality" emerged as racialized key words in American scientific and popular culture to define both the typical and the ideal body. Although the idea of the norm has a much longer history, by the twentieth century normality no longer meant the average; rather, social science statistics, mass media, and the pressure to conform together redefined normality as a norm that anyone, theoretically, could pursue and achieve. As Julian Carter and Anna Creadick have argued, normality emerged as a term that brought together the average and the ideal to describe the American body, mind, and character.[59] Although theoretically this body eschewed identity categories such as race, sexuality, gender, and class, in fact social and life scientists developed the epistemological category of normality from data drawn largely from upper-middle-class, white, heterosexual male bodies. Whiteness and heterosexuality emerged as synonymous with normality within the twentieth-century social science surveys that together produced the average American. As Sarah Igo has argued in her analysis of Robert and Helen Lynd's ethnography of Muncie, Indiana, published as *Middletown* (1929), social science's shift from the Progressive Era's "problem" populations of the poor, the immigrant, and the nonwhite to a focus on a "representative" community was achieved through a near-exclusive focus on white settler populations. "No longer were 'foreign elements' or 'Negroes' deemed crucial to the study," she argues. "Rather, they became hindrances to locating the typical."[60] By the post–World War II period, as David Serlin has shown, medical science joined with the extraordinary body to produce new hypernationalist narratives.[61] Whiteness, heterosexuality, and able-bodiedness became embedded in the average, typical body over the course of the twentieth century in ways that, as Julian Carter has argued, were signaled in "race-evasive codes"; as he argues, one of the hallmarks of modern whiteness was "the ability to construct and teach white racial meanings *without appearing to do so*."[62]

We see the legacy of nineteenth-century racial science in the twentieth-century race-evasive codes of the modeling industry's use of both the typical and the ideal body. Photographic modeling became the site of the "typical" body, where white, pretty, female models provided aspirational fictions for white consumer audiences. Black models have been forced to navigate a racialized landscape in which typicality has been a synonym for whiteness; as a

result, they have been systematically barred from whitestream publications, unless appearing as exemplars of the exotic—or the atypical. Fashion modeling became the site of the extraordinary body, where models of atypical proportions and features gained status—but here, too, whiteness has been signaled in race-evasive codes that anchor racial meanings without appearing to do so. Over the next chapters, I show how, historically, the modeling industry's racial history has unfolded in relationship to the model body.

Work! A Queer History of Modeling is framed by a number of historical questions concerning the relationship between the racialized body, sexuality, and the market. How can we understand the relationship between sexuality, public culture, and racial formation as it has changed over time, in tandem with other developments in US history? What role has the market played in mediating these relationships? How have commercial cultural brokers produced and managed specific feelings for commercial goods over time, and what roles have varying model types played in this history? What relation has this commercialized affect had to consumer desire, and to sexuality itself? *Work! A Queer History of Modeling* answers these questions through tracing the history of this relationship between the body, commerce, and desire, and shows how social and cultural ideas concerning gender, race, the body, and sexuality have been queerly and historically imbricated with the market cultures of modern capitalism.

From the Artist's Model to the Photographic Model

CONTAINING SEXUALITY IN

THE EARLY TWENTIETH CENTURY

Today, when one uses the term "model," most people think of the fashion model. And truly, this association does make sense: the editorial fashion model has garnered the most press attention, especially since the rise of the supermodel in the 1980s. But historically, the model emerged from the artist's atelier and came of age in the interwar years, when photography transformed advertising, creating an industry demand for photographic models. In this chapter, I sketch out some of the meanings of the term "model" in the first decades of the twentieth century, charting the shift from the older, nineteenth-century artist's model to the emergence of the photographic model in the first decades of the twentieth century. The turn to photography affected the fashion industry, of course, but it also revolutionized print advertising for the consumer products that exploded onto the American scene in the prosperous 1920s, including automobiles, radios, toothpaste, refrigerators, soap, rugs, perfume, cosmetics, and pianos. With the rise of photography within advertising and fashion in the interwar years, a market developed for actors or types to appear in these commercial narratives. Within fashion, in particular, a queer photographic aesthetic pioneered by Condé Nast's first paid staff photographer, Baron Adolph de Meyer, transformed how models were represented in the pages of the new fashion magazines. Quickly thereafter, John Robert Powers founded the first modeling agency in order to represent these new cultural workers, and sell their

labor to art directors and photographers, who began working with models on shoots for everything from furs to furniture. Members of the public began to encounter the new figure, the model, in the pages of the illustrated press, the cinema, and especially on the stage—a development I discuss in more detail in the following chapter. Working in dialogue with both photographers and the new modeling agencies, models played a central role in producing a commercialized zone of public discourse that linked gender, class, and racial meanings to commodity forms, and in which sexuality became inextricably linked to the marketing and sale of goods.

Artist's Models and Cloak Models: Working-Class Femininity on the Make

model as person

Before the early twentieth century, US merchants or dressmakers would display clothing on an inanimate store fixture, often made of wax, which the French called *mannequins*. The Americans used the term "manikin" as well (spelled in myriad ways), but throughout the nineteenth century the term referred to a model of human anatomy, such as those used in nineteenth-century natural history demonstrations. Up until World War I, with the exception of the artist's model, the term "model," in both English and French, referred not to the human being but to the material goods—the dress, coat, or corset—being sold. As with the early twentieth-century term "typewriter," which once referred to the woman who operated the machine, this new term slipped between a description of the object and the person, as new aspects of human behavior and subjectivity became organized through the market. By about 1908, the terms formerly used to describe the object—the model—migrated to the person, and trade accounts of department store merchandising, as well as the general press, began referencing "living models," which by the late second decade of the twentieth century had become simply "models."

Before the 1920s, the term "model"—when referencing a woman—connoted a number of related social types, all of which implied a form of sexuality at odds with Victorian (and Edwardian) mores. The figure most closely identified with the term in the period before World War I was the artist's model. The term "artist's model" described a woman (rarely if ever a man) who was part of the demimonde—a woman of bohemian leanings who would be willing to undress for money, and perhaps do more. Models were working-class women who began assuming the modeling stand in artists' Parisian ateliers in the 1860s; while artists and models did not necessarily pose nude to suggest immodesty, or as an erotic prelude, popular discourse constructed the artist's model as a working-

class woman whose chastity was easily compromised.[1] A sympathetic portrait of this type was immortalized in George du Maurier's *Trilby* (1894), in which the beautiful artist's model Trilby O'Farrell falls under the sinister spell of the musician Svengali.[2] Another popular example was Pierrette, the poor model for Pierrot, the "hungry, discouraged artist" hero of the much-performed pantomime "Le Réveillon de Pierrette," which later served as a model for the plot for Lady Duff Gordon's 1917 fashion show/theatre piece "Fleurette's Dream at Peronne."

As these brief examples suggest, the stock character of the "artist's model" was seen as primarily a French import, in which the "artist's model" had become a figure in the public imagination with the rise of mass media and panorama literature during the 1830s and 1840s.[3] In the US context, some representations of the artist's model allowed popular cultural representations of the lightly clad female form to avoid obscenity charges, as suggested by the popularity of early films concerning a variety of models, such as *The Substitute Model* (1912) and *The Model's Redemption* (1913).[4] As bohemian tastes migrated to the middle class, the romanticized version of the artist's model fueled the "living pictures" of the nineteenth century through the second decade of the twentieth century and Ben Ali Haggin's extraordinary popular patriotic spectacles for the Ziegfeld Follies, discussed briefly in the following chapter. The middlebrow appreciation for the artist's model continued through the late 1920s, resulting in, for example, a series of images and texts depicting "artists and their models" in the US women's magazine *Redbook*.

Another important site for the development of the model as person was the European couture establishment. As Caroline Evans has shown, while European dressmakers had also displayed their new clothing models on wax or wooden dummies, the British-born, Paris-based couturier Charles Frederick Worth learned how living models could showcase the way movement animated the goods on display.[5] Worth was a salesman for the most famous mercers of Paris, Gagelin, where young women, known as *demoiselles de magasin*, displayed shawls and mantles (the only ready-to-wear clothing items) for prospective buyers. These young women were proto house models, and Worth married one of them: Marie Vernet. With his wife Marie as house mannequin, Worth opened his own couture establishment in 1858, where he soon became the dominant couturier for the court of Napoleon III; Charles and Marie imported the mannequin parade from Gagelin while developing a new practice of having on staff several mannequins who were available to put on a dress for the client's inspection.[6] The massive scope of Worth's business (by 1871 he had a staff of twelve hundred), combined with his innovation of having each dress available

in several colors, meant that he needed more mannequins, or house models, to parade them before the princesses and duchesses who flocked to his establishment. (And because society expected every elite woman to wear a new gown to each social occasion, as well as to change her wardrobe up to six times daily, noblewomen visited Worth's with great frequency.)

But as Elizabeth A. Wissinger has argued about these early house models, there wasn't anything particularly glamorous about them. These working-class women merely had to be able to be somewhat polite to the clients and walk in a straight line.[7] The house model's working life combined frenetic fittings leading up to a society ball, for example, with boredom and exhaustion. Some house models worked for designers who created clothes directly on the body; these models posed for hours, for little wages. Other models waited, perfectly groomed, until a client arrived, only then moving into a calm frenzy of quick fittings. House mannequins wore, over their corsets yet underneath their couture clothing, a high-necked black silk satin *fourreau*, designed to cover the skin and highlight the couture design. These mannequins were meant to be walking clothes dummies; they did not speak to clients and, like other servants to the well-to-do, were meant to be simultaneously present and invisible.[8] The mannequin was, as Caroline Evans has argued, a "living object," an animated wax doll or show-window dummy who transgressed the borders between human and machine, woman and automaton.[9] Because the term "manikin" translates as "little man," as the French writer Colette observed, the mannequin's "very sex is dubious"; she is, in other words, a trans figure in multiple, contemporary senses of the word.[10]

It wasn't until the French designer Paul Poiret and the British designer Lucile began to cultivate the models' look, walk, and affect that public fascination with couture models began to develop outside the rarified space of the couture salon. Poiret understood that the model's affective engagement with his couture designs was essential to their success. He wrote in 1931 of the term "manniquin" that "the word is very ill chosen," as it failed to capture the model's corporeal work.[11] "A mannequin is not that wooden instrument," he wrote, "unprovided with a head or heart, on which clothes are hung as on a clothes hanger." Rather, he argued, "The living mannequin is a woman who must be more feminine than all other women. She must react beneath a model [couture design], in spirit soar in front of the idea that is being born from her own form, and by her gestures and pose, by the entire expression of her body, she must aid the laborious genesis of the new creation."[12] As designers began to cultivate the mannequin as a feminine avatar of sartorial creativity, she began, as fashion historian Diana de Marly has argued, to replace "the seamstress and the shop

girl in the imagination of the predatory male as the sort of girl who was ripe for seduction but not for marriage."[13]

As mannequins began to be employed by department stores and other manufacturers of ready-made clothing, they modeled for the trade that, in New York, developed on Seventh Avenue. In the years surrounding World War I, these wholesale models were known as "cloak models": they demonstrated ready-to-wear clothing for wholesale buyers, and would then sometimes entertain these out-of-town gentlemen after hours. Although the cloak model, or wholesale model, continued as a profession after World War I, it was the introduction of the cloak model to American audiences (often through literary and stage representation through, for example, a short story by O. Henry or a Montague Glass stage play) that paved the way for retail mannequins in the post–World War I years.[14] Out-of-town male (often married) wholesale buyers would visit wholesale ready-to-wear manufacturers where the chief of the manufacturer's showroom would demonstrate the firm's clothing "models" on the living model, one of several young women kept on staff to parade the clothing for the buyer's review. In New York City in 1916, for example a wholesale maker of suits for larger women kept on staff sixteen models. In a typical day, the models appeared at the wholesale showroom at 8:30 a.m. to put on the clothing models available for sale; at 9:00 a.m., when the buyers arrived, the firm's models would "parade" the clothing in a mass market adaptation of the couturier's fashion show, developed some years earlier in Europe, and introduced to the United States in 1908. In between parades before prospective buyers, the models would also help out the firm's sales efforts by folding advertising circulars or hanging completed clothing.[15]

In the wholesale trade during these years, the audience for the manikin parade consisted primarily of the buyers for a retail venue, such as a department store. Historically, most (but not all of) these buyers were men. Modeling became a key site for the elaboration of commercialized forms of heterosexual exchange that emerged with the rise of mass culture and urban forms of leisure in the early twentieth-century United States. Although few sources in this early period discuss the informal sexual expectations concerning such commercial exchanges directly, there is some indication that models were either expected, or chose, to socialize with the buyers outside the showroom. As one model wrote, despite arguing that it was a myth that models entertained buyers as part of their work, "I'm not saying that I've never gone to dinner or the theater with an out-of-town buyer, and I'm not even saying that, having gone with one of them, he hasn't tried to kiss me good night."[16] Some models anticipated these visits by the out-of-town buyers as a perfect opportunity for an all-expenses-paid

night on the town, as well as a chance to pick up a few "gifts" of cosmetics or other consumer items.

In an article detailing her work as a retail and wholesale dress model, "Nellie" described two of her colleagues that, in her view, fit the "conventional idea of models."[17] These women, she said, though pretty in a conventional way, overdid their rouge and powder—both of which were just becoming acceptable for young women, but which still retained their theatrical (and sexually available) connotations.[18] "Their sole object in life was to have a good time, and their pride was to graft as much as possible from the various young men of their acquaintance. They would spend hours boasting of how they had lured last night's swain into a drug store and held him up for a bottle of expensive perfume and a whole array of cosmetics. Yet," Nellie continued, "they were good girls who would have slapped the face of any youth who misinterpreted their motives."[19] The author of this *Saturday Evening Post* article used the pseudonym of "Nellie" to signify the "about town" model, fictionalized in the popular Broadway production "Nellie, the Beautiful Cloak Model" (1906); from 1906 through the mid-1920s, the term "Nellie the cloak model" was shorthand for working-class femininity on the make. As one observer noted in 1930, the cloak model of this era was fundamentally also a sexual hostess for out-of-town buyers: "It was generally conceded that their daytime work was supplanted by labor after office hours," to such an extent that "outdoor evangelists included 'cloak models' in their litany of brazen sinners."[20]

These models were fundamentally "charity girls," working-class women participating in the commercialization of sexuality known as "treating" in the years surrounding World War I. As historians Kathy Peiss and Elizabeth Alice Clement have argued, working-class men and women developed the courtship practice as part of the growth of commercialized forms of leisure in early twentieth-century cities.[21] Working-class women who worked outside the home, unlike the men in their family, often turned over their entire pay packet to their mothers, as a contribution to the family economy. This dutiful practice, however, left them without the funds to participate in the emerging mass consumer culture, identified in "Nellie's" anecdote as cosmetics but also including movies, dance halls, and other forms of commercial entertainment. Working-class women would often exchange sexual favors for a night on the town or the purchase of "gifts"; as there was no exchange of money, no one (except vice reformers) saw the practice as related to prostitution. By the 1920s, this commodified set of expectations (the man pays; the woman "puts out") became normalized, migrating to the middle-class practice known as "dating." Because of this history, wholesale modeling retained an element of scandal for families

shaped by middle-class morals; as the fictional Nellie explained to her readers, when she told her parents she planned to become a dress model, "a riot followed."[22] Nellie herself failed to see the pitfalls; from her perspective, seeking a living as a single girl in New York, she recognized the profession as "the only occupation for unskilled workers that pays a decent wage."[23] Whereas reformers and anxious parents might see modeling as a "hotbed of vice," to quote Nellie, or models as exemplars of a problematic "woman adrift" in the urban landscape, by the early 1920s modeling represented the epitome of independence, femininity, and glamour that a generation of young women identified with a postfeminist, postsuffrage female modernity and consumption.[24]

In the United States, the development of clothing modeling corresponded with the maturation of the department store and the women's ready-to-wear clothing industry. As a result, what had been primarily an intimate and exclusive practice of modeling unique gowns for high-end clients in closed showrooms migrated to free, public displays of ready-to-wear designs for a middle-class audience who viewed models displaying the new fashions in the department store, charity fashion parade, or Broadway show. Both the department store and the high-end couturier shop bore a close relationship to the New York stage in terms of set design, costuming, choreography, and performers (models). In the department stores, as Marlis Schweitzer, Caroline Evans, and William Leach have shown, the growing importance of fashion pushed department store owners to theatrical strategies in merchandising goods.[25] By the early twentieth century, the development of ready-to-wear clothing had catapulted the clothing trade to the third-largest industry in the United States, behind only steel and oil. The entire industry was largely derivative of French fashions before World War I: US wholesalers and retailers sent buyers and other representatives to Paris, who copied the Parisian upper-class trade for the American mass market.

More than any other single development, it was the fashion show that introduced the model to American audiences. By the first decade of the twentieth century, US department stores were relying on the living model to sell clothing to not only wholesale buyers but also retail customers. The term "fashion show" migrated from the trade term used to describe the still-life display of goods and (nonhuman) manikins in the department store show window; after 1910, "fashion show" described the animated parade of living models who demonstrated clothing designs within the store itself.[26] As Caroline Evans has shown in her magisterial work on early fashion shows in France and the United States, whereas the Parisian fashion show demonstrated couture for small audiences by invitation only, the American retail shows were open to the public: thousands

flocked to the emerging palaces of consumer culture, especially department stores, to see American fashion manufacturers' simplified interpretations of Parisian couture.[27] An elaborate fashion show premiered for two weeks as part of a fashion trade fair in September 1903 at New York's Madison Square Garden. But one of the most important venues for middle-class American exposure to living models and the fashion show was the department store, most of which had large lecture halls and auditoriums perfect for staging such events. Department store merchant Rodman Wanamaker prepared elaborate fashion shows for Wanamaker's Philadelphia store as early as the fall of 1908, when the "fashion Fête de Paris" featured enormous picture frames trimmed in black velvet, with live models posed in the latest Paris gowns inside. Emerging from their frames, the models paraded down a walkway to the middle-class, retail audience of nearly two thousand, accompanied by soft organ music and the scripted commentary of the show's director, Mary Wall.[28] Other stores soon followed suit: the trade publication *Dry Goods* declared "the introduction of living models in the fall fashion show of Joseph Horne & Co., Pittsburg," a success in November 1910—the first time a fashion show had been staged in that city.[29] Department stores hired young women to parade down ramps in department store theatres, often organized around themes such as the "Monte Carlo" or the orientalist "Garden of Allah"; in 1911, thousands were still coming to see the living models parade Paris gowns, millinery, and wraps through an Italian garden and pathway through the pergolas installed within Gimbels, one of New York's leading department stores. This show was so successful that it went through twenty variations in five years, with thousands of women pouring into the store daily to see the models parading up and down the theater ramp in the newest styles.[30] Macy's fall 1911 fashion show, held twice daily over three days, was attended by around twelve thousand people, according to Carolyn Evans.[31] The success of these fashion shows led the National Retail Dry Goods Association to put together a list of suggestions for organizing similar events in 1913.[32] During the war, as Marlis Schweitzer had detailed, the fashion show emerged as a favorite charity fundraising mechanism, further popularizing the spectacle for middle- and upper-class audiences.[33] By the early 1920s, the fashion show had become a standard feature of both wholesale manufacturers' events and department store retail selling methods.[34]

Fashion spectacles such as those at Wanamaker's helped render the work of the cloak model visible to young women, who by the early 1920s besieged wholesale houses and department stores for modeling positions. Celia Mohoney, who hired models for the clothing wholesalers clustered on New York's Seventh Avenue, told a reporter that she was swamped by applications in 1924, and

suspected that the girls who wanted to be cloak models were outnumbered only by those who wanted to be movie stars: "They picture themselves as strutting through gorgeous showrooms, bored but beautiful, overcoming buyers from Sedalia, Missouri, and Ottumwa, Iowa, with awe and admiration. They want to be close to costly and alluring for a few hours a day, even though the evening finds them wearing again their own commonplace dresses."[35] A contemporary couture mannequin, however, expressed a more cynical view of the wholesale cloak model, and her position at the bottom of an emerging professional hierarchy. As Augusta, a blonde mannequin draped across a couture showroom's elevated chaise lounge, told a *New York Times* reporter in 1920, "The best thing that can happen to that kind of model [i.e., the wholesale model] is to marry her buyer from Kansas City, where she can get fat at her leisure and wear ready-mades for life."[36]

By the World War I era, then, the model had emerged as an emblem of working-class femininity on the make: beautiful, sexually knowing, and confident, models were the "It" girls of mass culture. The relationship between modeling and the ineffable quality known as "It" is more than coincidence because, as I show in the next chapter, the term was coined by the sister and collaborator of the couturier Lady Duff Gordon, who imported the first living mannequins to the United States in the pre–World War I years. This sexualized allure was central to the work of modeling, which in turn became integral to consumer capitalism as an emerging mass consumer economy increasingly relied on the elaboration of multiple strategies of enticement to grow domestic and international markets for consumer goods. All the types of models discussed in this book—the artist's model, the wholesale clothing or cloak model, the couture model/showgirl, the photographic model, and the fashion model—contributed elements central to the development of the profession as it emerged in the twentieth century: a suggestion of immodest indifference to conventional sexual propriety; the coproduction of modern forms of glamour and celebrity; and a facility in the production of multiple physiognomies, gestures, and looks in the service of commodified affect. A critical development of the profession was the models' elaboration of a new form of public, commodified sexuality that straddled the putative divide between public and private.

Fashion Photography and Queer Affect in the World War I Era

While Americans were attending department store fashion shows to see the newest trends, they were also encountering models in fashion and advertising photographs—often the same models, in fact. Advertising for consumer goods,

whether couture or cutlery, required commercial illustration to communicate new styles and increasingly brand-name products to readers, who encountered these goods in the pages of *Vogue* magazine or the *Saturday Evening Post*. Within the fashion industry, the photographer who transformed how models and couture were represented on the magazine page was Condé Nast's first paid staff photographer, Baron Adolph de Meyer. De Meyer's virtuosity with the camera, drawn from his work within the fine art movement in photography, successfully convinced fashion magazine editors that photographs, rather than pen-and-ink illustrations, could activate viewers' affective engagement. With this shift to photography to describe couture, the high-end fashion magazines set the stage for a new profession, to become ubiquitous after the war: the fashion model.

Cecil Beaton, the British interwar portraitist and fashion photographer, referred to Baron Adolph de Meyer as the "Debussy of the camera": an artist who successfully wed feeling and photography in his fashion work for *Vogue* between 1913 and 1922. "Few have had greater influence," Beaton argued, "on the picture-making of today than this somewhat affected but true artist."[37] Here, in two sentences, Beaton brought together feeling (Debussy) and affect—but in the pejorative sense, as in "affected," a flamboyant condition associated with superficiality, artifice, and gay femininity. But Beaton, who like de Meyer was both queer and a lover of artifice, was sympathetic to de Meyer, one of the most influential of pictorialists (the era's fine art movement in photography), and who definitively reshaped the visual vocabulary of modern fashion photography.[38]

De Meyer invented his own history, including his name, as assiduously as he invented himself. He was born around 1868, probably in Paris, though he spent some of his childhood in Dresden; in most accounts, his mother was Scottish and his father, German. He was half Jewish, German, and homosexual in a period marked by antihomosexual and anti-Semitic panic, emblematized by the Dreyfus affair (1894) and the Wilde trial (1895). These aspects of his identity produced a name change (from von Meyer to de Meyer), a *marriage blanc* in the wake of the Wilde trial, and two migrations to the United States on the eve of the two world wars. Although de Meyer spent his early years in Paris, he was educated in Germany in the 1880s, where he (like his lifelong correspondent Alfred Stieglitz) became influenced by the emergence of amateur photography, especially the *Photographic Jubilee Exhibition* in Berlin in 1889 and the Vienna Secessionist exhibition *Artistic Photography* in 1891. De Meyer placed his own photographic work in most of the major international photography exhibitions between 1894 and 1912, in London, New York, Paris, Brussels, and

Turin. The Linked Ring Brotherhood, the international photo-secessionist group founded in London in 1892, accepted de Meyer for membership in early 1898; he remained a member until 1910.

De Meyer moved to London around 1895, at the height of the aesthetic movement. An aesthete himself, with enough family money to shield him from the business of making a living, de Meyer quickly placed himself in the orbit of the era's fashionable circles, a newly emerged combination of wealth and aesthetic sensibility that entertained and financed the creative circle surrounding the future king of England, the Prince of Wales (fig. 1.1). In 1896 or so, de Meyer met his future bride, the queer fellow traveler Olga Alberta Caracciolo. Prince Edward, who became King Edward VII in 1901, was Olga's godfather, and possibly her biological father as well (Olga's mother, the Duchesse de Caracciolo, was unmarried). Olga and Adolph made a perfect platonic pair: glamorous aesthetes and lavish entertainers. Catty insiders dubbed them "Pederaste and Medisante," a reference to Maurice Maeterlinck's 1893 Symbolist play, Pelléas et Mélisande, which Debussy scored for opera in 1902.[39] In some accounts, de Meyer became "Baron" de Meyer in 1901, when Prince Edward asked his cousin, the king of Saxony, to confer the title so that Adolph and Olga might attend King Edward's coronation at Westminster Abbey.[40]

De Meyer's passion during these prewar years was the aesthetic movement in photography. Pictorialism, a popular movement in photography from the early 1890s through World War I, built on nineteenth-century English models in arguing for the creative possibilities of the camera.[41] Pictorialism emphasized feelings, emotions, and sentiment over the tyranny of fact, long presumed to be the camera's singular contribution to representation. The movement is often understood as the effort to elevate photography to the status of fine art, and in both subject matter and formal strategies, many pictorialists did indeed emulate the effects of late nineteenth-century European painters. As a definition of artistic seeing entailed the ability of the artists to select certain details for creative expression at the expense of others, pictorialist photographers needed to disrupt the camera's utilitarian leanings. Unlike mechanical or scientific photographs, aesthetic photographs required different means toward different ends. The pictorialist photographer sought emotional expression, rather than indexical verisimilitude; the camera, like the brush, was to be considered as yet another tool toward aesthetic ends.[42]

Between 1903 and 1913, when *Vogue* published his first society portrait, de Meyer developed the aesthetic approach that transformed fashion photography. As with other pictorialists, de Meyer focused on light, tonal gradations, and differential focus as a means of conveying the emotional tone of the aesthetic

FIG. 1.1 Baron Adolf de Meyer dressed in costume inspired by a painting for the
Devonshire House Ball, 1897. Lafayette (Lafayette Limited) contact print on gold-toned
printing-out paper, 13 7/8 × 11 in. (35.24 × 27.94 cm.). National Portrait Gallery, London.

photograph. He began backlighting his sitters, using light to define the line of a jaw, a halo of unruly hair. He pioneered the use of artificial light, employing floodlights, reflectors, mirrors, and the low flash as techniques for achieving his atmospheric interior portraits and still-life studies. (When Edward Steichen replaced de Meyer as Condé Nast's chief staff photographer in 1922, he had worked only with natural light, and was overwhelmed by the elaborate equipment that staff assistant James McKeon made available to him.[43] Perhaps unnerved by de Meyer's campy theatricality, Steichen wrote Stieglitz that de Meyer was a "pimp of a man."[44]) During this period de Meyer also acquired a Pinkerton-Smith lens, which allowed him to focus clearly on the center of the image, while the edges of the piece dissolved in a luminous glow.[45] Eventually, to intensify the luminosity of his images still further, de Meyer stretched gauze or lace across the lens in the effort to disrupt the camera's indexicality. Through these pictorialist techniques, de Meyer pushed the camera image toward the connotative meanings of the aesthetic movement in photography: beauty, metaphor, symbolism, and emotional intensity. These techniques of producing aesthetic feeling became centrally important to his fashion photography at *Vogue* after 1913.

In the years after their patron King Edward's death in 1910, the de Meyers traveled with the Ballets Russes; in 1912 de Meyer photographed principal dancer Vaslav Nijinsky in his first work as a choreographer, the erotic and sensational ballet *L'après-midi d'un faune* (fig. 1.2). The de Meyers eventually settled in London, but when World War I broke out, they became the focus of rumors that both of them were German spies; they departed for New York with their friends the Speyers, wealthy London-based German-Jewish bankers who found themselves in a similar predicament. The de Meyers arrived in New York in 1914 with excellent connections but no money or patrons.[46] But they landed on their feet, as the de Meyers' arrival in New York coincided with the ascendancy of Condé Nast's magazine *Vogue* as the arbiter of American fashion, taste, and style.

Condé Nast, a Midwest-born advertising manager for the popular magazine *Collier's Weekly*, bought *Vogue* in 1909. Founded in 1892, *Vogue* had been a minor society gazette with a circulation of less than fourteen thousand, overshadowed by the numerous more successful magazines, such as the *Ladies' Home Journal* and the *Delineator*, both of which also covered fashion but which boasted circulation of over one million. Nast avoided the mass audience made possible by the "ten cent magazine revolution" of the 1890s: with *Vogue*, he explicitly sought to create an elite "class" magazine for American tastemakers, funded by advertising dollars from the nation's most exclusive retailers.

FIG. 1.2 Vaslav Nijinsky in *Prélude à l'après-midi d'un faune* by Baron Adolph de Meyer, 1912. Jerome Robbins Dance Division, New York Public Library Digital Collections, New York Public Library.

Of modest background himself, Nast's marriage in 1902 to Clarisse Coudert, whose family was part of New York's elite Four Hundred, guaranteed the necessary elite access (Nast's name, as well as those of three relations, was published in the *Social Register* for the first time in 1902).[47]

By 1911, two years before de Meyer's first photograph was published in *Vogue*, the new magazine had taken shape. Like its predecessor, it was designed as a handbook for the elite social life of the Edwardian bourgeoisie, covering mostly fashion (including patterns) and society news (weddings, summer resorts, and charity events). Specifically, Nast saw the magazine as the "technical advisor . . . to the woman of fashion in the matter of her clothes and her personal adornment."[48] He increased the magazine price from ten to fifteen cents, and reduced its publication schedule from weekly to bimonthly. New advertising, at exorbitant rates of ten dollars per thousand readers, pushed the page number of each issue from the formerly modest thirty pages to over one hundred; color found its way to each lushly drawn cover.

Fashion photography, as we might call it today, appeared in two guises in these early years: via *Vogue*'s "society portraits" and through the fashion essay. Each *Vogue* issue carried a "society frontispiece" by a portrait photographer; by 1917, each issue carried several such full-page portraits, spread throughout the issue. In the early 'teens, the portraits were generally straightforward descriptions of their well-known society, film, and theatre subjects, made by established commercial and theatre photographers such as Aimé Dupont, Ira L. Hill, and Curtis Bell. Very quickly, however, New York's leading aesthetic photographers began making *Vogue*'s society portraits, most frequently Arnold Genthe and Gertrude Kasebier, as well as E. O. Hoppé. In the January 15, 1913, issue, de Meyer's first photograph appeared in a full-page portrait of Mrs. Harry Payne Whitney (fig. 1.3). Also known as Gertrude Vanderbilt Whitney, de Meyer's subject was an art patron, philanthropist, and sculptor who founded the Whitney Studio Club in 1918, which became the Whitney Museum of American Art in 1931.

De Meyer's portrait perfectly connotes the social, economic, and aesthetic longings of *Vogue*'s implied readership. The slender Whitney stands imperially before the camera at a slightly oblique angle, her left hand resting lightly on her hip, while her right arm anchors her body to the indistinct studio furniture behind her. With her chin up, Whitney looks down her nose at the camera and the viewer, suggesting the elite class position that her surnames confirm. At the same time, her gown's gorgeous exoticism suggests a bohemian modernism, the artist's interest in overturning convention. As William Leach has argued of

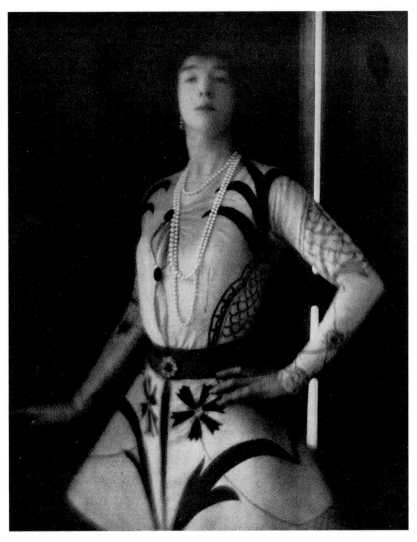

FIG. 1.3 Baron Adolf de Meyer, portrait of Mrs. Harry Payne Whitney. *Vogue,* January 15, 1913 [vol. 49, no. 2], 16.

this period, orientalist discourse worked to sanction the permissiveness of an emerging consumer culture.[49] Some viewers may have recognized the gown as the work of Leon Bakst, the Russian Jewish artist and stage designer who also designed the costumes for the Ballets Russes. A structuring band of vertical light encourages the eye to look the subject up and down, even while she looks down at us; de Meyer's lighting, as well as his Pinkerton-Smith lens, focus the viewer's eye on the gown's shimmering whites and the necklace's three loops of pearls. The image is stunningly beautiful, and in the context of *Vogue*'s other prewar portraits, is idiosyncratic in its sophisticated use of lighting, composition, and tonal gradation. Through this portrait, de Meyer introduced the two threads that became central to his later work for *Vogue*: the aesthetic feeling of pictorialist photography and the visual discourse of money—here signified most explicitly through Whitney's pearls, the portrait's literal focal point.

The second way that fashion photography appeared in the new *Vogue* was through the fashion essay: a series of fashion images that, anchored to captions and an accompanying text, described a specific fashion theme (the season's hats, for example, or gowns by a specific couturier). *Vogue* had been publishing multiple-page spreads of fashion photography for years before de Meyer's first effort appeared in the May 1, 1917, issue. Initially, Condé Nast would get his illustrations from the apparel house, such as Joseph, Bonwit Teller, John Wanamaker, or Abercrombie & Fitch. Photographs depicting the newest "models" in cloaks and gowns were presented alongside pen-and-ink illustrations from the apparel house; the mannequin wearing the clothing items was not identified, unless she was a society woman or otherwise well known to the magazine's readers. As photography began to push out the pen-and-ink illustrations in the midteens, however, Condé Nast began using the theatre and celebrity photographer Ira L. Hill to produce multipage fashion spreads (fig. 1.4).[50] Hill's images, while more than competent, are straightforward in their attention to detail; unlike the pictorialists, Hill didn't experiment with the lighting, focusing, and printing techniques that signified the aesthetic movement.

In contrast, de Meyer introduced all the visual techniques of the art movement in photography to his work at *Vogue*. His first fashion essay, on May 1, 1917, was a two-page spread featuring bridal lace and included a full-length image of actress Jeanne Eagels, in the rhetoric of the society portrait; a small still life of lace, candles, and a fan; and a stunning image of a young film actress, Vera Beresford (daughter of actress Kitty Gordon), modeling a bridal veil of white tulle bound by a wreath of orange blossoms (fig. 1.5). De Meyer lit Beresford from below; the camera picks up illuminated details of orange petals and delicate lips while casting dramatic shadows against the wainscoting above.

Like the simple duplicity of woman is a negligée of
orchid crêpe de Chine which is lined with salmon pink
crêpe de Chine, for one side of the garment crosses the
other in front, but later rejoins it amicably enough;
and the train, crossing over both, meets itself in front
under a fan-like ornament of gold and white silk braid

(Upper left) Over a long dashed garment of light jade
green satin hangs a trailing coat of chiffon, deep Delft
blue above and red chiffon below, which, before it
entirely ceases being a coat, becomes a train; its sur-
face is embroidered with paillettes in colors like those
of a Persian rug; the belt and ornament are of straw

(Left) Clad in a Paquin negligée of medieval lines,
she smiles, and a white brocaded satin reflection smiles
back; for nothing in the likeness of woman could re-
sist such a garment, from its drooping sleeves of lemon
yellow chiffon cloth and circular cuffs, to the uttermost
hem of its white brocaded satin coat and its lemon
yellow plaited undershirt. The belt, after the way of
a modern belt, is narrow

A TEA-GOWN WHICH IS PERSIAN, AND TWO NEGLIGÉES

WHICH ARE MEDIEVAL, YET MODERN, FROM JACQUELINE

Photographs by Ira L. Hill.

FIG. 1.4 Ira L. Hill, photographer. *Vogue*, January 1, 1917 [vol. 49, no. 1], 61.

FIG. 1.5 Baron Adolph de Meyer, detail of Vera Beresford. *Vogue*, May 1, 1917 [vol. 49, no. 9], 56.

With these images, de Meyer announced a technical virtuosity in photographing transparent and opaque materials while bringing to the work all the mystery and aesthetic feeling of art photography.

De Meyer brought to *Vogue* a specific Edwardian "structure of feeling" defined by a revolt against the rationality of the second industrial revolution as well as an oppositional celebration of aesthetic feeling. Raymond Williams used the term "structure of feeling" in an effort to link a culture's documentary expressions ("from poems to buildings to dress-fashions") to "all the elements in the general organization," what he has described as a culture's "whole way of life."[51] Pictorialist photography joined with other cultural documents, including Debussy's music, Nijinsky's dancing, and Whistler's painting (for whom de Meyer's wife Olga modeled), to create an oppositional culture that valorized feeling and emotion over rationality and system, the era's dominant culture. But there is another aspect of this transatlantic aesthetic culture that informed de Meyer's work: its queerness. Borrowing from Williams once again, this culture's documentary expressions (Beardsley's drawings, F. Holland Day's photographs) are constituent of a whole way of queer life for a transatlantic counterculture that saw its aesthetic vocabulary and emphasis on feeling emerge as a dominant cultural formation during the Edwardian era, before becoming a residual formation during the post–World War I modernist period.[52] De Meyer was at the center of these queer cosmopolitan circles on both sides of the Atlantic, and his aesthetic contributions played an important role in the transition of modernism in American fashion photography.

Baron Adolph de Meyer was "excessive" and "affected" (to borrow from Cecil Beaton) in both his personal life and his photographic work. Worldly, cultured, and multilingual, de Meyer was a part of the (effeminate) male aesthete circle in New York that included Carl Van Vechten and other creative artists. Florine Stettheimer painted her friend de Meyer in 1923 as an effeminate dandy figure: standing in front of his camera and tripod, draped with the lace through which de Meyer made many of his images, de Meyer gazes to one side, his lips delicately pursed, his arms girlishly akimbo on his slender yet accentuated hips (fig. 1.6).[53] George Platt Lynes, the photographer whose work I discuss in chapter 3, considered buying this painting in 1945 for what he called "for the professional aspects, for 'camp,'" but in the end decided against it.[54] De Meyer not only photographed the decorative works of his friends: he himself wrote articles on decoration and entertaining, accompanied by his own table settings and flower arrangements (which he photographed for *Vogue*). De Meyer's decorating aesthetic was eclectic and Victorian in its compulsive accumulation of objects; his work contrasts with his queer contemporary, Elsie

FIG. 1.6 Florine Stettheimer (American, 1871–1944), *Baron de Meyer*, 1923. Oil on canvas, framed: 44 3/8 × 32 1/8 × 3 1/2 in. (112.7 × 81.6 cm.); unframed: 38 1/8 × 26 in. (96.8 × 66 cm.). Gift of Ettie Stettheimer, BMA 1951.32, Baltimore Museum of Art. Photograph by Mitro Hood.

de Wolfe, whose interiors for the Colony Club signaled a more restrained style that signaled modernism's aversion to "decoration."[55]

De Meyer's camp theatricality, while queer in a broad sense, especially by contemporary usage, was historically more specifically a part of World War I–era New York fairy culture. By the 1910s and 1920s, men in New York City who identified themselves on the basis of their homosexual object choices, rather than an effeminate gender style, usually called themselves "queer," reserving the terms "pansy" or "fairy" to describe womanly men whose subcultural style of "affective excess" became known as "camp" as early as 1909, as in "ostentatious, exaggerated, affected, theatrical; effeminate or homosexual."[56] The flamboyant public styles of the World War I–era New York City fairy were signified most consistently through references to flowers (references to pansies, daisies, and buttercups were condensed in the code "horticultural lads"); the adoption of faux titles (the Duchess of Marlboro, Baron de Meyer); and feminine nicknames, often inspired by contemporary feminine icons (Salomé, for example, popularized by the many adaptations of Oscar Wilde's scandalous play of 1892). Baron de Meyer, an original horticultural lad, already had the title, which although always disputed, seems to have been accepted by his social circle and by *Vogue*. With the adoption of a new name suggested by an astrologist, Gayne, de Meyer enacted a pervasive cultural ritual central to World War I–era fairy culture. The name was an inspired choice: the word "gay" that begins the name was a contemporary code word that signified "the flamboyance in dress and speech associated with the fairies."[57] The name, an unusual but not unheard of boy's name in this period, takes its meaning from "gain" or "to get"—an interpretation that resonates with de Meyer's central role in aestheticizing the commodity form in his *Vogue* work. As this brief discussion of fairy culture suggests, one of its defining attributes was the public display of flamboyant style in dress, speech, mannerisms, and expressions: the affective excess of camp performativity.

De Meyer's *Vogue* excessive aesthetic can be seen in the profusion of objects, textures, fabrics, and flowers that give his work its signature style.[58] In these technically brilliant images, de Meyer lovingly delineates each flower petal, bridal jewel, and trailing ribbon. His work is exceptional in large part because of his success in using his innovative lighting techniques to illuminate the material objects—lace, tulle, and crystal—that other photographers, such as Hill, had been unable to bring alive through the camera. De Meyer's brilliance in animating the materiality of luxury commodity culture made his work indispensable to Nast, whose growing magazine empire depended on the support

excessive aesthetic

Materiality of luxury commodity culture

of luxury retailers such as Cartier and Tiffany. De Meyer's work with *Vogue* brought a queer aesthetic based on sensibility, excess, and artifice together with the market, producing a thread of queer capitalism that has been central to fashion ever since.

De Meyer's affectless collaborator in some of the most spectacular fashion essays was the British mannequin Dolores (née Kathleen Rose). Dolores was a working-class Londoner who had been transformed into one of the first Anglo-American mannequins by the British couturier Lady Duff Gordon (business name, Lucile, Ltd.). Duff Gordon, whom I discuss in more detail in the following chapter, was the first Anglo-American clothing designer to present her work on what was known then as the "living model"; her mannequin parades became a sensation in New York, and helped spark the midteens fashion show craze in department stores and charity events, such as *Vogue*'s 1914 fashion fête. By 1918, when de Meyer first photographed her, Dolores had moved from Lucile's showroom to become one of the very first "model-showgirls" in the *Ziegfeld Follies*, for which Lucile often designed the costumes. In other words, Dolores was the first celebrity clothes model: famous not for singing and dancing (she did neither) but for modeling high-end designs on stages, on both Fifth Avenue (couture) and Broadway (musical revues). Dolores's carefully honed performance of white affect functioned as the "straight man" for de Meyer's photographic excessiveness, in which luxury goods took center stage.

De Meyer photographed both Lucile gowns and Dolores numerous times in this period, but I'll focus here on one of seven pages in an April 15, 1919, *Vogue* fashion essay titled "Pearls and Tulle Spin Bridal Witcheries."[59] The article featured fourteen de Meyer photographs of bridal gowns (some also designed by de Meyer) and accessories, including "lustrous jewels" and a "silver net embroidered delicately with pearls." The second page of the spread (fig. 1.7) joins a portrait of Dolores modeling a de Meyer gown with three smaller still lifes of the bride's accessories. These accessories—a diamond barrette, for example, or an amber-handled white ostrich feather fan, both provided by Cartier—are, according to a caption, "almost as necessary to a wedding as the bride herself" (surely an understatement from the perspective of Cartier).[60] De Meyer's arrangement of these accessories is effusive yet studied: in each corner image, a satin slipper unsuccessfully competes for the viewer's attention, drowned out by a cacophonous profusion of cut flowers, lace, feathers, garlands, jewelry, and fruit blossoms. Yet de Meyer's brilliant lighting, emanating from behind and below the central arrangement, and complemented by smaller lights that selectively illuminate pearls and diamonds, successfully draws the eye. Here, de Meyer's

FIG. 1.7 "Pearls and Tulle Spin Bridal Witcheries." Baron Adolph de Meyer, photographer and designer; Dolores (Kathleen Rose), model. *Vogue*, April 15, 1919 [vol. 53, no. 8], 44.

decorative excess perfectly complements the conspicuous consumption of a nouveau riche leisure class.

Dominating the page spread, Dolores models a platinum-and-diamond Mercury headdress and a gown of silver cloth. De Meyer's lighting (from behind the model as well as from below), as well as the Mercury wings, leads the viewer to Dolores's face, especially her piercing gaze. She stares back at the viewer with studied affectlessness, her blank expression creating a somewhat intimidating canvas for de Meyer's accessorizing. This lack of expression was, in fact, one of Dolores's defining performances, and marks not only all her work for de Meyer but also, I would argue, became the template for fashion models more generally. In these de Meyer images, the complex history and cultural significance of racialization and class passing are condensed in Dolores's expressionless visage. A working-class immigrant herself, but one privileged with impeccable Anglo-Saxon credentials, Dolores's performance of elite whiteness helped consolidate what José Muñoz has called a "standard national affect" in the United States, against which other affective codes appear as "over the top and excessive."[61] Here, Dolores's lack of affect serves as an ideal canvas for both de Meyer's accessorizing and for the implied viewer's commodity longings. At this historical moment, this combination of de Meyer's queer pictorialist excessiveness and Dolores's laconic whiteness proved a powerful combination for Nast's elite readership.

De Meyer brought together pictorialism's aesthetic vocabulary with a queer cosmopolitan sensibility characterized by affective excess to create stunning fashion photographs that perfectly matched Condé Nast's needs. Unlike the flat documents of his photographic competitors, de Meyer's photographs animated the magazine's luxurious commodity culture. De Meyer's photographs sought to produce a utopian flight of aesthetic feeling that the text then tethered to a specific, preferred outcome: sales. As the caption for de Meyer's portrait of Jeanne Eagels notes, the arrangement of a "real lace veil . . . is one of the highest forms of art . . . if one craves it—and what bride wouldn't?—it can be purchased for five thousand dollars."[62] De Meyer's photographs, emerging from a queer cosmopolitanism that had once privileged the aesthetic movement's "art for art's sake," tied the utopian performative's desire for a better life to the accumulation of luxury goods.[63] Ironically, the man who had once called de Meyer a pimp for prostituting his art, Edward Steichen, not only replaced de Meyer at Condé Nast in 1923 but also then began his lucrative, twenty-year relationship with the J. Walter Thompson advertising agency.[64]

The World War I years mark the last gasp of pictorialism as the dominant aesthetic within art photography. In 1915–17, Paul Strand abandoned the pictorialists'

soft focus in favor of the hard edges and formal emphases of straight photography. Though art photography's move toward modernism is more complex than this single marker, in hindsight it is clearly the case that de Meyer's *Vogue* years corresponded with art photography's rejection of pictorialism's technical and emotional excessiveness in favor of modernism's sharp lines and camera eye.[65] Nothing signaled this transition more clearly than the staff changes at *Vogue*. De Meyer had been the first of several key defections from Condé Nast to Hearst; he left for *Harper's Bazar* for a much greater salary, more creative control over magazine layouts, and a Hearst-funded apartment in Paris (where he and Olga moved in 1922). In 1923, the year Steichen returned from France, Nast hired him as his magazines' chief staff photographer.[66] As Nast's biographer writes in what is generally representative of scholars' description of the shift from pictorialism to modernism, "Steichen swept away de Meyer's unreal, filmy creations and replaced them with a sculptural, clean, pure, realism."[67] This transition, however, can be understood in gendered terms as well, away from (female) "filmy" feeling toward the "pure" and "real" heteronormative masculinity of the conservative 1920s. De Meyer's gender and sexual queerness, inseparable from his photographic aesthetic, would find fewer outlets in the Coolidge-era "return to normalcy."

De Meyer's fashion photography brought an aesthetic vocabulary to a commercial medium (fashion) precisely at the historical moment when merchandisers teamed up with psychologists and advertisers to harness consumer longing and transform it into sales. Although it had been possible, technically, to introduce photography to advertising and fashion illustration since the halftone was perfected in the late 1880s, the medium's indexicality, combined with most photographers' lack of training in the principles of fine art, meant that most commercial photographs lacked the connotative codes necessary for commercial culture's appeals to emotion.[68] One of the more successful, though short-lived, efforts was Edward Steichen's photographs of Poiret gowns for the French art journal *Art et décoration* in 1911.[69] In the United States, it was pictorialism, as an aesthetic approach, that convinced art directors, account executives, and magazine editors that photography could compete with lush pen-and-ink illustrations by James Montgomery Flagg or Charles Dana Gibson. Pictorialism's emphasis on connoting feeling, its ability to stir the emotions, dovetailed perfectly with advertisers' increasing recognition that not only were the most effective sales appeals directed toward an emotional, rather than rational, buyer but also that the vast majority of purchases were made by women.[70]

Great summary ℍ

In the world of fashion photography, Baron Adolph de Meyer's pictorialist work convinced editors that photography could compete, and eventually surpass, the work of commercial illustrators. In advertising photography, the pictorialist incursion into commerce was indebted to the work of photographer Lejaren à Hiller; it was Hiller's work that led to the rise of the "photographic model" as a profession, as well as to the founding of the first modeling agency, by John Robert Powers, in 1923. As numerous scholars have shown, the period before World War I was the moment US advertising began to appeal to the consumers' subjective longings, rather than their reason; advertisers began to focus on the benefit a product offered (romance or beauty) rather than the product itself (a bar of soap, for example).[71] These new types of advertisements focused on creating an overall impression on the viewer, a more atmospheric approach that emphasized an emotional bond between the viewer and the advertising copy. The almost universally chosen route toward this emotional address was what the advertising profession called "human interest": using human figures interacting with the product in a narrative tableau that spoke to implied (female) consumer's hopes, longings, or anxieties. And although pen-and-ink illustration had long dominated American advertising, the prewar years saw the first successful incursion of photography into advertising, a trend that accelerated after the war.

New York City–based commercial photographer Lejaren à Hiller was born in Milwaukee in 1880. After apprenticing in the same lithography firm as Edward Steichen, Hiller moved to New York City in 1907, where he worked as a pen-and-ink illustrator for national periodicals such as *American Magazine* and *Harper's Bazar*; by 1913, he had a $7,500 per year contract with *Cosmopolitan* to provide photographically based illustrations for the magazine's fiction pieces.[72] As Hiller continued to introduce pictorial technique to his fiction and feature illustrations, however, he also emerged as the leading photographic illustrator of national advertising campaigns, producing photographic advertisements for Corning, Steinway, and General Electric, among other companies.[73] Hiller was the most accomplished commercial photographer in the United States in the World War I era; he played a critical role in convincing art directors and brand managers that photography had an important role in modern advertising.

In an era without a model industry, Hiller created his own protoagency by hiring a full-time model scout, Jenkins Dolive, in 1918. The New York and photographic press reported that by 1918 Hiller had compiled a photographic

card index representing the faces and physical measurements of two thousand to three thousand working models. Each card featured two photographs, one frontal and one in profile, as well as the model's height, age, weight, and other pertinent information. Many of the models were familiar faces to movie and theatre fans, while others were everyday New Yorkers whom Hiller decided represented ideal "character types" and subsequently convinced to pose. Eventually, in fact, Hiller stopped working with well-known figures (such as Marion Davies, whom he claimed to have introduced to his boss at *Cosmopolitan*, William Randolph Hearst) because, he argued, fiction and advertising required the subordination of the model's personality to the narrative, rather than using the narrative as a vehicle for the increasingly trademarked expression of the actress's stardom. Unlike the motion picture, in which the audience expects the personality of a Mary Pickford to "show through the part," Hiller argued, in print illustration the models "must be a character in the story and nothing else."[74] The forward movement of the narrative, whether in fiction or advertising, was threatened by the star quality of the well-known actress. As a writer for *Printers' Ink Monthly* explained in 1922, "The too-much-photographed face is unproductive of results."[75] The models assembled for Hiller's studio included artists' models, working-class men and women seeking a little extra cash, occupational "types" spotted in the city's streets and immigrant neighborhoods, and a small group of middle-class women who modeled for the excitement and pleasure of "being photographed with exceptional care in their best clothes."[76] While some models were contacted through the location scout, who would find the "real east side tradesmen, real farmers" or other authentic "types," others came to the studios through word of mouth.[77] By the late 1920s, Hiller had moved into motion pictures as well and, according to advertising executives with J. Walter Thompson, the ad agency responsible for Lux soap, was the "most expert man in the country" for anything having to do with advertising and movies.[78]

Hiller's photographic modeling archive indexed the physiognomic capital of an emerging mass culture industry. Unlike the nineteenth-century portraiture, in which the face's static features were intended to reveal, transparently, aspects of inner character, the models in Hiller's card index were valued precisely to the extent that their faces and expressions could shift to communicate new identities, new characters. In the visual landscape of modern mass culture, the charm of "personality" triumphed over immutable character, which in the context of commercial work would quickly limit a model's work prospects. A successful model was one who was able to appear in a variety of illustrations in different poses and situations while remaining, simply, a character in a story

"and nothing else." As with the stage, cosmetics helped "make up" these new characters; the growing acceptance of makeup promised personal transformation, the ability to change the self through a shift in external appearance.[79] Hiller took this transformation one step further, using models and makeup to communicate the transformative possibilities of consumption: ephemeral physiognomies sold the promise of authentic selfhood through the acquisition of goods.

It was Hiller's work photographing models for print advertisements that led to the founding of the first modeling agency in the United States. According to John Robert Powers, he and his wife, Alice Hathaway Burton, were both unemployed actors looking for work when Powers came across a newspaper ad for models, placed by a commercial photographer. When they arrived at the photographer's studio, the photographer (Hiller, I suspect, given that I found Powers's head shot among Hiller's papers) asked Powers to round up an additional seven unemployed stage friends, as the advertisement required eight figures (fig. 1.8). This initial experience as a model led Mrs. Powers to suggest bringing commercial photographers and the numerous underemployed theatre people of their acquaintance into contact with one another. They contacted "everyone [they] knew," had their photographs taken, made up a catalogue of forty descriptions and measurements, and sent it to prospective clients in New York City, including commercial photographers, advertisers, department stores, and artists.[80] Powers, the founder of the first professional modeling agency in New York (in 1923), pointed out in 1941 that the shift to photography within advertising had created a demand for models, which his agency sought to fill.[81]

By 1930, Powers had shifted the focus of his directory to include not only well-known actors of stage and screen but also advertising and fashion models. His 1930 agency book included John Barrymore and Norma Talmadge, as well as Marion Morehouse, Edward Steichen's favorite model and the future wife of poet e. e. cummings. His clear purpose in directories from 1930 to 1932 was to place what are clearly "models," rather than actors, in photographic print advertisements for consumer goods ranging from paper towels to furs. For example, Babs Shanton, who moved to the mainland United States from Puerto Rico in 1922, modeled for Lucky Strike's "Adam's apple" campaign of 1931, in which beautiful starlets claimed that the cigarette expelled harsh irritants from the throat, or "Adam's apple," region.[82] Powers also booked Shanton for Scot Paper Towels, yet in his agency catalogue she wears an elegant evening dress and full-length fur (figs. 1.9 and 1.10). No longer a "casting directory," the 1930 agency book of black-and-white images included not only head-shots and figure studies but also the model's physical and clothing measurements underneath

FIG. 1.8 Models for commercial photographer Lejaren à Hiller, ca. 1917–24. John Powers is the male figure on the top right. Visual Studies Workshop, Hiller Archive, Rochester New York.

each image. The result was the modeling industry's first agency catalogue. By 1932, most of the photographs were credited to the period's leading commercial photographers, including Nickolas Muray, Underwood and Underwood (where Hiller had become vice president), and Anton Bruehl. Commercial photographers in New York and Philadelphia took out full-page ads in the 1932 edition; an ad for Pagano photographers of 360 West 31st Street suggests that the implied reader (an art director, for example) let the new agency choose the models for the shoot: "One way to eliminate guesswork is to entrust us with the important work of selecting models for your photographs."[83] The agency book's focus on advertising and fashion work is implicit in the catalogue's organization, which privileged both type of model (male, female, older, younger—all white) and type of clothing (from lingerie to outerwear).[84]

Powers's market here was the growing advertising industry, which after prewar innovations such as Hiller's moved en masse to commercial photography as the industry's main medium, and which increasingly depended on a sanitized female sexuality to sell goods. As Roland Marchand has argued, in the early 1920s, the photograph was still the exception in advertising art, with only

6 percent of national ads in newspapers using photography as late as 1926. By the late 1920s, however, photography began a distinct rise in popularity, and surged during the Depression due to its relative cheapness in comparison to drawings or paintings.[85] Advertising efforts increased in general during the Depression, as companies invested even more money in the relatively new industry as a means of sparking consumer demand in a sluggish economy. Photography proved especially appealing, as the costs per model were relatively cheap; rather than sit for several hours or half a day while a pen-and-ink illustrator took down a model's likeness, a photographic model could be in and out of the studio relatively quickly, at a much reduced cost.

The rise of cinema also directly influenced photography's appeal within the advertising industry. Advertisers understood that photographs could be manipulated to convey dramatic narratives reminiscent of the silver screen while at the same time connoting a persuasive "realness" to the viewer. J. Walter Thompson (JWT) art director James Yates explained the importance of the movies to his colleagues in 1931, in an effort to get the company to draw more explicitly on cinematic techniques. He pointed out that both advertising and Hollywood used the same medium, the camera, and that while "sophisticated people" might recoil at the "cheap plots and vapid young actresses" of contemporary cinema, to Mrs. Consumer the movies "are the fulfillment of her heart's desires."[86] "Sitting in the movies," he continued, "her home is luxurious; her husband makes a lot of money. Sitting in the movies, she wears the same smart clothes as Gloria Swanson. She looks like Garbo and men like Gary Cooper fall in love with her."[87] Yates argued that JWT apply specific cinematic techniques, such as the close-up, to particular campaigns, such as their Jergens lotion account. He concluded his talk by outlining the central role that art directors needed to play in working with the model and the photographer. "We may have to do more than simply check on whether the girl model's hair is combed prettily," he argued. "For the emotional approach, the inspiration must come from us, if we hope to get dramatic simplicity by means of photography."[88] Yates succeeded with his appeal regarding the close-up of hands for Jergens: later that year, JWT minutes show that staff worked successfully with Steichen in "getting some very charming illustrations on what hands can do in building romance."[89] Within the modeling industry, this shift to the close-up led to further segmentation and the development of the hand model (fig. 1.11). Leading advertising firms such as JWT increasingly turned to narrative photography in the 1930s in the wake of Federal Trade Commission investigations into advertising's alleged use of fabricated celebrity testimonials for consumer products.[90]

FIG. 1.9 Babs Shanton in Lucky Strike ad, 1931.

FIG. 1.10 Babs Shanton. *John Robert Powers Annual* 6 (1930): 23.
Photomechanical print. Science, Industry, and Business Library, New York
Public Library, Astor, Lenox and Tilden Foundations.

FIG. 1.11 Hand model Wilma Rudd. *John Robert Powers Annual* 6 (1930): 85. Photomechanical print. Science, Industry, and Business Library, New York Public Library, Astor, Lenox and Tilden Foundations.

Models provided what the trade called the "human interest" in advertising, just as actors carried the narrative within Hollywood productions. For advertising, the models' ability to express emotions that drove the sales message became critical in the shift to photography-based advertising. As one article noted, the "cardinal feature" of contemporary advertising photographs is that "the characters register emotion. These emotions may be violent and intense; they may be, on the other hand, quiet and urbane. But the emotion is always there, sharply defined, easily discerned. And inevitably, these emotions affect the reader as surely as pictured emotions on the silver screen affect the audience in a darkened theater."[91] To make these new narrative advertisements, commercial photographers needed not only photographic models but also a well-equipped studio "sufficiently large for big settings," and that included backgrounds, props, windows, walls, doors, furnishings, wallpaper, overhead trolleys for moveable lights, scores of scorching lights, and all the other trappings familiar to any studio set.[92] The drive for realism within advertising photography led first to elaborate stage setting, and then to location shooting for the more expensive campaigns. A Mrs. Smith who worked on the photo shoots for the J. Walter Thompson advertising agency, and therefore with commercial photographers Edward Steichen, Victor Keppler, Anton Bruehl, and others, explained the importance of realism to JWT's creative staff in 1933. "One of the best things in taking a photograph," she told them, "is to have a real location."[93] She described organizing a shoot for Eastman Kodak with twenty-five models, five different cars, and three photographers for a day of shooting on Long Island for beach scenes, picnics, tennis, golf, and other outdoor activities. For Scot Tissue, Hiller's studio, Underwood and Underwood, presented JWT with an interior of a grocery store, working with a facsimile they'd used before in their Manhattan studios, but JWT felt that although they'd used models for clerks and customers, "it looked stiff."[94] So JWT found a large grocery store at the corner of First Avenue and 50th street, and arranged the shoot there—a new development. For another Eastman job, Steichen told JWT that "if you wanted people to look warm and happy in the sun you had to take them where there was warmth and sunshine."[95] When the team arrived in St. Petersburg, Florida, however they discovered that the local models that their contact had lined up was each a "cross between Clara Bow and Marlene Dietrich, plucked eyebrows, frizzy hair, everything wrong."[96] Mrs. Smith dismissed these vamps, found a high school dance, and watched closely while her male assistant danced with the young women in attendance. He engaged them in conversation while she watched their faces, as she needed to see their faces "in animation" in order to gauge their fit for the Eastman ad.[97]

Knowing that photographs connoted realism with an effectiveness that escaped pen-and-ink illustration, the advertising industry encouraged a shift to Hollywood-style narrative tableaux and photography. As one photographer told a group of fellow professionals in 1930, "You know there is an old saying that 'the camera cannot lie.' . . . I suggest you 'cash in on it' by using photographs. . . . Photography carries conviction in a way that no hand-produced illustration can do."[98] Advertising professionals understood they were competing for audience attention in an increasingly frenetic media landscape; as one industry professional summarized the burden facing contemporary advertising, "It is a mad scramble for the attention of the public."[99] To overcome what another writer called "eye indifference," or the "loss of the primitive keenness of sensation," advertisers turned to the photograph, which offered "'selected looks' for easy attention" in a busy, distracted world.[100]

By the late 1920s, work in advertising and print photography (including fashion) surpassed opportunities for work in showrooms, even though the field of photographic modeling remained little known to the general public. The days of models representing a particular couture house directly to customers was on the wane; instead, models worked for agencies, which sold their labor to professional photographers. During these years, the photographers worked with the ad agency's art director to script the ad. For example, J. Stirling Getchell, head of the eponymous agency, understood that the photograph was the nucleus of the advertisement, and gave the photographer tremendous latitude in developing a photographic narrative to illustrate the copy.[101] The photographers' job in working with the model was to create an image that would make the "prospect feel 'that would look pretty nice in my place'"; through photography, they needed to "make the thing desirable."[102] Photographers often booked models through the model agency, though, like Hiller, most also developed their own model files. The commercial photographers chose the models; directed poses and facial expressions; decided on lighting, exposure, and camera angle; and often produced the illusion of an outdoor setting via lantern slides projected on a mobile, ground-glass screen.[103] Photographers chose models based on their race, looks, character type, and body type (especially in fashion, where photographers sought tall, lean models to compensate for the camera's tendency to foreshorten the body), and models were expected both to have adequate wardrobes and to bring the needed garments to the shoot. In 1937, Powers models earned between five and ten dollars per hour, but after paying Powers his 10 percent, they reinvested most of their money in their wardrobes, as they needed large ones to become the business woman, college girl, mother, or socialite that different ads might require.[104]

As advertising photographs required models to convey the facial expressions necessary to carry the ad's dramatic narrative, photographers selected models for their "histrionic" abilities as well, something that the model could communicate only in the studio, in person.[105] Because advertising photographs appeared before the consumer's eye without the benefit of a movie theater's orchestra, staging, or moving images, the model's performance of emotion became especially important within the advertising photograph. Increasingly, commercial photographers and advertising managers understood that "building up" the "model's moods" was central in staging the "psychological moment" when the model's expression of emotion would not only look right on film but also feel right to the viewer—when emotion turned into commercial affect, circulating between bodies, with the model and the magazine page as medium.[106] As Powers model Jenny Judd explained, "I can show emotion—fear, happiness, worry, or anything else—at a moment's notice. This is grand for such things as soap, kitchen conveniences, insurance, and ads that tell a story with a picture."[107] Photographers relied on models to produce the affect necessary to make the ad's sales pitch persuasive.

Powers eventually branded his agency through the standardization of American beauty trademarked as his "long-stemmed American beauties," a racialized construction that connoted warmth and whiteness. Through the late 1920s and 1930s, Powers's main clients were advertisers and art directors seeking to sell a range of everyday household products, from automobiles to toothpaste, to American housewives. As Powers knew, "The use of photography [had] revolutionized the old methods of advertising."[108] And while the camera offered a clear view of the product, it also showcased the model: "However great the care taken in posing them, however painstakingly lights were used, the camera revealed only what it saw. And the girl who was artificial, self-conscious, or who lacked poise, was mercilessly recorded on the negative."[109] As Powers pointed out, "Advertising, as everyone knows, is directed at women who do most of the nation's purchasing."[110] He needed a new type of female visage to be represented in these print advertisements—pretty, to be sure, but not artificial, stagey, or vampish—models with whom potential American consumers would identify and emulate. "My job," Powers wrote, "was to find models with whom the women of the buying public would be willing to make that identification: models who possessed not only beauty, but breeding, intelligence, and naturalness."[111] He sought what he called "the natural girl."[112]

Powers explicitly contrasted this "natural girl" ideal with the reigning ideal of American Anglo-Saxon beauty, the Ziegfeld chorus and showgirl, whom I discuss in the next chapter. In the early years of his business, many of the women

who answered ads for modeling were working-class women who, Powers argued, "were unable to make themselves look like anything but chorus girls"—in other words, "heavily artificial types [who] were not the models whose appearance the average woman wished to copy."[113] Powers's first models were often chorus girls out of a job; as he claimed, they looked the type as well: "their make-up was extreme, their mannerisms exaggerated, they had a tendency to make themselves appear as glamorous as possible."[114] But since Powers recognized that this sort of vampish sexuality would fail to appeal to the housewives, he "cleaned up" the out-of-work chorus girl. Distancing himself from his show business predecessor, Powers claimed, "Ziegfeld's death was the death of the glamour girl. She has given way to the natural, well-bred, well-posed girl. . . . The Powers girl is now respectable. Popular."[115]

Distancing his models from the profession's working-class origins in the artist's atelier and the wholesaler's showroom, Powers's 1930s models were (he claimed) white, middle-class graduates of Wellesley and Smith, Phi Beta Kappas, and Junior Leaguers. In the wake of the stock market crash of 1929, debutantes whose families had run out of cash approached Powers for work. Betty McLauchen Dorso, one of Powers's top models, got her start when her father was laid off from his job as a designer for Cadillac; her dad put her in a cloche hat and a fur coat, posed her on a revolving platform in front of a luxury car, and sent the pictures off to Powers, who called Dorso in for an interview.[116] As advertising turned to photography in full force over the course of the 1930s, Powers needed more "respectable" models, young women who seemed a world away from the theater district's chorus girl. As Powers remarked, "Models are a commodity, a commercial product which must meet certain requirements."[117] His "long-stemmed American beauties" were sincere, intelligent, well-bred, and poised; they embodied an Anglo-Saxon beauty ideal clearly signaled through gesture, expression, and presence—even if the models themselves were only passing as white and middle-class, as Babs Shanton certainly was in her work for some clients. Powers sought to distance his models from the industry's nineteenth-century roots, in which both the artist and the cloak model were viewed as versions of "public" women, close relatives of the prostitute. Powers worked with the concept of distance—here, the magazine page—to establish the proximity and protection afforded by a sanitized sexuality central to the commodification of the female form under consumer capitalism. In his distancing of the model from her more messy, morally questionable roots, Powers developed a new vocabulary for model beauty, one that privileged class and racial hierarchies to construct an emergent parasexuality predicated on commodification and containment.

In claiming that the Powers Girl was now "respectable," Powers sought to bring the models' sexuality into conformity with normative expectations concerning middle-class propriety. Up until the sexual revolution of the 1960s, social norms dictated that women's sexuality be confined to marriage, and sexual expression outside of heterosexual marriage was considered outside the norm and criminal (same-sex relations, for example, or prostitution). Yet sexuality within the industry continued to confound the efforts of those who sought to distance modeling from its earlier roots in the loose sexuality of the artist's model and the cloak model. As late as the early 1940s, designer Bill Blass told journalist Michael Gross, "When I first came to Seventh Avenue house models doubled as escorts for out-of-town buyers. The assumption was true. Those girls really did put out, Christ, with the gross manufacturers who employed them. Most of the models were kept, and some turned a trick or two."[118] The models' sexuality, in this case, entailed not only the affective work expected for their "wages of glamour"—to borrow Kathleen Barry's wonderful term to describe the work of flight attendants—but also the sexual work of entertaining buyers. Their sexuality, in this instance, queered heteronormative scripts of proper womanhood, though very much in the context of implicit sexual and economic coercion.

Powers's genius was to repackage and sell the working-class, sexual femininity of the girl on the make as a commodified, managed sexuality that drew its power from this history while containing its threat through whiteness, the respectability of middle-class propriety, and the distance of glamour itself. By 1937, 120 "Powers Girls" posed for fifty thousand advertising photographs a year and earned a half million dollars in fees. As the journalist Thomas Sugrue pointed out in the *American Magazine*, these were "models who sell everything in America from lipsticks to baby carriages; girls whose photographed likenesses smile, flirt, beckon, or gaze serenely from the advertising pages of newspapers, magazines, posters, and billboards all over the United States."[119]

Two competitors, both of whom had been Powers models themselves, quickly challenged Powers's market control over the modeling industry. Walter Thornton (fig. 1.12) founded his agency in 1929, and Harry Conover began his in 1937.[120] Although Powers's reputation had been based on representing fashion models, especially after he moved his offices to Park Avenue, Conover's business was much broader; all three agencies supplied photographic models for the exploding demand for advertising copy. By the 1940s, Conover's office boasted twenty-three phone lines and over two hundred models, with purported gross annual billings of $1,200,000; Conover had started his own cosmetics line, named after his models, called Cover Girl—a business success

FIG. 1.12 Publicity photographs of Walter Thornton. *Actors Directory and Studio Guide*, January 1927, 167. Billy Rose Theatre Division, New York Public Library for the Performing Arts.

that lasted until 1959, when Conover was sued for failing to pay modeling fees to his child models.[121] Conover also borrowed Powers's emphasis on the natural girl. As his daughter reminisced, Conover supplanted the "bored-looking, sophisticated … European type with the natural-looking, healthy, outdoors American Girl. He knew that models were products that had to be merchandized and advertised … but he also determined that the basic product under the packaging would have authenticity and quality."[122] By the 1940s, models were a ubiquitous part of American mass culture, with movies focusing on both the Powers and the Conover models (*The Powers Girls*, 1943, and *Cover Girl*, 1944), and Powers Girls acting as paid beauties for international goodwill tours.[123] Together, the three firms developed the modern modeling industry, and dominated it until 1946, when Eileen Ford and Natálie Nickerson established Ford Models.

GOOD SUMMARY

THE MODELING PROFESSION has multiple origins in the US context, each with its own set of historical and culture meanings concerning the intersections of embodied labor, social hierarchies, affective circuits, and the history of twentieth-century capitalism. The early twentieth-century cloak, or wholesale, model emerged as a new emblem of working-class femininity, a modern, unattached woman whose work entailed an attention to the female form, undressing and dressing for pay, and opportunities for after-hours sexual treating. As haute couture modeling migrated from the rarified environment of the Parisian salon to the department stores and wholesale clothing districts of early twentieth-century US urban centers, working-class women flocked to these new opportunities to showcase the newest clothing designs for middle-class consumer audiences. At the same time that the "living model" appeared in merchandisers' shops, Baron Adolph de Meyer launched modern fashion photography through his adaptation of fine art aesthetics to the commodity form. Working with well-known actresses, society women, and increasingly professional models as his *Vogue* sitters, de Meyer mixed queer affective excess and pictorialist techniques to spark a circuit of commercial feeling between sitter, photographer, and consumer.

① cloak model was a charity girl

②

p. 50

De Meyer's work at *Vogue* provides just one example of queer culture at the heart of the modeling industry. As I discuss in chapter 3, creative professions provided a queer refuge for sexual and gender outsiders; the cosmopolitan, transatlantic sensibility of high-end fashion, with its close connections to visual and performing arts, engendered a rich network of queer cultural producers, who, while outsiders to mainstream culture, emerged as insiders within the

rarified atmosphere of elite fashion. These sexual and gender outlaws, working at the intersections of commerce and culture, coproduced a new form of public sexuality defined by desire and distance, Eros and absence. This new form of commercial sexuality emerged in tandem with early twentieth-century mass culture and had similar roots in the social and political transformations of a nation transformed by immigration and urbanization.[124] Young models "adrift" in the teeming metropolis, pushing against gendered expectations of feminine propriety that crossed lines of class and culture, engaged in sexual barter with wholesale buyers or stage-door Johnnies, while more elite figures, such as de Meyer, brought a queer sensibility to the industry's emerging commercial aesthetics. Out of nonnormative—or queer—sexualities, artists and models applied the foundation of modern glamour.

While de Meyer elaborated new techniques of commercial appeal in the page of high-end fashion magazines, Lejaren à Hiller brought his art school background to the world of commercial illustration. In the process, Hiller pioneered both advertising photography and the modeling agency itself. One of his former models, John Robert Powers, founded the first modeling agency in 1923; by the end of the 1930s, as consumer product advertising shifted from pen-and-ink illustration to photography, advertising needed models and their ability to produce convincing emotional expressions for capitalism's sales tableaux. As the new industry began to mature during this period, Powers and his competitors sought to distance the new modeling profession from its working-class, sexually illicit roots. In the 1930s and 1940s, Powers sanitized the modeling industry's queer origins—in terms of the models' nonnormative sexuality as working-class women on the make, as well as de Meyer's queer aesthetic—by elaborating a discourse of morally upright, all-American, natural beauty. Modeling agents such as John Robert Powers—seeing a wider commercial market for this explosive combination of sex, bodies, emotion, and sales—sought to straighten up the new industry through rendering his models sexually normative or, in his words, "respectable." These new models, such as those whom Powers signed in the late 1920s and 1930s, did the work of representation in American advertising, a job that required their affective labor in producing and circulating commercial feelings about material goods.

As industrialization and urbanization produced a mass consumer economy in the early twentieth century, one that relied on the elaboration of multiple strategies of enticement to grow domestic and international markets for consumer goods, modeling became integral to consumer capitalism. The artist's model, the wholesale clothing or cloak model, the couture model, and the photographic model all contributed elements central to the development of

the profession as it emerged in later years: a willingness to challenge norma-
tive sexual conventions; the coproduction of modern forms of glamour and
celebrity; and a facility in the production of multiple physiognomies, gestures,
and looks in the service of commodified affect. A critical development of these
early years of the profession was the industry's elaboration of a new form of
public, commodified sexuality that straddled the putative division between
public and private. In the first two decades of the twentieth century, cultural
brokers such as de Meyer and Powers channeled the newly emerging sexual
modernity of a new generation of women in public, containing it in the service
of the commodity form.

In the 1920s, however, while Powers was just getting his modeling agency
off the ground, and national advertisers were only slowly shifting to using pho-
tographic models for advertising work, couture models took center stage—
literally—with elaborate stage productions for both white and black audiences.
This development, which we will explore in the following chapter, firmly
ensconced the fashion model in the American popular imagination.

Race, Sexuality, and the 1920s Stage Model

interwar

fashion models
take center stage

In 1925, Linwood Kroger, president of the Baltimore branch of the National Association for the Advancement of Colored People (NAACP), denounced a touring theatrical presentation of Irvin C. Miller's beauty revue, *Brownskin Models*. Many of the scenes, he complained to the *Baltimore Afro-American*, were unfit to be witnessed by children.[1] Like other stage model revues of the period, the variety show featured singing, dancing, and comedy, as well as attractive women "posing" as artist and couturier models in revealing costumes, including transparent netting. Shows such as this one, Kroger argued, were "unfit for minds that are unable to discriminate."[2] Such variety shows were best viewed by more discriminating audiences who would be able to appreciate the aesthetic distinctions between the nude and the naked, Kroger implied. The proper viewing of female models required a finely tuned sensibility that would be able to harness the emotions produced by viewing attractive women in various stages of undress, and channeling them toward more productive and uplifting expressions, such as aesthetic appreciation. Kroger's intervention was successful in Baltimore: some of the show's "bad features" were eliminated the next night.

One of the striking features of this news notice is that it is the only example of a critical intervention regarding black female nudity in the thirty-year period in which *Brownskin Models* toured in the United States and Canada. The

producer, Irvin C. Miller, was successful in immediately reshaping the production to strike a less controversial balance between sexual display and aesthetic appreciation. The work of the model was instrumental in achieving this rapprochement between bourgeois morality and commercialized leisure. Her posing represented a critical site for the intersection of new public modes of looking: part aesthetic, part desire, and wholly commercial, the model tied together discourses of sexuality, the body, and the market in new ways during the 1920s.

In the 1910s and 1920s, as the modeling industry began to take shape in Seventh Avenue's wholesale district, in the studios of commercial photographers, and in modeling agency look books, the general public was more likely to associate the model with the couture model, and to encounter her on the American stage. While fashion photography and film eventually came to play important roles in producing model glamour in the 1930s, a development I discuss in more detail in the next chapter, the popularity of the model as a cultural type was produced and circulated in the 1910s and 1920s through the ubiquity of the model-showgirl, a hybrid figure that Florenz Ziegfeld inaugurated in 1918 when he hired the first couture manikins to perform as models on the segregated Broadway stage. In this chapter, I explore this history of the 1920s stage model through an analysis of the relationship between sexuality, aesthetic feeling, and race. In the first half of the chapter, I analyze the history of the couture model-showgirl as a racialized performance of Anglo-Saxon femininity. In the second half, I discuss the parallel formation in the black musical stage tradition: Irvin C. Miller's *Brownskin Models*. This black musical review, which toured forty weeks per year in the United States and Canada between 1925 and 1955, drew on the twin discourses of the artist's model and the couture model to create a new understanding of black female sexual modernity. The brownskin model and her representation drew on a discourse of aesthetic feeling to resignify the model as an elite figure, a move that produced different historical meanings for black and white audiences.

The model and her stage avatar tied the display of the female form to commodified forms of sexualized looking, in many cases directly linking this exchange of glances to the exchange of goods. In the era immediately preceding the rise of the segregated modeling industry in the late 1920s, the model's appearance on the theatrical stage marked an important way station in the longer history of the model's affective labor. Through the commodification of aesthetic feeling onstage, the model became distanced from the improper intimacies of the artist's model and the wholesale cloak model, enabling the elaboration of a sanitized female sexuality central to the rise of the modeling industry in later years.

Duff Gordon and Ziegfeld: The Invention of the Couture Model-Showgirl

The high-end couturier model was a little known figure in the United States until 1909, when the British couturier Lady Duff Gordon sent four of her London-based mannequins to the United States to help open her New York branch of Lucile, Limited. Although the American public was familiar with the artist's model and the cloak model as social types and stage personae, the high-end clothing mannequin was a relatively new figure for all but the wealthiest of Americans—those who traveled to Paris twice yearly to buy designs from French couturiers. These clothing models, known during this period in both Europe and the United States as mannequins, manikins, or sometimes "living models," demonstrated clothing for the society women who eschewed the emerging ready-to-wear industry in women's clothing and could afford to have their gowns custom-made.[3] Their introduction to US culture in 1909 complemented the beginnings of the US fashion show, discussed in the previous chapter, and inaugurated lasting changes in apparel merchandizing as well as popular culture, exhibited by the enduring public fascination with the model's performance of affectless femininity.

Duff Gordon was the first designer in the United States or the United Kingdom to display her clothing designs on living models, rather than on sawdust dummies, and also the first to choreograph her mannequins' movements for public display. Drawing on her earlier work in the theatre, she understood that movement was central to viewers' emotive connection to dress: they needed to see how the fabric performed in relationship to its wearer's every motion in order to imagine themselves as the gown's owner. Duff Gordon put her (clothing) models on living mannequins, who descended the stairs of her Hanover Square (London) salon, emerging into "that beautiful Adams room, with its Angelica Kauffman ceiling," their purpose "to lure women into buying more dresses than they can afford."[4] Viewing a custom-made gown became a performance, in which clients became cast members with living models as theatrical talent and Duff Gordon as producer, director, and choreographer. By 1915, with Parisian imports disrupted by the war, all the elements of the modern fashion show were in place in New York: imported mannequins brought the "inimitable walk that the Rue de la Paix made famous," in the words of a *New York Times* reporter; the gowns were presented with the aid of an accompanying play; the designers bypassed representatives by presenting directly to retail buyers; and mannequins presented each costume on a raised platform extending through the rooms at the level of the chairs—the catwalk.[5]

Duff Gordon, the pre-eminent producer of these new fashion spectacles in the prewar years, used emotion to turn what she termed the "serious business

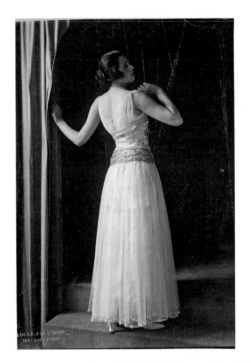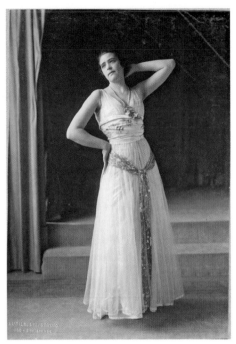

FIG. 2.1 Lucile, "'Bilitis' Hydrangea Blue Oriental Evening Gown," 1916–17. Lucile Collection, Scrapbook 13, "Autumn Models." Courtesy of Fashion Institute of Technology, SUNY, FIT Library Special Collections and College Archives, New York, NY, USA.

of buying clothes" into a "social occasion" laced with a whisper of Edwardian naughtiness.[6] In an era when dressmakers described their clothing models numerically, or else by brief descriptions such as the "black velvet," Duff Gordon harnessed viewers' fantasies by naming her dresses, as well as the mannequins who wore them. She described her dresses as her "Gowns of Emotion," and each example was individually named and given a description that identified the emotional state that the colors, fabric, and cut were meant to evoke:[7] "When Passion's Thrall Is O'er," for example, or perhaps its temporal twin, "Do You Love Me?" Duff Gordon named a dress of soft gray chiffon veiling an underdress of pink and violet taffeta "The Sighing Sounds of Lips Unsatisfied."[8] Some of the gown names connoted exotic, Sapphic sexuality, as in the 1916–17 "Oriental" evening gown "Bilitis" (Bilitis was the name of Sappho's fictional contemporary in Pierre Louÿs's 1894 collection of erotic poetry *Les chansons de Bilitis*) (fig. 2.1); other gowns more explicitly combined sexuality with orientalism, as in the same season's Persian tea dress "Djer Kiss" (fig. 2.2). The dress names were daring, to be sure, but not as daring as Lucile wanted them to

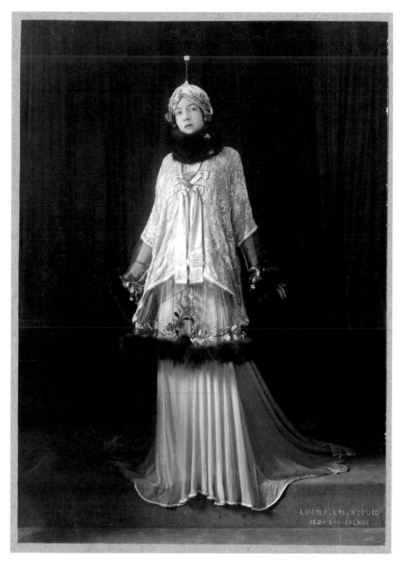

FIG. 2.2 Lucile, "'Djer Kiss,' Persian Tea Gown," 1916–17. Lucile Collection, Scrapbook 13, "Autumn Models." Courtesy of Fashion Institute of Technology, SUNY, FIT Library Special Collections and College Archives, New York, NY, USA.

be. Though she might wish to name a dress "Rendez-vous-d'amour," she knew that "the young ones couldn't wear it; the older ones wouldn't, and the ones who should would be afraid to. I shall call it 'The à Deux,' but we will know what it means!"[9] In New York in March 1910, the display of these "emotional dresses" drew a crowd outside Lucile's New York showroom. As Duff Gordon reminisced, "The names intrigued . . . practical New York has never thought of going out to dine in 'Love Will Find Out a Way,' nor to lunch in 'The Wine of Life.'"[10] She argued that the most important quality that the "truly great designer" must have was, "above all else, a thorough grasp of the great principles of psychology and the power to apply the reasonings of psychology to art."[11]

To showcase these emotional gowns, Duff Gordon staged elaborate fashion spectacles in her various showrooms, located (eventually) not only in London and New York but also in Paris and Chicago (fig. 2.3). In London, in preparation for her first mannequin parade, she installed in her showroom soft carpet, grey brocade curtains, and a small stage, hung with a misty olive chiffon background. In New York, for a time she presented her twice-yearly collections at the Little Theatre, with a small symphony orchestra, two singers from the Metropolitan Opera, and a stage set featuring sea-green chiffon; tickets were sold at five and ten dollars each to members of the Four Hundred and anyone else willing to pay the astronomical ticket prices (proceeds were donated to charity).[12] Duff Gordon sent her clients invitations on "dainty little cards," which they exchanged for programs, as if the showing was a social rather than a sales occasion (of course, it was both). She found her first set of six mannequins, working-class Londoners whom Duff Gordon sent to the hairdresser and the manicurist, and who quickly became the "incarnation of enchanting womanhood."[13] Duff Gordon commissioned her sister, Elinor Glyn (who later became a Hollywood screenwriter as well as the originator of the term "It" to describe modern celebrity), to write texts for fashion events that were a combination of the tableau vivant, the stage play, and the fashion show. Lucy's designs, her willingness to upend Victorian mores, and her modern aesthetic sense proved wildly popular; her list of clients became ever more numerous and elite, including society women, debutantes, and royalty, such as the Duchess of York (later Queen Mary).[14]

To connote the elite elegance of the upper class that could afford such custom-made designs, Duff Gordon redesigned the mannequin's natural walk. Her goal was to have the models' movements suggest an aristocratic elegance designed to "encourage a due humiliation in the rich bourgeoisie," producing an emotional (and covetous) prelude to purchasing. Duff Gordon made her mannequins walk up and down the showroom with books on their heads

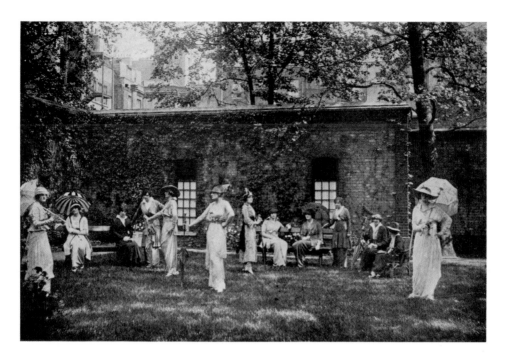

FIG. 2.3 Mannequin parade at Lucile's salon, London, 1913. From Lucy Duff Gordon, *Discretions and Indiscretions* (New York: Frederick A. Stokes, 1932), 239.

until they had acquired "perfect poise of head and shoulders."[15] The model's walk, she exclaimed, was "as old as the world. It is the walk of the Greek maidens carrying offerings to the temple. You stride straight from the hips, never swinging them from side to side, remaining at the same time supple and graceful."[16] Duff Gordon's focus on the remaking of her mannequins concerned class passing. She sought incarnations of upper-class, aloof sophistication with a poise, elegance, and hauteur that would mimic that of their well-bred clients, sparking envy and acquisitiveness. Consequently, Duff Gordon's models for movement were most likely the numerous treatises on deportment central to bourgeois self-discipline. These guidebooks, not unlike the model "how to" books of later periods, included sections on the proper way to walk, sit, descend and ascend stairs, and perform any number of everyday movements with grace and elegance. These systems, such as the Delsarte system of physical culture or the later Mensendieck system, valorized the vertical, erect posture as both biomechanically superior and—in the evolutionary, racialized discourse of the era—civilized.[17]

The gestures of Duff Gordon's mannequins were deliberate and under-stated: limbs moved close to the body, marked by fluidity and unhurried grace.[18] These studied movements, characterized by an elite hauteur signified by an uplifted chin and a condescending and unsmiling countenance, were syn-onymous with white pretension that underlay the modern, cultivated body. It was precisely this vocabulary of elite racialized body movements that enslaved blacks satirized with the cakewalk, their parody of slave owners' aristocratic pretensions in the plantation South. The cakewalk dance emphasized form, poise, and fancy dress; as Jayna Brown has argued, its execution must appear "graceful and leisurely, no matter how heavily one's bejeweled gowns weighed on the hips."[19] Ada Overton had first brought the cakewalk to England in 1897 when she appeared in the black musical review *Oriental America*; by the time Duff Gordon's London mannequins appeared in New York, en route to their own star turn on the Ziegfeld stage, the cakewalk had migrated from the African American stage to Broadway.[20] The subdued gestural vocabulary of the couture mannequin provided a marked departure from the exaggerated movements of most contemporary racialized performance styles, in which the tradition of blackface minstrelsy on both sides of the Atlantic conscripted black bodies into a performance style recognizable by exaggerated motions and expressions: "eccentric" dance styles marked by arms and legs akimbo, staring eyes, and clown smiles.[21] In contrast with these "primitive" displays, the subdued gestures of the couturier model performed a corporeal language that consolidated a discourse of Anglo-Saxon white supremacy for its elite viewers.

Duff Gordon's mannequins were an immediate sensation in London, and four of them—"Gamela," "Corisande," "Florence," and "Phyllis"—sailed to New York on the *Adriatic* in February 1910 to open the first US showroom. Their burden, according to the *New York Times*, would be to wear the Duff Gordon "dream dresses" representing "love and hate, joy and sorrow, life and death."[22] With the introduction of the mannequin, or living model, to the Anglo-American apparel industry, Duff Gordon usurped the place of the seamstress and the artist's model as the most emblematic icons of heterosexual male desire.[23] Duff Gordon's mannequins became, seemingly overnight, famous as models of exquisite beauty, elegance, and sophistication. But by 1915, Duff Gordon, although an excellent designer with an extensive client base and an unerring sense for publicity, suffered cash flow problems. In 1916, Broadway impresario Florenz Ziegfeld attended a performance of her orientalist gowns at the Little Theatre and came back to the dressing rooms. He offered to buy the costumes and the décor, and insisted on hiring four of the models as well. Lucile accepted

Ziegfeld's offer to design costumes for the *Ziegfeld Follies*, an arrangement that lasted through 1922.[24]

Most importantly for this chapter, Ziegfeld hired Duff Gordon's mannequins as well. The statuesque clothes horses became the first "showgirls" on the Broadway stage: unlike the chorus girls, who sang and danced, the model-showgirl's primary responsibility was to display clothing to Broadway audiences through the fashion processional.[25] Lucile mannequins who doubled as Ziegfeld showgirls through the early 1920s included the most famous model of the era, Dolores; Dinarzade (Lillian Farley, also a favorite model for Edward Steichen); Mauricette (of Swedish descent, with blue eyes and honey-colored hair); and Phyllis, an English mannequin with a square face and golden-blond hair.[26] Dolores, Dinarzade, Mauricette, and Phyllis, joined the cast of "Miss 1917," a Follies production that featured Irene Castle, Ann Pennington, and other stars.

"Dinarzade," or Lillian Farley, was born in Tennessee and had trained as an actor in Cincinnati. After two years of trying to sustain herself on the stage in New York, she was hired by Lady Duff Gordon to replace Hebe, one of the English mannequins who had returned to England to get married. Lucile renamed Lillian "Dinarzade"—after Scheherazade's quiet sister—upon Lillian's first appearance in the 30 Fifth Avenue studio, exclaiming upon learning her given name, "What were they thinking of? Anyone with that name should be blond and fluffy haired!" (Lillian was dark and small-featured).[27] Dinarzade immediately began earning eighteen dollars per week, every week of the year, modeling for Lucile—a wage that was soon increased (by late 1917) to twenty-five dollars weekly (fig. 2.4). These were extraordinary sums for a working girl in the World War I era. Later in the 1920s, Farley modeled for both Edward Steichen and Jean Patou in Paris at forty dollars per week as part of Patou's (and Condé Nast's) publicity stunt of importing American models to Paris (fig. 2.5); in 1926, Farley became a Paris-based buyer for Bergdorf Goodman's and still later served as the Paris editor of *Harper's Bazaar*.[28]

"Dolores" was a British-born dressmaker's model who moved from Lucile's New York couturier salon to the Broadway stage in June 1917, when she began performing in both the *Ziegfeld Follies* and the after-hours show the *Midnight Frolic* (fig. 2.6). Born Kathleen Mary Rose, Dolores was a tall (nearly six feet), working-class woman with a Cockney accent, blue eyes, and ash-blonde hair whom Duff Gordon reportedly discovered working as an errand girl in her London showroom.[29] Duff Gordon spent a year on her new creation, "Dolores," eradicating her working-class accent and teaching her the confidence, poise, and walking techniques central to Duff Gordon's mannequin parades.[30] The

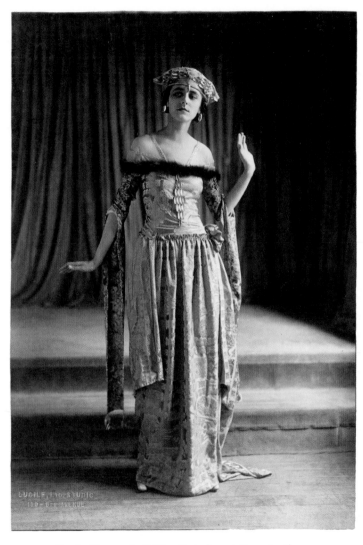

FIG. 2.4 Lucile, Dinarzade (Lillian Farley) modeling a Lucile gown, 1916–17. Lucile Collection, Scrapbook 13, "Autumn Models." Courtesy of Fashion Institute of Technology, SUNY, FIT Library Special Collections and College Archives, New York, NY, USA.

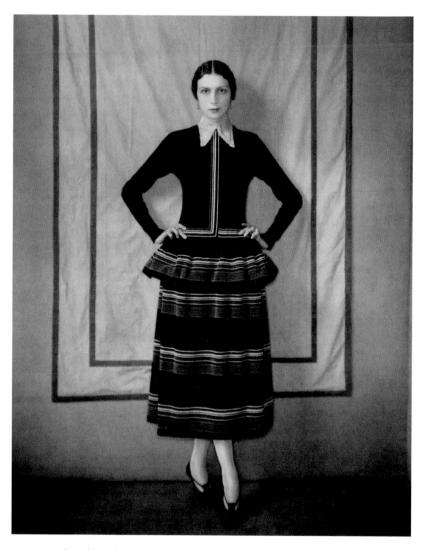

FIG. 2.5 Edward Steichen photo of Dinarzade. *Vogue*, November 1, 1924, 56. Edward Steichen / Vogue © 1924 Condé Nast.

PEARLS *and* TULLE SPIN BRIDAL WITCHERIES

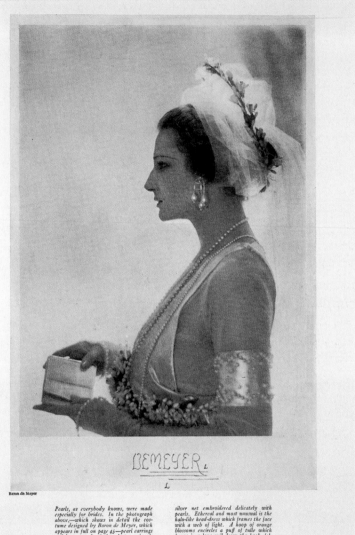

Baron de Meyer

Pearls, as everybody knows, were made especially for brides. In the photograph above,—which shows in detail the costume designed by Baron de Meyer, which appears in full on page 45—pearl earrings and long strands of these lustrous jewels are used with a gown of silver cloth and

silver net embroidered delicately with pearls. Ethereal and most unusual is the halo-like head-dress which frames the face with a web of light. A hoop of orange blossoms encircles a puff of tulle which hangs in a long veil down the back, following the trains like a spray of silver

FIG. 2.6 Dolores (Kathleen Mary Rose). *Vogue*, April 15, 1919, 43. Photograph by Baron Adolph de Meyer.

development of haute couture on the Ziegfeld stage licensed an upper-class gaze, both masculine and feminine, that licensed the public looking of feminine "pulchritude" while tying a sexualized, aesthetic looking to consumerism.

The stately majesty of the models' performance of racialized, upper-class femininity became the trademark of the *Ziegfeld Follies*. This version of spectacular femininity, a commodity manufactured by the model-performer in *Follies* numbers and in Lucile's showrooms, became immediately imbricated with luxury brand goods through costume, performance, and song. Dolores's first appearance in the *Follies*, for example, was as a human product placement: on July 15, 1917, she appeared as a Rolls Royce automobile, one of six "car girls" personifying aspects of the song "The Motor Girls," performed by Mabel Berry.[31] In October 1919, Dolores performed as one of several model-showgirls on a *Midnight Frolics* piece that functioned as a cobranding exercise linking Ziegfeld, his wealthy New York audience, and the Cartier jewelry firm. During this season, Cartier had a sensational hit with an expensive bracelet, composed of various jewels cut in the shape of letters that formed the word "Dearest" on the wearer's delicate wrist. Dolores appeared on Ziegfeld's stage as the "crowning jewel" of a performance in which each of seven "statuesque beaut[ies]" dressed in the color of her namesake jewel spelled out the name "Dearest" onstage.[32] During this same period, Dolores's work as a well-known couture model was regularly in evidence in the high-end fashion apparel in contemporary magazines such as *Vogue, Harper's Bazaar,* and *Town and Country,* in which she was photographed by leading fashion photographers, including Baron Adolph de Meyer.[33] As *Vanity Fair* wrote in 1918, "Probably no model of our time has been more widely posed or photographed as she."[34]

With the work of stage designer Joseph Urban and of choreographer Ned Wayburn, who were also hired by Ziegfeld in 1915, key aspects of the couture and department store mannequin parade became standard to Ziegfeld productions. A protocatwalk, for example, appeared in 1915 when Joseph Urban introduced a transparent glass runway to the *Midnight Frolics,* the after-hours cabaret that unfolded on the roof of Ziegfeld's New Amsterdam Theatre.[35] The model's walk down the couture "house" stairway onto a raised catwalk migrated to the Broadway stage in the form of Wayburn's "processional," a choreographed sequence featuring the model-showgirls (or, using Wayburn's taxonomy, the "A" chorines). The processional was fundamentally a slow-paced mannequin parade featuring the model-showgirls, usually involving a staircase upon which the model-showgirls maintained fashion poses. In a more complex variation of the procession, each of the model-showgirls might represent, through costume

and pose, an aspect of the song being crooned by the scene's soloist.[36] These numbers featured the least movement of all the performances, with the exception of the penultimate performance numbers, the tableaux vivants. The job of the showgirl was fundamentally that of the mannequin: to model the work of clothing designers, with the goal of stimulating awe, envy, and desire for both the clothes and the model wearing them; audience members captivated by the clothing designs could learn from their playbill who designed them, and where they could be purchased.

As several scholars have shown, Ziegfeld's version of feminine beauty glorified not simply the "American" girl but also whiteness itself. By the time that the Glorified American Girl became Ziegfeld's official motto in 1922, the show had been producing a racial categorization that equated beauty with an Anglicized definition of whiteness since the pre–World War I years. In the context of the nativism and xenophobia of the early 1920s, the mannequin parades on the Ziegfeld stage consolidated whiteness as both a racial and as an aesthetic category through an ongoing performance of statuesque beauty as whiteness.[37] Once onstage, however, Ziegfeld presented his white female cast members as anything but "Caucasian"; instead, as we can see from Duff Gordon's costumes and mannequins, as well as from Joseph Urban's designs, the shows exoticized the female form through the discourse of orientalism.[38] Ziegfeld and Lucile's orientalist production numbers followed the "Salomania" of the prior decade, when the popularity of Richard Strauss's 1905 adaptation of Oscar Wilde's scandalous 1892 play *Salomé* led to an Anglo-European craze for exotic, and erotic, female stage performances.[39] In Ziegfeld's song-and-dance episodes, orientalism enabled "glorified American girls" to perform as exoticized and erotized others in an invented landscape of sensuality, permissiveness, and opulence (fig. 2.7). As William Leach has argued, orientalism facilitated Americans' transition to a new culture of consumption, one based on the gratification of desire, rather than its repression.[40] In Ziegfeld's productions, Anglo and Anglicized chorus and showgirls functioned as raw material for the costumes, stage designs, lighting, music, and choreography that connoted the permissiveness of a newly emerging mass consumer culture.

The signature movement sequence of the model-showgirl was her walk, a racialized series of motions that signified Anglo-Saxon elegance, femininity, and deportment. The walk, refined in Duff Gordon's London, Chicago, and New York showrooms, connoted the class-specific habitus of the cosmopolitan elite, the moneyed classes (both old and new) able to afford high-end couture. Ziegfeld's audiences included the same clientele, who saw the couturier house mannequin parade restaged as the series of movements central to

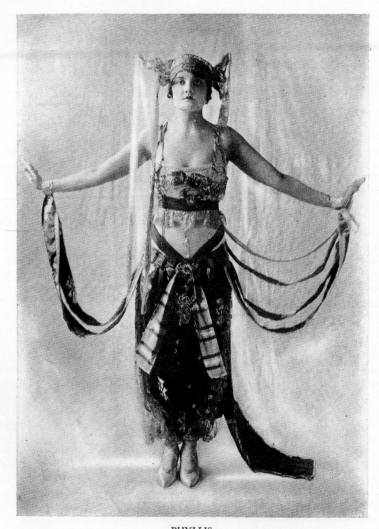

PHYLLIS
in a dress designed and made at my studio, 160 Fifth Avenue, New York, for the Ziegfeld 1916 Follies

FIG. 2.7 Phyllis, in a Lucile orientalist design, *Ziegfeld Follies*, 1916. Lucy Duff Gordon, *Discretions and Indiscretions* (New York: Frederick A. Stokes, 1932), 251.

the model-showgirl processional—what in 1917 became known as the Ziegfeld Walk. This walk, so familiar to us now through Busby Berkeley musicals from the 1930s, involved the slow descent down a staircase built at an oblique angle to the audience. The footwork, as dance historian Barbara Naomi Cohen-Stratyner reconstructs it, involved a simple step forward with the outside foot, followed by a closing step with the inside foot. As Joseph Urban's staircases were often built with greater distances between the treads than the norm of 7.5 inches, this method of descending staircases enabled the model-showgirl to descend in full costume without falling over.[41] As she descended the stairs, the model-showgirl turned her torso away from the path of her feet, toward the front of the stage, while her face would be turned to the audience. Her arms extended elegantly to either side of her body, with hands drooping from the wrist; this gesture allowed the model to display the gown, often presented with elaborate trains looped to the wrist. The outside shoulder would tip away from the arms, balanced by the opposite hip, producing an accentuated thrust of the pelvis as the model descended the stairs.[42] The overall effect was one of an unsmiling, stately elegance, devoid of the (often racialized) humor and high jinks that marked most other aspects of the revue.

Ziegfeld's model-showgirls produced onstage a form of affective labor central to expanding consumer capitalism. Although scholars disagree on the specificities of "affect" as a term, all would agree that the affective necessarily requires the work of the body in producing physiologically charged emotions, and which are often identified in the conscious mind as "feelings."[43] Following Sara Ahmed, we might think of affect as emotions circulating between bodies in public space, emotions that are identified by their feeling states. Affect, in this analysis, transcends the individual body; affect is a feeling that connects and creates bodies and worlds in public space.[44] Ahmed's formulation of affect as the circulation of emotion between bodies, producing feelings that are erroneously read as "private," is a useful framework for thinking about the affective labor of 1920s stage models. Through the work of the body, in its poses and movements, Ziegfeld's models participated in the production and circulation of feeling states central to the era's bourgeoning consumer economy. These feeling states were predicated on an aesthetic sense, an appreciation of beauty and taste; at the same time, however, these feeling states were tied explicitly to the market.

The aesthetic feelings that the Ziegfeld models trafficked in were heavily indebted to the affective labor of black performers who were otherwise barred from the Ziegfeld stage. Ethel Williams, the costar of the black musical comedy

Darktown Follies (1913), trained several white women dancers, including Irene Castle and the Ziegfeld chorus girls, but as Jayna Brown argues, this training happened behind closed doors, producing a racial mimicry onstage that rendered invisible the contributions and bodies of black performers.[45] Ned Wayburn, Ziegfeld's choreographer and the era's most famous chorus and showgirl dance trainer, introduced several aspects of African American performance traditions into his chorus work, including tap, modified shimmies, a subdued version of the end-chorine's oppositional antics (made famous by Josephine Baker), and several dances that had emerged from black cultural forms, including the Charleston and the Blackbottom. Both of these dances had become popularized through black musical productions associated with Irvin C. Miller of the later *Brownskin Models* fame, whom I discuss later in this chapter; according to one historian, in 1923 over one thousand pupils—as well as star performers such as Ann Pennington—practiced the Blackbottom daily in Ned Wayburn's school of stage dancing once Irvin C. Miller's *Dinah* had opened in New York, where the dance was first introduced.[46] But although Ziegfeld was willing to include some African Americans as starring acts (Bert Williams is the best-known example), most black performers were barred from the stage as either showgirls or chorines.

The scholarly literature on the *Ziegfeld Follies* generally agrees, following contemporaneous criticism by Siegfried Kracauer and Edmund Wilson, that these spectacles eroticized the standardized rhythms of mass production. In this reading, the introduction of a living curtain of chorus girls moving in mechanized lockstep revisited the pleasures of standardization from the managerial point of view and, in using the female form as a stand-in for the interchangeable parts of industrial production, eroticized the machine.[47] As persuasive as these arguments are concerning the rationalization of the body, however, they reference the cultural work of the mass-produced chorus girl, not the showgirl. Standardization arguments are most successful when describing the precision dancing and costumed uniformity of the majority of chorus girls, those in (using Wayburn's taxonomy) the B through E categories. But the A dancer, or the model-showgirl, played a somewhat different role in the Ziegfeld performances. Whereas the precision dancers sparked the visual pleasures of military formations and machine-age assembly lines, the model-showgirl processionals connoted the affective aspects of fine art appreciation, signifying then—as now—a specifically classed and racialized subjectivity.

Fine art aesthetic discourse was central to Ziegfeld's productions, for the allusions to high cultural forms secured a respectable, middle-class female

[handwritten margin note: eroticized the machine]

audience while simultaneously legitimizing what was, essentially, a "leg" show. Ziegfeld models even occasionally appeared nude onstage, through the penultimate tableau vivant, in which eroticized looking was sanctioned through the discourse of art appreciation.[48] It was this combination of spectacle and aesthetic sophistication that breathed new life into the vaudeville tradition, and that mesmerized the heterogeneous tastes of businessmen, New York's social elite, and critics alike.[49] This aesthetic discourse, often orientalist in tone, was instrumental in policing the boundaries of race and class—which is why Ada (later, Aida) Overton Walker's performance of Salomé (a black appropriation of a white orientalist discourse) represented a political transgression in violating white expectations that black performance was necessarily, and emphatically, a nonaesthetic performance tradition marked by comedy, eccentric movements, and the primitive. In the model-showgirl processionals, each of the mannequin promenades was introduced by an art song, such as Mendelssohn's *Spring Song*; the model-showgirls wore individual, custom-made costumes designed by contemporary couturiers. The reviews of these aspects of the Ziegfeld productions emphasize the relationship between aesthetic pleasure and the fine arts.[50]

The models' poise and grace, the costumes themselves, and the Ben Ali Haggin tableaux, signified not only a middlebrow appropriation of high culture but also the emotional cultivation necessary for the appreciation of aesthetic forms. As numerous historians have argued, the discourse of "civilization" in this period carried with it the assumption that those of Anglo-Saxon heritage represented the pinnacle of evolutionary development. The emotional sensitivity of the cultivated was part of this evolutionary heritage; while this sensitivity could sometimes become a burden (as in the case of neurasthenia), the capacity for deep (aesthetic) feeling was understood as an explicitly racial trait—of the Anglo-Saxon race, that is.[51] Both Lady Duff Gordon, working with her mannequins, and Ned Wayburn, choreographing their movement on the Ziegfeld stage, sought to produce racialized discourse of grace, poise, and elegance through the vehicle of their models' bodies and (e)motions. In this way, we can see the model-showgirls as performing a certain type of racialized affective labor. In this early case, models used their bodies to create emotional responses among their viewers: envy, perhaps, in Duff Gordon's showroom; racial wonder, maybe, at the *Ziegfeld Follies*. Their affective labor was critical in the production and circulation of emotion central to the creation of an elite Ziegfeld audience. And this emotion was, in turn, central in the production of consumers, who made a beeline to Fifth Avenue department stores and couturier houses at curtain's close.[52]

"Glorifying the Brownskin Girl": *Brownskin Models*

The Ziegfeld model-showgirls were not the only models on the interwar stage, however. In 1925, African American performers began a thirty-year stint with the traveling black musical revue *Brownskin Models*. Produced by theatrical impresario Irvin C. Miller, brother of Flournoy Miller, the show was hailed by the *Chicago Defender* as a radical departure from the usual "stereotyped plantation song and dance show."[53] Models and modeling scenes were a central element of Miller's show, as they were in Ziegfeld's productions. The use of the model allowed Miller to create a middlebrow cultural production that borrowed from Broadway's examples to showcase the female form, securing large audiences among both blacks and whites of both sexes. Miller's beauty revue provided one escape route from the minstrel form that had long marked black stage performances. At the same time, the use of the model allowed Miller to participate in a longer tradition of black stage performance that both appropriated and satirized middle-class cultural forms.

With the *Brownskin Models*, the commodification of aesthetic feeling allowed New Negroes to negotiate the two dominating pressures of black modernity in the 1920s. On the one hand was the legacy of black respectability, figured in this period through the discourse of artistic accomplishment and emblematized by W. E. B. Du Bois and the generation that Langston Hughes castigated as "elderly race leaders."[54] As Alain Locke argued, the "cultural recognition" won by the era's "talented group" of black artists would "prove the key to the re-evaluation of the Negro which must precede or accompany and considerable further betterment of race relationships."[55] On the other hand was the vernacular, commercialized modernism of the black metropolis, evident in the period's nightclubs, dance halls, and performance spaces.[56] The tension between uplift/respectability and commercial culture defined this generation, and played a central role in the later work of Langston Hughes, Claude McKay, and other younger artists.

Irvin C. Miller's *Brownskin Models* resolved these competing demands on black cultural production in the 1920s by joining together the discourse of art—central to the cultural politics of the Talented Tenth—with the musical revue, a form of commercialized leisure central to black modernity. Both the "high culture" of fine arts and the "low culture" of the leg show depended on the performance of femininity. Through the vehicle of the model as type, Miller created a middlebrow cultural production that used female display to negotiate a synthesis between the aesthetic poles of talented tenth racial uplift and working-class, red silk stockings (to quote another Hughes title).

This complex synthesis depended on the imbrication of aesthetic feeling, commercial culture, and black female sexuality. With Miller, the *Brownskin Models* coproduced a public, commercialized sexuality that made claims both on New Negro modernity and upper-class, artistic signifiers to rewrite the meanings of black femininity. Like other 1920s black women artists who used the market to produce and naturalize new forms of female sexual modernity—from beauty entrepreneurs to blues artists to gospel singers—black stage models of the time used the commodification of aesthetic feeling to rewrite the meanings of black female sexuality in the public sphere. In this articulation of New Negro modernity, Miller's model revue used commercial culture to produce a sanitized, black female sexuality that negotiated a careful path through the twin stereotypes of the hypersexual jezebel and the asexual mammy, opening up a cultural space for the profession of black professional modeling in later years.[57] Yet Miller's model revue, while "glorifying the Brownskin girl," furthered the commodification of the female form as part of early twentieth-century mass culture while at the same time reinscribing a color-based skin tone hierarchy in the casting of black chorus and showgirls.

Irvin C. Miller, the show's producer, had a long and illustrious history in African American variety theater as an actor, comedian, author, and producer (fig. 2.8). In the 1920s and 1930s, he was arguably the most well-established and successful producer of black musical comedy. Born on February 17, 1884, in Columbia, Tennessee, Miller graduated in 1904 from Fisk University, where he began producing shows with his brother Flournoy and another friend, Aubrey Lyles (Flournoy and Lyles, the premier black comedians of the Jazz Age, went on to create the Broadway hit *Shuffle Along* in 1921).[58] Eventually, Miller became involved in the writing and production of several important Broadway shows, including *Put and Take* (Irvin C. Miller, coauthor and director, Town Hall, 1921, 34 performances); *Liza* (Irvin C. Miller, author, Daly's Theater, 1922, 169 performances—the show that introduced the Charleston to Broadway audiences, and has been credited as the first black musical comedy owned and produced on Broadway entirely by black capital); and *Dinah* (Irvin C. Miller, author and producer—credited for introducing the black bottom dance craze of 1923–24).[59]

Put and Take, a revision of *Broadway Rastus*, had been on tour for a year before opening near Broadway at Town Hall in August 1921; though it predated *Shuffle Along* in production, its opening so near the "Great White Way" was testimony to Broadway's emerging willingness to showcase black productions after *Shuffle Along*'s stunning success with white audiences. Irvin C. Miller's *Put and Take*, unlike his brother's *Shuffle Along*, was set in the urban North;

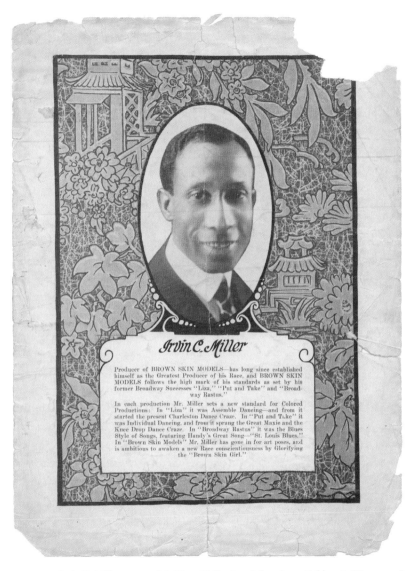

Irvin C. Miller

Producer of BROWN SKIN MODELS—has long since established himself as the Greatest Producer of his Race, and BROWN SKIN MODELS follows the high mark of his standards as set by his former Broadway Successes "Liza," "Put and Take" and "Broadway Rastus."

In each production Mr. Miller sets a new standard for Colored Productions: In "Liza" it was Assemble Dancing—and from it started the present Charleston Dance Craze. In "Put and Take" it was Individual Dancing, and from it sprang the Great Maxie and the Knee Drop Dance Craze. In "Broadway Rastus" it was the Blues Style of Songs, featuring Handy's Great Song—"St. Louis Blues." In "Brown Skin Models" Mr. Miller has gone in for art poses, and is ambitious to awaken a new Race conscientiousness by Glorifying the "Brown Skin Girl."

FIG. 2.8 Irvin C. Miller, c. 1925. Lily Yuen Collection, Schomburg, Folder 1/5, "Programs." Manuscripts, Archives, and Rare Books Division, Schomburg Center for Research in Black Culture, New York Public Library, Astor, Lenox and Tilden Foundations.

it shed references to the South and to the past, and instead adopted a contemporary tone. In avoiding minstrelsy's stereotypes, the show won exuberant praise from the *New York Times*.[60] Miller's *Put and Take*, however, drew criticism from *Variety* that castigated the show for placing too much emphasis on the "effort to be dressed up and dignified."[61] The critic complained that Miller had abandoned "indigenous" blackness for Ziegfeld's whiteness: "Colored performers cannot vie with white ones, and colored producers cannot play within an apple's throw of Ziegfeld and try to compete with him. . . . Here the colored folks seem to have set out to show the whites that they're just as white as anybody. They may be as good, but they're different, and, in their entertainment they should remain different, distinct, and indigenous."[62] In particular, the *Variety* reviewer singled out the women's costumes for censure: "the girls' wardrobe ran to tawdry gowns when they should have been fancifully dressed as picks, Zulus, cannibals, or cotton pickers."[63] Miller's emphasis on clothing, girls (songs included "Creole Gal" and "Chocolate Brown"), and "dressing up" represented unwelcome class and racial crossing. As Monica L. Miller has argued in her work on the black dandy, well-dressed blacks sauntering down Harlem streets, or in this case across the Broadway stage, were competitive, defiant performances of freedom, dignity, and self-worth, and as a result were threatening to hostile whites.[64] Despite a profitable first two weeks, objections were made to a "colored company" at Town Hall, and the show closed after just thirty four performances, even though *Put and Take* was the only black musical in town that season, and had been grossing nearly $8,000 per week.[65]

Irvin C. Miller had observed, along with other black producers, that Broadway's "discovery" of black talent in the wake of *Shuffle Along* had led to an increase in costs for mounting shows in New York. As a result, it became increasingly difficult to mount new black musicals without the support of traditional Broadway financing, and a consequent loss of creative control. The creative impact of this financial shift was the emergence of white behind-the-scenes talent for "black" Broadway productions (such as Lew Leslie) and, along with the showcasing of memorable black talent, the reinvigoration of racist stereotypes, emblematized by a massive half of a watermelon suspended over the stage of Lew Leslie's 1922 *Plantation Revue*.[66] Touring black productions on the road, however, away from the high financing requirements of a Broadway production, ensured both creative control and audience longevity. In response to these Broadway developments, Irvin C. Miller turned his attention to developing a traveling show.

Opening in October 1925 at the Howard Theatre in Washington, DC, a black theatre well known for launching successful national touring productions,

Brownskin Models was an immediate success.[67] In New York, it opened at the Lafayette Theatre and appeared annually at the Harlem Opera House through the 1930s. It toured every year from 1925 through 1955 throughout both the United States and Canada, with often record-breaking crowds.[68] The show continued to draw large audiences through the 1930s and 1940s, touring over forty weeks of every year, especially in the Midwest and the South, continuing with their "landslide of business wherever they appear."[69] As Miller remarked in 1939, "There isn't a circuit in the United States that *Brownskin Models* hasn't played."[70] (Irvin C. Miller also produced numerous other shows during this period; *Brownskin Models* was simply the longest-running.) In 1954, Irvin C. Miller engaged his brother Flournoy to work with *Shuffle Along* composer Eubie Blake to revive the show with new lyrics, but their interventions were unsuccessful: the show closed in 1955.[71]

Brownskin Models was a "beauty revue" that, like both the *Ziegfeld Follies* and Lee and J. J. Shubert's *Artists and Models*, used the figure of the model to anchor a series of otherwise unconnected scenes featuring chorus line dancing, tableaux vivants, dress promenades, comedic sketches, and original music. Miller brought together two different aspects of modeling in this long-running show: the long-established discourse of the artist's model, with her relationship to aesthetics, the fine arts, and transgressive sexuality; and the contemporary couturier clothes model, whose performances of stately femininity and opulent costumes had defined Ziegfeld's model-showgirls. A page from a 1926 souvenir program titled "Art Expressions" signified this double discourse of fashion and fine arts posing (fig. 2.9). In the top photograph, three showgirls smile at the photographer, posed in elaborate costumes and accompanied by the feather headdresses, richly ornate gowns, and boas popularized by Broadway's model-showgirls. In the bottom two images, two unclothed life models arrange themselves for the implied artist's gaze, lightly holding their studio drapery while looking away from the camera/artist. As Miller told a reporter years later, his idea was to "make Negroes conscious of the beauty of their own girls" through the display of the female form.[72]

The work of both the artist and the couture model provided the thread that linked the show's two acts and twenty-four scenes. In the first production, for example, Cecil Rivers sang a prologue song, "Painting a Picture of You," followed by "bits of posing" featuring Edna Barr, Bee Freeman, and Hazel McPherson.[73] The posing scenes were followed by a comedic monologue by Irvin C. Miller, two song-and-dance numbers featuring the "girls" and the chorus, a penultimate song by star Eva Metcalf, and a concluding bedroom comedy skit.[74] The focus of the show, however, was on the brownskin models themselves. As Ziegfeld

Eyvette Dotson Top—Misses Dotson Thompson and Yeun Cherrie Lamont

FIG. 2.9 Cast members from the production *Brownskin Models*, "Art Expressions" program, 1926. Lily Yuen Collection, Manuscripts, Archives, and Rare Books Division, Schomburg Center for Research in Black Culture, New York Public Library, Astor, Lenox and Tilden Foundations.

claimed to be "glorifying the American girl," Miller's production claimed an ambition to "awaken a new Race Conscientiousness" by "glorifying the 'Brown Skin Girl'" through chorus lines and model posing scenes and processionals.[75] As in Ziegfeld's productions, the chorus girls were complemented by the model-showgirl, who did not necessarily sing or dance; she merely appeared in costume, walked across the stage, and posed. As Miller described the work of Blanche Thompson, the show's lead model for much of its history (and, according to Miller, for many years the highest paid Negro woman artist on the stage), she had "nothing to do but walk from one side to the other before the footlights" (true for her work onstage, but offstage she was also the business manager of the company, and often made the costumes as well; figs. 2.10 and 2.11).[76] According to one journalist, *Brownskin Models* originated the model-showgirl type in African American theatre. The model-showgirl was "latched on to" by nightclubs, including the Cotton Club, "which in reality was nothing but a copy of 'Brownskin Models' and which gave rise to the fad of presenting fashion shows with models doing the entertaining."[77]

In addition to the slow promenade of the dress model, *Brownskin Models* featured "posing scenes," what were called "tableaux vivants" (living pictures) in Ziegfeld's programs of the same period. A 1930 review describes the effect: "The tableaux scenes were almost natural. Scantily attired and pretty girls posed artistically. Not a move was sighted while the tableaux [*sic*] was in form. The poses . . . offer a pleasing spectacle."[78] By 1931, 50 percent of the show featured "posing scenes," in which models posed onstage, an innovation that Miller borrowed from Ziegfeld and from the Shuberts. The discourse of posing, indebted here to the tradition of the artist's model as much as the clothing model, signified a rhetoric of aesthetic experience that legitimized (by purporting to desexualize) the audience's frank assessment of female beauty. As one reviewer wrote in 1926, "It is the most beautiful spectacle I have ever seen in the theatre. For the first time I saw the human form glorified not vulgarized. I asked a man if the poses of the models appealed to his baser or his higher senses, and he said that the girls impressed him as beautiful pictures, nothing more. With the real artist's attention to detail . . . it is essentially a show for the eye . . . every girl in the show is a worthy model."[79]

With the model as performer, Miller invented a formula for black variety theatre that addressed several competing and contradictory expectations concerning African American performance. Despite the flowering of New York black creative expression that became known as the Harlem (or sometimes, New Negro) Renaissance, as the history of Miller's *Put and Take* suggests, white producers and reviewers continued to castigate any black theatre that strayed

Top—Aurora Greely Middle—Saddie Tappan Lower—Blanche Thompson

FIG. 2.10 Photomontage of cast members from the production *Brownskin Models*, featuring Aurora Greely, Saddie Tappan, and Blanche Thompson (*lower image*), "Art Expressions" program, 1926. Lily Yuen Collection, Manuscripts, Archives, and Rare Books Division, Schomburg Center for Research in Black Culture, New York Public Library, Astor, Lenox and Tilden Foundations.

BLANCH THOMPSON
LELIA EDMUNDS, — in a
Spanish dancing ensemble that
sets off her Castillian beauty to
great effect. Few sweeter girls
than she, are to be found among
Harlem's "Smarter Set."

FIG. 2.11 Blanche Thompson,
c. 1926. Lily Yuen Collection,
Folder 6, "Scrapbook 1926–1930."
Manuscripts, Archives, and Rare
Books Division, Schomburg Center
for Research in Black Culture, New
York Public Library, Astor, Lenox
and Tilden Foundations.

too far from whites' primitivist ideas of black "nature."[80] Although the beauty revue was a long-established, if not conservative, form by 1925, black women's performance of an aestheticized femininity unaccompanied by coconut trees and jungle vines unsettled some white reviewers, who demanded that black cultural productions conform to their ideas of an essential black primitivism.[81] At the same time, Miller's work as a comedian addressed the class pretentions of the black community's "Talented Tenth": his first major production, *The Colored Aristocrats*, poked fun at the humorless morality of a black middle class that sacrificed entertainment for respectability. The model, through her relationship to aesthetics, referenced the cultural hierarchies implicit in black middle-class discourses of racial uplift; at the same time, the show's comedic structure participated in a longer tradition of black performance that used satire to parody black class aspirations and to cushion the blow of dreams deferred. For white audiences, the model's performance allowed a cross-racial engagement with black bohemia (Carl Van Vechten's *Nigger Heaven* was published in 1926) as well as activated a long-entrenched sexualized looking, reinvented in this context as an aesthetic discourse. As in all cultural texts, of course, such identifications and structures of looking were mobile and contingent; the historical viewer's experience of any particular show could be marked by dominant, negotiated, or oppositional readings of any specific scene.[82]

The star model for most of the show's run was Blanche Thompson. Nicknamed the "Bronze Venus," Thompson was born in Port Lavaca, on Texas's southern Gulf Coast, in a middle-class black family that included high school teachers and one college dean. She resisted her family's efforts to get her to teach as well, however, and moved into both cinema (including parts in two of Oscar Micheaux's films) and stage. By 1926, Blanche Thompson was the star performer of the *Brownskin Models* and was married to the producer, Irvin C. Miller. "Posing is my work," she told a reporter in 1938, arguing that she was the only woman to have posed in "practically every large theatre in Canada," in addition to every major city in the United States.[83] By this period, Thompson was the president of the Brown Skin Models Company, worked as the company's "head model," conducted the group's business affairs, made most of the costumes, and fashioned the posing scenes. She continued in these roles until the show's close in 1955, and died in 1987 in Corpus Christi, Texas.[84]

Reporters and reviewers made explicit and frequent references to the Follies as *Brownskin Models'* counterpart on the "Great White Way." Borrowing from Ziegfeld's trademark phrase, "glorifying the American girl," reporters described Miller's production as "glorifying the brownskin girl."[85] As one reporter wrote, "If 'Flo' Ziegfeld, master showman of the early twenties and glorifier of the

American showgirl[,] has an equal in the Negro theatrical world that man is Irvin C. Miller, connoisseur of sepia beauty and originator of the immortal 'Brownskin Models.'"[86] There were, indeed, numerous parallels between the two showmen. Like Ziegfeld, Miller organized his show as a nonnarrative revue that featured a commodified form of female sexuality that skated the line between vaudeville and burlesque. The figure of the model was central to this balancing act, for the model licensed looking at the draped and sometimes undraped female form, and the model's relationship to art legitimized this looking as an aesthetic, rather than a lecherous gaze. Of course, the impossibility of clearly separating these two types of looking was a productive confusion for stage producers working with the female form. Like Ziegfeld, whose first wife Anna Held was one of Ziegfeld's star attractions, Miller married his lead performer, Blanche Thompson. And, like Ziegfeld, Miller privileged whiteness in his shows' hierarchies of skin color.

The model-performers in Miller's production ranged in skin tone from "bronze" to "Creole," or what was known as "high yaller"—a range included within the new category of "brownskin" while nonetheless inscribing a color hierarchy that marginalized the darker skin tones. As Laila Haidarali has shown, the category of the "brownskin" emerged as part of a larger project of progressive race politics that brought together disparate elements of the African diaspora in the interwar United States.[87] Blanche Thompson, the star of the show for almost its entire run, was described as "bronze" in complexion by several reviewers; Lily Yuen, a performer/model with the show for many years, was also of a light complexion born of her mixed-race heritage (fig 2.12).[88] A later review from 1940 reflected more explicitly the politics of race and color in these chorus revues. A producer, interviewed for the piece, stated that all of the chorus girls needed to be "high yaller," or very light-skinned with European features, since this type approximated the "ideal" of the theatre, the white chorus girls.[89] The origins of the black chorus girl were in the black productions for white audiences, who demanded the "Creole type of girl" associated with New Orleans. The reviewer wrote that the chorus lines from the 1920s and 1930s did not include any darker girls at all and that the "color scheme is predominantly yellow or light brownskin" (this was in part why Josephine Baker enjoyed a much more successful career in Europe than she did in the United States).[90] *Shuffle Along*'s chorus complexion ranged from "light brown to near-white," while "Irvin C. Miller's 'Brownskin Models' . . . are made up mostly of light-skinned girls."[91] According to the reviewer, the white producer Lew Leslie's editions of 'Blackbirds' featured light-skinned girls almost exclusively until European audiences pointed out that "the girls aren't Negroes, they are white," and

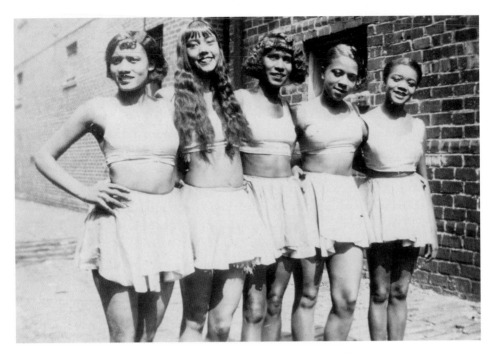

FIG. 2.12 Lily Yuen with fellow performers, c. 1926. Lily Yuen Collection, Folder 6, "Scrapbook 1926–1930." Manuscripts, Archives, and Rare Books Division, Schomburg Center for Research in Black Culture, New York Public Library, Astor, Lenox and Tilden Foundations.

demanded the darker types in 1938.[92] A Harlem dance teacher interviewed for the piece, Mary Bruce, blamed the producers for this color hierarchy, since they sought exclusively light-skinned performers: "I hate to say it, but both white and colored producers show this prejudice towards the dark girl. They want girls to look as nearly white as possible when they're on the stage, although the extremely dark girl is nine times out of ten the better dancer . . . but she [black girl] hasn't a chance in the chorus of today."[93] Though Miller's production introduced the glamorous model-showgirl to African American theatre, the rhetoric of "brownskin" beauty depended on, and helped construct, the continued marginalization of darker skin tones and non-European features.

Brownskin Models, like Ziegfeld's *Follies* and *Frolics*, used the figure of the model as a vehicle for the display of the female form. Like Ziegfeld, Miller made use of the discourse of "art" as a Trojan horse via which the bare skin and scanty costumes could be smuggled onstage. The *Brownskin* models wore costumes of transparent nets, with gold, silver, and rhinestone elements that drew

attention to calves, thighs, hips, and busts.[94] The rhetoric of the model, which included both the artist's model and the dress model, sanctioned a sexually appreciative gaze that would otherwise have crossed the line of salacious impropriety. Contemporary reviewers acknowledged the unprecedented display of female bodies but argued that the show's artistic tone successfully celebrated, rather than denigrated, the "brownskin beauty." A reviewer for the *Pittsburgh Courier* wrote in 1925 Miller was "truly glorifying the brownskin girl" through his choice of chorines.[95] "Beauty and symmetry of form are prime requisites of the chorus," argued the reviewer, and Miller "has drawn a fine line of demarcation between nudity and art. You'll see ART at the Elmore Theatre this week."[96] Two reviewers writing a bit later offered the historical perspective that Miller was the first producer to present his performers in the nude, as Ziegfeld had done in his tableaux vivants. Wilbur Thin, in discussing the glaring absence of the traditional leg show in Lew Leslie's 1931 *Rhapsody in Black*, exclaimed (tongue in cheek), "What? No legs?" He argued that Miller was the "first to glorify the brownskin girl in what the artists call 'the all-in-all.'"[97] Another reviewer credited Miller with "being the first to introduce the brown skin girl in semi-nude, glorified in a show artistically arranged and devoid of smut."[98] The girls are "carefully selected for their beauty, grace and form" and according to Miller are "closer to the patron and more carefully scrutinized."[99]

As these reviews suggest, *Brownskin Models* used the discourse of art as a strategy in displaying the nearly nude African American female form to mixed race and class audiences. How could African American producers present female beauty and sexuality for both black and white audiences without reinforcing racist assumptions of black women's "natural" lasciviousness, as the jezebel stereotype suggested? An ideal of black womanhood as morally (and sexually) respectable had become central to discourses of black racial uplift by the 1920s; to stage a frank performance of black female sexuality risked offending black middle-class audiences while reinscribing white racism concerning black female promiscuity. As scholars such as Davarian Baldwin, Kimberly L. Phillips, and James Grossman have argued, the increase of black Southern migrants in Northern cities during this period, especially black working-class women, threatened the dominance of the "old settlers" in postwar black communities, while jeopardizing their carefully calibrated relationship with white communities.[100] *Brownskin Models*' public performance of black female sexuality, as in the *Brownskin Models*, threatened to precipitate the "moral panic" described by Hazel Carby as the bourgeois reaction to black vernacular modernities.[101] Yet with the exception of one NAACP protest in Baltimore in 1925, Miller's emphasis on "beauty" and "form," signified by the presence of the "model," allowed him

to skate a very thin line between racist stereotypes of the oversexed black jezebel and the working-class bawdiness of burlesque.[102] The figure of the model provided an aesthetic distance between the viewer and the performer, while at the same time containing this exchange of glances in a rhetoric of the bourgeoisie: upper classes can distinguish between the nude and the naked.

THE APPEARANCE OF the stage model in the period between 1917 and 1925 drew from two contemporary discourses, both indebted to aesthetic appreciation and the female form. The Ziegfeld showgirl was a new social type, a statuesque beauty whose stately movements were drawn directly from the couturier house; indeed, the model's processional was performed by the same mannequin in both sites, in the case of Dolores. The models of Miller's *Brownskin Models* review, in contrast, elaborated a hybrid posing form that combined poses of the artist's model with the processional movements of the fashion show, a favored charity fundraising form in African American communities in New York and elsewhere by 1925. In all three locations—the couture salon, the Ziegfeld stage, and the *Brownskin Models* revue—the model coproduced an affective response in the audience, a set of aesthetic feelings tied both to a racialized class hierarchy and to commodity longing. In the case of Lucile's mannequins on and off the Ziegfeld stage, this conjunction of race politics, the body, and the merchandising of apparel helped contribute to the color line in the emerging profession of commercial modeling, a process under way offstage at the same historical moment. Irvin C. Miller's *Brownskin Models*, in contrast, used the discourse of both fashion and art to sidestep minstrel stereotypes and make a claim to an elite aesthetic realm long denied black performers. This class alchemy, however, was accomplished via the reinscription of hierarchies of skin tone and, one could argue, a new chapter in the commercialization of black sexuality.

The 1920s stage model emerged as a key site for the elaboration of a newly emerging modern form of sexuality, one that inhabited the middle ground between illicit forms of public sexual behavior—such as the prostitution that became the focus of urban vice reformers in this period—and the more private forms of illicit sexuality. The model's public performance of this middle zone of sexuality unfolded in the context of commercial leisure and in some cases was tied explicitly to the sale of goods, whether a Cartier bracelet or a department store frock. As Peter Bailey has argued, parasexuality emerged out of these everyday settings—such as the pub or the cinema—in which capitalism and its managers tethered female sexual appeal to the market.[103] Stage models coproduced sexual capital through their affective labor, using performance to thread

the needle between sensation and censorship. In this work, models abetted stage impresarios whose work entailed, in part, the managed release and containment of a liminal sexuality, one that courted the violation of bourgeois propriety without explicitly transgressing it. Models' affective work helped create cultural and economic space for a zone of commodified sexuality that became increasingly central to how goods were sold over the course of the twentieth century. Their work in producing—and containing—sexual feeling played a central role in the history of capitalism's strategies of enticement.

The courtship between sexuality and capital unfolded, in this context, in relationship to heterosexual norms. Models in both the Ziegfeld and the Miller productions walked, posed, and turned within a commercial narrative framework that assumed heterosexual desire. Yet the development of a public form of market-inflected sexuality brought with it new forms of possibility for queer subjects. Both blacks and queers (as well as, of course, those who inhabited both categories) have been barred, historically, from some of the key institutions of modern political life. Blacks, separated from the dominant white culture through the laws and extralegal violence of Jim Crow apartheid, turned to the market to claim economic citizenship. Gays and lesbians, as Michael Warner and David C. Johnson have argued, have long produced market-mediated cultural institutions—whether bars or newspapers—due to their exclusion from nonmarket forms of association (for example, recognized family structures or religion).[104] Accessing commercial forms and associations not built with them in mind, both groups have used the market to queer normative political and economic life.

The queering of capitalism's sexual history, however, should not necessarily be understood as a social justice narrative. As Michel Foucault argued long ago, sex and the discourses surrounding it are modern "management procedure[s]."[105] Parasexuality emerged in the interwar era as one of managerial capitalism's most effective management procedures. As we will see in the next chapter, queer fashion photographers and their models invented and entrenched glamour as one of sexual capital's most important technologies, producing the market as one of sexuality's most important sites of power.

3

Queering Interwar Fashion

PHOTOGRAPHERS, MODELS, AND THE
QUEER PRODUCTION OF THE "LOOK"

High fashion's commercial and aesthetic legibility depends not only on models but also on the fashion photographers whose images help animate the clothing. The clothes might be exquisite and the models may epitomize the season's look, but if the photographs fail to seduce the viewer, nothing will sell. Gowns, shoes, jewelry, and hats appear dead on the page when shot by a mediocre photographer; the commodities require an artist's aesthetic sensibility and technical ability to produce a viewer's emotional response. High-end fashion magazine editors have known this since World War I, when, as we saw in chapter 1, Condé Nast replaced Ira Hill with Baron Adolph de Meyer as *Vogue*'s first paid staff photographer. However, scholars have not written much about US fashion photography's central role in the history of commercial culture.

This chapter takes as its focus the history of high-end fashion photography in the interwar years. If readers know anything about fashion photography in this period, it's likely the work of Edward Steichen that comes to mind. Steichen took over at *Vogue* in 1923, after de Meyer decamped for *Harper's Bazaar*, and stayed at *Vogue* until 1937, when he resigned from Condé Nast Publications. Steichen's work in the New York *Vogue* studios is indisputably important to the history of commercial and fashion photography, as several studies have shown.[1] In many ways, however, the scholarly focus on Steichen's work has

overshadowed competing and equally important alternative histories of fashion photography.[2]

Argument

This chapter brings together the history of glamour, affect, and fashion photography to make the argument that glamour has been, historically, a queer production produced within a mainstream, heteronormative discourse. My focus here is on the gay and queer generation of interwar photographers who, together, invented the field of fashion photography. Photographers Baron Adolph de Meyer, Cecil Beaton, George Hoyningen-Huene, Horst P. Horst, and George Platt Lynes defined a queer aesthetics of fashion photography in New York, Paris, London, and Hollywood in the years until World War II. The photographic work they made stemmed from an elite, transatlantic, white queer kinship network that included both male and female models and that helped define a glamour aesthetic decidedly queer in its production, circulation, and reception. This work represents a queer counterarchive to Edward Steichen's important commercial work between 1922 and 1937. The mainstream magazines in which these photographers' work appeared—such as the American, British, and French editions of *Vogue* and *Harper's Bazaar*—produced a dominant public in which heterosexual attraction, racial hierarchy, and conventional gender roles were the unstated norm. This was a public organized, paradoxically, through queer affective cultural production.[3]

glamour = whiteness = elite status

The fashion images that these photographers produced, circulating in these high-end magazines, did several types of cultural work at the same time, within the same photograph. The photographs and magazines in which they appeared encouraged a dominant reading supported by the social formations from which they were produced: the images imbue high-end clothing with glamour, whiteness, and elite status. Yet I suggest here that these very same images, circulating in the same publications, were also a site of what Michael Warner, following Nancy Fraser, has called a queer counterpublic: a site of oppositional discourse constituted when social or political minorities have "no arenas for deliberation among themselves."[4] Usually the term "counterpublic" is used to delineate a parallel, alternative discursive realm, in which members of subordinated social groups—such as sexual and gender minorities—invent and circulate counterdiscourses to formulate oppositional interpretations of their identities, interests, and needs.

Thesis

Here, however, I argue that these queer fashion photographers invented and circulated counterdiscourses in the very same texts that also carried the normative fashion prescriptions. Like Roland Barthes's definition of the photograph as that which, like an "eternal coitus," belongs to "that class of laminated objects whose two leaves cannot be separated without destroying them both," interwar fashion photography's heteronormativity was laminated

onto a queer counterdiscourse; both these discursive leaves shared a mutual investment in whiteness and class hierarchy.[5] In other words, the same texts produced both white queer and straight publics simultaneously, and laminated together a commercialized and racialized queer affect.

This queer kinship network played a central role in establishing the model's "look" in the interwar period, at least with some high-end fashion models. By "queer kinship network" I mean a set of intimate relationships, both erotic and affective, that were not legitimized by the state but that nonetheless addressed fundamental forms of human dependency, including cohabitation, sexual expression, emotional dependency, illness, dying, and death.[6] As Elizabeth Wissinger has argued, fashion models are some of the most reliable conduits for the affective energy central to the industry, and the model's "look"—as represented in images but also as embodied and performed—is how these affective energies are gathered and communicated to industry professionals and consumers.[7] But the creation of this "look" is hard work, involving multiple players; as Wissinger argues, drawing on the important work of Ashley Mears, Joanne Entwistle, and Don Slater, "The look links photographers, agents, models, producers, consumers, and brands in circuits of exchange."[8] In the last section of this chapter, I analyze the "look" of model Ruth Ford as a queer look, one that emerged from a queer kinship network to produce a discourse of heteronormative, interwar glamour.

Historicizing Glamour

"Glamour" is a concept that is ubiquitous in modern culture, but one that can elude precise definition. Like its predecessors "charm" and "it," and its successor, "X factor," the term connotes a certain type of optical allure that suggests both beauty and sex appeal. According to dictionaries of modern English usage, the term "glamour" was originally Celtic and retained, in the nineteenth century, its older connotations as relating to "occult learning, magic, necromancy" as well as, according to one 1879 dictionary, "the supposed influence of a charm on the eye, causing it to see objects differently from what they really are"—a sort of "deception of sight."[9] Glamour, in other words, has historically been a visual experience, one associated with the dark arts of deception.

With the rise of mass culture at the end of the nineteenth century, glamour emerged as a key mechanism of capitalist modernity. The concept of parasexuality with which I began this book, as historian Peter Bailey has described, bears a close relationship to the concept.[10] As Bailey has discussed, as working-class women such as Victorian bar maids entered the commercialized public sphere,

they staged a public visibility that both solicited and contained the scrutinizing, and sexualizing, glance of their male patrons. Bailey emphasizes that these modern, working-class women became the bearers of glamour, which he ties to both mass culture and to distance. Glamour, for Bailey, is a "dramatically enhanced yet distanced style of sexual representation, display, or address."[11] The distancing mechanisms of the bar, the catwalk, or the magazine page contain and manage the otherwise explosive potential of female sexuality in the public sphere.

Markets depend on the circulation of emotion between bodies, what Sara Ahmed has defined as affect, and glamour functions as the contact zone linking markets, aesthetics, commodities, and bodies.[12] Historically, glamour has emerged as a key mechanism of capitalist modernity.[13] As Nigel Thrift has argued, glamour is a technology of public intimacy closely tied to market formations; it is through glamour, in part, that capitalism captures allure, desire, and other immaterial and affective qualities and bends them to commercial ends.[14] Thrift sees the public sphere under advanced capitalism as the affective site of intimacy—intimacies that were once private but have become imbricated with the public sphere through material and visual technologies of allure, particularly glamour. As he describes it, echoing Marx, glamour is a form of "secular magic," a "fetish . . . a means of feeling thought."[15] Glamour is a form of world-making that is dependent on style, the senses, objects, bodies, and personas. Fashion depends on glamour as a means of selling clothing, and photographers have, historically, been central to this cultural work.

The term "glamour" has its own history within the culture industries, one that dates to the late 1920s. Before 1927, glamour was not a key word in Hollywood or elsewhere; the key word was "vamp," and connoted the dark "vampire" whose sexuality threatened to devour men. This construction of dangerous sexuality was indebted to the vampire craze in fiction and film following the popularization of Bram Stoker's *Dracula* (1897).[16] In the United States in the 1920s, in keeping with the period's nativist discourse and suspicion of recent immigrants from Southern and Eastern Europe, especially the "provisionally white" Jews, Italians, and other non-Nordic races (to use the era's racial discourse), the sexualized "vamp" was racialized as the immigrant other. Mass culture producers did not see blond, Nordic women as aggressively sexual creatures in the same way; Hollywood, fan magazines, and other popular culture venues constructed transgressive sexuality as a foreign influence. After 1925, though, with Greta Garbo's appearance at Metro-Goldwyn-Mayer as a Nordic, Swedish beauty, glamour began to describe a new type of sexualized allure

for white women that lasted through the 1930s. In 1930 Paramount Pictures imported the nineteen-year-old German cabaret star Marlene Dietrich to compete with Garbo. The birth of Hollywood glamour, in other words, was also a racial project, one that made vampish sexuality available to unimpeachably white, Nordic women. The history of modern glamour is the history of making white beauty safe for sexual allure, while at the same time cordoning off the contagion of the darker races—always seen as more sexual, more promiscuous, more dangerous. Though often articulated in the discourse of Hollywood and fan magazines, the invention of modern glamour was equally a photographic production indebted to the fashion industry.

Up through the late 1930s, glamour served as a code word for transgressive sex. Northern European–looking actresses, such as Garbo and Dietrich, shifted from performing the virginal, asexual appeal of a (blond) Lillian Gish to a new type of sexualized femininity: confident, sexually irresistible, and often blonde.[17] This type of glamorous femininity was especially associated with MGM, home of Garbo, Norma Shearer, and Joan Crawford, but eventually also with Paramount and Marlene Dietrich. Glamour enabled the all-American (white, blonde) beauty to be aggressively sexual (consider, for example, George Hurrell's iconic photographs of Jean Harlow on the bearskin rug). As Stephen Gundle had argued, glamour took shape at the intersection of sex appeal and the market: "Glamour fostered feelings of desire, aspiration, wonderment, emulation, and vicarious identification."[18] Glamour emerged as a structure of enchantment produced by mass culture industries that produced transgressive sexuality and tied it to commercialized forms of leisure and consumption. For the first time, with the rise of the Garbo, Dietrich, and other blonde vamps, glamour enabled the all-American (white, blonde) beauty to be aggressively sexual within American mass culture.

Glamour became a key concern for censors involved with the Hollywood Production Code, first established in 1929, and accelerating after 1934 when the Catholic League of Decency focused their activism on reforming the movies.[19] Catholic activists saw glamour as a reference to an unacceptable lifestyle marked by nontraditional sexuality, immorality, and antisocial behavior. As a result of these struggles, Hollywood and the fashion magazines worked in tandem to redefine glamour, to transform it into a set of conventional beauty signifiers that connoted a pleasant, girl-next-door sexual appeal that was devoid of the dangerous, queer sexual energies of a Garbo or a Dietrich. By 1937, when Condé Nast launched its newest magazine, *Glamour*, the concept had become cleaned up, straightened up, and Americanized.[20] This process of sanitizing and

de-eroticizing the relationship between feminine gender performance and the market was also one that was under way in the modeling industry as a whole, as I discussed earlier through the work of model agency founder John Powers.

Although we might think of glamour as dependent on the moving image for its circulation, in fact photography's still image was central to the semiotics of Hollywood glamour. In Hollywood, stardom depended on the production and distribution of the still photographs central to the studio's star-making machinery. Garbo's contract, for example, stipulated the number of close-ups guaranteed for each production; these still photographs were distributed to fans (Garbo received fifteen thousand fan letters a week) and published in fan magazines such as *Photoplay*.[21] Hollywood photographers such as Ruth Harriet Louise, Clarence Sinclair Bull, and especially George Hurrell developed the visual codes of glamorous femininity through the photographic portrait between 1925 and 1933.[22] Hurrell developed a photographic semiotics of eroticized glamour that featured eyes heavy with mascara and false eyelashes; cosmetically defined lips and eyebrows; clinging gowns; suggestive poses; and the frank return of the viewer's (camera's) gaze. While the Hollywood photographers were influenced by developments in the New York–based fashion magazines, commercial photographers such as George Platt Lynes, Cecil Beaton, and Edward Steichen regularly shot movie actresses, working from their end to develop glamour's visual codes in fashion editorials for *Vogue*, *Town and Country*, and *Harper's Bazaar*.

Hollywood glamour photography borrowed a series of technical innovations from New York fashion photography en route to producing Hollywood's new commodity of glamorous femininity. In particular, Hollywood was rather late in shifting away from pictorialist aesthetics toward modern, "straight" photography, an aesthetic transformation under way for some time in the fashion work of Cecil Beaton, George Hoyningen-Huene, Horst P. Horst, and Edward Steichen. But by 1931, Hollywood glamour photography had adopted fashion's technical and aesthetic vocabulary, marked by a commercial sharp-focus Ektar lens rather than pictorialism's diffusion; a lighting shift toward Tungsten, which brought increased control and nuance; increased sharpness possible through Kodak's "super" panchromatic film; and mechanical retouching through stippling machines, which replaced the laborious work of hand-touching.[23] Although the visual codes of Hollywood glamour seem born of the motion picture, in fact the "look" of glamour is indebted to interwar fashion photography.

I am taking the time to discuss *Hollywood* photography because the film stars of the interwar years have shaped our conceptualizations of the term

"glamour." Yet historically, Hollywood and fashion photography have been closely intertwined, and Hollywood glamour photography was derivative of aesthetic and technical work pioneered first in fashion photography. George Hurrell himself demurred, "I used to subscribe to *Vogue* so I could see what Steichen and Beaton and those guys were doing. I'm sure I was influenced to some extent."[24] That New York set the pace for elaborating an aesthetics of glamour makes sense, since, as Elizabeth Wilson has argued, glamour's power stems from the fusion of fashionable dress, the wearer, and what sociologist Georg Simmel called the "force field" of the individual's personal aura.[25] Fashion photographers had the historical head start, as it were, describing these aspects of modern glamour, whether in the form of society portraits, theatre and film actress portraits, or models wearing the latest couture creations—all of which had been part of *Vogue's* coverage since Condé Nast purchased the magazine in 1909. Fashion photographers Edward Steichen and Cecil Beaton, among others, began photographing Hollywood stars in the 1920s for fashion magazines; by the late 1940s, *Vogue* had established an LA studio with George Platt Lynes at the helm. As Hollywood is not the main focus of the chapter, let me simply assert that the influence of high-fashion photography on Hollywood glamour photography is beyond debate.

Gay Femininities and Queer Accessories

Cecil Beaton
Hoyningen-Huene

The first generation of fashion photographers who worked for Condé Nast publications on both sides of the Atlantic in the interwar period all knew each other, as well as each other's work, and most all of them were both gay and immersed in a transatlantic gay and lesbian culture that linked Paris, New York, London, Tangiers, and, increasingly, Hollywood. The centrality of a gay sensibility to this circle is clear from an analysis of their professional and personal lives as well as of the work itself, which often carries with it an interest in ornamentation, texture, and detail, as well as a sense of humor, that seems at odds with what we have come to understand as photographic modernism. This fashion photography represents a queer counterarchive to Steichen's influential and important work at Condé Nast between 1923 and 1937. In many ways, we might consider Steichen's work to be the exception to the rule of a queer aesthetic in fashion photography in the pre-1945 period.

Cecil Beaton was British *Vogue's* primary fashion photographer in the interwar period, and indeed afterward (he worked for Condé Nast for nearly fifty years). Beaton spent his childhood and young adulthood constructing elaborate photographic tableaux in which he dressed his sitters (usually his mother

and his sisters) in period costume of his own design. As a public school student at Harrow, Beaton described himself as "quiet and weak and rather effeminate"; he wrote that he "always used to powder and often put red stuff on my lips," a habit that later made him "squirm" with discomfort as he became schooled in the production of gender normativity (fig. 3.1).[26] As an undergraduate at Cambridge, Beaton "set about becoming a rabid aesthete with a scarlet tie, gauntlet gloves, and hair grown to a flowing length," and immersed himself in the Cambridge theatrical clubs, in which he performed most of the female roles and photographed the productions.[27] Beaton's queer illustration and photographic work provided an entry into the fashion industry's "velvet underground": the editor of British *Vogue*, the lesbian Dorothy Todd, wrote Beaton "from her Mount Olympus home in Bloomsbury inviting me to photograph some of the poets and writers whom she had unearthed," marking the beginning of a career-long association with *Vogue* on both sides of the Atlantic.[28]

From this beginning, Beaton built a career in fashion over the next several years, a career developed through connections in the queer art and fashion circles. Osbert Sitwell wrote the exhibition catalogue for Beaton's first exhibition in London in 1927, in which Sitwell lauded Beaton's "theatrical glamour" (in the same year in which *Vogue* used the term for the first time); the following year in New York, when Beaton was establishing his photographic reputation, it was the couturier Lucile's close friend and designer Elsie de Wolfe (whom Beaton had met through her lover, theatrical impresario Elizabeth Marbury) who offered Beaton the use of her interior decoration studios on 57th Street for his first exhibition. This show, in Beaton's view, "helped make my American reputation" and led to a contract with Condé Nast Publications "to take photographs exclusively for them for several thousand pounds a year for several years to come."[29]

Beaton's affective life was shaped by the experience of being nonnormative in both his sexuality and his gender performance. As a young man, during an unhappy period working in his father's office as a clerk, Beaton found himself overcome with shame and confusion at his complete incapacity to perform normative masculinity. He saw his handwriting as a failure because it looked, in his eyes, too feminine: since the first time he'd laid eyes on a photograph of theatre star Lily Elsie at the age of three while snuggled in bed with his mother, he had been infatuated with the star and as a result had learned to imitate Elsie's handwriting. As an adult, while eating lunch in a sandwich bar, he dolefully observed the businessmen surrounding him. As he wrote in an autobiography, "I was equally out of my depth and had no idea what all these practical, average men in their black coats and pin-stripe trousers were talking about. I was, in short,

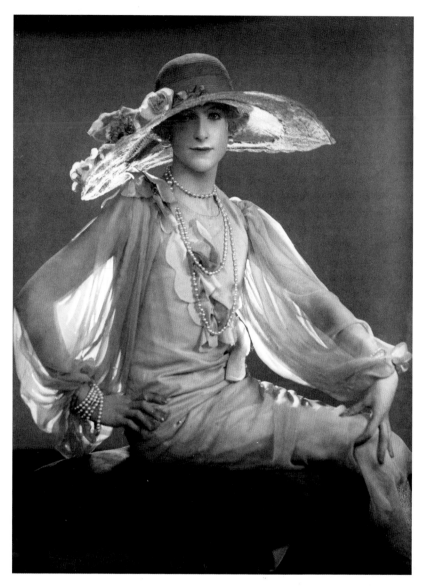

FIG. 3.1 Cecil Beaton in *All the Vogue* by Dorothy Wilding, 1925. William Hustler and Georgina Hustler / National Portrait Gallery, London.

a disastrous failure and I felt bitterly ashamed of myself."[30] Beaton considered himself an "embarrassment," and on weekends he would "give vent to my repressed enthusiasms by indulging in an orgy of photography."[31] Later, when his career was getting under way, Noel Coward (who should know) offered some pointers on how to tone down his flamboyant, feminine performance of self in

order to avoid these queer negative affects, and get work as well: "Your sleeves are too tight, your voice is too high and too precise. You mustn't do it. It closes too many doors . . . young men with half your intelligence will laugh at you."[32] According to Beaton's biographer, Beaton's great issue during these years (along with his class anxiety, stemming from his father's position in trade as a lumber merchant) was his insecurity about desiring men sexually. Writing in 1966, Beaton reflected on this interwar period, "It was only comparatively late in life that I would go into a room full of people without a feeling of guilt. To go into a room full of men, or to a lavatory in the Savoy, needed quite an effort."[33] As I will suggest later when considering the work of fashion photographer George Platt Lynes, the men's lavatory (in the Savoy and elsewhere) was an important site of gay male cruising in the interwar period, and for this reason was an especially anxious site for someone with Beaton's complex gender and sexuality.

Beaton's queer sensibility—born of his gender and sexual nonnormativity and the resulting queer affect—saturated his photographic work in the 1920s and early 1930s. Unlike the clean modernism of Steichen's work (which Beaton adopted later in the 1930s), Beaton's earlier work was marked by a sense of playful performativity and a "hysterical" excessiveness in choice of props, set design, color, and fabric. Beaton's attention to elaborate backgrounds and a profusion of props and accessories was directly inspired by the work of Baron Adolph de Meyer, whom Beaton greatly admired and felt did not receive the place in history he deserved. As discussed in chapter 1, describing de Meyer's influence on Beaton's photography in the 1920s and early 1930s, Beaton wrote that de Meyer's work was "the epitome of artificiality and luxury," and *therefore* the "ideal" toward which he directed his efforts.[34] Like de Meyer, Beaton backlit his sitters so that "such a welter of radiance" enveloped them that "their transparent skirts were bathed in a glorious halo, their hair an aureole of spiders' skeins, their faces seen in its becoming reflections."[35] (It was de Meyer's love of backlighting his sitters that tied femininity to this mode of lighting, an association carried on in Hollywood's adaptation of backlighting in the glamour work of the later 1920s and 1930s.) A profusion of props—in great contrast to both Steichen's and later Irving Penn and Richard Avedon's spare modernism—was essential to this queer photographic style. As Beaton reflected of his "rococo" work in the 1930s: backgrounds were "equally exaggerated and often tasteless. Badly carved cupids from junk shops on Third Avenue would be wrapped in argentine cloth or cellophane . . . wooden doves, enormous paper flowers from Mexico, Chinese lanterns, doilies or cutlet frills, fly whisks, sporrans, egg beaters, or stars of all shapes found their way into our hysterical and highly ridiculous pictures" (fig. 3.2).[36] In figure 3.2, Beaton's sister Baba, Wanda Baillie-Hamilton, and

FIG. 3.2 Portrait of Baba Beaton, Wanda Baillie-Hamilton, and Lady Bridget Poulett, 1930. Photograph by Cecil Beaton. The Cecil Beaton Studio Archive at Sotheby's.

Lady Bridget Poulett emerge from a sea of over thirty balloons, wrapped in cellophane; they pose for Beaton's lens wearing cloche hats adorned with lengthy strings of round ornaments whose shape echo that of Beaton's enthusiastic, airy, props. Although Beaton disparaged this effusive approach to photographic accessories with the adjective "tasteless" when writing in 1954, one could argue that for Beaton, "hysterical" and "highly ridiculous"—and quite probably even "tasteless"—were far from pejorative terms.

An exaggerated and tasteless attachment to bad objects is a hallmark of modern gay sensibility. Such object-oriented enthusiasm is not the only marker of a gay mode of feeling, of course; the specific, nonstandard appreciation for flowers, doilies, and badly carved cupids has historically signified a certain gay femininity that marks not only a gay style but also, more importantly, as David Halperin suggests, a "dissident way of feeling and relating to the world."[37] What is at stake here is not so much the sexual acts of the photographers and models participating in this queer interwar fashion world but the cultural sensibility produced as a result of their sexual and gender subaltern status: I am interested in the aesthetic practices, as much as the sexual practices, at work in this New York City–London–Paris–Hollywood velvet underground. In other words, I want to hold on to the historical relevance of sexual and gender minority subcultures while at the same time moving away from a strict focus on LGBTQ+ "identity," which would be a historical misnomer in any case here. My focus is a nonnormative gender and sexual cultural formation that shaped the aesthetics of the photographic situation in the interwar period. This formation both indexed and produced a specifically queer mode of feeling, one that can be understood as a dissident relationship to objects, aesthetics, and attachments. This queer affective culture was not the only photographic cultural formation in the interwar years, as Steichen's well-deserved prominence suggests, but is one of central historical significance to the history of fashion photography and the modeling industry as a whole.

A key aspect of Beaton's queer photographic aesthetic was the sense of irony with which he approached his work. Beaton had a camp sensibility predicated on a willingness to make fun of the most serious of enterprises. A sense of humor is central to much of gay male culture, and is especially in evidence in the camp celebration of gay femininity; it is through such humor that gay culture has sought to contain the affective damage wrought by a homophobic and transphobic mainstream culture.[38] Beaton understood that it was his queer approach, his (seeming) lack of earnestness, that distinguished his work (and those of other queer interwar photographers) from Steichen, who was the "Almighty Photographer" at the time. As Beaton wrote of Steichen's work,

> His rich and meticulous studies, so full of character, so full of light and shade, were now covering the pages of *Vanity Fair* and *Vogue*. But, much as I admired Steichen's work—and I used to examine his prints with absorbed curiosity—I knew that it would be hopeless for me ever to try and work in this vein. My work was at the opposite end of the photographic pole, and the success of my first published pictures was partly due to their

divergence from the Steichen tradition. Whereas Steichen's pictures were taken with an uncompromising frankness of viewpoint, against a plain background, perhaps half black, half white, my sitters were most likely to be somewhat hazily discovered in a bower or grotto of silvery blossom or in some hades of polka dots.[39]

Beaton places Steichen's "frankness of viewpoint" at the opposite end from his own photographic "pole," one characterized with a "hades of polka dots" in contrast to Steichen's "plain background." With even this brief description, we can see the camp sensibility and ironic humor that mark gay culture: polka dots as Hades, the classical god of the underworld, ties together feminine materiality, a neoclassical sensibility that is already a marker of gay aesthetics (especially in the 1930s), and queer displacement (Hades as underworld). This queer sensibility, as I have been seeking to explain it, is signaled photographically through the materiality of the photograph's set design, in particular the props that bear twin sets of cultural associations, both normative and queer. Those photographers, models, and art directors imbued with the industry's queer sensibility, if not the cultural history of homosexuality, view interwar fashion photography through the "double consciousness" of queer feeling: "This sense of always looking at one's self through the eyes of others, of measuring one's soul by the tape of a world that looks on in amused contempt and pity."[40] Beaton and other queer fashion photographers drew on the "twoness" of queer accessories—cupids, cellophane, polka dots— to signify a camp sensibility that was otherwise unreadable to a normative audience.

Beaton's other photographic mentor, and another master of camp humor and queer props, was George Hoyningen-Huene, *Vogue*'s Paris-based photographer. Hoyningen-Huene was born in Russia into an aristocratic family (his mother was American, the daughter of Michigan senator George Van Ness Lothrop, and his father was a Baltic nobleman), and fled to London in 1917 during the Russian Revolution. After serving in the war against the Bolsheviks on behalf of the British, he ended up in Paris, where he found work as a movie extra. "It was all a new adventure and a new world," he told an interviewer in 1965.[41] "But it did one thing for me—it taught me how to light people and sets. I was watching and observing all the time how they did it, and I was fascinated by the motion picture medium and by photography."[42] In figure 3.3 Hoyningen-Huene demonstrates his capacity for strong composition and dramatic lighting (as well as camp) as he poses, cigarette at the mouth with a slow wink at the camera, in a parody of a Hollywood movie director (fig. 3.3).

FIG. 3.3 George Hoyningen-Huene impersonating an American movie director, 1934. Photograph by Horst P. Horst. Estate of Horst P. Horst.

Hoyningen-Huene's sister had opened a couturier shop, Yteb, and she asked her brother to draw illustrations for the catalogue. With no drawing experience, he would visit the Académie de la Grande Chaumière to sketch from the live model in five-, ten-, and thirty-minute poses. His drawing improved, and in a period when designers refused to allow their collections to be photographed for fear of design piracy, Hoyningen-Huene trained his memory to remember the details of over one hundred different dresses in order to sketch them later, after returning from the races, nightclubs, parties, or wherever he'd encountered them.[43] He became adept at drawing, and for a stint even worked as an illegal copier of haute couture for a pirate manufacturer; by 1925, he was selling his fashion illustrations to *Harper's Bazaar*, *Women's Wear Daily*, and *Le Jardin des Modes*.[44] He collaborated on a portfolio of the most beautiful women in Paris with his close friend Man Ray, with photographs by Man Ray and

illustrations by Hoyningen-Huene, which they sold to a New England department store.

In 1925, when he was twenty-five years old, Hoyningen-Huene became employed by *Vogue* in their Paris studio. His job was to prepare and design backgrounds for the photographers, including Man Ray, and a series of other photographers who were being tried out by *Vogue* as Condé Nast sought to establish the Paris studio. When their favorite, erratic American photographer failed to show up at work one day, Hoyningen-Huene was told to make the photograph, and did so. It was published full-page in *Vogue* in 1925, and launched his career as *Vogue*'s Paris photographer. In 1929, he received some help from Steichen, head of the New York studio, whom Hoyningen-Huene described as being a "tremendous help." "From then on," he reminisced in 1965, "I suppose I can say that I became the best fashion photographer between 1930 and 1945."[45]

Hoyningen-Huene's fashion photography was shaped by his immersion in the queer, bohemian life of interwar Paris. Jean Cocteau was at the center of this circle, which also included painters such as Salvador Dalí and Joan Miró; American photographers Man Ray, Berenice Abbott, and George Platt Lynes; and Hoyningen-Huene's model and lover Horst P. Horst, the photographer who took over work at Paris *Vogue* when Hoyningen-Huene moved to *Harper's Bazaar* in 1934.[46] Among his closest friends was fellow Russian émigré, the surrealist painter Pavel Tchelitchew, who designed sets for Diaghilev as well as painted gorgeous covers for high-end magazines.[47] Tchelitchew's long-term intimate partner was the American writer Charles Henri Ford, and Ruth Ford, one of George Platt Lynes's favorite models, was Charles's sister. In an era in which fancy dress parties among the artistic elite were routine, Hoyningen-Huene hosted one at *Vogue*'s studios on the theme of *Shanghai Express* (1932), Joseph von Sternberg's vehicle for queer glamour icon Marlene Dietrich.[48]

Although Hoyningen-Huene had an arrogant personality and could be quite short on patience, he also enjoyed the camp sense of humor that was a dominant gay aesthetic sensibility in the pre-Stonewall era. "Camp," a term that emerged in the pre–World War I era, derives from the French *se camper*, "to pose in an exaggerated fashion." Although the term continues to elude precise definition, those who have written about camp can agree on some common elements: camp is a style that favors exaggeration and artifice; it often exists in tension with mainstream, commercial culture; the ability to produce and perceive camp aesthetics stems from social marginality; and camp has historically been associated with homosexuality.[49] What could be a more fruitful site for camp sensibility than the world of fashion photography, where the pose—and

FIG. 3.4 Model Helen Bennett modeling a white crepe dress with chiffon scarf. *Vogue*, June 1, 1939, 61.

its exaggeration, even in the discourse of the "natural"—is the foundational scene? Fashion models and the society women that Beaton, Hoyningen-Huene, Horst, and Lynes photographed in these years inhabited an exaggerated version of femininity; theirs was the gender performance of the diva, with her power, authority, and stardom. Well-known fashion models of the 1930s, such as Horst's favorite model Helen Bennett, achieved power through the exaggerated, excessive, over-the-top performance of a conventional femininity defined by beauty, grace, and allure; this exaggerated femininity, joined with sexual power, combined to create 1930s glamour (figs. 3.4 and 3.5). In figure 3.4, Horst has photographed Bennett in a white crepe dress with flowers against a

FIG. 3.5 Models Helen Bennett, Muriel Maxwell, and Bettina Bolegard. Cover of *Vogue*, November 1, 1939. Horst P. Horst / Vogue © 1939 Condé Nast.

deep rose background. Bennett stands as regally as the classical bust behind her, looking imperiously to the right of the frame, her left arm akimbo: she seems to only grudgingly allow the viewer access to the dress while at the same time signaling through pose, expression, and gesture her own remote beauty. In figure 3.5, Horst's cover photograph for the November 1939 issue of *Vogue*, Bennett joins Muriel Maxwell and Bettina Bolegard in a triangular composition. Although it is clear that the models are arranged on the floor, with Horst's

camera above them, Bennett (at the bottom of the frame) meets the camera lens with cool detachment: with her perfect eyebrows, red lipstick and nails, and golden curls piled high, she is beautiful, glamorous, and unreachable. As David Halperin has argued about the appeal of midcentury feminine movie icons to gay style, movie stars such as Crawford "disclose a form of power that gay men can claim as their own."[50]

Hoyningen-Huene's camp humor regarding diva femininity is on display in his 1933 film featuring Gerald Kelly, the American friend who had introduced him to Horst (fig 3.6). The film *L'Atlantide* was originally a 1921 silent film featuring two French soldiers who stumble upon the lost city of Atlantis in the Sahara desert, and encounter Antinea, an aging queen who captures her male lovers and, when ennui sets in, kills and embalms them in gold. In March 1932, Hoyningen-Huene saw the filming of G. W. Pabst's version of this story while in Berlin with Horst and Lucien Vogel, the French avant-garde founder of the *Gazette de bon ton*, *Le Jardin des modes*, and *vu* who was editor of French *Vogue* in the early 1930s.[51] Hoyningen-Huene was inspired to make his own version—the first of four films he eventually made, including a documentary on fashion photography for *Vogue* in 1933. However, Hoyningen-Huene cast a different "aging queen" for the female lead: his balding, middle-aged friend Gerald Kelly, who cross-dressed in the role of Antinea, played by Brigitte Helm in Pabst's 1932 version. In figure 3.6, Kelly's Antinea finds herself swept up in the arms of her handsome lover, her left arm outstretched in a histrionic gesture of low camp excessiveness, while Kelly's strong jaw reaches for her man's waiting lips. Hoyningen-Huene parodied Brigitte Helm's hairstyle in Gerald Kelly's curls; Horst used the same classical hairstyle in some of his 1936 shoots featuring *Vogue* model Helen Bennett, whom Cecil Beaton described as having "an early Egyptian catlike beauty, with the flat curls of a Greek statue."[52] The background of Hoyningen-Huene camp parody still suggests the film may have been made in Hammamet, Tunisia, where Horst and Hoyningen-Huene designed and built a home in 1932–33.[53] According to Horst's long-term lover and biographer, Horst thought the whole thing hilarious. Although the film was shown only privately, Gerald Kelly apparently expressed some worry that he might be recognized by his fans in Paris.[54]

In many ways, however, Kelly's drag performance as Antinea, Queen of the Desert, was atypical for Hoyningen-Huene. Unlike Beaton, Hoyningen-Huene's photographic work was characterized more by the restrained vocabulary of Steichen's modernism than by the hysterical excessiveness of de Meyer or Beaton's earlier work. In fact, Hoyningen-Huene was deeply influenced by Steichen's spare, clean sensibility and took every opportunity to work with him

FIG. 3.6 Gerald Kelly in drag, 1933. Photograph by George Hoyningen-Huene.

in the late 1920s and 1930s, before moving to Hollywood (in 1946) to work as a color consultant for queer Hollywood director George Cukor. Hoyningen-Huene considered Steichen to be "extremely patient and kind" and revealed that he allowed the junior photographer to watch him work; Hoyningen-Huene found that Steichen's "moral support was more than any technical support I could have had at that time."[55] Hoyningen-Huene saw his challenge as one of making the models appear at ease, lifelike, rather than as if they were stiffly posing for their portraits. Illustrators sketched models outdoors, in movement, wearing clothes the way an implied reader would wear them, but in the years before handheld 35-millimeter Leicas and fast film, fashion photographers relied on cumbersome eight-by-ten cameras, making the infusion of vitality into

the fashion image especially difficult. Hoyningen-Huene spent years trying to get the models to look like anything but "wax figures in wax-work museums," and eventually came to the conclusion that the profusion of props surrounding the models needed to be minimized.[56] Like Beaton's 1930s work, and that of other fashion photographers in the 1930s, including his lover, former model and protégé Horst P. Horst, Hoyningen-Huene's photography was marked by a clean, modernist aesthetic that was indebted to Steichen's work in New York. He focused on suggesting the movement of the model within the contours of the static pose, while the model herself worked on inhabiting the clothing as if she had been born wearing the dress, rather than having put it on just moments before the shoot. "I gave up my entire life to these problems," Hoyningen-Huene stated, "and it took me years and years and years."[57]

Although Hoyningen-Huene minimized the props surrounding the model, he still used them to communicate the neoclassical aesthetic that framed his work as a whole. Hoyningen-Huene was a lifelong admirer of ancient Greek art, especially sculpture, and in 1943 produced a travel book documenting Greek antiquities titled *Hellas: A Tribute to Classical Greece*. His photographic work was marked by the neoclassical ideal of the perfect human body (usually white and male, with defined musculature), in which moods were indicated through pose rather than expression; an interest in drapery to communicate tone, narrative, and balance; and classical-themed props to signify the classical heritage of the human form. The vogue for neoclassicism in the arts was inspired by art historian J. J. Winckelmann, whose eighteenth-century celebrations of male beauty in classical Greek art helped produce a visual arts discourse that allowed the veneration of same-sex desire and beauty among men; by Hoyningen-Huene's time, this adoration of the male form had made its way into every aspect of gay male culture, from physique magazines to Ivy League seminar rooms. In figure 3.7, Hoyningen-Huene's interest in Greek art is clear from the model's backdrop, in which two Greek busts dominate the scene; the model's dress, by the French couture house Paquin, echoes classical themes. Hoyningen-Huene's fashion photographs abound with Greek columns, balustrades, urns, busts, and pedestals; favorite sets include ancient temples, sites, and ruins (fig. 3.7).

Hoyningen-Huene's heavy emphasis on neoclassical props represents another strategy in which fashion photographers queered glamour in the interwar years. Cecil Beaton, who greatly admired Hoyningen-Huene's fashion work, recognized a kindred (though understated) camp spirit that distinguished Hoyningen-Huene's work from that of his mentor, Steichen. "Whereas Steichen seldom approached his subjects with humour," Beaton wrote, "there was

FIG. 3.7 Model wearing evening dress by Paquin, 1934. Photograph by George Hoyningen-Huene.

something almost frivolous in the way Huene brought a whole new collection of properties to his studios. . . . Huene's violent activities in the pages of *Vogue* gave me my greatest incentive to rival his eccentricities."[58] Though straight audiences may have read simply a beautiful homage to classical civilizations, viewers familiar with gay aesthetic sensibilities would have also understood

Hoyningen-Huene's doubled references to Winckelmann's queer—perhaps even camp—celebration of the male form as the epitome of beauty—even though the model might be female.

But even the fashion models themselves became—under protest—queer props in the production of modern glamour under Hoyningen-Huene's direction. Hoyningen-Huene's volatility made him difficult to control, leading to his explosive departure from Condé Nast (and his immediate hiring by Carmel Snow at *Harper's Bazaar* in 1934, whereupon he relocated to New York).[59] During the fashion shoot itself, Hoyningen-Huene required absolute silence: no music, no talking, and no whispering. He was the first photographer to pose the model on the floor, with the camera overhead, arranging the drapery of the model's dress as if she were a Greek frieze. Lauren Bacall, a model for Hoyningen-Huene during these years, described what it was like to work with him: "He posed me like a statue," she said. "Whenever he said, 'hold still,' I started to shake. I was a disaster. He was not pleased. *I* was not pleased. Not pleased? I was suffering. I hated him."[60] Ancient Greek statuary, it seems, was easier to work with than living models, perhaps the female ones in particular. Horst, Hoyningen-Huene's former lover and protégé, may have been more accommodating.

The "Amorous Regard" of George Platt Lynes

Another important interwar fashion photographer central to this queer transatlantic world linking Paris, New York, and Hollywood was George Platt Lynes, a midtwentieth-century American photographer known today primarily for his work as a portraitist and dance photographer, as well as for his erotic portraits of nude men. But Lynes was also a prominent fashion photographer in the late 1930s and 1940s for Condé Nast publications and *Harper's Bazaar,* an important aspect of his work that has gone unnoticed by scholars. Born in 1909, George Platt Lynes graduated from the Berkshire School in Sheffield, Massachusetts, where he had been a classmate of Lincoln Kirstein.[61] Although Kirstein and Lynes would later work together closely when Lynes became the main photographer for Kirstein's New York City Ballet, at the Berkshire School they were not close. Kirstein considered Lynes to be a "sneering little bitch" who considered his life a "pose"; he wandered from reading room to post office "waving his extremities with the nonchalance" of vaudeville faux-French actress Fifi D'Orsay. Lynes's queer femininity made him an outcast at the Berkshire School, where he was bullied and teased until one day, in a fit of desperation, he "whipped out his knife and melodramatically stabbed" another student—it

was not until this moment that Kirstein softened a bit toward Lynes.[62] The student survived, and after graduation Lynes went to Paris and became part of the circle of artists and writers orbiting around Gertrude Stein and Alice B. Toklas. In 1927, Lynes met Monroe Wheeler and Glenway Wescott, two artist/writers who had been together since their days as students in Chicago and had moved to France in part to be together as a couple; Lynes's close relationship with these two would last the remainder of his life (and would include being Monroe's lover for about sixteen years, as well as living with "Monie" and "Glen" from 1934 to 1943).

In 1929, Lynes took up photography at the suggestion of Wheeler and Wescott, and used his five-by-seven-inch camera to make portraits of his queer Bohemian milieu in France, with photographs of André Gide, Gertrude Stein, and eventually other friends, such as Somerset Maugham and Katherine Anne Porter—though he also photographed male nudes, a passion that he would continue for the remainder of his life. His first showing of his portraiture was at the Wadsworth Athenaeum, where the queer Chick Austin was director, but after crossing the Atlantic with Julien Levy in 1931, Lynes landed a show with Walker Evans at Levy's important avant-garde gallery in 1932 (on the same ship was Dr. Mehemed Agha, the new director of *Vanity Fair* and *Vogue*, who dictated the pictorial taste of Condé Nast publications). That summer, for financial reasons, Lynes started doing advertising work for D'Orsay perfume (somewhat prescient, given that Kirstein's reference to Lynes as Fifi D'Orsay, a stage name based on this perfume company, was penned in 1922). As in most of Lynes's career, this arrangement emerged through queer connections: the heir to the French perfume fortune was Jacques Guérin, with whom Glenway Wescott was having a sexual liaison, and in whose Paris apartment Lynes was living. This entrée into the commercial world was successful, and by 1937, Lynes, based in New York, was one of fashion's most sought-after photographers.[63]

Throughout these years, and indeed through his death in 1955, Lynes photographed the male nude. These images are extraordinary in their eroticism, beauty, and (criminalized) intimacy. Lynes could risk circulating these candid images only with a small circle of trusted friends, most especially Glenway Wescott, Monroe Wheeler, and Paul Cadmus. As Wescott wrote Lynes in 1947 in relationship to a new set of nudes, when Lynes was head of *Vogue*'s LA studio, "Dear George, there used to be a practical peril for me in the sea-change of your photographic art, did there not? No longer. On the contrary. Pornography when it is blessed, when it is timely—vain unconsumatable [*sic*] imagination better then defeated sentiment. I say to myself that if I could receive a set of photographs like this every week I could keep from bitterness,

foolishness."[64] Wescott's embrace of representational risk is all the more moving given the context: in the same letter, he describes yet another sexual contretemps at the Museum of Modern Art, where his partner Monroe Wheeler was a chief executive; Wheeler had hired his lover Bill (Christian) Miller at MOMA, and as a result was fighting off rumors concerning his homosexuality from "the trouble-makers, the anti-queer queers and that lot" at the museum.[65] These nudes are extraordinary photographs, and unlike Lynes's fashion work, have been the subject of sustained attention since they were exhibited for the first time in the late 1970s.[66]

My goal is to read Lynes's fashion work in relationship to his male nudes in order to show how Lynes's immersion in queer midtwentieth-century sexual and affective cultures shaped his fashion work, providing one of many examples of glamour's queer history. As a working method, Lynes orchestrated a photographic situation that was predicated on an exchange of glances between model and photographer that was saturated with the visual discourse of longing, a set of looks he called "the amorous regard" or "the amorous glance."[67] This visual exchange was an extension of Lynes's active sexual life, in which he enjoyed intimate relations with many of his models; the amorous regard with his male nudes was often the look of cruising, the frank erotic exchange of New York City's Times Square hustler culture, a regular part of Lynes's sexual itinerary. In the context of Lynes's fashion work, however, the amorous regard was a queer, heteronormative fiction that Lynes produced as a means of coaxing specific, desire-laden looks from his mostly female sitters. But this was a knowing fiction coproduced with his models, some of whom knew Lynes socially as part of their own queer kinship networks, and most of whom certainly knew that in almost all cases, except for a few of his female fashion models, such as Laurie Douglas and Helen Bennett, his amorous preference was generally for members of his own sex.

In the context of modeling, the production of desire was central to the entire enterprise. The visual discourse of longing, central to the model shoot, was a mobile, affective assemblage that historically emerged from Lynes's adaptation of male-male sexual subcultures. Yet in the context of midtwentieth-century US homophobia, the open secret of the fashion industry's queer kinship networks, as well as Lynes's sexuality as a gay man, needed to be hidden—though often in plain sight. Lynes and his female models collaborated in laundering the affective and erotic dimensions of their shared queer kinship networks— networks that often included a sexual component—through the heteronormative front of mainstream fashion discourse.

At the height of Lynes's career in 1941, a feature about his work was published in *Minicam Photography*—one of the main publications for commercial photography. Titled "The Private Life of a Portrait Photographer," Lynes's text purported to invite readers into his private life.[68] To some extent, this turned out to be the case: Lynes describes beginning to take photographs in 1929, and working half the year in New York and half the year in Paris until 1933, when he opened a professional studio in New York. He identifies what it is he looks for in photographing faces: "Some odd note, and angle, or aspect, or expression unfamiliar to me." He seeks, he writes, to make faces "reveals secrets."[69] He describes photographing Paul Cadmus, André Gide, and Gertrude Stein, among others, without of course identifying their centrality to queer transatlantic kinship networks in the interwar years, nor his personal friendships with all of them (fig. 3.8). His greatest challenge, he argued, was photographing the professional beauty: "Everyone's imagination photographs them, so to speak; and you must go on arousing, in their honor, admiration or envy or amorousness."[70] He describes his working method: sometimes exhausting the sitter in order to catch him off guard, but other times "it is psychologically right to sweep him off his [*sic*] feet."[71] Although there are some promising textual leads in this piece—a reference to secrets, to amorousness, to sweeping him off his feet—by and large the text is far from intimate. We in fact learn very little about Lynes's private life at all: not that Lynes had longstanding friendships and intimate relationships with many of his famous sitters, stemming from his expat sojourns to France in the 1920s and 1930s; that he had been living in a ménage à trois with the MOMA membership director and curator Monroe Wheeler and the writer Glenway Wescott on the Upper East Side since 1934, and which was within a month of breaking apart; nor that he had been taking nude, erotic portraits of men for ten years, which he did not exhibit or mail due to a well-founded concern that they would be confiscated as violating obscenity laws.[72] Rather, the article reads very much like any number of other "famous photographers talk about their work" features in journals such as *Popular Photography* and the *Commercial Photographer* during these years. In other words, the article is a "fluff" piece about Lynes's work, a feature essay written by a famous photographer that was bound to be of interest to *Minicam* readers.

In the photographs that Lynes used to illustrate this feature, however, we can see the "*Private* Life of a Portrait Photographer." These celebrity portraits of public figures reveal Lynes's so-called secrets: his private life is hiding in plain sight through his choice of illustrations, which together produce a queer

FIG. 3.8 George Platt Lynes with Paul Cadmus on the set, ca. 1941. Courtesy of the Harry Ransom Center, University of Texas at Austin.

public intimacy predicated on glamour and highbrow celebrity. The feature is bookended by two of his lovers: a study of the *Vogue* fashion model Helen Bennett and a portrait of Lynes's studio assistant and lover George Tichenor. In between Bennett and Tichenor are portraits of Marion "Joe" Carstairs, a masculine-identified extraordinarily wealthy lesbian and friend of Lynes; the gay artist and close friend Paul Cadmus, whose sister Fidelma was married to Lincoln Kirstein (who self-identified as queer); Gertrude Stein, the doyenne of American expat arts and letters, and a friend of Lynes from his time in France

in the 1920s; George Balanchine, dancer, choreographer, former ballet master of the Ballet Russes, and cofounder (with Lincoln Kirstein) of the New York City Ballet; and the French writer André Gide. The final page spread featured Lynes's lover George Tichenor, who was killed in World War I soon after these portraits were taken. In the wake of George Tichenor's death, Lynes fell in love with George's brother Jonathan and broke up his long-standing household arrangement with Wescott and Wheeler to set up household with Jonathan in 1943—only to have Jonathan leave him for a woman. In other words, the private life of the photographer is in fact fully on display in this *Minicam* piece, but in the photographs—not in what was most likely Wescott's cautious text. Like gay men and lesbians in the elite public world of interwar New York, Lynes's private life was hidden in plain sight, available for anyone to see who knew the codes to look for.

Lynes's queer private life was also hidden in plain sight in his fashion photography, in which both the models and his working method were informed by his immersion in midtwentieth-century gay subcultures. The relationship between the two poles of photographic practice I am exploring here—fashion and male nudes—are represented in the *Minicam* piece by the bookend images of Bennett and Tichenor (figs. 3.9 and 3.10). In the opening photograph, favorite model Helen Bennett poses with a large, white cube, an abstract composition that references Lynes's engagement with currents in contemporary art; in the closing image, Lynes's lover George Tichenor, dressed in his Ambulance Corps uniform, looks to his left while seated in a wicker enclosure, reminiscent of an air balloon basket. Lynes moved from celebrity portraiture to fashion work in 1933, soon after his father died of a heart attack and was unable to help subsidize Lynes's extensive expat sojourns in France and Italy.[73] Lynes's friend Frederika Fox, who knew her way around the fashion business in New York, became an unofficial agent who brought him work; by the summer of 1933, while Lynes was in Europe, Fox was replaced by Mary Conover Brown, a debutante and society person who built Lynes's fashion business rather quickly and then later married Paul Mellon, the philanthropist who funded the National Gallery of Art in Washington, DC, and the Yale Center for British Art. By August of 1934, Lynes had moved into both a new studio at 214 East 58th Street and a new apartment with Monroe Wheeler and Glenway Wescott at 48 East 89th Street. Lynes's business was taking off, but his ambivalence about fashion work is clear in a letter he wrote to his close friend Katherine Anne Porter in 1934, at the age of twenty-seven. Lynes confessed that he was presently hating photography, "all that necessary and commercial faces of it, to which, thanks to my economic disorder, I am having to devote my energies.

A Portrait Photographer

BY GEORGE PLATT LYNES

FIG. 3.9 AND FIG. 3.10 George Platt Lynes, portraits of fashion model Helen Bennett and studio assistant George Tichenor, *Minicam*, 1943. Courtesy of the Harry Ransom Center, University of Texas at Austin.

I like to photograph for fun, for the hell of it."[74] Despite this ambivalence, by 1937 he had a very successful career as a fashion photographer, with hundreds of his images appearing in *Vogue*, *Harper's*, *Town and Country*, and other "class" magazines in the mid-1930s and early 1940s.

Lynes's production of the model's "look" was informed by the amorous exchange of glances central to queer desire, an exchange that was imbricated with the market in the context of both commercial modeling and midtwentieth-century homosex subcultures. As a window into this set of looks, which Lynes called the "amorous regard," allow me to draw our attention to another piece that Lynes wrote about his photography, which appeared in *Bachelor* in 1937. In an essay he titled "The Camera Knows When a Woman Is in Love," Lynes described his working methods. To put his sitters at ease, he wrote, "he usually worked the way a masseur or athletic instructor works, tiring my sitter out, until he or she relaxed and looked natural, or looked wonderful."[75] But, Lynes

muses, how does he get a beautiful picture from even an ugly sitter? Here is his strategy:

> Every woman is beautiful to some man, X, or she has been, or she will be.... Given a Jill, one may assume the existence of a Jack—he understands her, he appreciates her, he regards her with amorous regard. I decided always to place myself in X's place, Jack's place—or, to be more exact, to put my camera in it . . . trying to use the camera so that it will have an amorous glance. Amorous when the model is young and beautiful, or wants to be . . . the photographer has to learn the thousand tricks of the trade . . . he has got to work his imagination to death. He has got to start dreaming the minute the client comes in the door, and keep it up.[76]

In this piece, Lynes uses the language of heterosexual desire to describe working methods that include metaphors of the masseuse or the trainer, tricks and hustling (all of which are central to gay men's culture, of course, then and now), and the imaginative effort required to "put his camera in it" and to "keep it up" as soon as the client walks through the door. The joke is on any chance heterosexual readership of *Bachelor* magazine, though not, of course, on the gay men who surely read it. The description of Lynes's work behind the camera, possibly ghost written by Glenway Wescott, suggests a dominant reading of heterosexual attraction, yet words such as "tricks" and inclusive pronouns such as "he or she" encourage queer readings of this working method, and in particular the mobile and untamed possibilities of the "amorous regard."

In the context of fashion photography, the "amorous regard" is the look that Lynes offers his sitter, but one that is also sometimes returned directly to the photographer, the camera, and implicitly, of course, the viewer. The look of love doesn't necessarily need to be returned to have the image saturated with a discourse of longing, and Lynes was expert at producing and communicating a free-floating affect of desire in his photographic work. The production of desire is central to fashion photography, since the whole point is to generate longing for a specific commodity, which is for sale by, say Marshall Field or Henri Bendel or Saks, or any of the other high-end clients for which Lynes worked. In Lynes's work in fashion as well as with his male nudes, we see a brilliant example of the queer production of commercialized affect, in which his skills in creating the amorous regard in one context are tied to the commodity form of another. These aspects of desire and the commodity form are central to modern glamour. As I will discuss a bit later, in the case of fashion work with favorite models such as Ruth Ford, Laurie Douglas, or Helen Bennett—models who were part of Lynes's queer social network—the models themselves coproduced

a theatrics of amorous regard while fully realizing the fictive dimensions of the implied heterosexual framing.

The queerness of Lynes's "amorous regard" in his fashion work is informed by his simultaneous immersion in midtwentieth-century homosexual cultures, of which his portraits of nude men are an important visual record. From the 1930s until his death in 1955, Lynes was at the center of a highly sexual circle of friends and lovers—not only Wheeler and Wescott but also a host of New York artists and writers who had first connected as expats in France in the 1920s, particularly in Paris and Villefranche. Some of these figures included Paul Cadmus, Jared French, and Margaret French (who made work together as PAJAMA; Jared was sexually involved with both, though he married Margaret); Lincoln Kirstein; and several of the NYC ballet dancers, whom Lynes came to know as the ballet's main photographer in the 1930s and 1940s. In his later years, especially after he broke with Wheeler and Wescott in 1943, Lynes became much more intensely involved with hustler cultures around Times Square. He developed a close friendship with the masochist, tattoo artist, and former English professor Samuel Steward; both of them became key informants for Alfred Kinsey in the late 1940s and early 1950s, and some of Lynes's male models traveled to Bloomington to be filmed having sex.[77] Beginning in the 1930s, Lynes made beautiful erotic portraits of these men, many of whom were his sexual partners (surely one of the ways in which he "tired his sitters out" before photographing). Because of obscenity laws, however, Lynes did not risk exhibiting or sending these images through the mail; instead he circulated them privately among his friends. As he wrote Wheeler in 1948, "I've done my best work when I've worked only for pleasure, when I've not been paid, when I have a completely free hand, when I've had a model who has excited me in one way or another."[78] The nudes were the work he cared about the most, while fashion photography was something that simply paid the bills.

In the context of gay male sexual subcultures, the "amorous regard" is the ocular component of cruising. As Marc Turner has argued, cruising is the "moment of visual exchange" that takes place mostly in urban, otherwise anonymous environments; it is an act of "mutual recognition" in which the specificity and duration of the glance can dispel ambiguity, clarifying the look as an explicitly erotic overture.[79] Cruising is historically determined, site-specific, and ephemeral. As Turner has pointed out, "The problem of writing about cruising is that . . . it doesn't remain static, it passes quickly, it's over in the time it takes to shift one's eyes."[80] Lynes's work, however, thematizes the "amorous regard" of cruising, the moment before one looks away; as a photographer, Lynes's goal was, in fact, to make that moment static through the photographic image,

which he then circulated privately to his friends and lovers. As Gavin Brown has argued, however, though the look—the backward glance, the frank stare— is central to cruising, it is not the only embodied, affective aspect of this modern urban practice. Brown emphasizes the "complex choreography of postures and gestures" that accompany the gaze, or the "amorous regard."[81] Brown emphasizes in particular the mirroring process of gestures and movements, from moving one's eyes down the other's body to the step closer to the loosening of a belt buckle, that represents what he calls the call-and-response refrain through which each party registers and intensifies interest in the other until, eventually, all ambiguity is dispelled and an encounter is consummated.[82] This process is a narrative one that involves movement across time and (public) space; it follows the quickly passing moment of the initial meeting and holding of the look.

Lynes's work thematizes several key choreographic moments in gay cruising cultures, including both the look and the mirroring of glances, gestures, and movements that work to clarify desires and intentions in the context of public sex. Lynes has encoded the images with discursive hints that signal many of cruising's common scripts. In figure 3.11, the model John Ellestad stands with his back to the camera as Lynes's light sculpts the contours of his hips, ass, and upper thigh. His head is turned to the camera, offering the cruiser's "backward glance," one of the first signals of interest in public sex. The hint of a doorway and two shadowy figures further suggest a narrative of movement toward a soon-to-be consummated encounter. In these double portraits of Chester Nielsen and J. Ogle (figs. 3.12 and 3.13), the men are separated by a glass partition: the hard, opaquely reflective surfaces suggest institutional dividers in public space, such as the dividers between bathroom stalls in a public toilet. Surely this was Lynes's intention, given the suggestive positioning of the model's head in the left image (let alone the fingers edging around the partition) and, in the right image, the downward gaze of the near model as he assesses the package of the man on the other side of the barrier. The visual codes of gay sexual subcultures are clearly in evidence here. Finally, a series depicting two nude men, one in shadow, also thematizes visual and corporeal cruising scripts (figs. 3.14 and 3.15). In the left image, a young man frankly meets and holds the amorous regard of the man in shadow. Contact made, we see in the right panel his departure, as he goes off-frame to, presumably, a space of intimacy and potential encounter. That he has succeeded in capturing the attention of the man in shadow is clearly signaled in his body language, as he shifts his weight to his left leg and cranes his head in the direction of the departing figure.

Other portraits, however, feature the model's direct address to the camera. Cruising requires breaking the implicit codes of urban life whereby city goers

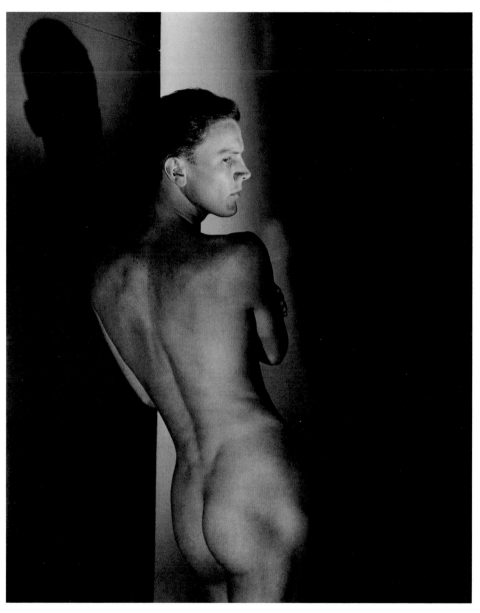

FIG. 3.11 John Ellestad, ca. 1943. Photograph by George Platt Lynes. Estate of George Platt Lynes.

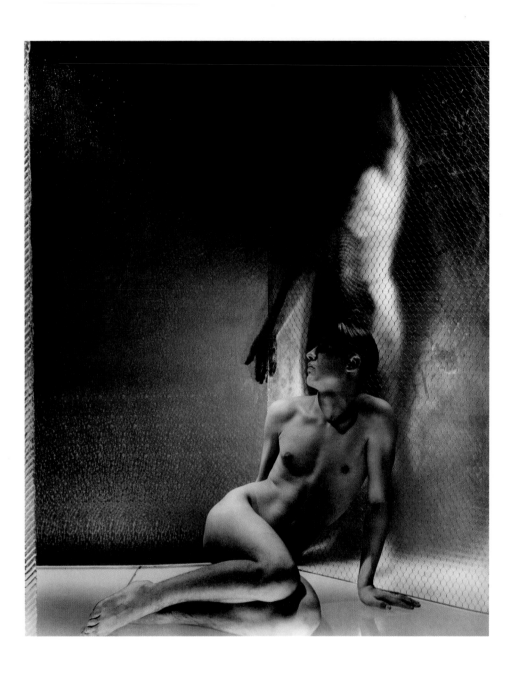

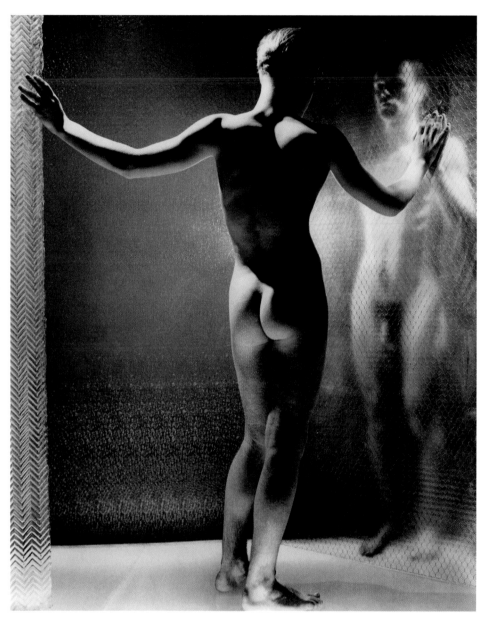

FIG. 3.12 AND FIG. 3.13 Chester Nielsen and J. Ogle, ca. 1954. Photograph by George Platt Lynes. Estate of George Platt Lynes.

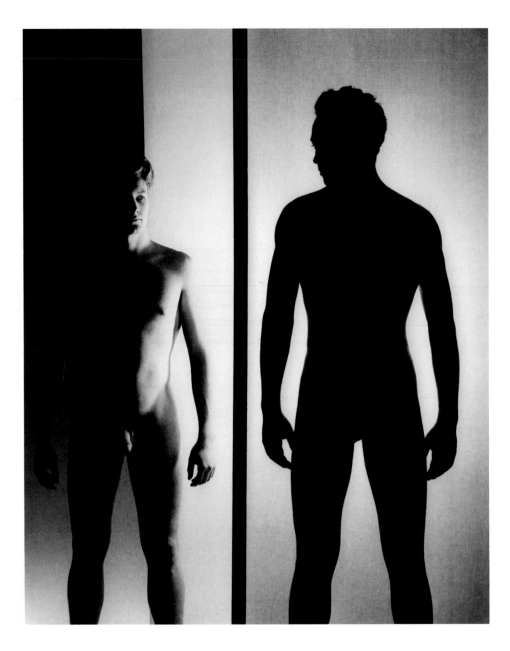

FIG. 3.14 AND FIG. 3.15 George Platt Lynes, *Two Male Nudes (One in Shadow)*, n.d. Gelatin silver print, 10 × 7 7/8 in. (25.4 × 20 cm.). Gift, anonymous and in kind, Canada, 1998, 98.4827, Solomon R. Guggenheim Museum, New York.

discreetly avert their gaze in public space, looking at the street ahead rather than into the eyes of passing strangers. The cruising look is a frank look, bordering on the stare, held past the moment of polite friendliness. There is an affective intensity, invitation, and *duration* to the look that distinguishes it from other visual exchanges between strangers. The willingness to meet and hold the gaze, to refuse to look away until after the microsecond that distinguishes a "hello" from a "helloooo," is the first salvo in the call-and-response exchange. In most of Lynes's more explicitly erotic portraits, the viewer's position is that of Lynes, and both viewing positions is that of the one who looks first—the cruiser who initiates the exchange. In other words, it is for the most part we, the viewers, who are cruising in Lynes's images. Lynes's models place themselves on display for our erotic interest: to quote Lynes's piece on fashion portraiture, he is "trying to use the camera so that it will have an amorous glance."[83]

Historically, the Times Square area in which Lynes lived and worked was an important site of gay cruising from the 1910s through the postwar period. Cruising sites included not only the streets but also hotel bars and cultural venues that Lynes and his circle frequented. Times Square was a logical site for the development of a gay enclave, as so many gay men lived and worked in the theatre and entertainment industries centered in midtown. As George Chauncey has shown, Times Square had become one of the city's most important sites for male prostitutes in the 1920s, with two types predominating: the effeminate fairies and the group that appealed to Lynes, what Chauncey describes as "well-dressed, 'mannered,' and gay identified hustlers who serve[d] a middle-class, gay-identified clientele."[84] These hustlers generally met their johns on the west side of Fifth Avenue, anywhere from 42nd to 59th street, and generally went home with them, often to their upscale bachelor apartments in the West Forties and Fifties (in the 1930s, Lynes was at 44 East 50th Street, between Madison and Park, about ten blocks from Times Square, and precisely in the neighborhood Chauncey describes). The presence of gay men's street culture was so well known in the 1920s and 1930s that *Vanity Fair*'s 1931 *Guide to New York* directed interested tourists to the area for a "dash of lavender."[85] By the 1930s, Times Square had become masculinized, as rough trade hustlers, aggressively masculine in their style, had pushed out the fairy prostitutes to Bryant Park, at 42nd and Sixth Avenue.

After a period of sexual permissiveness in the context of Prohibition, New York City officials commenced a campaign to eradicate gay sociability in the public sphere. As George Chauncey notes, the State Liquor Authority began shutting down any establishment that served homosexuals, which in turn produced the ghettoization of queer social life into gay bars; these bars usually

lasted only a few months before the police shut them down. More elite estab-
lishments, such as the Oak Room at the Plaza and the Astor Hotel bar, located
at the corner of Seventh Avenue and 45th Street, had a better chance of surviv-
ing the raids. During the war, the Astor Hotel bar developed a national reputa-
tion among gay servicemen as an important cruising site. As Alan Bérubé has
shown, gay GIs "carefully put out feelers and used subtle eye contact to identify
each other without exposing themselves" while cruising, especially in mixed
spaces such as the Astor Hotel bar, where straights congregated on one side,
and gay men (including servicemen) on the other.[86] One of Chauncey's interview
subjects remembered of the Astor that gay men could congregate there, just so
long as they were not "too buddy, or too cruisy."[87]

More elite gay men, such as Lynes and his circle, had the resources to patron-
ize exclusive public venues, where their class and race privilege gave them ad-
ditional protection from police harassment. Clubs such as the Rainbow Room
at the Rockefeller Center penthouse, nightclubs such as Tony's near Times
Square, in the Fifties, and hotel bars such as those in the Astor, the Biltmore,
and the Hotel Claridge were known places where wealthy white gay men and
lesbians could hide in plain sight, meeting others and cruising surreptitiously
with less risk of exposure. Elite white gay men and lesbians also produced
exclusive cultural sites, such as the Metropolitan Opera and the New York
City Ballet, as queer public spaces in which their sexuality could be signaled
through dress and comportment without risking police harassment. As one of
Chauncey's interviewees explained, "Since there were no known instances of
police raids on such distinguished cultural events, all stops were pulled out as
far as human grooming. Hairdos and outlandish clothes many gays wore were
not to be equaled until the punk rock era."[88] The Metropolitan Opera, which
Lynes attended weekly, "for years had been a gay male cruising mecca," whereas
the ballet, for which Lynes was the main photographer for decades, was a "sea
of furtive glances as gay male soldiers and civilians cruised each other," accord-
ing to Bérubé.[89] Lynes's diaries map out the urban spaces of an elite gay public
sphere in these years, with daily, multiple references to the opera, the ballet,
movie theatres, clubs and restaurants such as 123 and the Plaza.[90]

Unlike some of his elite set, however, Lynes also was involved in Times
Square's hustler cultures. When Samuel Steward visited Lynes for the first time
in 1951, they both visited the "elegant apartment of the then head of the Mu-
seum of Modern Art" *and* "the sleeze of 42nd Street," which, as Steward wrote,
"as early as the 1950s was much troubling the fuzz with its accumulation of
whores and pimps and hustlers."[91] They visited a "hustler's bar on 42nd Street
near Times Square," where they had a drink with the playwright (and alcoholic)

William Inge.[92] Inge, eyeing a hustler in a Western outfit to take home, asked Lynes and Steward, with some trepidation, "Do you think he'd murder me?" Lynes replied coolly, "That's a hazard of our profession. Nothing ventured, y'know."[93]

Lynes and Steward shared a double life as professionals and as gay men who shared overlapping interests in hustler culture, group sex, and homoerotic cultural expression. With Steward based in Chicago and Lynes in New York, they traded photographs, pornographic vignettes, artwork, sexual trophies (including pubic hair, which Lynes needlepointed into couch cushions), as well as keeping each other up to date on their various sexual activities. Steward wrote Lynes of the cruising he enjoyed while visiting San Francisco: "Sometime you should walk down Market Street at two ayem [sic], to see the leather-jacketed, dungareed and booted handsome young toughs of San Francisco fingering themselves and announcing by word or glance their easy availability." Overall, Steward wrote Lynes, it was a "sucksexful" trip.[94]

But while cruising was certainly part of the pleasures of urban life for both men, Lynes generally preferred playing at home. Cruising's "amorous regard" was, ideally, an entrée into a network of sex partners who played together in large parties hosted at both men's apartments. Steward acted as Lynes's pimp, in Steward's words, sending Lynes young men for both his photography and his "ratfucks," while Lynes recommended young men for Steward's organized daisy chains and what he referred to as his "spintriae." For example, Steward let Lynes know about twenty-four-year-old Gene Maday, a six-foot-one long-limbed ballet dancer with a "sensual-cruel face" but who was "not swish a-tall." As Steward wrote, "He's not mine of course, but he shares what he has of handsomeness with me freely and I don't ask any more of him than that he be trade; so I don't know what might happen with you and him sxly, but I'll be there in speerit, looking through the peephole behind the main screen in yr studio."[95]

Lynes saw himself as an erotic director of sorts, the spider at the center of a sexual web that consensually entrapped younger, beautiful men. He referred to his time with these younger sex partners as his "boydays," and contrasted them with his other homosexual and literary life; by the early 1950s, Lynes wrote, "Indeed most of my days are boydays."[96] Lynes's summer of 1953, he wrote Steward, "was all the same, ring around the rosy. My new web is beautiful and efficient. There's always somebody, and a lot of the time somebody's somebody as well."[97] In 1953, already ill with cancer, Lynes explained that he'd slowed down a bit, limiting his parties to once a week. "No more big pushes. I'm trying to limit my

guests to ten—and so far it has worked and been pleasant—but I haven't yet gotten around to reestablishing myself in my old spider-in-web role. I mean to. I don't like bars. I don't circulate well at other people's parties. I do best simply sitting at home and encouraging my young and beautiful to produce their young and beautiful."[98]

Like Glenway Wescott, Lynes enjoyed watching; in this context, his amorous regard was also that of the voyeur. As he had written to Steward about watching models Johnny Leapheart and Buddy McCarthy having sex, "Voyeurism's one of my foibles."[99] The images from this session include Lynes's well-regarded "Man in His Element," of the black Leapheart and the white McCarthy in an intimate, perhaps postcoital, embrace. Steward responded with enthusiasm, and a tale of his own: "I wish I could've been behind the screen when John and Buddy were playing at two-backed beast. As I told you, I'd planned a spintriae for that weekend, and it worked out wonderfully well—I wish you could've been there to watch (or be in) that one. Eight of them all together."[100] In Lynes's sexual life—whether cruising, photographing, or weaving his queer spiderweb—practices of erotic and amorous looking bound together sex partners, friendships, and photography.

This subcultural economy of sexual looking helped shape, I am arguing, what Lynes referred to as the "amorous regard" in his fashion photography. In fashion shoots for high-end clients such as Henri Bendel, Lynes collaborated with his female models to produce and circulate an amorous regard that borrowed from Lynes's sexual life but that became affectively laundered as both heteronormative and commercialized in the context of midcentury fashion photography. Since Lynes photographed both sets of models—the male nudes and the female fashion models—in his studio, it is not surprising to see an overlap of backgrounds and approaches between the two sets of images.[101] In figure 3.16, we can see the opaque glass used for a Bendel ad from 1938. Model Toni Sorel poses in a black crepe cocktail dress in an advertisement for Bendel's that appeared in *Harper's* in 1938. Sorel's arms reach above her head, while behind her a man in a suit stretches to embrace her. A narrative of erotic intimacy is connoted in both this fashion photograph and the male nudes in 3.12 and 3.13, which features the same opaque divider. While both figures 3.11 and 3.12 lend themselves to a reading of market exchange, the Bendel ad suggests both heterosexuality and commodification, with a tagline that draws the implied female reader's attention to the clothing item for sale: "The black crepe cocktail dress, which you wore dining and dancing these February nights. Henri Bendel." The spatial and material barrier between the man and the woman, as

FIG. 3.16 George Platt Lynes, ad for Bendel's, with model Toni Sorel, 1938. *Harper's Bazaar*, The black crepe cocktail dress, which you wore dining and dancing these February nights. Henri Bendel. vol. 71, no. 2705, 88.

well as the model and the magazine reader, suggest the distancing mechanisms of a managed sexuality, central to commercial appeals.

Lynes's visual rhetoric of gay cruising cultures provides a queer narrative for a double-page advertisement for Carolyn Modes from 1938 (figs. 3.17 and 3.18).[102] Although this is clearly taken inside the photographer's studio, Lynes's

bare branch and a purpose-made fence suggest an outdoor encounter between two women. The distance between the two women suggests they are strangers, rather than friends, yet their bodies are turned toward each other; the woman on the right stares purposefully at the woman on the left, who looks away while allowing the model on the right, as well as the viewer, to view the goods on display. Lynes's subdued backlighting connotes an evening rendezvous, perhaps (as the branch suggests) in a park setting. The models' arms are sharply angled, a body pose suggestive of purpose, movement, and self-determination; the imposing fence, oddly exceeding the height of the most ambitious of country fences, provides an almost penitential gloss. Certainly, a dominant reading of this image pair would suggest an innocuous narrative: two women meet in a country setting to display gloves, hats, and the "glamorous armour fox" adorning the model on the right. But could the model on the left, eyes averted with body open, be the hen for the glamorous, amorous, fox? A queer reading, then and now, reads the intimacy, setting, and corporal language here as signifying the erotic energies of the chase. Read in the context of Lynes's privately circulated nudes, the fashion tableau references public, outdoor cruising practices, a sexual subculture not generally associated with upper-middle-class white women. In this way, Lynes queers not only fashion photography but also cruising itself.

This fashion image narrating an "amorous regard" between two white, upper-class women reveals a queer erotics where a heteronormative desire for the commodity offers a safe port in the storm of unruly, queer desire. Without much evidence for how actual white, feminine fashion magazine readers understood this image, and those like it, my interpretation must remain suggestive. While my argument does not focus on the reception of Lynes's images, and instead focuses on their production and circulation, it is worth troubling the presumed heteronormative reading practices of feminine, white, middle- and upper-class readers in the 1930s and 1940s. As historians Elizabeth Lapovsky Kennedy and Madeline Davis cautioned over two decades ago, the emphasis on turn-of-the-century constructions of hetero- and homosexual identities can work to rigidify homosexuals and heterosexuals as distinct kinds of people, when sexual and erotic attachments historically were often less easily defined.[103] Julian Carter's research on what he calls "non-lesbian sexual relationships" between conventionally feminine, middle-class white women has demonstrated just how queer—and racialized white—these conventionally feminine women could be as they rejected the primitivism of lesbianism while embracing the hot sex of same-sex desire, an erotics that did not in any way foreclose heterosexuality or conventional marriage.[104] The

FIG. 3.17 AND FIG. 3.18 George Platt Lynes, ad for furs. *Vogue*, January 15, 1938, 12–13.

amorous regard of a conventionally feminine white woman, as imaged here, certainly includes the commodity form—but may well have taken in the female form as well.

Queering the "Look"

The production of fashion's "amorous regard" requires the collaboration of several people for any specific shoot: photographer, art director, model, and stylist, among others. The fashion industry, in particular, is in the business of producing such an eroticized affect, since desire is the prelude to buying. As scholars such as Ashley Mears and Elizabeth Wissinger have argued, the model is centrally important to the creation of this dense affective site that seems to lack an agreed-upon name: Elinor Glyn referred to "it"; the interwar period called it "glamour"; today the industry calls it the "X factor."[105] But whatever it is, it's a collaborative affective production in which capitalism and culture intersect with sexuality and commerce. The model is key, since it is through the model's affective labor, in collaboration with the designer, photographer, stylist, makeup artist, photo editor, and other coproducers, that commodities become imbricated with an orchestrated "look," or "feel," designed to produce sales. In the interwar period, this affective assemblage was known as glamour, and models played a central role in its coproduction.

The model's "look" is a coproduced ineffable something that, as Joanne Entwistle and Don Slater have argued, bridges materiality and representation, time and space.[106] Like the brand, the model's look summarizes how selling and consumption are organized; the look, they argue "is a kind of metacommodity, a logic that makes sense of past and future jobs, and allows them to be narrated and produced as a career, across time and across contracts."[107] The model's look is coproduced by the model herself, but also by the agency or booker, who sends particular jobs her way; by the stylist; by the hairdresser and makeup artist; by the photographer; by the dress designer; and by other cultural intermediaries who work together to produce a commercial container that together designates the model as a good "fit" for an identifiable type of product and buyer. As Wissinger and Mears have argued, the "look" is more than the sum of its parts; it is a "volatile mix of energies," in Wissinger's words, an affective flow that "links photographers, agents, models, producers, consumers, and brands in circuits of exchange where the product is more of an event than a thing."[108] The model's "look" is what she sells; it needs to be constantly performed, monitored, adjusted, and refined, both on set and off, in print and in the flesh. It is for this reason that the sociability of models off-camera is paramount: where

she socialized, where she is seen, with whom—all are part of maintaining the brand.

The queer sensibilities and kinship networks that I have been describing helped produce the model's "look" in both meanings of the term: the model's look at the camera, which I have discussed in relationship to Lynes's work, above, but also the model's overall style, which Lynes and other queer artists played a critical role in developing. As Nigel Thrift has argued, for all its excitement and allure, glamour operates on the human scale, offering just enough familiarity to spark the imagination, to launch the viewer's sense of utopic possibility.[109] These microutopias are produced through objects and bodies and their arrangement; style, in other words, is the vehicle through which one experiences the affects of material seduction. Fashion models enliven material objects; their job is to perform enchantment in relationship to the dresses, hats, shoes, and gloves they wear. In the interwar era, I am suggesting, the model's "look" was a collaborative, queer, production. Models worked with art directors, fashion designers, magazine editors, stylists, makeup artists, and, of course, photographers to create the end product, whether a photo spread in a class magazine such as *Vogue* or a runway show during fashion week. In the interwar, transatlantic fashion world of which Lynes was a part, the model's "look" was informed by a network of queer alliances that bridged both sides of the camera, as well as both sides of the Atlantic.

Although I could make this argument in relationship to many of the prominent models of the 1930s, such as Laurie Douglas (whom Condé Nast viewed as "one of the best models who has come along in many a day") or Helen Bennett (Horst's favorite), I'd like to describe the queer kinship networks of just one model: Ruth Ford.[110] Lynes, Horst, Hoyningen-Huene, Beaton, Steichen, and others photographed Ford a number of times in the mid- to late 1930s, before she succeeded at her career as a stage and film actress (fig. 3.19). Figure 3.19 shows a scrapbook page of Ford at the height of her modeling career, posing in a tailored red spring jacket for a February 1939 *Vogue* cover photographed by Horst. Ford bends her slender figure in elegant dialogue with the props before her, the red feathers of her hat echoing those on, and in, the birdcage before her. Key figures in this queer transatlantic art and fashion world both produced Ford's look of quiet elegance and launched her career; these figures included not only Horst and Lynes but also Ford's brother Charles Henri Ford; his longterm lover Pavel Tchelitchew; fashion photographers George Hoyningen-Huene, Cecil Beaton, and Peter Watson (Beaton's great and unrequited love); the gallery director Julian Levy and his wife Joella; Djuna Barnes; Glenway Wescott; Man Ray; Cole and Linda Porter; and others.[111]

FIG. 3.19 Ruth Ford, cover of *Vogue*, February 15, 1939. Record of Photographers and Models in *Vogue*. Photograph by Horst P. Horst. Courtesy of Fashion Institute of Technology, SUNY, FIT Library Special Collections and College Archives, New York, NY.

George Platt Lynes was also photographing Ruth Ford during this period, and a closer look at Lynes's portrait of Ruth provides further evidence about the queer production of modern glamour (fig. 3.20). Here, Ruth poses in a striped gown, her right arm akimbo, while her left hand holds a cigarette aloft, cool smoke adorning her aloof expression. Lynes has shot Ford from below, and this classic subordinating perspective, combined with the elegance of Ford's pose and its reference to 1930s Hollywood movies, connotes the glamorous celebrity of 1930s stardom. The objects in this image (dress, shoes, cigarette) combined with the elements of corporeal style in Ford's presentation (gesture, facial expression, gaze, hair) create the visual semiotics of interwar glamour. But it turns out that pretty much everything about this look was a collaborative, queer production—one that launched Ford's successful, lifelong career as a model and actress.

As a photographer, Lynes worked with Ford, but he was also part of the queer network that designed Ford's overall look. Let's begin with Ford's dress. It was designed by Russian émigré and surrealist painter Pavel Tchelitchew ("Pavlik"), with whom Lynes had been friends since 1925; Lynes's lover Monroe Wheeler organized a major exhibition of Tchelitchew's work at MOMA a few years later, and Lincoln Kirstein was a lifelong champion of his work.[112] Tchelitchew was also close to other queer artists who worked for Condé Nast and Hearst publications (such as *Harper's Bazaar*) before World War II, especially fellow Russian émigré George Hoyningen-Huene.[113] Tchelitchew was Ruth Ford's brother-in-law, more or less, as Tchelitchew's life partner was Ruth Ford's brother, Charles Henri Ford, the surrealist poet, novelist, and editor of the surrealist magazine *View*, which he produced in New York in the 1940s (Charles Henri Ford also cowrote one of the first gay-themed novels, *The Young and the Evil*, with Parker Tyler, in 1933).[114] The dress itself was made by Mrs. Agha, wife of Mohamed F. Agha, art director for Condé Nast publications *Vogue, Vanity Fair,* and *House and Garden*; Mrs. Agha had recently opened a swanky clothing shop on East 57th Street, one block away from Lynes's studio. In the closely knit cultural world of 1930s New York, the live performance of such queer collaborations informed the look's cultural capital. Ruth Ford wrote her mother about the dress on April 19, 1937, "I wore it to the opening night at the ballet—George Lynes took me"; she then "wore it to Elsa Maxwell's ball on Friday night. Bubu [her brother, Charles Henri Ford] and I went—it was a red, white, and blue ball given in the Waldorf."[115] Ruth's entry into this queer world was through her brother Charles, and she, Charles, and Pavlik were extremely close, as her late 1930s Valentine card to Charles and Pavel suggests (fig. 3.21). After Charles's

FIG. 3.20 Ruth Ford, ca. 1937. Portrait by George Platt Lynes. Estate of George Platt Lynes.

FIG. 3.21 Ruth Ford, Valentine card to her brother Charles and his lover Pavlik, late 1930s. Courtesy of the Harry Ransom Center, University of Texas at Austin.

expat years of the early 1930s, Ruth and her brother lived in separate apartments in the Dakota on New York City's Central Park until Ruth died in 2009.

Charles Henri Ford and his partner Pavlik Tchelitchew, well-connected artists who moved easily between New York and Europe in the interwar years, played a key role in launching Ruth's modeling career by both designing her look and introducing her to the most important fashion photographers of the era, including George Platt Lynes but also the other key queer interwar fashion photographers, George Hoyningen-Huene, Horst, and Cecil Beaton. In the mid1930s, Ruth was just beginning her career as a model. She had moved to New York from her native Mississippi while her brother Charles was living in Paris with Tchelitchew and circulating in the interwar queer arts scene of Paris and New York. Charles and Pavlik wrote to Ruth regularly with extraordinarily specific constructions concerning her hair, her clothing, and her overall look all with the (successful) goal of getting her on the inside track of New York's modeling world. They both designed Ruth's "look," especially her hair, and choreographed her social calendar by directing the production of cocktail parties and other social occasions designed to ensure that Ruth came to the attention of Lynes, Horst, Beaton, and Hoyningen-Huene, thus launching her career.

To give some insight into the specificity of Charles's and Pavlik's assistance with Ruth's "look," let us spend a moment on Ruth's coiffeur in the mid1930s.

Hair, as Joseph Roach and Nigel Thrift have argued, is critical to the production of modern celebrity and glamour because of its liminal relationship to the body: adjacent to skin, at the borders of body/nonbody, hair can be cut, grown, colored, coiffed.[116] Allow me to suggest as well the queer meanings of the coiffeur, from Cecil Beaton's long hair in his aesthete days to Gerald Kelly's Greek coif in Hoyningen-Huene's parody of Brigitte Helm, with a brief reminder of the "outlandish" hairdos sported by gay men attending elite cultural events during a period of increased police activity against gay men in 1930s New York. Hair is central to the articulation of style (hence the term "hairstyle,"); as David Halperin says, "a hairstyle is about something. It *has* to be about something. If it's not about anything, it's not a style—it's just hair" (fig. 3.22).[117] For whatever reason, the amount of attention that Charles and Pavlik bestowed on the specifics of Ruth's hair seems both ridiculous and fabulous—in other words, queer—in their near daily letters to her during the mid-1930s, when she was first seeking to break into the modeling industry. Their sensitive cultivation of her look and style was their gay gift, one that became overdetermined by heteronormative readings when in public circulation.

In August 1935, while vacationing from Paris in Italy, Charles wrote Ruth with a vision of what her "fall and winter coiffure must be." Worried that his drawing wouldn't properly convey the look (and indeed, it was a rather poor drawing), Charles described the style he saw on a young Italian woman at the beach:

> The hair was braided all-in-one braid beginning from the top of the head. This braid was laid from the top of the head (hairpinned to you) to the nape of the neck, *where it separated into two similar braids*, curving around each side, their ends tucked in at the top of the head, where the big braid began. Now what could be more simple and elegant? But that's not all. She had clipped her hair in front to make a wisp of a "fringe," but that was rather disordered as she was on the beach; it was neither here nor there[,] neither straight or curly, but *yours* must be right in front, brushed back a bit where the part now is and curled by the irons to test its success—later you can get a permanent. Perhaps your hair will have to be thinned out some more to make the proper braids, for they were not heavy but just right. The hair on top will be curled in the effect I tried to get last winter with your side hair, pinned up at the sides near the back and curled forward—you remember. Now don't worry about these curls the middle and on top, which will hide your part, but we can do without it . . . if invisible hairpins will not hold them in place you could very well

FIG. 3.22 John Rawlings, portrait of model Helen Bennett having her hair styled. *Vogue*, February 1, 1937, 112. John Rawlings/Vogue ©1937 Condé Nast.

insert a small band. Now I think it will plus have the most ravishing and modern hairdresser in Manhattan—what do you think? And just suited to your Italian personality.[118]

Successive letters followed, enquiring as to whether Ruth had taken Charles's direction in this important matter, and providing still more coiffeur pointers from both Charles and Pavlik.

These ideas about Ruth's hair are braided with Charles's plans to weave Ruth into his queer social network in order to launch her career as a model. Charles and Pavlik were good friends with Lynes, Beaton, Hoyningen-Huene, and Horst; their letters to Ruth direct her on how to make sure they photograph her in New York. One of Charles's letters to Ruth, for example, was written on the back of one of Cecil Beaton's letters to Charles and Pavlik, which began "Dearest Boys" and asks "where you will be in September as I long to join you anywhere you may be." Charles worked hard to bring Ruth to Beaton's attention, and Beaton's reference in this letter to "I hope I shan't miss the beauty you have awaiting me" may refer to Ruth.[119]

George Hoyningen-Huene, another friend of the Fords, was instrumental in getting Ruth's first exposure in *Harper's Bazaar*, where Hoyningen-Huene was the chief photographer working under the direction of art editor Carmel Snow. Ruth wrote her mother in July 1935 that she'd had a drink with Hoyningen-Huene, who had promised her that he'd try to get a full-page photograph of her in *Harper's* and that he'd already mentioned Ford to Carmel Snow. (Ruth then had lunch with George Platt Lynes, Glenway Wescott, and Diana Vreeland, *Vogue's* editor.)[120] This plan was a success, as Hoyningen-Huene's photographs did in fact launch Ruth's career, as Charles references in a later letter to Ruth regarding his newest plan to introduce Ruth to Horst, the rising star of fashion photography in the mid-1930s.

In August 1935, Charles turned his attention from *Harper's Bazaar* to *Vogue*, and therefore from George Hoyningen-Huene to Horst, who had taken over as *Vogue's* chief Paris-based photographer when Hoyningen-Huene defected first to *Harper's,* and then to Hollywood. At the beginning of Charles's successful efforts to bring Ruth to Horst's attention, Charles directed her to telephone *Vogue* to find out when they were expecting Horst in New York City so that he could photograph her. "I'm writing him about you," Charles assured Ruth, "but he may not get the letter before you see him."[121] Two months later, Charles wrote Ruth with some urgency to let her know that Horst was still in Paris, about to sail for New York:

I'm having dinner with him tomorrow night with Pavlik, and we're going to tell him about you and see if he won't get you to pose in his photos for *Vogue*. He's going to stay in New York for some time and if you got in with him it would be a good chance for you. Will tell him how George Hoyningen-Huene (who is his friend and started him off in his career of photographer) discovered you last year and launched you in *Harper's Bazaar*, how Cecil [Beaton] is going to work with you this winter but he must do more than Cecil. That you want to make a career as mannequin, like many other young girls in New York, that he will find you charming.[122]

Charles's letters to her over the next few weeks keep her informed of how the plan is unfolding on his end, with specific suggestions on what she must do in New York. Charles explained to Ruth that he'd learned from Beaton that his own New York trip had been delayed by *Vogue* until after Christmas, which, Charles assures Ruth, "will be all the better for Horst and you—less of Mimsie Taylor in more of Ruthie Ford—the Paris *Vogue* is sick of Mimsie Taylor in every Beaton photograph anyway."[123] Charles directed Ruth to organize a cocktail party to welcome Horst to New York, complete with an invitational script: "And telephoning the guests say you are giving a cocktail for 'Horst, the Paris photographer for *Vogue* who has just arrived.' In introducing say Mr. Horst. He doesn't use any given name." Horst is German, Charles informed her, but "speaks English perfectly."[124] The following day, Charles wrote Ruth to let her know that he and Pavlik had had dinner with Horst in Paris the previous evening, and that he had further information for her. Horst was scheduled to sail on the SS *Île de France*, arriving in New York on October 15, 1935—the day after Charles's letter should reach Ruth. Charles let Ruth know that Horst

> will be at the Waldorf <u>where George Hoyningen-Huene is now</u>—did you know it? Of course add George to your cocktail list. I talked about you to Horst lots and so did P[avlik]. Horst asked for a letter of introduction to you and I gave him one with your telephone number on the envelope. He said he would certainly do some photography with you.... You must tell him how much you like his recent photographs ... He photographed Mary [Mimsie] Taylor while she was in Paris but he doesn't like her looks <u>at all</u>.... Don't forget to telephone Horst a couple of days after the *Isle* arrives—told him I'd written you about him. (By the way he is a good friend of Cole and Linda Porter—though he says Cole is a snob—he likes Linda better).[125]

Apparently Ruth followed Charles's suggestions, because she did develop a modeling connection to Horst, though she wasn't thrilled with it. As she wrote her mother about Horst in March 1937, during the height of the Depression, "Horst is here . . . I really can't bear him—his pretentiousness and sham refinement make me sick—but anyway he photographed me last Tuesday, with another girl—an ad for Marshall Field. However, I doubt if he was the cause of it and I pose for Steichen for *Vogue*, Monday. I don't know how that happened either—he has never photographed me."[126]

I go into this detail with Ruth and Charles Ford, Tchelitchew, Lynes, and Horst to show how queer kinship networks were instrumental in building the look and the connections that were so foundational to the production of glamour in the interwar fashion world. The modeling industry, like other industries, is built on connections and networks, and in a highly aestheticized field such as fashion, these connections are cultivated through sociality. In the interwar period, the aesthetic realm was one of the few fields in which gays, lesbians, and queer people could find some degree of tolerance for their sexuality and expression for their cultural sensibilities. In the interwar period, gay people became artists in part so that they could in fact be queer; it is for this reason, for example, that Glenway Wescott actually became a writer.[127] So in many ways it is not at all surprising that the interwar modeling industry and the glamour that it manufactured was, in part, a queer production.

WORLD WAR II brought an end to both Lynes's career as a fashion photographer, for all intents and purposes, and seemingly (for a time) to the queer hegemony in fashion photography. Although Lynes had moved to Hollywood to head up *Vogue*'s new studio there in 1946, by December 1947 he was complaining, "I find I'm rather bored a good deal of the time. There is not enough work and there is very little external stimulus. I have met very few people of interest to me."[128] Soon after, in May 1948, he left for New York with lover Randy Jack, a "beautiful 21-year-old" housemate whom Lynes came into "possession" of when Jack's lover Wil moved out of Lynes's home in a pique over Thanksgiving in 1947.[129] Despite some initial work for the fashion magazines in New York, by the 1950s much of Lynes's fashion work had dried up. His fashion work for *Vogue* in 1948, for example, appears conservative and uninspired in contrast to Penn's innovative fashion and society portraits, photographed in Penn's signature set of acutely angled, grey walls and rough concrete floor.[130] In a 1946 fashion photograph for *Glamour*, three junior models pose facing an angled wall, a backdrop that Penn was soon to make famous; perhaps,

FIG. 3.23 George Platt Lynes, *Three Models Sitting with Backs Turned. Glamour*, July 1, 1946, 52. George Platt Lynes / Glamour ©1946 Condé Nast.

like the models, Lynes felt himself turning his back on the industry (fig. 3.23). Lynes's finances were in shambles, to the point that in January 1952, the IRS, to cover back taxes, seized all of his personal property for auction, including his entire studio: lights, cameras, negatives, prints, and darkroom equipment; fortunately his brother Russell bought the lot and loaned it back to him.[131] At the same time, the postwar years became the era of an assertive heteronormative masculinity in fashion photography, exemplified by the public personae of

Richard Avedon and Irving Penn both of whom became public figures based, in part, on their relationships with glamorous female models (even though, in Avedon's case, his sexuality was hardly normative).[132] By the post-war years, then, Lynes's moment in fashion history had come to a close.

In the 1950s, however, Lynes continued to explore the "amorous regard" with the male nudes. It was around this time that Dr. Alfred Kinsey entered the Lynes circle; Kinsey first interviewed Monroe Wheeler as part of his collecting project regarding the sexual histories of painters and other artists.[133] Soon Glenway Wescott became fast friends with Kinsey, who was interested in homosexual writers' sexuality. Wescott arranged several sex parties for Kinsey to observe in New York, and Kinsey watched Lynes having sex in New York, writing Samuel Steward of Lynes, "I have never, in all the course of our studies in sexual conduct, seen anyone go about it more skillfully. He made love better than anyone I have ever witnessed!"[134] Members of the Lynes-Wheeler-Wescott erotic circle such as Monroe's former lover Bill (Christian) Miller, Lynes's current sexual partner Chuck Howard, Jack Fontaine, Michael Miksche, and Carl Malouf went to Bloomington to be filmed at the Kinsey Institute.[135] In 1952, Lynes became much closer to Samuel Steward, a former English prof and a tattoo artist who was also one of Kinsey's informers. They had a lot in common (both erotic risk takers, both collectors of sexual trophies), and became fast friends in these last years before Lynes's death in 1955. Both men contributed erotic materials to the Kinsey Institute, and together exchanged photographs, trophies, and sex partners.[136]

In the years when Lynes began spending more time photographing his erotic male circle, the Cold War hostility against homosexuality intensified.[137] In the context of midtwentieth-century homophobia and the criminalization of same-sex desire, Lynes could not take the risk of exhibiting his nudes, nor selling prints (despite his real financial need), nor even sending the images through the mail, all for well-founded fear of prosecution. In describing an April 1952 photo shoot with John Connelly (Wescott's lover) to Monroe Wheeler, for example, Lynes wrote that they had worked with a "bag of drag" (T-shirt, sailor whites, trunks, and sweater) rather than "go all out"; the photographs were "no crotch . . . simply so that I would be able to send you all that I took."[138]

The erotics of sexual attraction, of the "amorous regard," played a central role in Lynes's photographic work. In the context of midtwentieth-century homophobia and the criminalization of same-sex desire, Lynes could not take the risk of exhibiting his nudes, nor of selling prints for fear of prosecution. Many of Lynes's private intimacies, in other words, could not be risked being made

FIG. 3.24 George Hoyningen-Huene, portrait of Baron Adolph de Meyer. *Vanity Fair*, August 1, 1934, 53. George Hoyningen-Huene / Vanity Fair © 1934 Condé Nast.

public. Yet the production of heteronormative glamour required the creation of public intimacies through discourses of desire and technologies of allure. Lynes solved this representational dilemma through the queer production of modern glamour.

Lynes's photographic work exemplifies the queer context of interwar glamour in fashion photography and modeling. Photographers such as Cecil Beaton, George Hoyningen-Huene, Horst, and Lynes drew on the queer aesthetic foundations of Baron Adolph de Meyer, transforming his pictorialist vocabulary into a modernist aesthetic that coded a queer sensibility through props and accessories (fig. 3.24). This transatlantic queer kinship network included important cultural intermediaries in the interwar fashion industry, including models, art directors, and designers. During this interwar period, queer kinship and aesthetics provided the foundation for capitalism's glamour industries. By World War II, the glamorous models of the US fashion industry were part of an interconnected set of culture industries, including Hollywood and

mass circulation periodicals, that relied on circuits of commercial, sexual feeling to sell goods.

The interwar fashion world was intimate, transnational, elite, queer, and white. None of the fashion magazines for which any of these photographers worked would consider working with nonwhite models: the modeling industry was rigorously segregated, in both photographic and fashion work. From the perspective of racial justice, in other words, interwar fashion's queer glamour reproduced and naturalized whiteness, abetted by white models' race-evasive affective codes. In the immediate postwar years, however, with incomes rising among all Americans, black activists began to pressure white manufacturers to include black models in product advertising. Black models broke Madison Avenue's color line in the prosperous late 1940s and 1950s, and it is to this chapter of US modeling's history that we now turn.

p. 114 — good sentence

p. 104 — bottom of pg.

p. 107

161 — great summary

glamour discourse used to sell clothing

"Amorous regard" of George Platt Lynes — 132, 143

⊕ visual rhetoric of gay cruising culture

145 — good ex. of this

Cecil Beaton / Hoyningen-Heune

⌐ queer sensibility, camp (excessiveness) found its way, helped define, into fashion photography

151 — queer production of modern glamour

queer kinship networks drove the queer production of fashion photography — one detailed in pages before 158

(interwar) FASHION PHOTOGRAPHY WAS, IN LG. PART, A QUEER PRODUCTION

Black Models and the Invention of the US "Negro Market," 1945–1960

In 1963, a group of civil rights activists from the Congress of Racial Equality (CORE) set up seven television sets on a Harlem street corner. They tuned each television to one of New York's seven major New York stations and, every Saturday, CORE activists offered passersby a dollar for every black face they could spot on any of the seven stations, excluding athletes. After six weeks and hundreds of viewers, the activists were able to give away only fifteen dollars. This informal survey of racism in American media was the precursor to a more sustained effort by CORE's New York chapter to draw attention to the absence of African Americans from broadcast media in general, and advertisements in particular. Led by chapter president Clarence Funnyé, the activists launched its TV image campaign in 1963 as an effort to force Madison Avenue to change its representation of blacks in advertising, to create a more favorable depiction of black life in America through the inclusion of black models in integrated environments in nonstereotypical roles.[1]

As Jason Chambers has shown in his excellent history of Madison Avenue's color line, CORE's TV image campaign was part of a much larger wave of civil rights activism that focused on blacks and advertising in the early 1960s. CORE, the National Association of Colored People (NAACP), and the National Urban League joined forces to change the advertising industry by pressuring advertising agencies to not only hire more black professionals but also to integrate their

print and television advertising through casting black models. With the passage of federal, state, and city antidiscrimination laws, human rights commissions and equal opportunity committees, civil rights activists' campaigns had the additional leverage of antidiscrimination law. In New York City, where the vast majority of the nation's advertising industry was located, mayor Lindsay Wagner established the Mayor's Committee on Job Advancement. Organized in late 1962 in the wake of a yearlong study of four major magazines that found only two advertisements with black models, the committee's express aim was to "stimulate the use of integrated advertisements."[2]

Civil rights activists' focus on commercial culture was not a protest against commodification, as later 1960s militancy might suggest. Rather, activism in the earlier postwar years focused on black inclusion within mainstream commercial culture, and a shift in the visual rhetoric used to describe African Americans. Rather than a protest against commodification, some blacks in the immediate postwar years constructed themselves as a market that white advertisers could no longer afford to ignore. Visibility as a market emerged as a goal for not only black industry insiders but also for some civil rights leaders. In a fully commercialized culture, which the United States was in the wake of World War II, many blacks understood social and political equality in market terms. From the perspective of white middle-class college students protesting the "remote control economy" of 1962, with its "gluts of surplus commodities" and "market research" techniques to deliberately create "pseudo-needs in consumers," this commodification of everyday life was a distinct problem. From the perspective of some black Americans, however, only rarely the subject of market research before this period, and for whom the purchase of "surplus commodities" offered one of the few instances where market transactions were not always fully overdetermined by redlining and discrimination, access to this "remote control economy" meant equality.

Historians usually conceptualize the segmentation of the US consumer market in the immediate postwar era as a development instigated by mainstream merchandisers seeking new consumer markets. Though this is often the case for some demographics, such as the youth market, the opposite was the case for black consumers in the rising prosperity of the late 1940s and 1950s. As Brenna Greer has brilliantly shown, long before civil rights activists targeted Madison Avenue's color line in the early 1960s, black marketing professionals invented blacks *as a market* in order to become visible as a consumer demographic; this market visibility was imperative if blacks were to participate in the promises of what Charlie McGovern and Lizabeth Cohen have called consumer citizenship.[3] Precisely at the moment when blacks were fighting against segregation in

housing and education, market segregation—or segmentation—paradoxically proved an important route toward racial visibility and inclusion, key aspects of liberal civil rights politics.

Black models and modeling agencies played a central role in the creation of a "Negro market" in the period between 1945 and 1960. What was at stake for these agencies and for blacks more generally in the success of these companies? What were the racial and sexual politics of representation in this particular moment, a period of rising prosperity for all Americans, including blacks, but one that was also unfolding in the context of the long civil rights movement as well as the longer history of racist advertising? This chapter explores these questions through an analysis of two New York City postwar black modeling agencies, the Brandford Models agency and the Grace Del Marco Agency. These agencies, working mostly in the photographic model market, rather than in fashion modeling, redefined discourses of both bourgeois respectability and midcentury glamour to define a commercial space for the display of the black female body that sidestepped older stereotypes of the asexual mammy on the one hand, and the hypersexual jezebel on the other. Postwar black models and agents pursued their work in dialogue with three historical situations: the legacy of racist advertising imagery against which black modeling agencies sought to construct a progressive counterarchive; the birth of the "Negro market" in the immediate postwar years; and the unyielding whiteness of the contemporaneous fashion industry, which continued to bar almost all models of color throughout this period. In modifying the historical discourse of black female respectability through the visual signifiers of midcentury glamour, black models and agents built upon a longer history of black women's body activism in resisting and reframing the meanings of embodied race, gender, and sexuality.

Advertising's Minstrelsy Archive

The postwar black modeling agencies, seeking to cast black models for white-owned businesses marketing to black consumers, had their work cut out for them. The issue for blacks contemplating the brandscape of twentieth-century America was not simply the relative dearth of blacks as advertising models. There were black models in mainstream advertising before the postwar period, of course: it's just that these models were confined to scripted roles that reinscribed racial hierarchies. All postwar representations of African American men and women in advertising took place in dialogue with a longer history of racial stereotyping in American advertising, an archive of racial representations indebted to histories of slavery and white narratives of racial and regional

reconciliation premised on white supremacy. As Fath Davis Ruffins has shown, the history of commercial imagery depicting American ideas about race and racial hierarchy extends back to the colonial period, when colonial Virginians labeled their hogheads of tobacco with pictures of enslaved Africans to guarantee the product's authenticity as being from the New World.[4] By the early post–World War II period, this history of racism and representation had become condensed into a few recognizable stereotypes that had increasingly become the focus of civil rights politics. For African American men, the most persistent representations were those of the Pullman porter, cook, or waiter, sometimes called the "Uncle Tom" or "Uncle Mose" type; for African American women, the ubiquitous and only advertising model was that of the "Mammy," or "Aunt Jemima," who populated ads as cook, laundress, and housekeeper.[5]

The archive of racialized stereotypes in advertising illustration is exemplified by the work of model Maurice Hunter, who from the 1920s through World War II was the single most photographed black man in American advertising (fig. 4.1). Born in South Africa and adopted by American missionaries, Hunter emigrated to Brooklyn when he was about seven; when he realized his adopted parents planned to send him back to Africa as a missionary himself, he ran away and survived through a series of limited jobs open to black men in the World War I years: messenger, shoeshine man, window washer, elevator operator. In 1918, while working in a downtown Manhattan studio building, a young art student suggested he might try working as an artist's model, and introduced him to the well-known artist and commercial illustrator Dean Cornwell. Through these initial contacts, Hunter developed a career as an artist's and photographer's model that lasted until his death in 1966, at age eighty.[6] As an artist's model, he posed for well-known artists such as Robert Henri and Daniel Chester French, as well as for those commercial illustrators whose work dominated the covers and fiction of the era's major periodicals, such as Charles Dana Gibson and James Montgomery Flagg. Hunter was the model for numerous racist types in the pages of illustrated fiction in *Collier's*, *Redbook*, and other mass-circulation magazines. As Edgar T. Rouzeau wrote in an issue of the *Journal and Guide* in 1939, Hunter has posed as an "Arab, Indian Fighter, African tribal chief, or Zulu head hunter. . . . Although little known, he is the world's most photographed Negro."[7]

Most of Hunter's work, however, was in advertising illustration, where he was the ubiquitous model for nearly every stereotype of African American masculinity in interwar advertising. As a "Talk of the Town" reporter in the *New Yorker* wrote in 1935, "You can be pretty sure that any darky waiter you see in a cigarette or whiskey ad is Hunter, or any dusky pirate, sheik, Moor,

FIG. 4.1 Maurice Hunter, model, head-shot sheet, c. 1930. Maurice Hunter Scrapbooks, Folder 1, Photographs and Prints Division, Schomburg Center for Research in Black Culture, New York Public Library, Astor, Lenox and Tilden Foundations.

African, South Sea native, or Negro cotton-picker, convict, or crap-shooter you see in the magazine illustrations."[8] In the 1920s, Hunter was both of the two crapshooting "darkies" startled by a red-nosed Irish police office for a Fisk Tire ad (1927) and the obsequious porter carrying a white lady's luggage as she stepped off the train into her husband's arms in a 1925 ad for Palmolive soap (fig. 4.2). In this lush, full-color illustration, Hunter is literally marginal to the page and subordinated to the two white models, whose activities—especially those of the white woman—dominate the narrative. In the 1930s, Hunter's visage appeared in the pages of the *New Yorker* as a smiling waiter exclaiming "Yes, Suh, Boss, I's Got De Best!" while holding a tray of Laird's Apple Jack brandy. In a 1934 cover for the *Saturday Evening Post*, Hunter is the implacable porter carrying golf clubs and luggage for a suave and slender white blonde holding a bouquet of yellow flowers. As advertising shifted from pen-and-ink to photographic illustration in the interwar years, an increasing percentage of Hunter's bookings were for photographic advertising illustrations. As a 1947 article in *Ebony* began, "The next time you see a Negro's face on a cigarette or whiskey ad, the odds are 1000 to 1 that it will be Maurice Hunter."[9] He sold "beer, whisky, clothing, oil, gasoline, soft drinks, radio, and cigarettes," often (though not always) as a waiter.[10] He was the smiling waiter delivering cocktails for Four Roses and for Calvert's whiskies (figs. 4.3 and 4.4); a redcap enthusing over the 1940 Plymouth's "luxury ride"; the forty-foot face of a beaming station porter for the Pennsylvania Railroad's massive photomural of railroad employees in Grand Central Station; and finally, in a comparatively progressive representation, though by today's standards a stereotypical one, a bass player for Esso's "Swinging along with Power" campaign.[11]

Hunter considered himself a successful artist whose work in posing and expression allowed him to both pay the bills and express himself creatively.[12] "I just like to model," he told a reporter. "It makes me feel free and good."[12] According to both his own reports and those of the artists he posed for, his popularity as a model stemmed from his lean and muscled physique (he was five feet eleven and 165 pounds in the interwar years), his ability to hold a pose for lengthy sessions of up to several hours without moving, and his skill at becoming the "character" needed for the commercial illustrator for whom he was posing. Hunter prided himself on his ability to assume a variety of convincing emotional expressions in rapid succession, such as fear, mirth, pathos, guilt, and rage; this ability to pantomime emotional expression became the focus of a series of character studies he performed for the general public in sketches he called, variously, "African Pantomime," "Art Recitals," and "Silent Drama" (in which he mimed as music was played or sung).[13] His ability to assume the character,

The years have not robbed her of her beauty

Hers is the Natural Loveliness
that comes from protective care.
Millions are retaining the charm
of youth in this simple way.

The "middle-aged woman" is fast becoming a relic of other days.

Age no longer is the line of demarcation between days of charm and allure and the tasteless complacency of a chaperon's corner.

Women have learned to stay looking young . . . and "looking" young means *being* young.

A GIRL yesterday, a woman today . . . then suddenly, "middle-aged."

You want to avoid it. Every woman does. And you *can* if you wish. Note the scores of women young at 30, charming in the forties that you see everywhere today. That will prove the point to you.

To gain it . . . that priceless gift of youth . . . you must follow natural laws of cleanliness in skin care. Artificial methods have been supplanted in modern beauty culture.

Start with Palmolive, nature's formula to *keep* that schoolgirl complexion. Don't let it slip away from you. You can't regain youth, but you can *keep* it.

*DO THIS . . . then note the
changes in your skin*

Wash your face gently with soothing Palmolive. Then massage it softly into the skin. Rinse thoroughly. Then repeat both washing and rinsing. If your skin is inclined to be dry, apply a touch of good cold cream —that is all. Do this regularly, and particularly in the evening. Use powder and rouge if you wish. But never leave them on over night. They clog the pores, often enlarge them. Blackheads and disfigurements often follow. They must be washed away.

Avoid this mistake

Do not use ordinary soaps in the treatment given above. Do not think any green soap, or represented as of palm and olive oils, is the same as Palmolive.

It costs but 10c the cake!—so little that millions let it do for their bodies what it does for their faces. Obtain a cake today. Then note what an amazing difference one week makes.

MADE IN CANADA

*Palmolive Soap is untouched by human hands until
you break the wrapper—it is never sold unwrapped*

PALMOLIVE

FIG. 4.2 Maurice Hunter, model, in Palmolive soap ad. *Canadian Home Journal*, 1925. Courtesy of Duke University Ad Access.

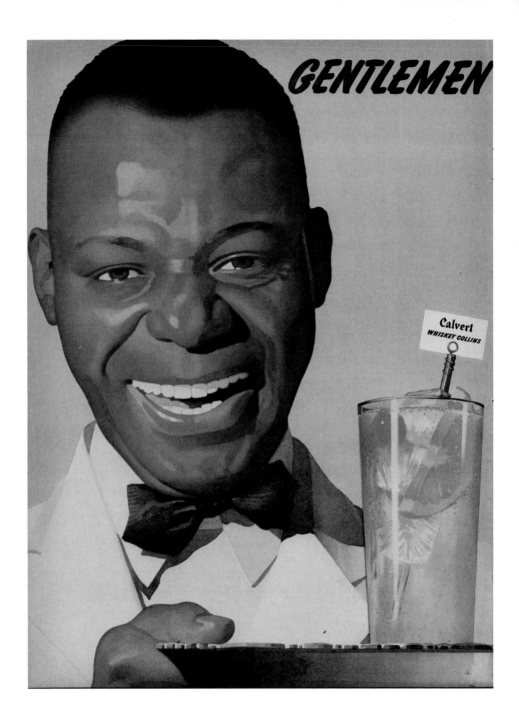

FIG. 4.3 AND FIG. 4.4 Calvert's Whiskey campaign featuring Maurice Hunter, September 1941. Maurice Hunter Scrapbooks, Folder 1, Photographs and Prints Division, Schomburg Center for Research in Black Culture, New York Public Library, Astor, Lenox and Tilden Foundations.

pose, and expression expected of him made him invaluable as a model for white commercial illustrators. The representation and commodification of emotion has been central to American advertising since the early twentieth century, and Hunter was especially adept at producing, instantaneously, the range of expressions required of him. As commercial illustrator Karl Godwin testified about his work, "Maurice Hunter has been working for me for 10 or 12 years and has great ability to get character in his work. He has always given me just what I wanted in the spirit and action of the pose which is wanted by the magazines in their pictures."[14] Hunter's market value stemmed from his ability to perform, convincingly, the emotional expressions that white audiences expected of black bodies. These emotional expressions provided the affective currency for racialized commercial feeling within midcentury advertising.

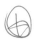

Hunter's expertise, in other words, was his versatile ability to pantomime white racist stereotypes of Africans and African Americans to an implied white audience. White illustrators seemed unaware, and certainly uncritical, of this restricted racial role playing, despite decades of protest by civil rights activists over racist representations in, for example, D. W. Griffith's *Birth of a Nation* or Quaker Oats' persistence in using a fictive Aunt Jemima to sell ready-made pancake mix.[15] Hunter, in turn, found nothing to criticize (in public, anyway) in his work or in the representations that he helped create. On the contrary, he felt that his work as an interpreter and communicator of human emotion constituted his contributions as an artist to the race. "If I can make people realize that my race is artistic," he told a reporter, "I'll feel that I've done a lot . . . if I can help [the artist] catch that emotional play and change which makes up the temperament of my people, I'll feel that I have done something for the artistic expression of the negro race."[16] He saw himself as an artist collaborating with other artists to express fundamental emotional truths about African American subjectivity.

Despite Hunter's creative intentions, his work nonetheless helped reinscribe the range of stereotypes that formed the visual archive of American advertising through the 1950s. His work performing the range of male stereotypes (craps shooter, waiter, porter, and eventually musician) was complemented by that of female models, whose representations of black femininity were similarly narrow in range. Regardless of the talents of those who posed for advertising illustrations, white advertisers and fiction illustrators cast black women nearly exclusively as variations of the mammy stereotype. The persistence of these casting requirements in midcentury advertising can be seen in the career of actress and chorale singer Virginia Girvin (1902–1975), who supplemented her stage work by modeling for advertising illustrations.

Girvin had an active career as a singer, actress, and print-ad model from the 1930s through the 1950s (fig. 4.5). She played a variety of roles in the interwar black theatre, including several Works Progress Administration productions such as an adaptation of Rudolph Fisher's *The Conjure Man Dies* and the "First Negro Dance Recital in America" for the New Negro Art Theatre (1931), for which she is listed as a singer.[17] She was also a member of the Hall Johnson and Juanita Hall Choirs. During the war, Girvin performed on tour with an integrated cast in a traveling USO troupe. After the war, she played the part of Ameena, wife of Joe Horn in an all-black production of *Rain* staged at the Apollo Theatre (1945). In the late 1940s and early 1950s, Girvin's work presented her to white mainstream theatregoers in a variety of parts. For example, Girvin played Gertrude, the "forthright Negro maid," in the traveling Shubert Theatre revival of *There Goes the Bride*, with Ilke Chase (daughter of *Vogue* editor Edna Chase) and Robert Alda as leads. Girvin was a lifetime member of the Negro Actors Guild, and became its vice president in 1970.

Girvin was also a community activist and member of the Southern Christian Leadership Conference (SCLC) and in the 1960s worked as a real estate agent for Donbar Enterprises-Sundale, a corporation that developed a number of integrated communities throughout the northeast in the 1960s. Between acting roles in the 1930s–1950s, Girvin supplemented her work as a model for print ads. Most likely referencing the racial stereotyping of this work, Girvin referred to it as "some very silly jobs in between theatre engagements."[18] Nonetheless, it paid the bills. In an ad for Goodrich that ran in *Time* magazine in 1941, a plump, smiling, and be-aproned Girvin stands behind an ironing board, holding an iron, while the white mistress of the house places a Goodrich ironing pad over the board. In an ad for Heisey tableware, a uniformed and smiling Girvin polishes crystal wine goblets while exclaiming to the white child looking on, "It's Heisey honey! And this has been a 'Heisey family' since I was as young as you!" Girvin's spectacles signify her advanced age; the mammy here is as loyal to her employer as the family has been to the brand. Her phrase "It's Heisey, honey!" suggests the longevity of Aunt Jemima's popular catchphrase, first popularized at the 1893 World's Fair in Chicago, "I'se in town, honey."[19] In a 1946 *Collier's* illustration, Girvin as faithful mammy holds a frightened white woman in a protective embrace (fig. 4.6).

As numerous scholars have shown, the "Mammy" figure appeared within nineteenth-century US culture as a white romanticization of slavery's sexual and racial violence.[20] In contrast to the "Jezebel" figure, whose lustful sexuality whites invented as the cause of white men's sexual violence across the color line, the mammy represented an ideal of how black women behaved when

ON TOUR WITH PLAY.—Virginia Girvin, veteran actress of New York, currently on an eight-week tour with the Gloria Swanson-Robert Alda starer, "There Goes the Bride," which closed a three-day run in Kansas City's Music Hall last week. Miss Girvin won considerable attention here for her performance in the role of a forthright maid.

FIG. 4.5 Portrait of actress and model Virginia Girvin, used to publicize her performance in the play *There Goes the Bride* in *The Call* (Kansas, Missouri), April 23, 1948. Virginia Girvin Collection, MG 639, Box 1, Folder 11, Manuscripts, Archives, and Rare Books Division, Schomburg Center for Research in Black Culture, New York Public Library, Astor, Lenox and Tilden Foundations.

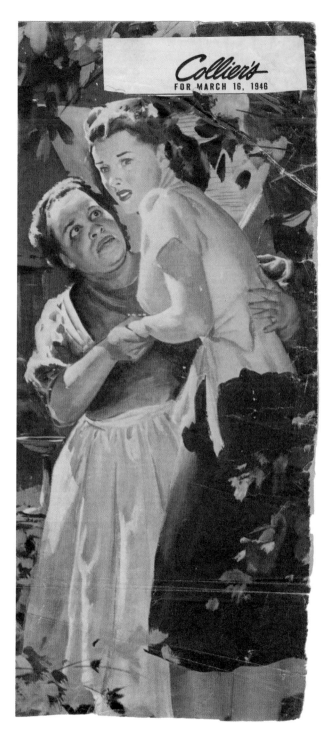

FIG. 4.6 Virginia Girvin, model, in an illustration for *Collier's*, March 16, 1941. Virginia Girvin Collection, Box 1, Folder 11, Manuscripts, Archives and Rare Books Division, Schomburg Center for Research in Black Culture, New York Public Library, Astor, Lenox and Tilden Foundations.

under proper white authority and control. The mammy was a strong, asexual figure whose unwavering devotion and loyalty to the white plantation family soothed white guilt over slavery and white rape of black women; the presence of the mammy uplifted white women by making it unnecessary for them to enter the kitchen, clean toilets, or perform other everyday domestic labor. The mammy was, in Deborah Gray White's view, the "personification of the ideal slave, and the ideal woman" for antebellum Southerners, a product of both the nineteenth-century cult of domesticity and white racism.[21] In the 1880s and 1890s, whites invented the slaveholding Old South as a romantic fable of racial reconstruction that allowed white Northerners and white Southerners to reconcile sectional differences through the segregation, disenfranchisement of, and violence against, actual blacks. The mammy was a key figure in this popular romanticization of the plantation South. Clearly, one of the most enduring representations of the mammy has been the invented spokesperson for boxed pancake mix, Aunt Jemima—first a secular slave song, then a minstrel figure from the 1870s, then a pancake mix trade name from 1889.[22] By the early twentieth century, as actual memories of the Old South dimmed, invented memories of loyal black house slaves preventing the "rape of the South" (meaning, Yankee domination of Southern ways of life) became more sharp: mammies proliferated on stage and screen to protect Southern virtue and feed pancakes to tired Confederate soldiers and (eventually) middle-American families. By the 1920s, the visual and verbal features of the mammy figure became codified through a national discourse of product advertising, as admen such as J. Walter Thompson's James Webb Young drew on the racial stereotypes of the Old South to provide the visual props that anchored white middle-class consumption. The mammy was always heavyset; almost always wore some aspect of clothing that signified domestic service or Southern origins, such as an apron, bandana, or head wrap; her features conformed to the two acceptable emotional expressions of happy or sassy; and when she spoke, it was almost always in dialect.

The mammy figure brought together histories of sexual violence, racism, and commercial feeling that obliquely referenced the long history of white men's sexual violence toward African American women. She emerged as a loving and asexual domestic caregiver to combat abolitionists' claims that the institution of slavery was rife with rape and sexual depravity; in response to these critiques, slavery's defenders legitimized relationships between white men and black women as maternal and affectionate, rather than violent or sexual. As Micki McElya has shown, the idealized mammy figure set the contours of the faithful slave narrative.[23] The mammy's feeling capacities as loving, forgiving, affection-

ate, and nurturing obscured both slavery's brutal economic history and its history of sexual violence. In the late nineteenth and twentieth centuries, the commercial marketplace appropriated the mammy—a sort of commodity fetish for white men's rape of black women—as an emblem of sentimental nostalgia to sell consumer products to white audiences. For models such as Virginia Girvin, posing as a product's mammy accessory provided one of the few positions available in a white-dominated and racist industry.

Blacks, who regularly read not only their own press but also major white magazines, were painfully aware of the minstrelsy stereotypes that dominated American advertising. When Paul K. Edwards, an economics professor at Fisk University, conducted his survey of Southern black urban consumers in the late 1920s, *The Southern Urban Negro as Consumer*, he asked respondents to comment on a series of J. Walter Thompson advertisements featuring Aunt Jemima. Respondents disapproved of the ad, citing their objections to the mammy figure in particular. One respondent, for example, commented that he disliked "pictures of Aunt Jemima with a towel around her head," while another remarked, "I am prejudiced intensely against any picture of former slave mammy."[24] The great majority of interview subjects saw the handkerchief as a symbol of subservience and ignorance; some were mystified at the mammy's resilience within popular culture, commenting, "Don't see why they keep such pictures before the public."[25] Importantly, many respondents commented on the disparity between the representation and what they saw as their own lived experience. One commented that the advertisement was "not lifelike," while another told Edwards that she didn't like "colored characters in advertisements" because they are "always shown as menials."[26]

The print illustration modeling performed by Maurice Hunter and Virginia Girvin in the interwar years constitutes an archive of racist feeling that shaped the dominant discourse of black modeling in the early postwar years. Of course, blacks had long constructed photographic counterarchives to combat the visual violence of racist representation, from public exhibitions (such as W. E. B. Du Bois's showing of black portraiture at the 1900 Paris Fair) to photojournalism within the pages of the black press to the ubiquitous framed family portraits within black homes.[27] But within mainstream, white-dominated commercial culture, the color line's visual iconography remained virtually unchanged between the dawn of Jim Crow in the 1880s and the end of World War II. To be black and a commercial model at the dawn of the postwar era meant to be (in representation) a mammy or an Uncle Tom—there were no alternatives in the white advertising pages.

The founding of the postwar black modeling agencies was directly related to an emerging visibility of the African American population as an untapped, national consumer market.[28] At the close of World War II, with some exceptions, the advertising industry was fundamentally a segregated one, with black newspapers carrying advertisements directed toward black consumers, and white periodicals carrying advertisements directed toward an implied white consumer. To the extent that advertising directors considered black consumers, they simply placed their usual copy in black periodicals with no change in visual or verbal appeal, and certainly no change in white model casting decisions. The emergence of black modeling agencies in the late 1940s signified a renewed wave of efforts by black market experts and civil rights groups both to render visible a black consuming public and to change how blacks were depicted in white advertising campaigns directed toward black consumers. Model agents' efforts to land jobs for black models were successful in direct proportion to the African-American market's visibility to national, white-owned businesses and their advertising agencies.

As W. E. B. Du Bois argued in 1909, the problem of the twentieth century was the problem of the color line.[29] Black activists and their white supporters devoted much of the first two-thirds of the twentieth century to challenging, or ameliorating, the worst effects of segregation and Jim Crow rule, legalized through the Supreme Court's decision *Plessy v. Ferguson* (1896). In the South, African Americans emigrated first to Southern cities, in some cases, and then north to urban centers such as Baltimore, New York, Detroit, and Chicago to escape racial violence and find better-paying work; once north, they founded key civil rights organizations, such as the National Association for the Advancement of Colored People (founded 1909) and the Urban League (founded 1911).[30] What historians call the "Great Migration," the time when blacks moved north to take up better-paid, manual work made newly available through the war's impact on immigration, resulted in the urbanization of the African American population: between 1900 and 1940, an estimated 1.7 million blacks moved to Northern or Western cities. Once in these cities, white racism led to segregated housing markets and the formation of black metropoles. Although, as Robert Weems, Jr., Jason Chambers, Susannah Walker, and Brenna Greer have shown, the interwar years saw the founding of black merchants' associations and even the beginning of market research into the African American consumer market (conducted by black professionals), the vast majority of white corporations ignored the massive

demographic transformation in the wake of World War I, as well as its implicit market opportunities.[31]

World War II accelerated the demographic changes set in motion after World War I, while civil rights activism by A. Philip Randolph, Bayard Rustin, and others forced Roosevelt to ban racial discrimination in government war contracts—the first federal law banning racial bias in the United States. As many African Americans had moved to northern, midwestern and far-western cities to take up well-paying, often skilled jobs in the defense industries, the passage of the Fair Employment Act (a.k.a. Executive Order 8022) helped raise the overall standard of living among the US black population. These two changes—the rise of a black, urban population and the increase in their disposable income—led to a renewed focus on the "Negro market" in the immediate postwar years. As the pioneer market researcher David J. Sullivan argued in 1945, "It is the general opinion of advertisers and marketers that a majority of Negroes live on the other side of the railroad tracks, or resemble something closely akin to a sharecropper."[32] In making the case that there is, in fact, "such as thing as a Negro market," Sullivan showed that the gross annual income among the US black population more than doubled between 1940 and 1943, jumping from 4.67 million to 10.29 million. "Here then is a market bigger in size than the entire Dominion of Canada by approximately 10 per cent, and with over $1,250 million more in income in 1943," he concluded—a claim that soon found its way into Edward Brandford's public pronouncements concerning Brandford Models.[33]

Tracking the size and purchasing power of the postwar African American market was an essential survival strategy for black newspapers and periodicals, which needed reliable data to convince white businesses to advertise in these media outlets. As a result, the period saw a series of research studies into this market, usually either commissioned or produced by black newspaper and magazine publishers. Although this work built upon important precedents in the interwar years, such as Edwards's study on Southern urban blacks' consumer habits, these later studies don't reference the pre–World War II research, as limited as it was.[34] The results of these later studies were reported on heavily in the black press, however, with less attention paid in the white press until the early 1960s, when articles on the "ethnic market" and the "Negro market" appeared with increasingly regularity in the business trade press.[35] One of the early studies into the Northern, urban "Negro market" was conducted by Edgar A. Steele of the Research Company of America, and commissioned by the Afro-American chain of newspapers in cooperation with the Urban League. Steele was commissioned to conduct the study of more than three

thousand black homes in Washington, Baltimore, and Philadelphia in order to provide "much more complete and dependable facts than had previously been collected and analyzed." The study, conducted in 1945 and published in 1947, summarized findings concerning income and educational attainment but focused more specifically on consumer brand choice. The study demonstrated which brands had leading market shares in which cities in a variety of categories, including packaged coffee, flour, pancake mix (where 70.6 of all pancake mix purchasers preferred Aunt Jemima), laundry soap, toothpaste, alcoholic beverages, cola, cigarettes, and cars, among other products. Steele concluded, "The Negro is very brand conscious." "More importantly," Steele argued, "he is unusually 'brand loyal.' Sales executives should take note."[36]

Studies such as Steele's report from 1947 were picked up and extended by later academic researchers, such as Marcus Alexis's "Pathways to the Negro Market" in 1959.[37] In general terms, these research endeavors produced a consistent narrative that emphasized the relative growth of black income after the war; the growing urbanization of the black population, which increased the number of blacks who could be reached by mass media; the numerical size of this market (as large as Canada at first, and by the late 1950s, as large as the United States' total export market, some studies claimed); the tendency among African Americans to spend a larger percentage of their income on consumer goods than whites in the same income bracket; this group's especially high degree of brand loyalty; and African American women's important role in making purchasing decisions for white households, as so many black women were employed as domestics.[38] The studies addressed as well the two main reasons cited by white advertisers for not marketing directly to the black community: the assumption that African Americans lacked the necessary purchasing power to make investment in the market worthwhile, and the fear that catering to blacks would alienate white consumers and adversely affect sales, especially in national marketing campaigns.[39] As Robert E. Weems, Jr., has pointed out, one manifestation of corporate America's interest in African American consumers was the first appearance of the term "Negro market" in volume 19 of the *Readers Guide to Periodical Literature*, covering April 1953 to February 1955.[40]

The relationship between the so-called Negro market and a high level of brand loyalty emerged as an important aspect of this collective portrait. Market researchers, both black and white, agreed that blacks' consumer goods purchasing power exceeded expectations based on income because discrimination hampered where blacks could spend their money. As one article from 1952 argued, "Negroes are denied many recreations in parts of the country that whites take for granted . . . access to theatres, restaurants, nightclubs, beaches,

travel facilities vacation resorts and the like."[41] Even in the North and the West, where discrimination was less pronounced, market analyzers argued that blacks had more money to spend on nonrecreational items. "The Negro, therefore," this article continued, drawing on the contemporary rhetoric of poor black self-esteem, "will spend much more money in order to help overcome his insecurity neurosis."[42] Furthermore, market analysts agreed that African Americans were more loyal to brands than were other consumers. As Susan Strasser has shown, the history of the brand is inseparable from manufacturers' effort to guarantee quality goods. In the case of African Americans, who had a long history of being shortchanged by white merchants or having to choose among inferior goods, brands guaranteed not only quality but also equality in the marketplace. As John H. Johnson argued in a 1949 *Ebony* article "Why Negroes Buy Cadillacs," the ability of African Americans to buy luxury cars signified not simply wealth and standing but, just as importantly, "an indication of ability to compete successfully with whites, to maintain the very highest standard of living in this nation"—despite Jim Crow.[43]

The entry of John H. Johnson into the postwar publishing and advertising world radically altered the relationship between white businesses and the "Negro market." As Jason Chambers has argued, "Johnson's importance in generating corporate interest in black consumers can scarcely be overestimated."[44] Already a successful publisher of *Negro Digest*, a *Reader's Digest*–like magazine that focused on African Americans, Johnson launched *Ebony* in November 1945 as a middle-class magazine for blacks, modeled on *Life*, which eschewed the political focus of most black newspapers in favor of the "happier side of Negro life." Like *Life*, each monthly issue was heavily illustrated with narrative photographs that described articles concerning, for example, personalities, fashions, theatre, politics, books, and music. Most covers featured well-known female personalities or models presented in the visual discourse of the postwar pinup or glamour girl: the cover of the issue from August 1946 featured Lena Horne, while the cover from February 1949 featured a smiling female model in ski attire accompanying the story lead "Skiing: New Favorite as Negro Winter Sport" (fig. 4.7).

Ebony was an instant success. Circulation numbers reached over 200,000 in a few weeks, bringing a new challenge for Johnson: how to secure additional advertising revenue to meet rising production costs. Johnson did what he could to avoid filling his pages with the ads for patent medicines, psychics, and other gimmicks that had both supported struggling black newspapers and alienated potential white advertisers, though in the lean years of 1945–47 he made some compromises, such as an ad for "Smiley," the "happy ash receiver"—a black

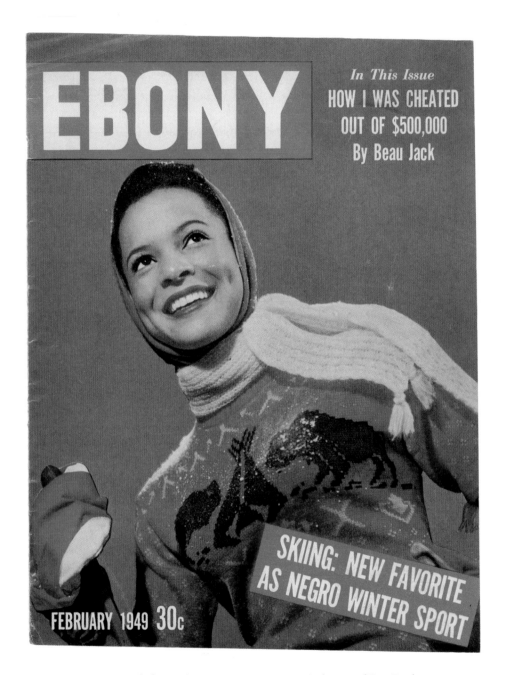

FIG. 4.7 Cover of *Ebony*, February 1949. Manuscripts, Archives, and Rare Books Division, Schomburg Center for Research in Black Culture, New York Public Library, Astor, Lenox and Tilden Foundations.

figurine with a wide open mouth designed to "receive your ashes and butts." In 1946 Johnson succeeded in getting Chesterfield and Kotex to place the first full-page color ads ever to appear in a black magazine. Most ad agencies, however, refused to place ads in a black periodical, citing client resistance; as a result, in 1947 Johnson bypassed the agencies and went directly to their clients. This strategy bore spectacular results when Zenith Radio's commander Eugene McDonald not only agreed to an advertising schedule in *Ebony* but also agreed to assist Johnson in securing advertising commitments from other white-owned businesses, such as a 1953 ad for Calvert whiskey featuring unidentified male Brandford models.[45]

By the early 1950s, with advertising revenues securely in place, Johnson became the premier interpreter of the "Negro market" for white advertising and marketing directors. He developed his own research arm at Johnson Publications to survey the size, income level, and brand preferences among blacks in major urban centers, and developed strategies for communicating this market research data to both advertising executives and manufacturers' salesmen. For example, beginning in 1953, Johnson produced *Ebony and Jet Magazines Present the Urban Negro Market for Liquors, Wines, and Beers*—a serial study that began by presenting brand preference among black consumers in fourteen northern urban markets using survey data from 350 retail outlets, and by 1957 had expanded to 674 retail outlets in twelve major metro markets. (Not coincidentally, these studies showed that Calvert's was one of the two best-selling whiskey brands in 1953). Picking up on the work David J. Sullivan, Johnson wrote articles in the advertising trade press featuring marketing advice regarding black consumers. Johnson even produced films concerning the so-called Negro market, such as *There's Gold in Your Backyard* and *The Secret of Selling the Negro*, designed for marketing professionals.[46] His reports and ceaseless marketing efforts succeeded in convincing white-owned businesses that blacks were an important market for high-end goods, and that this market could be best reached through the Johnson publications of *Ebony*, *Jet*, and *Negro Digest*.[47]

The success of Johnson's publications as well as that of his competitors, such as New York–based monthly *Our World*, created the postwar market for black models. As researchers constructed and sold the "Negro market," they underscored the relationship between winning black consumer loyalty and the presence of black models within the advertisements themselves. In his 1932 study on black consumers, Paul K. Edwards had focused on advertising models and the question of race. Edwards showed his black respondents two identical Rinso laundry ads, with the difference that in advertisement "A" two white

women discussed the product, and that advertisement "B" was integrated, with both a white and a black woman discussing Rinso's virtues. Edwards concluded that in Nashville, 80 percent of respondents preferred the ad with the African American model, while in Richmond, 57 percent did.[48] Retail liquor proprietors, managers, clerks and bartenders interviewed by staff field representatives of the Johnson Publishing Company in 1953, for example, asked respondents if they thought the advertisers should be using black models in the ads.[49] These studies, among others, emphasized the central role that race played in building brand loyalty among black consumers.

The Founding of Black Modeling Agencies, 1946–1960

When black marketing professionals and media buyers sought to package and sell the "Negro market" in the mid-1940s, racial stereotypes emerged as a specific list of what advertisers needed to avoid when approaching black consumers. In a 1943 article in *Sales Management,* marketing pioneer David J. Sullivan outlined the racist advertising and marketing practices that continued to demean and belittle blacks. His list of marketing "don'ts" includes several of the racist tropes that shaped Hunter's and Girvin's work in this period: "Don't picture colored women as buxom, broad-faced, grinning mammies and Aunt Jemimas," he admonished his readers. "Avoid incorrect English usage, grammar, and dialect" such as "'Yas, suh,' 'sho,' 'dese,' and 'dem.'"[50] Sullivan recommended that advertisers avoid the "Uncle Mose" stereotype, the Southern counterpart to Aunt Jemima, whose northern migration had resulted in the innumerable waiters and porters for which Maurice Hunter was Madison Avenue's most popular model.[51]

The first black modeling agencies were founded in the immediate postwar years as a means of providing black models for advertisers seeking to reach the "Negro market" through less overtly racist sales appeals. Although the small literature on the growth of black modeling in the civil rights era emphasizes fashion modeling, the initial destination for these black models was not in fact the fashion industry, where the color barrier seemed insurmountable in 1945, but print advertising.[52] In the context of a booming postwar economy and increased discretionary spending in the growing black middle class, black entrepreneurs were optimistic that white businesses would need black models to win brand loyalty among black consumers for household consumer products. In the context of a Jim Crow modeling industry, where the dominant modeling agencies barred blacks from bookings, a duplicate black modeling

industry emerged to provide models for duplicate advertising directed at black consumers.

Although numerous black modeling agencies were founded in the late 1940s and 1950s, the two most nationally visible agencies were both founded in New York, the center of the nation's advertising industry, in 1946.[53] The Brandford Models agency (after 1954, Barbara Watson Models) was founded by three partners: commercial artist Edward Brandford, stylist Mary Louise Yabro (the only white member of the business), and Barbara M. Watson, a Columbia University graduate who had worked in radio broadcasting for the Office of War Information during the war (fig. 4.8). Born in Jamaica, Brandford was educated at Cooper Union Art School in New York, where he graduated in 1930. He opened a successful commercial art studio at 55 West 42nd Street and became one of the very few blacks working in marketing in any sort of professional capacity; *Advertising Age* mentions Brandford as the nation's "foremost Negro commercial artist."[54] In 1948, two years after the modeling agency opened, Brandford founded his own advertising agency, Brandford Advertising, and specialized in providing a "unique" service to "manufacturers who realize the importance of this $16,000,000,000 Negro market." The new agency was the first black advertising agency that included merchandising, public relations, artwork, production, and model services.[55] In a very highly segregated business and city, Brandford was one of the few black professionals whose commercial expertise promised access to the big money of postwar consumption: white-owned businesses and advertising campaigns.[56] Mary Louise Yabro brought her experience as a stylist at the Arnold Constable and Company department store to the new business; her later position as fashion editor for the black middle-class New York–based magazine *Our World* helped ensure a venue for Brandford Models.[57]

Barbara Watson, the third founder, basically ran the business after 1949, as Ed Brandford played less and less of a role; by 1954, Watson had renamed the company Barbara Watson Models and established new offices at 505 Fifth Avenue, at 42nd Street.[58] Watson was the daughter of judge James S. Watson, a West Indian immigrant and New York's first black municipal court judge. During the war she worked for the United Seaman's Service and also did broadcasting in French and English for the Office of War Information. Using her experience at OWI, Watson launched her own radio dramatic program on WNYC designed to promote improved race relations called *I'm Your Next Door Neighbor*.[59] Watson continued to direct the agency until 1956, when she closed both the modeling agency and its affiliated modeling school on 35th Street and Park

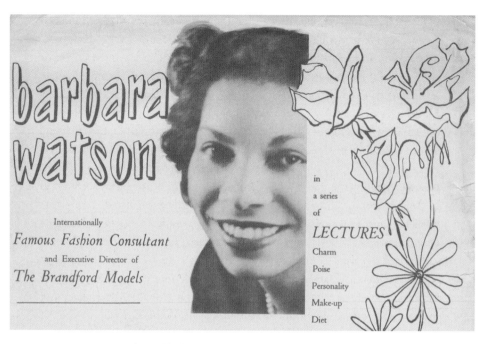

FIG. 4.8 Portrait of Brandford Models director Barbara Watson, taken from a promotional flyer, ca. 1950. Barbara Watson Papers, MG 421, Box 9, Folder 4, Manuscripts, Archives, and Rare Books Division, Schomburg Center for Research in Black Culture, New York Public Library, Astor, Lenox and Tilden Foundations.

Avenue. In 1962, Watson graduated third in her class at New York University's law school; she eventually became the first African American assistant secretary of State, serving in the Johnson, Nixon, Ford, and Carter administrations, and also served as US ambassador to Malaysia in 1980–81.[60]

The other main agency to attract national coverage in the late 1940s and early 1950s was the Grace Del Marco Modeling Agency, also founded in New York in 1946. This agency, eventually headed by Ophelia DeVore when her partners pulled out due to the new industry's erratic cash flow, distinguished itself from the Brandford Models by focusing on the fashion industry. The mixed-race DeVore, passing for white, attended the *Vogue* school of modeling in New York in the late 1930s and landed some jobs as a "northern European" model. In 1946, tired of advertising stereotypes depicting African Americans "hanging from a tree or scrubbing floors," she started Grace Del Marco Modeling Agency to sell "the idea of Black models to the advertising industry."[61] She saw her models as the products she was selling to advertisers; to "develop the product, and then create a market for it," she founded a modeling school (Devore School

of Charm), became a fashion columnist for the *Pittsburgh Courier*, produced fashion shows, and eventually expanded into public relations (she developed a promotional campaign for Nigeria, for example, in 1969).[62]

Agency founders for both Brandford and Grace Del Marco emphasized the centrality of the growing black consumer market to the founding of the new agencies, as well as the central role of nonstereotypical black models in reaching African American consumers. Their initial efforts focused on convincing advertisers to use black models in sales campaigns directed at retail consumers of household goods, not the apparel industry. When asked by *Labor Vanguard* magazine why he had opened his agency, Brandford declared, "Negroes in America represent buying power equal or greater to that of the people of Canada. Until fairly recently, this market has been pretty much neglected or entirely ignored by the manufacturers of nationally known products."[63] Mary Louise Yabro told the *Afro-American* newspaper that the idea of starting a "colored agency" was sparked when three hundred advertisers at a May 1945 Chicago meeting told her that they would be willing to "do something about the colored market" if they had "colored models" to work with. The main purpose of Brandford Models, Yabro told the interviewer, "is the strong drive to aid advertisers who wish to get the colored market to use colored models in a glorious, dignified, human fashion . . . we will not release an 'Aunt Jemima' or 'Uncle Tom' type because we believe this is not a true picture of the colored people."[64]

While Brandford Models continued to specialize in commercial modeling, Ophelia DeVore began a long-term, mostly unsuccessful effort to crack the color line in the apparel industry, both wholesale and retail. Black marketers realized early on that the fashion industry would be much more difficult to integrate than print advertising. One of the main excuses that white industry executives gave for excluding blacks from both fashion and photographic modeling was a concern that a black model would somehow contaminate the market for the white consuming public, a familiar argument that nonetheless lacked evidence. A wholesale merchandiser working with Mary Louise Yabro, for example, balked at using a black model to photograph his tennis suits. Although as a Jew he told Yabro he knew all about discrimination, and agreed it existed in the industry, his hands were tied: "What will Bergdorf Goodman say! What will they think if a Negro wears a suit I sell to Bergdorf's?"[65] Although this was the same anxiety that faced black publishers in getting white businesses to advertise in black periodicals, "Negro market" researchers such as David Sullivan, and later Jack Johnson, were eventually able to convince white-owned businesses to address black consumers. The fashion industry,

however, had no equivalent advocates for black clothing consumers. The Seventh Avenue fashion industry remained a widely recognized holdout against black modeling through the 1940s and 1950s. As Ophelia DeVore told the *New York Post* in 1955, "The Negro model is still not accepted by the business world. This is especially true in the wholesale clothing field. Designers don't use Negro models at their showings, for example."[66] Dolores Jackson, a black model, also singled out the apparel industry. Although she was able to get work in photographic ads and in fashion shows, she couldn't get jobs on Seventh Avenue (the wholesale district) nor in department stores: she was always, she said, too skinny or too fat. "But actually," she told the reporter, "I am sure it's because we are colored."[67]

Despite the widespread recognition that fashion would not provide many employment opportunities for newly minted black models in the early postwar years, however, the fashion show played a central symbolic role in announcing a new chapter in race progress. When Brandford Models opened as an agency, it was launched to advertisers and the press via a fashion show at New York's elegant Hotel Astor in Times Square, with actor and civil rights activist Canada Lee as the master of ceremonies. At this initial launch, the models were students, artists, and dancers for Katherine Dunham's company who had taken classes with Yabro and Watson on deportment, posture, clothes, and grooming. As Yabro recalled, "We got an immediate response. The majority of calls were not about models at first. But the advertisers saw the value of going after the African American market, and they called to ask 'how can we get to this market to sell our products?' We started to tell them not only to use Negro models, but also to change the tone of their ads" from emphasizing a Negro laundress, for example, to using a "very attractive Negro matron as a model" washing clothes for her own family.[68]

The fashion show was a familiar spectacle by 1946 to both black and white audiences, with varied meanings resulting from the history of racist representations of American beauty. Racially segregated, all-white fashion shows were the descendants of *haute couture* mannequin parades, which were popularized in the United States in the years just before World War I through department store spectacles, as discussed in chapter 1. In African American communities, although fashion shows were used as sales vehicles as well, their more important function was as a form of black body politics, one that emphasized black beauty and sartorial elegance to black audiences in the context of white racism. Historically, black fashion shows were upper-class events, often serving a charity function, that along with sorority events and debutante balls helped shape a black politics of respectability that tied elegance, comportment, and class to

race progress.[69] By launching the Brandford Models agency as a fashion show at the elite Astor Hotel, the principals tied disparate historical meanings to a new, postwar formula that effectively linked black bourgeois respectability to the politics of the market.

Whiteness and Postwar Fashion Modeling

The Brandford and Grace Del Marco agencies had more success placing their models in the field of photographic modeling than fashion modeling, due to the mainstream fashion industry's unrelenting racism. In the 1940s and 1950s, the whitestream modeling agency was undergoing some significant changes of its own. These changes unfolded as New York emerged as the global fashion capital in the wake of World War II and included the dominance of an upstart modeling agency, a new way of organizing model payments, and the emergence of a new generation of fashion photographers mentored by the recent émigré talent at the major fashion magazines. In the 1950s and early 1960s, African American fashion models began to make inroads in high-end fashion model-ing, but only through work in Europe or with European designers based in New York. The work of fashion models such as Dorothea Towles and Beverly Valdes paved the way for some of the more momentous industry changes in the late 1960s and 1970s.

After the war, the white New York modeling industry, the center of the US fash-ion world, thrived in a network of bookers, models, agency offices, photography studios, and models' rooming houses throughout midtown Manhattan. Yet the older industry stalwarts, the trio of John Powers, Harry Conover, and Walter Thornton, were losing their touch. At John Powers's office on 47th Street in New York City, models waited on couches while banks of phones rang, picked up by bookers whose job it was to place Powers's several hundred models with photographers, department stores, and other clients throughout the city. Natálie Nickerson—the tall, white, gangly "It" model of 1946, who began working with a young Richard Avedon that fall—was one of them. Although she was making forty dollars an hour, the highest-paid model in the industry, Powers couldn't remember her name: his secretary had to lean down, close to Powers's ear, and whisper it to him when they met. To make matters worse, Powers owed Nickerson thousands of dollars.[70]

The clients had paid Powers directly, but Powers had not paid Nickerson. It was at this moment, meeting with an aging Powers, clearly out of touch with his own models, that—according to Eileen Ford's biographer—Nickerson began to think about a new business approach for the modeling industry. Nickerson

began billing photographers and clients directly for her work, then sending a 10 percent commission to Powers: rather than Nickerson working for the John Robert Powers Agency, Powers would be working for her. The postwar couture model and agency director Dorian Leigh, model Suzy Parker's sister, remembers this history differently: in her narrative, the voucher system was her idea, which she shared with agency competitor Huntington Hartford, who put the idea into practice.[71] This new voucher system inverted the industry, transforming models from poorly and intermittently paid occasional workers who did their own hair and makeup to what US fashion became in the second half of the century: a highly structured industry with models at the recognized center, with some guarantee of payment regardless of unexpected rain in the Bahamas during a beachwear fashion shoot, department stores' delay in paying agency invoices, or photographers arriving late to their studios while the models waited, impatiently, outside.

Nickerson's off-and-on roommate at the Barbizon Hotel for Women was stylist Eileen Ford, who had first hired Nickerson when Ford worked as a booker for the Arnold Constable catalogue in 1945 (where Mary Louise Yabro also worked, before leaving to cofound Brandford Models). Ford had already grilled model Dorian Leigh about Leigh's short-lived New York model agency, which Leigh had started on a shoestring after becoming frustrated with Harry Conover's inefficient business operations.[72] Late at night, with the twenty-four-year-old Eileen sleeping on a camp cot in Nickerson's room, they developed a plan. Eileen would work as a secretary for Nickerson and another model on a monthly salary of thirty-five dollars, booking clients and looking after models, while Nickerson talked up the arrangement with other models, who eventually left Conover, Powers, and Thornton to work with Eileen Ford and her husband Jerry. Within a year, the business made seven thousand dollars. Eileen drew from her prior experience as a booker and a stylist to develop her eye for the ineffable something that distinguished one white, quirky, ugly-beautiful face from another. Jerry ran the business side, introducing new client fees to protect models' time, including cancellation fees, and payment for models' time preparing for the shoot in fitting rooms and with stylists, including hair and makeup specialists. By 1950, Ford Models emerged as the dominant modeling agency in the United States, and in the world, representing the white brand names of postwar high fashion glamour: Carmen Dell'Orefice, Dovima (Dorothy Margaret Virginia Juba), Dorian Leigh, and her sister Suzy Parker.[73]

Ford Models began at an auspicious moment in US history. The United States' entry into World War II after the bombing of Pearl Harbor pulled the nation out of its lingering Depression, as the government poured millions into

defense contracts, which, in turn, brought good jobs and higher wages for many Americans. By the early 1950s, the United States was at the beginning of a major consumer boom that would last through the energy crisis of 1973.[74] In advertising, the period between 1945 and 1965 is now known as the "creative revolution," in which, as Thomas Frank has shown, advertising agencies such as Ogilvy, Benson & Mather developed the visual strategies undergirding the hip consumerism of this *Mad Men* era, with "hard-goods girls" playing a key role in selling these new consumer items.[75] In fashion, the industry's center of gravity began to shift from Paris to New York, partially due to the war, but also because of the work of fashion industry publicist Eleanor Lambert. With a background in advertising and in publicizing the work of American artists at the Whitney Museum of Art and elsewhere, Lambert turned her considerable skills to the fashion industry during the war years. In 1940, she established the "International Best-Dressed List" and in 1943 organized what she called a "Press Week" in New York, in which she invited women's newspaper section editors from all across the country to come to New York to see the work of fifty-three American designers, whose work Lambert organized in a series of runway shows at Manhattan's Plaza hotel.[76] This event was the origin of Fashion Week, which soon succeeded in reorienting the US market away from Paris and toward domestic designers. In 1948, Lambert organized the first gala for the Metropolitan Museum of Art's Costume Institute, a yearly party that remains one of the most important events in the fashion industry, and in 1962 Lambert founded the Council of Fashion Designers of America.[77] In the late 1940s, at the same time that Eileen Ford's agency took off, Lambert promoted designers such as Claire McCardell, Clare Potter, and Vera Maxwell, who excelled at taking high-end Paris fashion—such as Dior's "New Look" of 1947—and translating couture into mass-market and casual clothing that middle-class Americans would actually wear.[78] Some of this translation bordered on piracy, as US manufacturers illegally copied French haute couture designs, despite the elaborate efforts of Dior and other members of the French Chambre Syndicale to prevent design thievery.[79] As a result of this combination of factors, by the end of the 1940s, New York had become a major fashion center in its own right, building a major demand for white fashion models. These models, in concert with bookers, agents, art directors, and photographers, produced and naturalized whiteness as the industry's racial norm.

While Lambert and a generation of US designers reoriented American buyers to the domestic market, the major fashion magazines underwent profound changes. Just as Dior had introduced the New Look in fashion, the magazines, photographers, and models introduced a new look in the industry's visual

culture. In 1932, fashion editor Carmel Snow had left *Vogue* and joined *Harper's Bazaar*; she made émigré Alexey Brodovich her art director, and the magazine soon surpassed *Vogue* in style and class, with work by Henri Cartier-Bresson, Man Ray, Martin Munkácsi, Toni Frissell, and others. European émigré Alexander Liberman, a former editor of the influential French magazine *Vu*, joined US *Vogue* in 1941 as its art director.[80] The postwar era's most prominent photographers, Richard Avedon and Irving Penn, were both nurtured by Brodovich at *Harper's Bazaar*: Brodovich hired Avedon as a staff photographer in 1944, and Irving Penn took courses with Brodovich while a student at the Philadelphia Museum School of Industrial Art (now the University of the Arts). In 1943, Alexander Liberman, *Vogue*'s new art director, hired Penn as his assistant; his first cover for *Vogue* appeared on the October 1, 1943, issue.[81]

Avedon and Penn transformed fashion photography in the postwar years, bringing both a new aesthetic sensibility and a publicly visible, white heteronormative masculinity to the field. Fashion photography's whiteness was safeguarded by the art directors: for example, when Alexey Brodovich reviewed Gordon Park's fashion portfolio in 1944, Brodovich explained that he couldn't work with Parks. "I must be frank with you," he told Parks. "This is a Hearst organization. We can't hire Negroes. I'm embarrassed and terribly sorry, but that's the way it is."[82] During the same years, fashion photography's queer talent went underground only to return to fashion photography in the 1970s. Avedon, whose work I discuss in more detail in the following chapter, developed a signature visual style: he photographed favorite models against a plain backdrop while stage directing the physical and psychological dynamic between himself and the model. Penn brought his art training to his fashion work, photographing models and commodities with a quiet, distanced stillness that dissolved boundaries between the organic and the inorganic. Avedon became so well known as a figure in fashion and popular culture in the 1950s that the 1957 film *Funny Face*, starring Fred Astaire and Audrey Hepburn, was based loosely on his life and career; he served as a visual consultant, and two Avedon models—Dovima and Suzy Parker—appeared as themselves in the film.[83] *Funny Face* and Avedon's marriages provided a heteronormative public persona, shielding Avedon from public scrutiny regarding his nonnormative sexuality. Penn, for his part, married one of the most successful models of the midtwentieth century, the Swedish sculptor Lisa Fonssagrives, whom he met in 1947 while shooting a group portrait of the *Vogue*'s most-photographed models over the prior ten years (fig. 4.9).[84] In this often-reproduced image, Fonssagrives—in pearls, white gloves, and evening wear—perches on a café chair to the right of the stepladder, in what *Life* described as a "posed, detached, almost

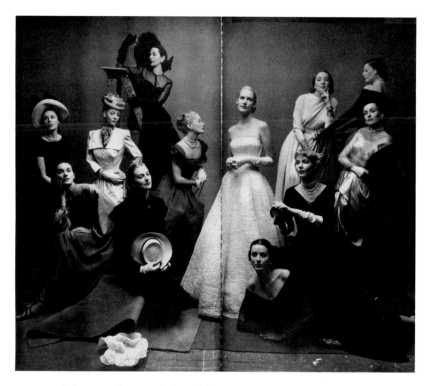

FIG. 4.9 "The Most Photographed Models in America," 1947. Models: *seated, from left to right,* Marilyn Ambrose, Dana Jenney; *standing, from left to right,* Meg Mundy, Helen Bennett, Lisa Fonssagrives; *in background,* Betty McLauchlen; *in foreground,* Dorian Leigh; *seated,* Andrea Johnson; *standing, from left to right,* Lily Carlson, Elizabeth Gibbons, Kay Hernan; *in background,* Muriel Maxwell. *Vogue,* May 1, 1947.

bored" attitude.[85] According to a *Time* cover story about her that same year, as the highest-paid and highest-praised model of all time, Fonssagrives was an "illusion that can sell evening gowns, nylons, and refrigerators. She can sell motorcars, bank loans, and worthy causes. She can sell diesel engines, grapefruits, and trips to foreign lands." She is a "billion-dollar baby with a billion-dollar smile and a billion-dollar salesbook in her billion-dollar hand. She is the new goddess of plenty."[86] And her 1950 storybook marriage to her photographer, *Vogue*'s Irving Penn, helped secure the fashion and modeling industries' ties to heterosexuality in the postwar public imagination. During a period of increasing conservatism concerning sex and gender, Avedon and Penn successfully regendered fashion photography in the postwar years, turning the profession into a perceived site of white, virile, heterosexual masculinity while pushing the profession's queer history further underground.[87]

In 1953, Eleanor Lambert of the New York Dress Institute spoke at the fourth annual meeting of the National Association of Fashion and Accessory Designers, a black fashion industry organization. In addition to telling her mostly black audience that there was a "growing awareness of the importance of the Negro market," she assured her listeners that there was a "complete absence of racial prejudice in the fashion field."[88] Nothing could have been further from the truth. The developments in the postwar white fashion industry with which Lambert was familiar were, for the most part, a world away from black modeling in the same period. Postwar models who posed for US fashion designers and for major brand product advertisements came from diverse backgrounds, but they had one thing in common: they were, almost to a person, white. In the period before the late 1960s, black models seeking a career in high-end fashion modeling went to Paris, not New York.

The first African American model to succeed as a high-end couture model was the light-skinned, platinum blonde Dorothea Towles, who had attended modeling school in Los Angeles in the 1940s, and began her couture career with Christian Dior in 1949. Towles was born in 1922 in Texarkana, Texas, to a farming family, but moved to Los Angeles to live with her well-off uncle when in her twenties. Dorothea's uncle, Dr. Henry H. Towles, was a founding member and stockholder of the Golden State Mutual Life Insurance Company, while her sister Lucy Towles was a concert pianist and a member of the music faculties of Fisk and Tennessee State Universities.[89] Towles graduated from UCLA and began working as a teacher, then married her first husband, dentist Dr. Nathaniel Fearonce. In 1949, while on a two-month vacation in Paris, where her sister Lois was touring with the Fisk University choir, Towles decided to try modeling, and was hired by Christian Dior to replace a vacationing employee.[90] When she didn't return home at the end of her vacation, her husband sued for divorce. She became the first African American model to work for Christian Dior, Pierre Balmain (where, according to the *New York Amsterdam News*, she was his "number one model"), and other designers, including Robert Piguet, Jacques Fath, and Elsa Schiaparelli.[91] Reporter Floyd Snelson described Towles as five feet seven and 119 pounds, with a tiny waist of twenty-two inches. Her skin, Snelson reported, was "butter milk colored," and her signature platinum blonde hair had replaced the dark brown hair of her childhood while she was modeling for Balmain in 1949 (fig. 4.10).[92] By the early 1950s, Towles was back in the States, presenting haute couture to black audiences in society and sorority events such as Los Angeles' "Parisian Fantasy," a ticketed society gala with a Champs-Elysées set, where Towles modeled her thirty-thousand-dollar wardrobe designed by Dior, Fath, Balmain, and others;

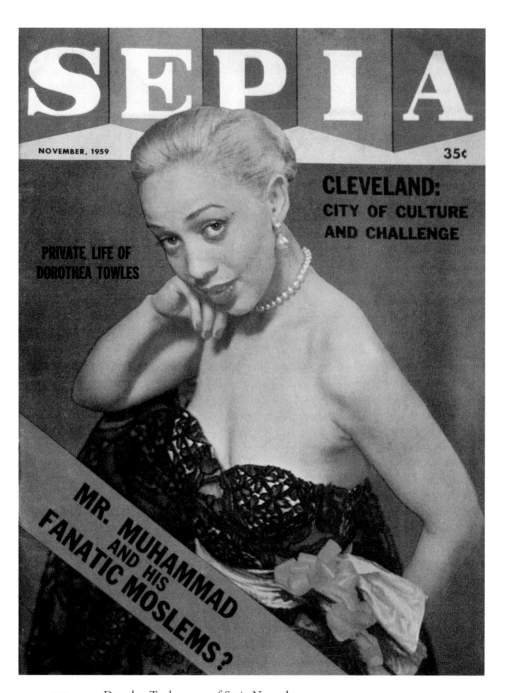

FIG. 4.10 Dorothea Towles, cover of *Sepia*, November 1959.

Josephine Baker, whom she likely knew from her work with Balmain in Paris, presented Towles with a bouquet.[93] In 1963, Towles married New York attorney Thomas A. Church, the nephew of civil rights activist Mary Church Terrell, and a graduate of Howard and Georgetown Universities; based in New York, she opened the Dorothea Towles Charm and Modeling school and signed with the Grace Del Marco modeling agency.[94] Over the course of the 1960s, Towles's politics moved further to the left: she went from insisting that race was irrelevant to talent, and that "race or color in fact are irritating to me" in 1952 to staging a graduation show in 1964, "Fashions for Freedom," in which her students designed and wore period costumes depicting black heroes such as Sojourner Truth, Madame C. J. Walker, Josephine Baker, and even Daisy Bates, a civil rights activist who played a leading role in integrating Little Rock (Arkansas) High School in 1957.[95] Towles has been widely acknowledged, then and now, as breaking the color line in couture modeling, an accomplishment possible only in Europe during this period.

Towles's success in Paris paved the way for other models to launch careers in Europe as a staging ground for work in the United States. For three years, between 1959 and 1961, black models registered with the Grace Del Marco Agency won the heavily publicized beauty pageant associated with the Cannes Film Festival: Cecilia Cooper (1959); LeJeune Hundley (1960); and Emily Yancy (1961).[96] As Malia McAndrew has argued, Del Marco agency owner Ophelia DeVore used the international stage to showcase black model beauty to the world, strategically placing her models in European venues to build their careers.[97] Grace Del Marco model Helen Williams, the most famous black fashion model of the late 1950s and early 1960s (and the mother of Vanessa Williams, the first black winner of the Miss America title in 1984) was initially blocked from white agencies and publications in the United States, but DeVore was successful in landing her a photo shoot with Dior in 1959; Williams was offered a modeling position with the French couturier Jean Dessès in 1960.[98] Back in New York in the early 1960s, Williams was eventually successful in winning several contracts as a photographic model for Budweiser and Modess, in ads printed in mainstream publications, including *Life* and *Redbook*, but fashion modeling for high-end, white designers remained off-limits. Just as in the wake of World War I, it was in France where black Americans, including fashion models, found a welcome reception in the postwar years.[99]

Finally, in 1961, a New York fashion world French-born designer working in New York, Pauline Trigère, hired the first African American as a model in a Seventh Avenue showroom, the Grace Del Marco model Beverly Valdes (fig. 4.11). Although Valdes made her 1961 debut as a Trigère house model

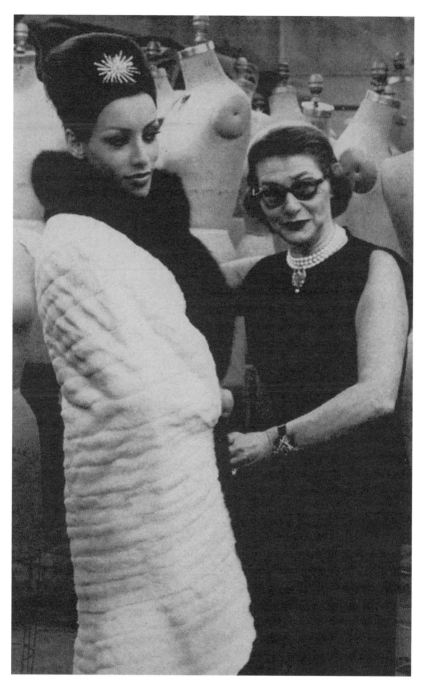

FIG. 4.11 Model Beverly Valdes and designer Pauline Trigère try an ermine cape with sable collar. *Life*, June 29, 1962. Courtesy of the *Life* Magazine Collection, Ryerson Image Centre, Gift of Peter Elendt, 2011.

during the New York Couture Group's fall showings, where she was presented to press editors from all over the world, she had previously appeared modeling a Trigère design in a *Look* magazine fashion spread in 1958.[100] The white-owned modeling agencies began integrating very slowly in the early 1960s: Gillis MacGill, owner of the Mannequin agency, added Mozella Roberts in 1961, and Ford Models signed Liz Campbell, Gordon Parks's first wife, in 1963.[101] By the time Richard Avedon featured black model Donyale Luna in his April 1965 guest-edited edition of *Harper's Bazaar*—a development I discuss in more detail in the following chapter—black fashion models had been working with French couturiers for over fifteen years, but were still barred, for the most part, from the white-owned New York modeling agencies.[102] With the exception of Roberts and Campbell, no black models were signed to white agencies as fashion models until 1967, when another European working in New York, agent Wilhelmina Cooper, reluctantly signed Naomi Sims. With the growth of the "Negro market," however, product advertising offered a possible route to both building a black modeling industry and desegregating the advertising page.

Race, Sexuality, and the Body Politics of Black Models

In the sector of the modeling industry focused on photographic, rather than fashion, modeling, efforts by black publishers, marketing experts, and modeling agency personnel had succeeded in changing the advertising landscape of black periodicals by the mid-1950s—especially the weekly magazines, whose advertising revenues surpassed those of the older newspapers. Readers of *Ebony*, *Jet*, and *Our World* found large, often full-page advertisements featuring black models enjoying a range of consumer products in advertisements whose visual rhetoric represented a marked departure from mammy and Uncle Tom stereotypes. Most, though not all, advertisements were for personal care products (hair, cream, sanitary napkins, toothpastes, and deodorants), tobacco, and alcohol. Brandford model Dorothy McDavid relished a smoke for Lucky Strike (fig. 4.12), while two other Brandford Girls, as they were known, discussed the merits of Lysol for "intimate use" (fig. 4.13).

As black models made their way into advertising campaigns directed at black consumers, the rhetoric used by "Negro market" entrepreneurs to describe the cultural work of black models shifted accordingly. Rather than emphasizing the history of racist stereotypes while arguing for the importance of an invisible "Negro market," those involved in the new black modeling agencies elaborated on a preexisting discourse of black femininity that combined a sanitized glamour with wholesome sexuality that, while appealing, lacked the aggressive

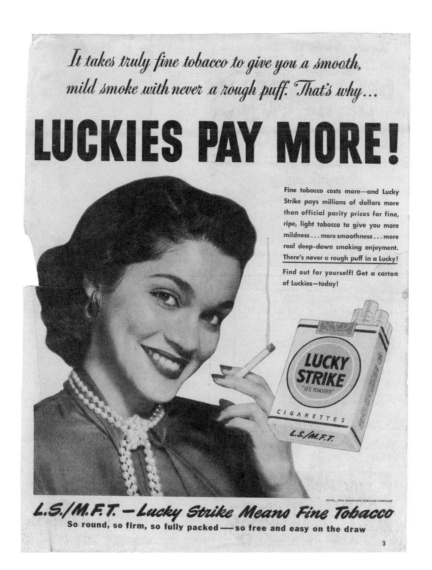

FIG. 4.12 Dorothy McDavid, model, in advertisement for Lucky Strike, c. 1952. Barbara M. Watson Papers, MG 421, Box 9, Folder 4, Schomburg Center for Research in Black Culture, New York Public Library, Astor, Lenox and Tilden Foundations.

overtones of the interwar vamp. The wholesome appeal of the glamorous black model drew on the interwar efforts to sanitize the model's public image, as discussed in prior chapters, as well as the transformation of the pinup model after World War II from an assertive, sexually aware woman to a more passive ingénue. Both developments involved parasexuality—the containment of female

FIG. 4.13 Brandford Girls, as they were known, discuss the merits of Lysol for "intimate use." *Ebony,* December 1953. Barbara Watson Papers, Schomburg, Box 9, Folder 5 (1953), Manuscripts, Archives, and Rare Books Division, Schomburg Center for Research in Black Culture, New York Public Library, Astor, Lenox and Tilden Foundations.

Important News for Married Women...

New "Lysol"
Thoroughly Effective

for intimate use...
YET NEEDS NO POISON LABEL!

IMPROVED FOR GREATER DAINTINESS. Now, as the result of many years' work by "Lysol" scientists, this leading disinfectant has been dramatically improved in two ways. New "Lysol" has *no poison label.* And "Lysol" has a light, clean odor . . . but don't let that fool you! "Lysol" has the very same cleansing efficiency women have trusted for years. Yes, in every way new "Lysol" is a modern formula—better than ever for feminine daintiness.

CLEANSE AND DEODORIZE—SAFELY! Used in a cleansing douche, new "Lysol" kills germ life quickly, *on contact,* even in the presence of mucous

matter. Yet it will not harm delicate tissues, when used according to directions for feminine hygiene.

PROTECTS EFFECTIVELY! New, improved "Lysol" is the reliable, pleasant, modern way to help protect yourself against unpleasant odor, and the risk of offense. No other liquid germicide today offers you this intimate protection more effectively, more safely. Used in a cleansing douche, it promotes complete internal cleanliness . . . helps keep you dainty, confident, sure of your charm.

Today . . . Get New-Formula

"Lysol"
Brand Disinfectant

Product of Lehn & Fink

Free! **EXPERT UP-TO-DATE ADVICE ON FEMININE HYGIENE!**
Harriet Dean
Lehn & Fink Products Corp.
Dept. E-5312. Bloomfield, N. J.
Please send me, in plain envelope, a FREE copy of booklet, prepared in collaboration with a leading gynecologist, entitled "Don't Depend on Hearsay."

*Name*_____
*Street*_____
*City*_____ *State*_____

51

sexuality—in this case through the discourse of the natural girl. In the early to mid-1950s, the African American modeling industry positioned itself as offering a black equivalent of this sanitized and commodified version of female sexuality, which had become so central to the marketing of goods within white-dominated advertising agencies and campaigns. In doing so, marketers drew on shifting ideas of postwar gender and sexuality as a whole in order to commodify black female sexuality for the purpose of creating consumer desire, while at the same time sidestepping the other stereotypical pole of black female representation: the jezebel. The market emerged, in other words, as a route toward inclusion in the American dream through consumer citizenship while also performing hegemonic labor toward twin contradictory projects: elaborating a counterarchive of nonracist commercial representations while, at the same time, reinscribing the color, class, and gender hierarchies of the black bourgeoisie.

In 1946, when the Brandford and Grace Del Marco agencies opened, product models and their agents—in both segregated markets—remained reliant on a public discourse that emphasized models' normative, middle-class femininity. Magazines regularly featured stories that demonstrated marketers' understanding of female consumers' identification with advertising models. Magazine stories on well-known white models routinely distanced their subjects from any suggestions of moral impropriety, emphasizing instead "beauty and breeding" safely contained within the familiar roles of wife and mother. A 1944 article feature in *Life* titled "Model Mothers," for example, pointed out that half of all models were married, and half again were mothers; reigning model broker John Robert Powers, the article states, believed that "being a mother usually improves a girl's disposition."[103] A 1947 *Life* article explicating the "myths" and "realities" of the model's life disputed, as did Powers in his work, the model's public image as a "luscious creature" with "low morals and not very much in the way of a brain"; instead, the article detailed how the era's well-known white models had smarts, Ivy League educations, and business acumen.[104] "Indeed," the article concluded, "the only characteristic left to bear out the popular notion of models is that they are beautiful."[105] The rhetoric of beauty and allure, reworked in the 1930s as a version of glamour, were still central to the model's public image, and to the sale of goods she facilitated, but Powers and his popularizers successfully contained any potential threat from the model's public performance of sexual appeal through a discourse of domesticity and middle-class propriety.[106]

This sanitization of the model's sexuality was part of a larger transformation within American popular culture in early postwar America. As Maria Elena

Buszek has shown, during World War II mainstream pinup iconography was emblematized by Alberto Vargas's work for *Esquire*, illustrations depicting models as "sexualized yet pointedly active women usurping and clothed in the accoutrements of male power, learning drills and semaphore."[107] As the war ended, and soldiers returned from overseas, white middle-class women were, in Elaine Tyler May's terms, "homeward bound"; conservative gender roles became the norm, and popular culture's representation of an idealized femininity shifted from an assertive, if not aggressive, sexuality of the prewar years to a contained, domesticated sexuality.[108] At *Esquire*, the Varga Girl was replaced in the postwar period by new illustrations that, in Buszek's words, "eschewed the working woman and sexual dynamo for the bobby-soxer and cuddly coed."[109] By the late 1940s, white models were represented as beautiful, to be sure, but their glamour was also safely contained within the familiar, and unthreatening, roles of wife and mother. This shift from vampish chorus girl of the 1920s to the natural, well-posed coed of the late 1940s was a public relations triumph for Powers and later the Fords, the midcentury modeling agents who dominated an industry that has always been haunted by accusations of moral and sexual improprieties.

In the context of African American modeling, the rebranding of the model from vamp to collegiate or mother illuminated a path between the twin abysses of the mammy's asexuality and the jezebel's promiscuity. Within the black modeling industry, a discourse of glamorous African American womanhood as an exemplar of race pride replaced the early postwar year's emphasis on the "Negro market." Models pioneered a new manifestation of black women's political engagement that reinterpreted an older body politics based on corporeal and sartorial respectability to instead incorporate glamour, sexuality, style, and race pride. As Brenna Greer has argued, the sexualized image of black women became central to black consumer campaigns in the postwar period, especially in the context of John H. Johnson's publication empire, which included *Ebony*, *Hue*, and *Jet*.[110] The discourse of African American beauty, elaborated most fully in beauty contests but also closely tied to the emergence of the black modeling industry, was central to a liberal civil rights discourse that linked racial uplift to both the accomplishments of the "Talented Tenth" and the commodification of sexuality. The black beauty contests of the late nineteenth through mid-twentieth centuries were one of several methods through which the black middle class constructed and displayed racial pride during an era when de facto and de jure segregation was the norm.[111] By the postwar era, these beauty contests, working in dialogue with an overlapping history of black beauty culturists, had elaborated a rhetoric of race progress and middle-class propriety to

define new meanings for the public display of, and sanctioned looking at, black female bodies.[112] Black marketing entrepreneurs inserted the "Negro model" into this cultural space, thereby explicitly tying the display of the female form to the market of goods—but through a discourse of glamorous black femininity.

The black models featured in product advertising directed toward the emerging "Negro market" exemplified a specific class and gender-inflected ideal with long roots in African American discourses of respectability. Evelyn Brooks Higginbotham has shown how black Baptist church women in the early twentieth century, working to oppose white supremacist social structures and symbolic representations, elaborated what she has called a "politics of respectability" to shepherd blacks toward middle-class, assimilationist ideals concerning the body and its comportment.[113] The politics of respectability emphasized "manners and morals," while at the same time asserting traditional forms of protest such as boycotts, petitions, and verbal appeals to justice.[114] In the same period, discourses of respectability and racial uplift were tied to ideals of exemplary beauty, as images of black women designed to "Exalt Negro Womanhood" became regular features in African American publications such as the *Messenger*, *Crisis*, and *Opportunity*.[115] By the post–World War II period, the visual signifiers of this middle-class politics of respectability were readable both at sites of African American commercial culture, such as beauty contests and salons, and also on the female body itself, signified through deportment, skin color, clothing, and (straightened) hair. As Danielle L. McGuire has shown, the politics of respectability is part of a larger history of black women's body politics, as black women's sexuality became a critical battleground in the long civil rights movement, with whites using rape and threats of rape to ensure white supremacy.[116] By the mid-1950s, in the wake of the *Brown v. Board of Education* decision, the body politics of black respectability became a key strategy in the civil rights boycotts and sit-ins. Leaders of the major civil rights organizations emphasized the importance of dressing neatly in cardigan sweaters, skirts and dresses, nylon stockings, pearls, and modest pumps, with one's hair freshly pressed, in order to combat white racist stereotypes of blacks as wanton, promiscuous, and unkempt.[117]

The advertising and marketing work featuring black model Sara Lou Harris exemplifies how postwar African American models helped construct a discourse of glamorous beauty that drew on, while updating, and older class-inflected politics of black respectability. Harris, along with Sylvia Fitt Jones, was the period's most famous black photographic model; in 1954, unlike most of the underpaid and underemployed black models in the fledgling industry, both Harris and Jones earned the going rates of ten to twenty-five dollars per

hour and had their pick of assignments.[118] In an advertisement for Remington adding machines in 1952, Harris appears as a clerk leaving her desk at the end of the workday (fig. 4.14). Dressed for departure in a well-fitted outdoor coat with a tasteful scarf tucked around her neck, she smiles at the camera while pulling on a pair of fitted ladies' gloves. The understated makeup, clothing and accessories, light skin, straightened hair, and elegant deportment signify the discourse of middle-class respectability that had long eluded the representation of black women in whitestream American media.

In contrast to this carefully crafted image of the black model's respectability, in 1951 *Ebony*'s cover featured a buxom vixen clothed only in a leopard-skin bikini to accompany the featured story "Is It True What They Say About Models?" (fig. 4.15).[119] The article opened with the stereotypes of the model's reputation as "a loose, reckless party-girl" only to argue, as did *Life* in the 1940s in their stories on white models, that the new black models were college-educated career girls with husbands and children. The article introduces nationally famous black model Sara Lou Harris as a wife and mother: "Most of us are family girls who are simply doing a job," she says. "We are seeking a decent life and some security . . . we have ideals too."[120] These protestations worked to contain the otherwise explosive sexuality of Harris as a glamorous beauty, a necessary element to her marketability, and one that was featured in other coverage, such as her pinup profile on the cover of *Jet* magazine as the "glamour queen of the disc jockeys" (fig. 4.16).[121] Postwar models such as Sara Lou Harris brilliantly brought sexuality and desire to bear on the body politics of respectability, without tipping the balance toward the racist images of black women as wanton and promiscuous, stereotypes referenced by *Ebony*'s 1951 cover.

THE DEPLOYMENT OF a sanitized version of female sexuality had long marked the history of American capitalism, where in advertising, the comely charms of Kodak and Coca-Cola girls had beguiled consumers since the late nineteenth century. Yet racism within main vehicles of distribution and consumption in American capitalism—marketing and advertising—had also produced what might be called a parasexuality color line: only white women had been cast as sanitized sirens in mainstream advertising's pageant of consumer cornucopia.[122] Sexual capital's racial history meant that black women faced different challenges when deploying the commercial discourse of glamour within postwar commercial culture. Whitestream advertisers such as Fisk Tires, Laird's brandy, and Heisey crystal ware typecast interwar black models such as Maurice Hunter and

FIG. 4.14 Sara Lou Harris, model for Remington Rand. *Ebony* 1952. Barbara Watson Papers, Schomburg, Box 9, Folder 5. Manuscripts, Archives, and Rare Books Division, Schomburg Center for Research in Black Culture, New York Public Library, Astor, Lenox and Tilden Foundations.

Virginia Girvin in racist stereotypes of Uncle Tom and the mammy, enlivened by the segregation and racial apartheid of Jim Crow America. These models' ability to produce and communicate emotional expressions that conformed to white expectations of black subordination linked commercial feeling to a history of racism, both inside and outside the modeling and marketing industries.

FIG. 4.15 The cover of *Ebony*, November 1951.

FIG. 4.16 Model Sara Lou Harris featured on the cover of *Jet* magazine, June 18, 1953. Manuscripts, Archives, and Rare Books Division, Schomburg Center for Research in Black Culture, New York Public Library, Astor, Lenox and Tilden Foundations.

The postwar recognition of the "Negro market" for white-dominated industries, and the marketing strategies that ensued, joined for the first time the visual representation of black models with the commercial, managed sexuality that had long been the signal elements of modernity's imbrication of the market and gender. With the visibility of blacks as an economically attractive demographic, African Americans began to win recognition and inclusion into mainstream American life through their role as consumers. The advent of the black modeling agencies in the 1940s, and the duplicate marketing strategies of which they were part, marked a liberal, assimilationist breakthrough in the longer politics of race and representation. For the first time, both black men and women were depicted in national advertising campaigns in the visual vocabulary of black middle-class respectability: as career women, for example, or as whiskey-sipping (rather than whiskey-serving) men at leisure—rather than, solely, as mammies or Uncle Toms. Blacks used the market as a means to rewrite the visual rhetoric of black bodies in commercial representation: from the hyper- or hyposexualized discourses of jezebels and bucks, or mammy and toms, to the middle ground of commodified sexuality—the parasexuality of commercial discourse.

Black models continued to navigate middle-class suspicion that their work, as Marion Burton of Detroit complained, "is equivalent to that of being a prostitute."[123] In responding to Burton's stinging critique, Dorothea Towles complained that she was "sick of the misunderstandings and abuses of the modeling profession."[124] Black models such as Towles, Sylvia Fitt Jones, and Sara Lou Harris worked with black modeling agents Ophelia DeVore, Barbara Watson, and others to distance the modeling profession from what Towles characterized as "those who flaunt sex until it's nauseating."[125] Throughout these years, black models queered the fashion industry as well, strategically winning triumphs at Cannes and on Seventh Avenue, thereby underscoring the absurd race-evasive protestations of industry insiders such as Eleanor Lambert. Black models' body politics drew on a midcentury version of glamour— the sanitized version that had emerged by the end of the 1930s—to join black female sexuality in the commercial sphere with the racial progress rhetoric of black respectability politics. At the same time, however, marketers codified the color, gender, and class hierarchies of the black bourgeoisie.

This rapprochement between the marketing, fashion, and modeling industries and the black middle class was not without its critics, however. Even while black businessmen were succeeding in establishing duplicate advertising campaigns suffused with a renewed politics of black respectability, the sociologist E. Franklin Frazier was writing what emerged as a devastating critique of the

→ duplicate advertising campaign

complacency of what he termed the "black bourgeoisie." Published in Paris in 1955 as *Bourgeoisie Noire* (and translated in 1957 as *Black Bourgeoisie*), Frazier critiqued college educated, middle-class blacks—and the black business class in particular—for abandoning social justice for conspicuous consumption. In Frazier's view, the postwar shift in the black press to celebrate black "achievements," as in the pages of *Ebony*, insulated the black leadership class from the real problems facing all black Americans, creating a world of "make believe" that compensated for blacks' inferiority complex without changing it.[126] While the book was immediately controversial within the black community, Frazier's critique found a sympathetic audience with many student activists, including one of Frazier's undergraduates at Howard University, a young Stokely Carmichael. As president of the Student Non-Violent Coordinating Committee, it was Carmichael who would work with this important civil rights group founded by Ella Baker away from King's liberal integrationist politics toward the radicalism of the black power movement, with its critique of both racism and capitalism.

created a new target audience

176 - the mammy stereotype

postwar - realization of untapped, national consumer market

Ebony - 1945

Great Migration urban black migrat.

[Fair Employ. Act - 179 & more disposable income]

John H. Johnson Ebony - 1945 Jet, Negro Digest

Maurice Hunter - 166 emblematic of most famous stereotyped roles in media for blacks
→ very emotive - 172
→ ability to pantomime white racist stereotypes

Uncle Tom issue

Virginia Girvin — mammy stereotype between Jim Crow in the 1880s (177) + WWII white mainst. commercial culture

NYC - 1946 black models agencies.
— Brandford Model Agency
— Grace Del Marco Agency

success. careers in Europe as step (196) prep for entry into U.S.

(198) (202 - GOOD SUMM. SENT.)

"You've Got to Be Real"

CONSTRUCTING FEMININITY

IN THE LONG 1970S

As the 1960s dawned, the cool glamour of well-known 1950s haute couture models such as Dovima, Lisa Fonssagrives, and Dorian Leigh gave way to an emerging, market-savvy youth culture that eschewed the salon and celebrated the street. Fashion shows became transformed as a new generation of designers, catering to an emerging youth culture, upended the elite calm of the couture salon in favor of loud music, blazingly quick tempos, and energetic, irreverent models. "Chelsea Girl" Mary Quant overturned couture conventions through a panicked, inspired moment at the old-fashioned Palace Hotel in St. Moritz in the late 1950s, where she was showing her shockingly short flannel tunics, colored stockings, and knee-high boots as part of a British-sponsored fashion promotion. As she quickly realized while watching the other designers unpack, her anticouture clothing would disappear amid the grandness of the British ball gowns. The only possible way to make a statement, Quant understood, "was to break the tempo of the whole evening with one great burst of jazz and let the girl come in at terrific speed in the zany, crazy way in which my clothes should be shown."[1] Model Bronwen Pugh opened the show by kicking up one leg at the top of the staircase and running down the stairs "in a sort of Charleston manner."[2] The orchestra caught the mood, and "the music changed to hot jazz."[3] In other words, Quant and Pugh drew on black cultural expression—the Charleston and jazz—to upend the stiff proprieties of 1950s couture culture

by adding music and movement to the display of clothes. In borrowing from black culture, Quant revolutionized how fashion would be displayed on the postwar whitestream runway. Importantly, Quant understood this racialized intervention through the discourse of the real, in contrast to the artificiality it displaced. "I want girls who exaggerate the realness of themselves," she argued, "not the haughty unrealness like the couture models do."[4]

Models are hired for their ability to perform the authentic, to seem to be someone they are not. As the face of mod culture in the 1960s, Jean Shrimpton, wrote in 1965, "I spend a morning as a chic fashion plate or posing in a sultry Tondelayo-ish costume . . . at two o'clock on the same day I may be a merry teenager on a toboggan . . . at 4:15 I may be a housewife breaking eggs in a mixing bowl, and at 6:15 I'll call my agent to find out about a trip to the Côte D'Azur. *Which is the real me? None of them.*"[5] Realness is in the eye of the beholder, at least where modeling is concerned. Outside the modeling shoot, Shrimpton confessed, she was an introvert: her shyness meant she loathed going to restaurants; entering a room of people felt like "going to the stake"; and ironically she "dread[ed] making an exhibition of [her]self."[6]

In the 1960s, youth culture pushed aside couture in favor of street style, fashion boutiques, and a renewed emphasis on the erotic circuit between the model and the photographer. Sexuality emerged as a central theme of European films such as *Qui êtes-vous Polly Magoo* and Michelangelo Antonioni's *Blow-Up*, based loosely on the life of British fashion photographer David Bailey and featuring 1960s fashion model Veruschka. Bailey, one of the three working-class Londoners who documented and helped create the swinging London of the 1960s, understood fashion photography as "a most definitely sexual thing. The only thing between you and the girl is the camera. A three-legged phallus."[7] Jean Shrimpton, one of Bailey's favorite models as well as his girlfriend in this period, reflected on her production of a sexualized affect while being photographed with actor Steve McQueen for a *Vogue* series. McQueen mistakenly thought she was coming on to him. But as Shrimpton reflected, "I wasn't; that's how models work. I was not turning on my sexuality for any reason to do with him; I was simply doing my job. It was an automatic reflex: turn on, stop, sit back, wait, and then turn on again until the photographer was happy."[8] Bailey had gotten his start as a studio assistant to the gay British fashion photographer John French, whose gorgeous, studied images of haute couture were the British equivalent to the work of Condé Nast's Horst P. Horst and John Rawlings. But whereas French, Horst, Cecil Beaton, and other gay fashion photographers had emphasized the clothes and the models' cool glamour, Bailey and others in

this new generation of postwar fashion photographers honed in on the women wearing the clothes—the models—as well as their movement and sexuality.

In one of many descriptions of the erotic rapport between photographer and models, reporter Richard Busch followed British model Penny Ashton through a typical New York photo shoot in 1966. The American photographer, Len Steckler, selected some rock music to set the scene; as he explained, music was very important to his working method, and he selected it "according to the mood he wants the model to feel."[9] Busch describes the ensuing rapport between Steckler and Ashton as a contagious "seduction," with himself "breathing a little harder" as he watched. "The excitement . . . was disarming, and Penny knew it. She knew she was being coaxed, enticed, seduced, and she knew how to respond."[10] Busch struggled to find the vocabulary to describe this palpable, erotic, and affective relationship between Ashton and Steckler. "It was more than rapport. It was too close, too exciting to be just that . . . it was movement and it was sex plus Rocky Roberts and his Airedales [the soundtrack]; it was emotion and control, and maybe even a little magic; it was seduction. . . . And it was Penny Ashton, barely old enough to vote, who knows all these things and how they fit together."[11] The result was a set of photographs that another reporter described, in a related context, as "having the quality of a thirty minute love affair between the photographer and the girl."[12]

In photographic shoots such as this one, the model produced her sexuality and femininity in relationship to a heterosexual narrative being scripted by both the photographer and the culture at large. As one reporter summarized, models "perform, act, and display their femininity in arresting pictures that require a look and a second look."[13] The model produces what Marcia Ochoa has called "spectacular femininity": femininities produced in relationship to the idea of them being seen and consumed by others.[14] Like Shrimpton's turning on of her sexuality for the camera, the production of this spectacular femininity was also a job, one that models turned on and off as part of their work. There's nothing "natural" about this production of femininity, which seems obvious to everyone in the business; instead, the goal is the production of a persuasive *discourse* of the natural and the real in relationship to that gender and its representation. Such spectacular femininity needs to be seen as authentic in order to be persuasive. The photographic literature is filled with directives on how those behind the camera can produce this realness on film.[15]

As these models and photographers understood in their own terms, femininity is a biopolitical production of self that is culturally and commercially produced through affective labor performed by the model, the photographer,

femininity

the designer, the advertising team, and the consumer. Despite advertisers' reliance on normative femininity as natural, this gender is a commercial product that, like all historical artifacts, changes its meanings and manifestations over time. In the long 1970s, in the context of social movement critiques of mass media and advertising as consumerist and inauthentic, beauty ideals and their commercial representations shifted to connote naturalness, realness, and sincerity. White second-wave feminists, in particular, attacked the mass media as producing an inauthentic representation of American womanhood, mounting protests against advertising campaigns and beauty contests that, they argued, demeaned women. These critiques of femininity as represented in contemporary advertising presumed an authentic, unmediated femininity whose erasure was threatened by male-dominated mass media. Yet, historically, as these sources demonstrate, the intersubjective coproduction of "natural" femininity was equally constructed, commercialized, and political.

The terms "natural" and "real" are often, though not always, racialized categories in this period. "Natural," I would suggest, often connoted a specific ontology of white being, aligned with middle-class values and developed within New Left and feminist politics as authentic and antimarket; the term was quickly adopted by Madison Avenue as a selling point for a range of consumer products. Depending on its context, the term "natural" could sometimes work as a race-evasive code for white femininity. While African Americans sometimes used the term to describe specific components of soul, as in the au naturel hairstyle, sometimes Anglicized to "the natural," blacks did not generally use the term "natural" to describe their ontological aspirations, although sometimes they did. Instead, they were more likely to use the term "real," which is why the term shows up in Mary Quant's description of her late St. Moritz fashion show, where—by her own description—her work uses black musical and performance traditions to subvert stiff Anglo couture. Judith Butler has famously pointed to the "like" in the 1967 Carole King/Gerry Goffin lyric, "You make me feel like a natural woman," popularized by Aretha Franklin in 1967, to underscore the constructed nature of gender performativity.[16] While Butler's arguments regarding gender continue to inspire works such as this one, I would suggest that Franklin's emphasis on "like" is equally about race: in the context of the 1970s, the natural woman was often racialized as white and tied to an ideology of biological essentialism. Blacks, having to battle centuries of racial primitivism and its discursive imbrication with the natural, were more (though not always) likely to use the term "real" to describe a sense of authentic ontology, as in Sylvester's 1978 hit disco single, "You Make Me Feel (Mighty Real)." Sylvester, whose work emerged from the queer and trans disco and ballroom

scenes of the 1970s, used "real" as a performative aspiration. The performance of the real, as in the "realness" category of the black and Latino/a ball house scene, offered an ontological utopia for trans belonging, a meaning still in use today. In the context of black urban culture, the term "real" also connotes a sense of authenticity, of being true to one's code of ethics, one's self, and one's community. In this sense, "realness" is not a synonym for "mimesis"; instead, it indexes a more subjective, personal truth, as in the 1970s black cultural expression "keeping it real." It is this sense of "being real" that Janet Mock draws on when she tells her readers, in the prologue to *Redefining Realness*, her memoir of growing up a poor trans woman of color, "I hope that my being *real* with you will help empower you to step into who you are and encourage you to share yourself with those around you."[17]

 This chapter examines the varied discourses of the natural, the real, and the authentic within the modeling industry between the mid-1960s and the early 1980s. I begin with a discussion of a normative version of white femininity, the natural and wholesome "Breck Girl," and then explore competing versions of femininity that challenged the white, cis-normative industry, beginning with the "Black Is Beautiful" movement and then focusing on models Naomi Sims and Marcia Turnier. Nonwhite models, including Asian American photographic models, worked within a racialized discourse of the "natural" that presumed a unique relationship between women of color and the exotic; here, white discourses of natural femininity were imbricated with orientalism and primitivism. I examine these models' productions of femininity against the counterarchive of second-wave feminism, whose critiques of sexism shifted in these years from a radical critique of militarism, racism, and capitalism to a celebration of authentic womanhood rooted in biological difference. White feminists criticized the modeling industry and consumerism for producing an artificial, plastic, manufactured version of femininity; in contrast, many began to emphasize, in the early to mid-1970s, women's biological differences as the site of authentic womanhood. This grounding of sexual difference in biology was widely shared outside of the feminist movement, including in the modeling industry, and had devastating consequences for trans models such as Tracey Gayle Norman.

Dreaming of the Breck Girl

Brands' identities can be powerful agents in the production of gender, as well as the maintenance of brand loyalty. Consumers' identification with a product brand can be powerful and affective, and once established, offers tremendous

sales potential. Knowing this, the New York–based public relations firm KCSA, hired by Breck hair care products to reinvigorate the brand in the late 1980s, sent Breck a series of letters written by potential model contestants describing their relationship to the Breck product, and its avatar, the Breck Girl.[18] Some of the letter writers mentioned famous actresses, such as Kim Basinger and Jaclyn Smith, who had gotten their start as Breck Girls. But the most compelling letters described the complex process through which the market shapes our subjective and affective lives—how images, models, and marketing have intervened, historically, in the most intimate understandings of self. Katherine Matlock-Katy, age twenty-one, wrote from Texas, "From as long as I can remember, I have always dreamed of being a Breck Girl." Mari Collins, age thirty-four, described playing make-believe as a child growing up in Texas: "My mother would wash our hair every Saturday with Breck shampoo. My sister and I would see the Breck commercials on TV and pretend that we were Breck Girls."[19] The letter writers didn't simply enjoy the product; they wanted to *become* the invented brand icon, the Breck Girl.

The Breck models embodied and performed a specific iteration of white, heterosexual femininity that the company had been elaborating since artist Charles Sheldon painted his first pastel portrait in 1936. Over fifty years later, the Breck Girl connoted classic, natural, girl-next-door wholesomeness: beautiful, certainly, but approachable and inspiring. These letter writers found in the Breck Girl a model for femininity that they sought to embody and perform. Every Saturday, as Mari's mom washed her hair, or each time Janelle reached for the shampoo bottle, packaged with its seemingly timeless icon of wholesome white femininity, girls and women produced their gender, and their whiteness. In this sense, these young, white women were "doing" gender; through the repetition of gendered acts, they produced and naturalized a normative femininity.[20] The Breck Girl as icon masked the intersubjective work that is always at stake in the creation of gender; in this case, as in much advertising of the late 1960s and 1970s, the vehicle through which this secret of gendered labor was rendered invisible was the racialized discourse of the "natural." Unlike the glamour girl—a cultural production based on the technologies of artifice—whether makeup, clothing, or photographic retouching—the Breck Girl connoted innocence, authenticity, and the natural.

The Breck Girl was one of twentieth-century advertising's most enduring icons of normative, white femininity. Her beautiful hair, open smile, and wholesome looks signified a girl-next-door prettiness that was explicitly anti-glamour: a "natural" beauty, rather than one produced through glamour's technologies of artifice. Founded in 1908 by businessman John H. Breck, Breck's

advertising had always been a local, old-fashioned affair, even after 1963, when American Cyanamid bought the company, and all the advertising was turned over to Young and Rubicam. Until the mid-1960s, when the company shifted to photographic portraits of Breck Girls, the brand was defined by both its gold foil packaging and by old-fashioned pastel portraiture featuring girl-next-door Breck girls with luxurious hair. In a lecture on Breck advertising from 1964, Breck employee Peggy Cullen described the first full-color ads to run in the January 1946 edition of the *Ladies' Home Journal*. "People criticized the ads then as they do now," she told her audience. "They said they were old-fashioned. No exaggerated claims, informative copy, no glamour girls."[21]

Rather than "glamour girls," the models for the Breck ads were either non-professionals (in the 1930s and 1940s) or professional models selected for their natural, nonglamorous look (1950s through 1970s). Both Sheldon and Ralph William Williams, the two main painters of the Breck girl portraits between 1936 and the 1970s, emphasized their work with everyday, girl-next-door models, since the idea that "anyone" could be a Breck Girl contributed to the overall brand identity. Sheldon worked with his own secretaries as models, as well as with family members and Breck employees. Jean Ivory Stephens, for example, whom Sheldon painted seven times for Breck advertisements between 1947 and 1952, noted, "We Breck girls of the Sheldon period were an anonymous group. No one ever recognized a Breck girl from her appearance in an ad."[22] By the time Sheldon passed the brush to painter Ralph William Williams in 1955, he had painted 107 "Breck Girl" pastels, working with local, nonprofessional models.[23] By the 1960s, Breck worked with professional modeling agencies such as Eileen Ford, whose models approached their photograph shoots with Breck as no different from any other commercial work.[24] Williams would work with these modeling photographs to paint a pastel portrait that continued to imbue the Breck Girl with a racialized rhetoric of authenticity, simplicity, and "old fashioned" values.

For this version of white, wholesome femininity, "natural" was an important key word, epitomized by the Breck Girl. The Breck look was white, young, female, usually blonde, and explicitly antiglamour. We have seen this version of sanitized white femininity before, as it is a reworked version of Ziegfeld's efforts to "glorify the American girl" and John Powers's "natural" girl—both icons of sanitized white femininity. As creative marketing director Estelle Ellis declared to *Printers' Ink* in 1962, the market was reacting against the glamour of 1940s and 1950s models. "The big trend in fashion," she argued, "is to *natural* beauty."[25] Although beautiful, the Breck Girl's appeal was welcoming, not threatening; her mild, innocent sex appeal was that of the girl next door. As

copy in an ad featuring a Williams pastel of high school student Cheryl Bates exclaimed in 1963, "She's a classmate of yours . . . she lives next door . . . maybe in the next town . . . she borrows sweaters . . . she thinks kittens are cute . . . she's like you in countless little ways."[26] The ad went on to state, "She has fresh, natural, honest beauty. And Beautiful Hair." Cheryl was also the subject of one of the few two-page spreads featuring a Breck Girl in a series of activities in her hometown of Lynn, Massachusetts: readers saw photographs of her in biology class, practicing ballet, bowling, and ice skating with a young man. The accompanying copy describes Cheryl's involvement in these girl-next-door interests in "biology, ballet, bowling, and boys."[27] The Breck Girl represented the clean, white, sanitized and natural beauty of the "girl next door."

While it may seem that the appeal of the Breck Girl had little to do with sexuality, in fact it was the white, wholesome "girl next door" of the John Powers/Breck Girl that Hugh Hefner targeted for his new men's magazine, *Playboy*. Like the Breck Girls, the playmates were not professional models; they were known to the magazine before they posed, especially in the earlier years. As Carrie Pitzulo has argued, Heffner explicitly focused on the wholesome "girls next door" for the playmates, and accompanied the centerfold with short narratives about the girls' hobbies in an effort to deobjectify them.[28] Through the narratives, not unlike Cheryl Bates's two-page Breck spread, Hefner constructed the *Playboy* models as wholesome, all-American girls—who happened to enjoy sex as well. *Playboy*'s version of wholesome femininity, like that of Breck, explicitly tied a sexualized white femininity to the market. *Playboy*, whose first issue was published in December 1953, was first and foremost a middle-class men's leisure and lifestyle magazine that tied heterosexuality to consumption. At a time when male consumption might connote the sissy or the dandy, Hefner succeeded in gendering masculine consumption as heteronormative, and the role of the nude or seminude "girl next door" was central in tying a fragile-gendered, emerging market (that of the single, heterosexual, male consumer) to a bedrock-gendered, established cultural formation (that of the wholesome "girl next door," from Ziegfeld through Powers and pinups).[29] In this way, Heffner anchored the heterosexuality of the postwar male consumer while reinscribing long-standing commercial linkages between sexuality, white femininity, and the market.

The Breck Girl, however, did not survive the 1970s. In 1975, American Cyanamid repriced the product line at the low end of the market, effectively killing the Breck Girl campaign in the process. Although there were efforts to save the old-fashioned Breck Girl from being torn up in a new consumer landscape of liberated shampoo women "all on bikes and horses, running around

town, at work and at play," the "memorable pastels" that had marked the Breck Girl were to be no more.[30] As Blair Sabol remarked in the *New York Times* in 1992, the 1970s Breck Girl ended up in a "no-win identity crisis. Try as they might to make her 'relevant' with flower power portraits of long-haired hippie blonds and some black women with Afros, the campaign seemed to stop working."[31] As the 1970s unfolded, the Breck Girl was out of step with the advertising industry's appropriation of second-wave feminism, epitomized by Leo Burnett Company's 1968 campaign for Virginia Slims cigarettes, with its memorable catchphrase "You've Come a Long Way, Baby." But while the Breck Girl seemed old-fashioned by the late 1960s, the idea of the "natural" within advertising, and in second-wave feminism in general, had only just begun.

Protesting the Plastic Spectacle Auction Sale

Women's liberation exploded into mainstream American culture through a political action, or "zap," that targeted the Breck-*Playboy* girl-next-door sexual wholesomeness as emblematic of women's oppression. Both radical and liberal feminists critiqued the relationship between women and consumer culture within the advertising industry, a critique that centered on the use of women's bodies and beauty to sell products, and therefore directly implicating both the modeling industry and models themselves in the commodification of the self. Contemporary critics saw this commodification as emblematic of corporate capitalism, and antithetical to alternative values such as "finding a meaning in life that is personally authentic," to quote the founding document of the New Left, the *Port Huron Statement* of 1962.[32] Perhaps no second-wave feminist political action has been more written about than the Miss America protest in Atlantic City in 1968, an event that foregrounded the use of women's bodies to sell consumer products. This episode of political theatre succeeded in placing radical feminism on the map of mainstream America and has played a central role in how second-wave feminism has been remembered, and misremembered, ever since. Here, I go back to the archival material surrounding the Miss America protests as a way to understand how second-wave feminists understood the accoutrements of normative beauty, including wigs, makeup, girdles, and bras, as not only emblematic of women's oppression but also exemplars of the antinatural, of artifice and technology—a discourse concentrated on the key word of the late 1960s: "plastic." Within this critique, second-wave feminists saw models as the nonhuman, as "walking commercials," in Robin Morgan's words. As Morgan wrote of the runway-walking Miss America contestants, "Wind her up and she plugs your products."[33] This critique of beauty

as artifice, of normative femininity as phallocentric technology, and of the model as the nonhuman became pervasive in second-wave feminist critiques of normative femininity, critiques that activists consistently tied to militarism, racism, and consumerism. By the mid-1970s, the radical feminist suspicion of normative femininity as man-made, a technological monstrosity, had become transformed into a cultural feminist celebration of the "natural" woman. As we will see at the conclusion of this chapter, this biological essentialist understanding of femininity dovetailed with mainstream fashion's transphobia, foreclosing the possibility of trans feminine modeling until the early 1980s, when this essentialist model of gender formation began to unravel.

The Miss America Pageant protest in 1968 was an action designed by New York Radical Women, an important women's liberation group, with much of the organizing accomplished by Robin Morgan, a twenty-six-year-old radical feminist and poet. The demonstration's "advisory sponsor" was Flo Kennedy's Media Workshop—an activist group Kennedy founded in 1966 to protest the media's representation of blacks—along with the feminist Jeannette Rankin Brigade and the American Civil Liberties Union.[34] The demonstration's purpose was to protest the Miss America pageant taking place at the Atlantic City Convention Center that New York Radical Women saw as the symbol of racism, militarism, and sexism in contemporary American culture. As Morgan wrote afterward, "The protest was chosen as a target for a number of reasons: it has always been a lily-white, racist contest; the winner tours Vietnam, entertaining the troops as a Murder Mascot; the whole gimmick is one commercial shill-game to sell the sponsor's products. Where else could one find such a perfect combination of American values—racism, militarism, sexism—all packaged in one 'ideal symbol,' a woman?"[35] Demonstrators convened outside on Atlantic City's boardwalk, carrying signs, singing songs, and throwing instruments of "woman-garbage" such as "bras, girdles, curlers, false eyelashes, wigs, and representative issues of *Cosmopolitan, Ladies' Home Journal, Family Circle*," as well as *Playboy*, into a "Freedom Trash Can" (fig. 5.1).[36] Inside the Convention Hall, during the live telecast several protesters unfurled a large banner from the balcony rail that read, "Women's Liberation"; the protesters' shouts stopped the contest for about ten seconds. Protester Peggy Dobbins was arrested for disturbing the peace and "emanating a noxious odor" when she sprayed Toni hair spray, a pageant sponsor, around the mayor's box inside the Convention Hall.[37] Perhaps inspired by the Yippees, who had nominated a pig for the US presidency the previous week, the protest's political theatre culminated in the crowning of a live sheep as Miss America and a midnight candlelight funeral dance for the "death of the concept of Miss America" (fig. 5.2). Overall, the

FIG. 5.1 "Freedom Trash Can," Miss America Pageant Protest, 1968. Alix Kates Shulman Papers, David M. Rubenstein Rare Book and Manuscript Library, Duke University. Photograph © c. 1968 Alix Kates Shulman. Used with permission.

protest drew about one hundred demonstrators as well as unprecedented press coverage, both positive and negative, concerning women's liberation.

As an opening salvo of New Left–inspired radical feminism, the protest directly tied technologies of normative femininity to consumer culture, militarization, and racism. One of the protest songs was designed to be sung to "A Pretty Girl Is Like a Melody," the 1919 song that Irving Berlin wrote for Ziegfeld's model-showgirls, and which later became the signature song for the *Ziegfeld Follies*. The song demonstrates the historical relationship between the beauty contests such as the Miss America competition and the model; both emerged in the post–World War II era of commodified white femininity and urban boosterism. Protesters replaced Berlin's lyrics with their own, with the

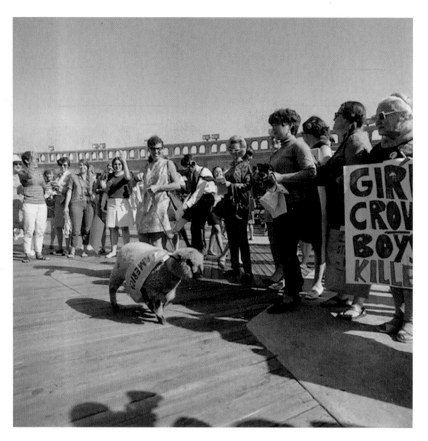

FIG. 5.2 Miss America protest, Atlantic City, 1968. Robin Morgan Papers, David M. Rubenstein Rare Book and Manuscript Library, Duke University. Used with permission from Robin Morgan.

first stanza critiquing advertisers' use of women (i.e., models) to sell goods: "A pretty girl is a commodity / with stock to buy and sell / When the market is high / and you see her pass by / count up your shares / in what she wears / that pay you dividends." Another song, to the tune of "Ain't She Sweet," echoed the critique of model/contestants as corporate shills: "Ain't she cute / Walking in her bathing suit / Selling products for the corporation."[38] Although the protesters were not using the term "model," their critique of advertisers' use of women's bodies to sell goods was a critique of the modeling industry, and, implicitly, of the model herself.

These radical feminist protesters explicitly tied technologies of normative femininity to both racism and the ongoing war in Vietnam. The second point of protest, after the pageant's representation of women (meaning, presumably,

white women) as the "degrading Body-Boob-Mindless-Plastic-Girlie-Symbol," was the pageant's racism. "We protest," Morgan's press release stated, "Racism with Roses. Ever since its inception in 1921, the pageant has not had one black finalist, and this has not been for a lack of test-case contestants. There has never been a Puerto Rican, Alaskan, Hawaiian, or Mexican-American winner. Nor has there ever been true Miss A.: an American Indian."[39] Using the language of the inauthentic, here signaled by the term "plastic," the protesters simultaneously critiqued the pageant as sexist, militaristic, and racist.

Although natural and synthetic materials, later known as plastics, were part of pre–World War II culture in the form of shellac, celluloid, and Bakelite, the war years witnessed an unprecedented expansion of the industry, in which war industries produced 818 million pounds of plastic for helmet liners, mortar fusers, and bayonet scabbards. After the war, synthetic plastic moved to consumer products, replacing wood and metal in the production of toys, furniture, flooring, dishes, luggage, and Christmas trees; by 1960, the annual production of plastic had exceeded six billion pounds.[40] In the 1950s through the mid-1960s, plastic could connote the technocratic utopianism of science and the avant-garde, as suggested by Paco Rabanne's space-age frocks, modeled by Donyale Luna in a series of unpublished fashion photographs by Richard Avedon. But by the late 1960s, toddlers and teenagers had grown up surrounded by plastic, and by their young adulthood the term "plastic" had become a synonym for everything that they detested in their parents' lives and, by extension, in white, middle-class American culture. Plastic had always carried with it the connotation of imitation and artifice, as the material had been used to simulate, for example, the more expensive materials of ivory and marble. Plastic's ability to fake nature became a red flag for (usually white middle-class) critics of white middle-class culture, who railed against what some white activists decried as the "white honkie culture that has been handed to us on a plastic platter."[41] Yale law professor and author Charles Reich argued in his best seller *The Greening of America* that the corporate state had made Americans dependent on artificial things: "Our life activities have become plastic, vicarious, and false to our genuine needs."[42] Feminists such as Robin Morgan, whose activism had been forged in the antiwar protests of the New Left, drew on this rhetoric to critique the sexism they saw embedded within whitestream beauty culture.

While the Miss America Pageant protesters objected to the pageant's commodification of white femininity, they also critiqued the pageant's racism—suggesting, implicitly, that the event's sexism might somehow be satisfactorily addressed through a more racially inclusive pageant. Indeed, at the same time that the all-white Miss America protest was unfolding, a counterpageant—the

first Miss Black America Pageant—was being staged a few blocks away at Atlantic City's Ritz Carleton hotel. Roy Wilkins, the president of the NAACP, had criticized the Miss America Pageant for being "lily white" and for not having had a black finalist since the pageant had been founded in 1921; in response, the Miss America Pageant announced a one-thousand-dollar scholarship for black contestants in August 1968.[43] At that pageant, Philadelphia resident, feminist, and civil rights activist Saundra Williams won the contest with an African-inspired "Fiji" dance and her hair styled "au naturel," or unstraightened. "It was like an impossible dream coming true," she recalled. "For years I'd been brainwashed into thinking that beauty consisted of straight hair, a thin, straight nose and thin lips. The contest proved what I'd recently learned—black is beautiful."[44] As winner for the Miss Black America contest, Williams won a week's vacation and a modeling contract.[45] At the same moment that Morgan, Kennedy, and other protesters were castigating the official Miss America contest for racism, the Black Miss America pageant celebrated black skin, African features, and natural hair as a challenge to white beauty standards, if not to the genre of beauty contests as a whole.[46]

In the wake of the 1968 pageant protest feminist attacks on consumer culture proliferated, as both radical and liberal feminists understood the advertising industry as central to the use of women's bodies to sell consumer products. These feminist critics emphasized a natural/artifice binary in making their critique of the advertising, beauty, and modeling industries. Feminist Dana Densmore, writing in 1968, lambasted normative beauty culture as enticing women to make themselves beauty objects: "To the extent that we keep our self-image as persons as we manipulate ourselves in this way, it will seem artificial and unnatural."[47] In 1970, the New York City chapter of the National Organization for Women (NOW) began presenting advertising agencies with "old hat" awards—symbolized by a plastic reproduction of a straw hat—for ads that included stereotyped and degrading portraits of women.[48] In 1972, the liberal feminist magazine *Ms.* institutionalized the feminist critique of advertising as sexist by creating the "No Comment" page, to which readers submitted advertisements that they felt degraded women.[49] Harriet Lyons and Rebecca W. Rosenblatt, writing for *Ms.*, contrasted the artificiality of the cosmetics and beauty industry with "natural" femininity through the lens of body hair, where women were expected to "slavishly remove body hair and substitute *artificial* scents for *natural* body odors," obfuscating who "we really are."[50] Almost all white feminists, regardless of their politics around the war, racism, socialism, employment, or other issues, shared this critique of contemporary beauty culture. The most visible exception, perhaps, was Helen Gurley Brown,

the editor of *Cosmopolitan*, whose version of liberal feminism did not see a contradiction between equality and normative beauty culture. She remained cynical about her feminist contemporaries' celebration of "natural" femininity, especially as embodied in the 1970s hippie: "Those back-to-goodness-and-nature hippies are certainly not natural," she asserted. "They may not wear make-up, but some of them bleach their hair and their fringy, furry, funky costumes certainly didn't grow on their bodies (though they sometimes smell like it); the clothes are carefully, 'unnaturally,' collected from thrift shop and Army surplus stores."[51] But most liberal and radical feminists critiqued cultural producers of "artificial" beauty: feminists protested Playboy Clubs around the country, and in 1974 members of New York City's NOW chapter picketed Olivetti Typewriters' New York offices for an offensive ad campaign that featured a pretty model and the tagline "The typewriter that's so smart that she doesn't have to be."[52]

The model for the Olivetti ad was Shere Hite, a Columbia University PhD candidate in history who later became a household name for her studies on female sexuality and the (myth of) the vaginal orgasm. In the early 1970s, to earn money for school, Hite became a model for both fashion and print advertisements; she was represented by Wilhelmina, earned about $250 an hour, had a walk-on part as a model in the Jane Fonda film *Klute*, and modeled nude for *Playboy* and *Oui*. Although she enjoyed some aspects of her work, "in truth," she wrote, "most jobs made me feel alienated."[53] She reported being sexually harassed on the job by top fashion photographers such as Hiro, and penalized with poor assignments after she bowed out of an evening's entertainment with an agency owner.[54] In one of her last jobs, Hite won the contract for the Olivetti Typewriters TV commercial. While on the set, the director asked her to "flirt with the camera" and "cross her legs provocatively."[55] Confused as to why, Hite asked the director to explain, which he did: "You're supposed to be a dumb blonde—act it!"[56] Soon after, Hite read in the *New York Times* that members of New York's NOW chapter were picketing in front of the company's Park Avenue headquarters because of this ad campaign, which they argued denigrated women. Midge Kovacs, an advertising executive and NOW activist, led the Image of Women Committee for NOW's New York City chapter, and Hite joined the group and the protest. Hite's involvement in the NOW protest of the advertisement in which she was featured marked the beginning of Hite's research and activism on feminist issues.[57]

Late 1960s and early 1970s feminists such as Hite argued that stereotypical representations of women in contemporary communications media, including advertising, limited and demeaned women, preventing them from "experiencing our full possibilities."[58] In the early to mid-1970s, this critique of women in

advertising played a greater role in feminist activist energy than did the battle against pornography, which Carolyn Bronstein and Whitney Strub argue did not emerge as the root cause of women's oppression (for some feminists) until later in the decade.[59] As the Miss America Pageant protest shows, however, feminists critiqued advertising and the modeling industry for tying femininity to technologies of commercialized, synthetic, normative beauty. In this equation, feminists interpreted technologies of gender normativity, such as fashion and makeup, as limiting women's full potential: out with the "Plastic-Girlie-Symbol," in with the "natural" woman.

The 1968 Miss America Protest expressed the late 1960s' tendency, among radical feminists, to tie a critique of women's oppression not only to capitalism, colonialism, and militarism—traditional sites of critique for the New Left— but also to their oppression as a gendered "class," that is, as *women*. The shift from a radical feminist critique of militarism, sexism, and racism to a celebration of women's natural difference from men is what critics then and scholars since, following historian Alice Echols, have described as the turn to "cultural feminism" in the mid-1970s. In the view of many Marxist feminists, influenced by the orthodox Marxist base/superstructure dichotomy rather than neo-Marxism's reconceptualization of culture as a site of politics, the turn from an explicit critique of patriarchal class power to a celebration of women's alternative culture represented an evisceration of feminism's political commitments. As radical feminist Brooke Williams critiqued this shift in 1975, "Cultural feminism is the belief that women will be freed via an alternate women's culture. It leads to a concentration on lifestyle and 'personal liberation,' and has developed at the expense of feminism, even though it calls itself 'radical feminist.'"[60] In Williams's analysis, "It is not culture, but power, men's class power," that is responsible for women's oppression, and only a "mass, political women's movement" could "overthrow male supremacy."[61] In 1975, however, Williams was fighting a rear-guard action in her critique of cultural feminism. Activists and writers such as Jane Alpert, the later Robin Morgan, Adrienne Rich, Mary Daly, and Susan Griffin increasingly emphasized women's difference from men, a difference they saw as based on biology and the capacity to mother.[62] In the face of patriarchy's devaluation of women, this vein of feminist thought celebrated what they understood as women's unique ways of knowing, and helped spark an alternative women's culture organized around bookstores, music festivals, newspapers and magazines, sports, coffeehouses, and university women's centers. Scholars have charted the emergence of this vein of feminism in the mid-1970s and have debated its relationship to other forms of radical feminism.[63]

226 CHAPTER 5

The thread I wish to emphasize here is the emerging emphasis on the natural, with an associated antipathy to technology, in the mid-late 1970s intellectual history and, in particular, in post–women's liberation era feminist thought. In 1970, Shulamith Firestone saw women's biology as the basis of patriarchal oppression, but she also saw recent developments in assisted reproduction technology as having the potential, for the first time in human history, to transform the biological basis of women's subordination.[64] A decade later, however, cultural feminists saw women's reproductive biology not as a site of "tyranny" but as the locus of women's unique powers. For writers such as Susan Griffin, women's biology aligned them with nature and against the synthetic: "We know ourselves to be made from this earth. We know this earth is made from our bodies. For we see ourselves. And we are nature. We are nature seeing nature. We are nature with a concept of nature. Nature weeping. Nature speaking of nature to nature."[65] These feminists saw nature and woman's capacity for motherhood as a unifying ground for feminism, one that could heal recent battles over lesbianism and race within the movement. This turn to essentialist, biological understandings of womanhood as the ground for feminism, a shift that was also antitechnology in its sensibilities, had unintended consequences, however. The universal category of "woman" elided differences based on race, for example, as well as biology—with implications for trans women, in particular.[66] At the same time, white feminists' critique of the beauty industries as "artificial and unnatural," in Densmore's phrase, ignored the role of racism in producing normative standards of beauty. Nonwhite women, long ignored and denigrated through the racism of normative beauty culture, had a different battle to fight in the 1960s and 1970s when it came to the advertising, modeling, and beauty industries—but in this fight as well, the idea of realness played a central role.

Black Is Beautiful

Saundra Williams's victory in the first Miss Black America Pageant emerged in a changing media landscape in which decades of black activism had made it more and more difficult for advertisers to ignore black consumers and models. As discussed in chapter 4, black models had been part of black advertising and fashion culture for decades, but only in a segregated context. In 1958, black models became organized nationally into an organization called the "Little Foxes," with hat designer and president of the Detroit camera club Bill Howard as executive director; this group met annually through the late 1960s, organizing gatherings featuring well-known industry figures such as

Dorothea Towles, Helen Williams, LeJeune Hundley, and Ophelia DeVore, as well as local black modeling agencies, charm schools, and aspiring models.[67] In 1963, black activists involved in the Civil Rights movement began pressuring the segregationist advertising industry to include more black models within the advertising industry. New York mayor Robert Wagner's Committee on Job Advancement, formed in October 1962, wrote to the presidents of eighty-nine major corporations and seventeen of New York City's largest ad agencies asking them to place more blacks and other members of minority groups in more ads.[68] Clarence Funnyé of New York City's Congress on Racial Equality, the major group behind this early 1960s effort, sidestepped the agencies themselves, meeting directly with large advertisers, such as Lever Brothers and Proctor and Gamble, as a means of integrating advertising in American life.[69] By the mid-1960s, this activist pressure was beginning to bear fruit.[70]

Despite some success in both consumer goods advertising and couture fashion, as discussed in the previous chapter, black models had uneven success in crossing the fashion magazine modeling industry's color line. In 1960, Mozella Roberts began working for designer Chuck Howard on Seventh Avenue, even though Howard's boss refused to hire any black models for the showroom.[71] The following year, in June 1961, Trigère hired Harlem resident Beverly Valdes as a Seventh Avenue house model. By 1962, Liz Campbell had signed with Ford Modeling; Mozella Roberts signed with model Gillis MacGill's newly launched agency Mannequin; and LeJeune Hundley, veteran of *Ebony*'s Fashion Fair and fresh from her 1960 crowning as Miss Cannes and her work modeling for Dior in Paris between 1959 and 1962, was a house model for New York City designers Tiffeau and Busch. Also in 1962, the musical *No Strings*, starring Diahann Carroll as an African American fashion model based in Paris (and which may have been based on Dorothea Towles's career), ran for 580 performances and won a Tony for "Best Musical" that year; Mozella Roberts modeled Donald Brooks's designs during a costume audition for that show. As *Newsweek* reported, "Negro models have begun to crack the U.S. fashion industry."[72] Despite these inroads on Seventh Avenue and in popular culture, as well as in the European haute couture shows and salons, the high-end fashion magazines (such as *Vogue* and *Harper's Bazaar*) remained lily-white.

In 1967, Naomi Sims became the first model of African descent to be photographed for the cover of a major fashion magazine when she appeared on the cover of the *New York Times' Fashion of the Times*. Appearing on the modeling scene in the wake of Donyale Luna's departure, which I discuss in further detail below, Sims's ascendancy within both print and fashion photography catapulted her into black popular culture, sparking an avalanche of correspondence

from would-be black models from around the country. These young women wrote how much they admired Sims, and how much they wanted to be just like her. Like the Breck letters, these Sims letters are saturated with an affective intensity demonstrating how desire, subjectivity, and the market are mutually constitutive. Jeannette Reid of Philadelphia, age eighteen, politely wrote Sims, "Dear Ms. Sims: I know every day you get a thousand letters just like mine. But you are a very beautiful person and I wish someday to be just like you."[73] Ms. Monterey Lane was more colloquial when she wrote Sims, "Black Sister Sims, Right on with your bad black self."[74] Many of these letters included photographs of the letter writer, usually sent with the hope that Sims would provide feedback on whether the writer had the potential to be a model herself. R. Lydia Greene, for example, sent Sims six black-and-white head-shots showing her in different poses, with glasses and without, her hair both straightened and natural. In large letters, Greene asked Sims: "Which one is the real R. Lydia Greene?!?"[75] The implication is that there is no real R. Lydia Greene, or they are all equally "real": in modeling, what matters is the visual rhetoric of realness, the performance of an authentic self.

Naomi Sims has been heralded as the "first black supermodel," the woman who became the 1970s "flesh-and-blood personification of Black is Beautiful."[76] Although born in Oxford, Mississippi, Sims was raised in Pittsburgh first by her mother, and then in a group home after age ten; she was eventually adopted by a black family, but felt more like a "helper" than a daughter. Her mother lived nearby, where she raised Naomi's older sisters. Sims's father, a porter whom her mother described as an "absolute bum," separated from the family when she was an infant. During her teenage years, Sims sold Avon products and became a top seller. She won a scholarship to study at the Fashion Institute of Technology and moved to New York City in 1966.[77] As her scholarship wasn't enough to support her, on the advice of a school counselor she called up professional photographer Costa Peterson, whose wife Patricia Peterson was the *New York Times'* fashion editor. It was through this connection that Sims appeared on the cover of the August 1967 *Fashion of the Times.*[78]

Despite this success, however, Sims had difficulty finding an agency that would represent her: the modeling industry was still rigidly segregated. Sims visited the major modeling agency of the postwar period, Ford Modeling, but was rebuffed when she wasn't even able to get an appointment with Eileen Ford herself; instead, she was seen by Sunny Harnett, a former model who then worked as an assistant at Ford Modeling. At a time when Ford Modeling was known as the "White House" for its lily-white model book, Harnett rejected Sims, falsely claiming, "Ford already has too many models of your type."[79] Sims

then approached Wilhelmina Cooper, the Dutch-born former haute-couture model who had founded a competitor agency to Ford Modeling with her husband Bruce. But Wilhelmina Models had only opened in July of 1967, the same summer that Sims's image had appeared on the *Times'* biannual fashion supplement, and Willie (as she was known) and Bruce were reluctant to sign Sims.[80] Bruce Cooper, whom model Carmen Dell'Orefice remembers as a "real creep, with yellow teeth and halitosis," told her that despite her beauty, there wasn't enough work for a black model, and he urged her to go to Europe, as successful black models such as Dorothea Towles, LeJeune Hundley, and Donyale Luna had done before her.[81] To prove the Coopers wrong, Sims told Wilhelmina that she would send out the magazine to ad agencies on her own, with Wilhelmina's number as the contact, and if anyone called, Wilhelmina Models would get the commission. It worked: within a year, Sims was making one thousand dollars per week, and had appeared in both television ads (such as a national television campaign for AT&T) and in print; on October 17, 1969, Sims appeared on the cover of *Life* magazine as part of their cover story "Black Models Take Center Stage." Between July 1971 and January 1972, Sims had modeled for ads in *Harper's Bazaar, Essence, Redbook, McCall's, Vogue,* and *Cosmopolitan.*[82] Later that year, Sims left Wilhelmina Models for the Ford Modeling Agency, citing dissatisfaction with Wilhelmina's management, including the fact that the agency had declined an NAACP request for Sims to appear at a fundraiser without first checking with Sims.[83] Although Ford had rebuffed Sims only two years earlier, by January 1969, Ford had begun booking black models; the agency maintained that it had doubled its roster of black models in order to handle a quadrupled load of requests, and that black models were being booked interchangeably with whites.[84] Though this was surely an exaggeration, a bit of industry spin, the White House was no longer quite so white: the segregated modeling industry was over, although structural racism continued to shape the career opportunities of nonwhite models.

Unlike the fair-skinned black models of the 1920s, or 1950s couture model Dorothea Towles, who modeled for Dior, Schiaparelli, and other European couturiers between 1949 and 1954, Naomi Sims was dark. At over five foot ten with long limbs, dark skin, and a beautiful, heart-shaped face, Sims's look personified a new representation of blackness in American modeling. Sims realized that her success was partially related to having the right "look" at the right moment. As she told journalist Bernadine Morris in 1969, there had been other "Negro mannequins" before her. However, "they tended to have light skin and I am really dark. It's 'in' to use me and maybe some people do it when they don't really like me. But even if they are prejudiced, they have to be tactful if they

was dark

want a good picture."[85] Sims was aware that her blackness was a novelty in the industry, one that she couldn't escape. "I get questions all the time about being Negro," she told the *Ladies' Home Journal*. "I hate having to be made aware and always having to use my brain about being colored. . . . Beauty does surpass prejudice at a point, yet sometimes the effort people are making to assimilate us seems contrived."[86]

Sims's dark skin and clearly African features were indeed a new look for black models within the white world of fashion and advertising. Sims made African American and fashion history when she was featured on the cover of *Life* magazine on October 17, 1969 (fig. 5.3). This powerful image focuses on Sims's head, hair, and shoulders. The photograph connotes an authentic, black "naturalness" that was in the process of being produced as marketable commodity in the late 1960s, as advertisers discovered the "soul" market. Although Sims was a model who wore clothes for a living, in this image she is photographed without them, a long-standing primitivist representational strategy that has produced black bodies as closer to nature and the natural.[87] Sims's hair is pulled back against her scalp, a hairpiece knotted behind her left ear, extending around her neck in a noose of black hair that suggests a generalized African tribalism.

Sims's look connoted a discourse of black authenticity that contrasted with the studied artifice of the fashion and advertising industries. In the context of late 1960s black nationalism and its celebration of black cultural expression, Sims's blackness connoted a natural look, one independent of the white beauty ideals. As a model, she upended the withdrawn aesthetic of the white fashion model, a look inaugurated by Dolores in the 1910s. Projecting what one observer called the rare combination of "sultriness and rectitude," she avoided the conventional glide of most models, developing instead a distinctive walk defined by beautifully controlled serpentine movements of her arms, legs, and torso.[88] She pranced in front of the camera and on the runway, using her long limbs to full advantage; she communicated her love of clothing through her body, breaking runway convention by laughing and smiling. A 1972 ad for Virginia Slims shows Sims's energy and motion. The camera captures her mid-step, her long body striding ahead while she turns back to laugh at the camera; her layered orange dress perfectly describes the movement of her body, which tosses the light fabric in a swirl of movement (fig. 5.4). "I don't really like to pose," she said; "I want to look natural."[89]

Sims's natural movement style emerged out of black fashion's emphasis on music and motion, a standard approach to staging fashion shows today, but one whose origins lay in black cultural expression. An important postwar source for this alternative movement approach was *Ebony*'s Fashion Fair (1958–2009),

FIG. 5.3 Naomi Sims, cover of *Life* magazine, October 17, 1969.

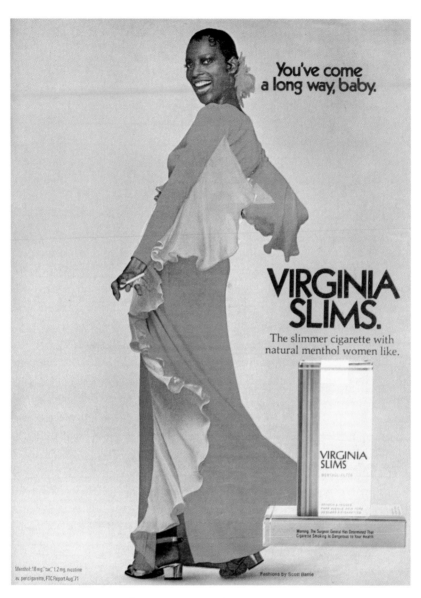

FIG. 5.4 Naomi Sims, ad for Virginia Slims, *Ebony*, March 1972, 151.

a traveling fashion show and fundraiser in which the models exploded onto the stage, dancing to contemporary music, in a spectacle designed as entertainment and uplift. As Tanisha Ford has argued, in its inaugural fashion show in 1962, Harlem's Grandassa models premiered their show "Naturally '62: The Original African Coiffure and Fashion Extravaganza Designed to Restore our Racial Pride and Standards" with a rhythmic walk, performed to popular music, while engaging in a back-and-forth with an ecstatic audience, who shouted and cheered as the models walked in "African" hairstyles and African-inspired garments.[90] In the 1960s, white fashion designers, influenced by British designer Mary Quant's appropriation of black culture for her runway shows featuring her mod miniskirts, colored stockings, and high boots, also began to emphasize music and movement in their fashion presentations.[91] Another key influence on Sims's movement approach was the work of Stephen Burrows, an important black, gay designer of the early 1970s who worked with many black models, most especially Pat Cleveland but also Bethann Hardison, Alva Chinn, and Billie Blair, among others. Burrows was at the Fashion Institute of Technology (FIT) at the same time as Sims, who modeled some of Burrows's designs at a Fire Island shoot for *Vogue* during this period. Burrows encouraged his models to have fun, cut loose, and respond to the music: he preferred soul, especially Al Green, for its sensuality and groove. Burrows's shows, such as the Versailles show of 1973, introduced white fashion audiences to the energetic movement that had long been a hallmark of black shows produced for black audiences, as well as to the black queer, camp, end-of-runway pose that came to be known as "voguing."[92] As American designer Oscar de la Renta explained, while emphasizing the importance of the Versailles show to the rise of the black model, "Black models have a great sense of original style. They project a kind of drama into a designer's collection that most White girls rarely give."[93] Another source for this movement culture emerged from the models themselves, who drew from black cultural expression outside fashion, especially soul but also the early (racially mixed, queer) disco scene, to energize the runway. As model Billie Blair explained to *Newsweek* in 1975, "We grew up with rhythm and beat. My first Clovis Ruffin show, I jiggled, I hammed, I boobied. I cut it up, man, and those poor tired buyers loved it."[94] Burrows agreed that blacks had, what he called, "an inborn style, flamboyance, and poise." In his view, black models excelled at their work because "they make the clothes look more natural."

Black women's emphasis on the "natural" hairstyle and "natural" movement were innovations in black women's body politics that allowed black women to challenge respectability's corporal norms. Their appropriation of African-inspired styles and the movement vocabulary with which they wore them

enabled black women to express their sexuality in public, tying freedom of movement and style to progressive and radical racial politics through a discourse of the natural. The theatre critic Clive Barnes, reflecting on the rise of black models within the industry, ascribed their new success to the rise of theatricality and showmanship on the runway, in the wake of the famous 1973 Versailles show. Black models, Barnes argued, understood theatrical entertainment in a way that white models did not. The black model, he argued, is "both the result of Black Liberation and Women's Liberation." Unlike white models, who were meant to be "a nonexistent coat hanger for what she was wearing," a black model had "no inhibitions about outstarring the dress she happens to be wearing."[95] And for Barnes, the black models' theatricality had everything to do with movement: "See them walk on like the great Black dancer Judith Jamison in her African Queen mode. They don't just hear the music, they react to it."[96] Black models drew from a longer discourse of the black exotic to produce a new soul style that resignified the meaning of black sexuality in the public sphere.[97]

After several years at the top of the industry, Sims retired from modeling to start a business manufacturing and selling wigs and hairpieces for black women. Throughout her modeling career, she had mostly worn her hair close to her head and had never worn a wig because she couldn't find wigs and hairpieces that she thought "looked natural on a black woman"; she had her hairpieces custom made, at prices most women could not afford.[98] Although black women bought up to 40 percent of wigs in the United States, the texture was always wrong: the hair fibers were too shiny and straight. "They look like black Caucasian hair without the nappy—that's black jargon for kink—look of real Negro hair," Sims explained to New York Times reporter Angela Taylor.[99] In contrast to Caucasian hair, Sims told the Kansas City Star, "our hair is totally different." Black hair's comparative coarseness "means better in this case," asserted Sims; "it's like 'black is beautiful.'"[100] In 1973, a Japanese chemical concern, owner of the Metropa Company, approached Sims to collaborate on the production of a line of wigs for black women. Sims agreed, so long as she could approve the fiber and styles as well as lend her name. The resulting pieces, which were based on the sheen and texture of Sims's own hair, were made of kanekelon preselle, a manmade fiber with a tiny amount of kink. Sims introduced her first wig collection in June of 1973, which two years later had grown to twelve wig styles and six hairpieces distributed through two thousand department stores nationwide.[101]

By 1973, when Sims introduced her line of wigs and hairpieces, the Afro as the paradigmatic hairstyle of the "Black Is Beautiful" movement had run its

course. The Afro, as Robin D. G. Kelley has argued, had originated in high-fashion circles in the late 1950s; beauty culturalist Lois Liberty Jones claimed to have pioneered what was also called the "natural" hair style as early as 1952. In the late 1950s, black models wore their hair unstraightened in "au naturel" modeling shows popular among the black New York City elite, while black cultural producers Abbey Lincoln, Odetta, Nina Simone, and Miriam Makeba wore the au naturel look by the early 1960s.[102] Yet few African Americans outside of these elite cultural circuits challenged the cultural expectations of straightened hair because to do so would violate the politics of black respectability, threatening to position black women, in particular, as wild, untamed, and sexually promiscuous. As Susannah Walker and Maxine Craig have shown, even as late as 1966, black women were rarely seen in public with anything but the press-and-curl treatment that had defined the style politics of black, respectable femininity for decades.[103]

By the mid-1960s, chic, bohemian black women had migrated from the au naturel to the Afro, increasingly worn by black men as well, as a new symbol of rebellion, militancy, and the Black Power movement. As Kelley has argued, "Thus, once associated with feminine chic, the Afro suddenly became the symbol of black manhood, the death of the 'Negro' and birth of the militant, virulent Black man."[104] Whereas the au naturel has been used to describe any unprocessed hairstyle, the Afro was a specific type of au naturel style, characterized by its round shape and valorized for its length. At the same time, the Afro signified a shift in black female politics as well: as activist Gloria Wade-Gayle said of this post-1966 period of more militant, student-led activism, "An activist with straight hair was a contradiction, a lie, a joke, really."[105] As Tanisha Ford has shown, Angela Davis's 1970 arrest and subsequent trial gave the hairstyle transnational visibility as an emblem of soul style and radical politics; her image, with her impressive Afro, circulated on FBI fliers in gas stations and convenience stores and in mainstream US magazines such as *Newsweek* and *Life*, and internationally in magazines such as South Africa's *Drum*.[106]

But almost immediately, natural hair became commodified. Clairol, for example, as a result of Caroline Jones's work, began to sell hair products designed to produce the "natural" look: as an advertisement in *Essence Magazine* in 1970 explained, "Anything you do must look natural, natural, natural. And this indeed is the art of Miss Clairol."[107] The "natural" look in black hair was part of a much larger "Black Is Beautiful" movement in American commercial culture, in which in advertisers and merchandisers rushed to find marketing strategies designed to appeal to what became increasingly known as the "soul" market; by 1968, Madison Avenue's interest in commodifying blackness was so

entrenched that filmmaker Robert Downey Sr. could satirize white efforts to profit from hip blackness in *Putney Swope* (1968). By the early 1970s, the Afro had gone mainstream, losing its specific political meaning, while the style's association with black masculinity contributed, Kelley argues, to a backlash against women with natural hair. In 1973, when Naomi Sims introduced her line of wigs and hairpieces made from manufactured fibers, the Afro was no longer seen as either rebellious or revolutionary.

Nonetheless, natural hair—commodified or otherwise—remained controversial for 1970s black models working in a white-dominated modeling industry. Marcia Turnier was a successful black model, an immigrant from Haiti, who began her career in 1976 with Wilhelmina; she did both editorial and commercial modeling, with covers for *Glamour* and campaigns with Heinz, Clairol, and Dr. Pepper.[108] Turnier was part of the first wave of black models, along with Beverly Johnson, Barbara Summers, and Naomi Sims, who integrated the fashion and advertising industry in the late 1960s and early 1970s. She described everyday examples of racial injustice, including being directed to the colored elevator and receiving less pay than white models on the same or similar shoots. She spoke out about this discrimination, refusing additional work with clients whose racism translated into less money or expected industry standards relating to travel and lodging.

For Turnier it was her hair, and the expectation that she wear a wig on shoots, that exemplified the industry's racism. "The only thing that I also objected to in my career as a model," she exclaimed, was that she was often asked to bring a wig on a shoot. She would become "very rambunctious" about her insistence on refusing the wig, preferring instead that she be photographed with her own hair, which she wore short and unstraightened at the time. But her natural hair was a problem for her clients because it continued to challenge gendered and classed notions of black female (sexual) respectability. On one shoot, Turnier was told to wear a wig because she didn't "fit the image of Black models" because she was "too strong," a characterization she could never quite understand, but which she came to associate with her hair, rather than her skin color or facial features: "Too strong meant . . . I don't know what that meant and very often I was told that I was too strong. And I never figured it out. But in my mind, I thought because, I'm not wearing a wig and have a hat put on, you know. It was like that Sunday churchwoman look that they wanted and I kind of fought that. I wanted to be a contemporary Black woman." In the context of the 1970s, Turnier's natural hairstyle symbolized for her, independence and modernity, but for clients "too strong" meant, erroneously in this case, black militancy. Despite her insistence on being photographed with

her own hair, Turnier recognized the ongoing popularity of wigs for black women. "Today," she observed, "everybody wears a wig." Perhaps for this reason, Turnier was eventually a model for Naomi Sims's wig line, with Richard Avedon as photographer.

Modern Primitives

The turn to nonwhite models brought together several threads of post–World War II American culture. One of the most important was the revival of authenticity as a positive, strongly felt subjective state that promised a sense of communal belonging. This shift to the subjective as the site of the authentic has a much longer history, but quickened during the mid- to late fifties through the 1960s as white, middle-class kids in particular turned to the cultural arena—from folk music to soul food—to redefine authenticity as all that was "natural."[109] As Matthew Jacobson has shown, descendants of Ellis Island immigrants turned to ideas of community and authenticity during these years as an antidote to perceived loss in the wake of assimilation and upward mobility.[110] For New Left activists, including the organizers of the Miss America pageant protest, authenticity provided a corrective to the loneliness and alienation of modern consumer culture.[111] Authenticity connoted the real, the natural; its appeal functioned through affective means. As Grace Elizabeth Hale has argued in her work on the *Port Huron Statement*, New Left activists matured "as ideas about authenticity as realistic representation (looking right) gave ways before new ideas about authenticity as an emotional state (feeling right)."[112] Implicitly and sometimes explicitly, the authentic—defined in these terms—was antithetical to the market. This cultural shift was racialized, as white New Left baby boomers often located the "real" in black culture, from Chuck Berry and B. B. King to Lew Alcindor (Kareem Abdul-Jabbar) and Cassius Clay (Muhammad Ali), in a dialectic of "love and theft" that Norman Mailer identified as early as 1957 in his essay on "The White Negro." Authenticity signified truth if it *felt* right, if it felt real. From Aretha Franklin's soul classic "You Make Me Feel Like a Natural Woman" (1968) to Cheryl Lynn's disco hit "You've Got to Be Real" (1978), authenticity, realness, and the natural came together in a powerful, affective mix that signaled a generational rejection of the contrived, the fake, and—to paraphrase the film classic *The Graduate* (1967)—the plastic.[113]

In the long 1970s, the cultural turn toward the authentic dovetailed with a major post-1965 demographic shift—and associated marketers' response—in postwar American life. The quiet passage of the Immigration and Naturalization Act in 1965 ended preferential immigration quotas for Europeans

precisely at the time that mass marketing was on the wane as a merchandising strategy, to be replaced by niche marketing. At the same time, after decades of assimilationist models of national belonging, Congress passed the Ethnic Heritage Act of 1974, recognizing in law the tremendous support for an emerging cultural pluralism that celebrated the distinctive histories of the nation's ethnic populations. As Marilyn Halter has argued, in the wake of these developments, merchandisers turned away from mass marketing approaches to develop niche-marketing strategies focused on specific ethnic groups.[114] Advertisers' turn to nonwhite models, as I have discussed here, is part of this transformation, though the more nuanced technologies of niche marketing and "multicultural brand management" were as yet only in their infancy.

But how does one signify the authentic, the natural, in the context of the nonwhite model? Advertisers, campaign directors, and photographers drew, not surprisingly, on both orientalist and primitivist discourses in framing the representation of these new models. Primitivism and orientalism are both discourses that construct the "natural" along lines of race, racism, region, and ahistorical temporality. The eruption of these discourses constitutes another site for the production of the "natural" within the modeling industry during the long 1970s. These editorial and advertising spreads often situated nonwhite models as exotic, with a timeless, essentialized relationship to non-Western cultures, even if the models themselves had been born in Detroit or New York City.[115] At the same time, the models represented versions of glamour whose femininity helped sell technologies of modernity, whether AT&T's newest phone or ready-to-wear fashions. The representation of nonwhite models, in other words, was ambivalent and contradictory, moving between stereotypes of the racialized other and photographs of glamorous, "Western" femininity sometimes in the same photo essay; each represented different, yet equally compelling, "looks." This section explores how nonwhite models and their photographers worked with, and against, historical tropes that signified the East, the primitive, and the exotic with advertising and fashion. Skin—models' skin, animal skin, and clothing as skin—emerges as a central site where imbricated discourses of the primitive and the modern coalesce. In the context of the 1970s, the exotic sold, especially when tied to emerging cultural values regarding ethnic pluralism, the search for "roots," and a high regard for the authentic.[116]

Kedakai Lipton was an Asian American model of mixed Japanese and Irish heritage who began modeling on the commercial side of the business in the early to mid-1960s. Although she knew of China Machado, at the time many years her senior, Machado's work in editorial, fashion, and runway modeling seemed a world away: until Lipton, there were no Asian Americans represented

in print ads or TV campaigns for commercial (nonfashion) products. Represented by Wilhelmina for most of her career, Lipton modeled for Revlon and did major campaigns for Clairol and Cover Girl. As the only model of Asian descent working at the time, all the jobs featuring orientalist ad appeals went to her.[117]

For many of these jobs, Lipton's Asian heritage made her a fit for advertising campaigns seeking multicultural representation. In her view, she was Asian, to be sure, but her mixed ancestry assured she wasn't *too* Asian. Looking back on these images now, she sees herself as part of the American melting pot rather than separated as racially other. Yet at the time, her mixed Asian-Irish heritage meant that sometimes she wasn't Asian *enough*. On set, campaign directors often yellowed her skin, so that she would appear more "Asian" in the ad's color photograph. One of these ads was the famous AT&T campaign of 1968, in which Lipton, Naomi Sims, and a third model were featured in fashions by Bill Blass in an advertisement for the Trimline phone, designed by Henry Dreyfuss in 1965 (fig. 5.5). This ad was a breakthrough for Naomi Sims because it showed her face; it helped her, she said, "more than anything else."[118] Here, the three models are clustered together in slumber party intimacy, their triangle composition echoed by the elongated phone cord. The name of the new phone, "Trimline," reappears in the lines of trim adorning their pink-and-white nightdresses. In this ad, because Sims's skin was already a dominant color, the studio added yellow to Lipton's skin in order for her to be read as authentically, naturally Asian.

Although Lipton may have been the first Asian American model to appear in US-based advertisements, as with the history of black models, Asian models had already been working in the European-based haute couture industry. These models were also hired, in part, for their "exotic" looks. Of Chinese-Portuguese descent, Machado was raised in Shanghai until 1947, when her parents moved to South America. She later moved to Paris, where she worked as a nightclub singer and appeared as an extra in a number of French and Italian films as a "Madame Butterfly" type.[119] Her first modeling job was in Givenchy's salon, where she made $120 a month. American designer Oleg Cassini met her in Paris and convinced Machado to move to New York, where she caught the attention of Diana Vreeland, the indomitable fashion editor for *Harper's Bazaar*, and signed with the Ford modeling agency.[120] Model agency director Eileen Ford had tried sending Machado to *Vogue*, but according to Ford, someone rejected her there, saying "She's too 'Chinky' for us." When Avedon learned this, he told Ford to send Machado to him, and according to Eileen Ford it was Avedon who made Machado's career as a model.[121] Avedon photographed

Fashions, Bill Blass...Trimline' phone, your Bell Telephone business office. AT&T

FIG. 5.5 AT&T campaign of 1968; with Kedakai Lipton, Naomi Sims, and a third model in an ad for the Trimline phone.

Machado in haute couture for *Harper's Bazaar* as early as 1959, and continued to work with her throughout the early to mid-1960s. Later, when Machado was a fashion editor for *Harper's*, she brought Luna to Avedon's attention.[122]

Japanese-born Hiroko Matsumoto, whom *Life* described as exemplifying "exotic good looks," modeled for Pierre Cardin in the early 1960s, and was photographed by Avedon, Irving Penn, and other fashion photographers.[123] Japanese model Mieko Takashima Wikstrom was "discovered" by Yves Saint Laurent in

Tokyo in 1963, and was persuaded to move to Paris, where she modeled some of his more "exotic clothes" for international buyers.[124] Hong Kong–based model Sin-May Zao modeled Pierre Cardin's designs for the Paris spring collections of 1968, presenting his work with what *Life* described as a "slant-eyed punch."[125] Lipton's work in print advertising was indebted to the work of these models within haute couture. Yet all of them negotiated orientalist expectations that naturalized stereotypes of "Eastern" femininity.

While Lipton's work with these stereotypes required changing the color of her skin so that it would conform more closely to white ideas of the East Asian "exotic," black models were also chosen for their "exotic" look. Photographers, designers, and art directors produced a generalized "African" aesthetic that relied heavily on African animal skins and prints to connote primitivist ideals. These props and prints promised the timeless energy and libidinous vitality of the untamed self, the id without the superego: irrational, wild, sexually potent. Unlike the civilized denizens of Manhattan and Palm Beach, according to this narrative, primitives are free, in tune with nature, uninhibited. Anthropologists and others produced these primitivist tropes within the longer history of scientific racism and European colonialism; they have been constitutive in the production of modernity itself. Photographers and advertisers drew liberally from this longer history of primitivism in representing the black women who first broke through the color line in modeling in the 1960s.

Model Donyale Luna's historic work with Richard Avedon in 1965 exemplifies the imbricated discourses of racial primitivism and modernity within high-end fashion modeling. In March 1965, *Harper's* photographer Richard Avedon guest-edited a special issue of the magazine, and he and Luna made fashion history when Luna featured in the first editorial fashion photographs featuring an African American model to appear in an elite, white US fashion magazine. The fallout over this photo shoot was one of several factors that led to Avedon's resignation from *Harper's* after a career of over twenty years, while Luna ended up moving to Europe to pursue her modeling career. Yet their work together at *Harper's* played a central role in convincing fashion editors that work with black models was possible within the whitestream industry, paving the way for Naomi Sims's crossover work just a few years later.

The mixed-ancestry model Donyale Luna (born Peggy Ann Freeman to working-class parents in Detroit in 1946) began calling herself "Donyale" in high school. According to her sister, she was a "very weird child, even from birth, living in a wonderland, a dream," with a striking personality and long, slender limbs. With apparently few natural acting abilities, Luna—a last name she adopted in the early 1960s, perhaps in reference to the era's fascination with

lunar expeditions—began acting in Detroit's black community theatre productions. According to Richard Powell's painstaking research, a Detroit theatre director remembers her as "kind of a kook," walking around barefoot and feeding the pigeons in Civic Center Park.[126] Her classmate and friend Saunders Bryant III explained their unconventional interests: "We were the last of the Beatniks," hanging out in coffeehouses and wearing black beatnik apparel. In 1963, while Luna was still in high school, she encountered David McCabe, an English photographer (based in New York) who was in Detroit photographing for the Ford Motor Company.[127] When McCabe saw her strolling down the street in her school uniform's plaid skirt, he found her incredibly striking and approached her with one of his cards. He encouraged her to come to New York to work as a fashion model, and she moved there in October 1964. Once in New York, McCabe introduced her to *Harper's Bazaar* editor in chief Nancy White, art directors Ruth Ansel and Bea Feitler, and model and fashion editor China Machado. Luna accepted an exclusive one-year contract with the magazine, and in January 1965, appeared in several drawings by Katharina Denzinger, including the cover illustration, for a feature titled "New Proportions '65." Denzinger, a German-born fashion illustrator and model who moved to New York in 1962, drew Luna with vivid colors, heavy lines, and flattened pictorial space; Luna's impossibly long arms and legs exemplify, perhaps, the season's "chic proportions." Denzinger's drawings may have been inspired by Joan Miró, whose profile appeared immediately before the Denzinger sequence as part of the issue's feature on Spain's "illusive Iberians"; Avedon's photographs for this shoot featured dark-haired models dressed in Emilio Pucci's "crepe Harem dress" and "African geometrics."[128] China Machado, who was at that time working as a fashion editor for *Harper's Bazaar*, soon introduced Luna to staff photographer Richard Avedon.

The timing was perfect, as Avedon was soon to guest-edit an important issue of *Harper's* on youth culture, and he was looking for ways to crack open the high-end fashion magazines' refusal to work with black models. Avedon came from a New York, Jewish immigrant family with roots in the clothing trade. He attended Dewitt Clinton High School, a celebrated, integrated public school whose students mostly reflected the second-generation, leftist, assimilationist Jewish culture that helped shape New York intellectual and artistic life in the mid-twentieth century (alums included, for example, Waldo Frank, Henry Roth, and Lionel Trilling). While at Dewitt, Avedon began his lifelong friendship with the black, gay writer James Baldwin; as inseparable friends, they coedited the school literary journal *The Magpie* and in 1946 collaborated on a never completed text-image project, "Harlem Doorways." But

documentary in the tradition of Walker Evans and James Agee didn't work for Avedon; rather than perform what Sara Blair has called "racial espionage" in Harlem, Avedon found his passion in fashion photography, where he felt himself to be—productively—a "spy in another country," focusing on "the confusing nature of beauty, the uses of power, and the isolation of creative people."[129] Avedon had begun his career at *Harper's Bazaar* in the 1940s, and by the mid-1960s, still working for the magazine, was postwar America's most famous photographer.[130] He transformed fashion photography in many ways, including emphasizing the model's movement and, in at least one model's view, her femininity and her authenticity. Rather than asking the model to strike a pose and freeze, Avedon moved around the model with his camera, keeping up a conversation, explaining what it was he wanted her to feel and express. As model Dorian Leigh remembers, he transformed the business because "Dick wanted his models to look like real people wearing real clothes; he wanted real expressions on their faces."[131]

Avedon's work with Luna at *Harper's* emerged on the heels of Avedon's engagement with the civil rights movement and his increasing impatience with the fashion industry's racism. Although the fight for civil rights had been ongoing, the mainstream press treated the movement as a regional issue until May 1963, when as a result of organizers' "Project C" (for "Confrontation") photographs of Birmingham, Alabama police brutality against peaceful demonstrators became front-page news throughout white America. Baldwin himself appeared on the May 17 cover of *Time* with a story about Birmingham; in this context, other well-known photographers, such as Magnum's Bruce Davidson and Henri Cartier-Bresson, as well as Avedon, headed south to document white racism and publicize the movement.[132] In 1963, the year he met Luna, Avedon and James Baldwin collaborated on a new antiracist photo-text project, one that they hoped would join the mass public of his fashion work with Baldwin's ascending literary fame to produce a coffee-table "photographic polemic about racism."[133] Avedon traveled to Georgia and Louisiana to document white racism (as in his chilling portraits of the generals of the Daughters of the American Revolution) and black resistance (documented by his photographs of the leaders of the Student Nonviolent Coordinating Committee, among others). Produced in collaboration with designer Marvin Israel, *Nothing Personal* represented a stark departure from the documentary-inflected image-text collaborations that had preceded it.[134] Created separately from one another, Baldwin's text and Avedon's photographs are interwoven throughout the book; the photographs work within a discourse of concerned portraiture,

rather than documentary, and Baldwin's text makes its meaning independently from the book's visual components.

Baldwin's passionate, stream-of-consciousness narrative chillingly ties the contemporary racial crisis to modern consumer culture, emblematized by the white model's parasexuality: "I used to distract myself, some mornings before I got out of bed, by pressing the television remote control gadget from one channel to another," Baldwin begins. "Blondes and brunettes . . . washing their hair, relentlessly smiling, teeth gleaming like the grillwork of automobiles, breasts firmly, chillingly encased—packaged as it were—and brilliantly uplifted forever . . . sex wearing an aspect so implacably dispiriting that even masturbation (by no means mutual) seems one of the possibilities that vanished in Eden."[135] For Baldwin, the mechanical parasexuality of the model selling hair spray, cigarettes, and Wonder Bread exemplified America's parched landscape of despair, while nature—water, snow, the unrehearsed voice—offered redemption.

The book featured four photographic portfolios, including one of racists and activists, drawn from Avedon's travels in the South during 1963.[136] At times, the book's stark juxtapositions make it very clear where the artists' sympathies lie: full-page close-ups of black student activists Jerome Smith and Isaac Reynolds gaze quietly at the camera, a "Freedom Now" button visible on Smith's lapel (fig. 5.6); the following page spread features two repelling portraits of George Wallace, looking stubborn, insincere, and ratlike. Avedon considered his photographs for the project, which appeared only three months after the passage of the Civil Rights Act, "some of my very best work."[137] Off-camera, Avedon had tried, unsuccessfully, to raise money for the civil rights movement from within the fashion industry: "I find it hard to believe," he told Doon Arbus, "that [in] an entire industry I wasn't able to come up with $20 contribution to the Civil Rights Movement in 1964."[138] On camera, Avedon began looking for African Americans as models as a way to break high fashion's color line.[139]

Luna in Galanos: Glamour and Race

Model Donyale Luna's historic work with Richard Avedon in 1965 broke open the high-end fashion modeling industry to black models, but did so through a racial script that brought together both primitivism and modernity as the material preconditions for black participation within the industry. The 1965 *Harper's* issue represented US fashion's recognition of the hegemony of youth culture, a development that, in the fashion and music world, has been under way

[margin handwriting: good summ.]

FIG. 5.6 Jerome Smith and Isaac Reynolds, civil rights workers, New York,
December 10, 1963. Photograph by Richard Avedon. © The Richard Avedon Foundation.
From Richard Avedon and James Baldwin, *Nothing Personal* (New York: Atheneum, 1964).

in Britain for some years. Avedon used the issue, which he guest-edited with the London-based gay freelance designer Nicky Haslam, to interpret American youth cultures—including black culture—for a white, mainstream audience.[140] The issue promised a "partial passport to the off-beat side of Now" and included a glossary of contemporary slang, much of it drawn from black culture (e.g., "jive," "groove," "bread"); a feature on op and pop fashion; a Tom Wolfe essay on "the new chic," a series of Avedon portraits of female models dressed as astronauts; and a model reclining on a "moon beach" by the Sea of Tranquility. The avatar of British mod youth culture, Jean Shrimpton, made her US fashion debut on the cover, photographed by Avedon as an astronaut wearing a pink space helmet. Modern artists Jasper Johns and Robert Rauschenberg, as well as a young Bob Dylan, appear in full-page portraits. Visually, the issue was a stark departure from prior issues. Roy Lichtenstein's full-color *Pop Art Fantasy*, as well as Avedon's photographs of "Galactic Girls" adorned in space helmets and moon-silver tights, for example, cover the pages in a full bleed.

Avedon marked his departure from past issues through his choice of models. On page 178, favorite Avedon model China Machado—identified as "our own China"—spins skyward in Galitzine pajamas, while on the opposite page an unidentified black model cavorts in Valentino. Then, on pages 184 and 185, Luna appears with Avedon favorite model Veruschka frenetically dancing "the frug." As if to prepare the reader for Luna in couture, the next page spread celebrates a heavier white model as "the new Botticelli girl," while the caption reads, "We recognize, and revere, as many kinds of individual feminine beauty as there are forms in nature."[141] The following feature, "Luna in Galanos," named Luna in both the title of the piece and the caption, and showed Luna in four James Galanos gowns, one design per black-and-white page, each in a full bleed. Luna modeled the two dresses in the next feature as well, which featured a moiré-patterned fabric inspired by the work of physicist Dr. Gerald Oster. Later in the issue, Avedon included a one-third-page portrait of a very young Lew Alcindor (after 1971, Kareem Abdul-Jabbar) in uniform, palming a basketball, looking down at the camera while a city apartment building looms behind him; the caption offers the eighteen-year-old Alcindor as a sign of the future, an example of "what's about to happen in basketball."[142]

But if *Harper's* editor Nancy White was willing to break the color line—however briefly—with Luna, several of the couture designers whose work appeared in the *Harper's* pages were not. The 1965 issue corresponded to when the magazine was scheduled to showcase the work of Mainbocher, the American designer who had made his reputation in Paris in the interwar years. But Mainbocher, who had veto power over who modeled his work, refused to allow

Luna to appear in his designs. "My customers come from Texas," he explained. "To see a black girl in a dress that they might wear is to absolutely end the possibility of their buying the dress." Avedon turned to the younger designer Norman Norell, who responded, "Out of the question."[143] Finally, Avedon secured James Galanos's permission to have Luna appear in his designs. Avedon, however, was pretty sure that Galanos "hated" his Luna photographs, "hated what his clothes looked like, and hated what Luna looked like in them"; Avedon suspected that Galanos was expecting a celebrity model like Lena Horne.[144]

Luna's placement alongside pop art, moon suits, kinetic fabric, and other avatars of the "now" situate her as an emblem of the modern, the contemporary, and, implicitly, the future. But although Avedon's 1970s interview suggests how he sought to distance his work with Luna from "that noble savage business," the photographs and their captions show the persistence of the visual and material discourse of racial primitivism.[145] In figure 5.7, Luna crouches on all fours while sheathed in James Galanos's tiger-print chiffon; on the opposite page, figure 5.8, Luna claws at the camera while wearing Galanos's diaphanous, leopard-skin design, also made of silk. Animal-skin fabrics, posing on all fours, paw/hand raised with claws/fingers extended—these photographs situate their meaning within a long history of primitivist discourse that places black bodies closer to "nature," to the wild, to a timeless vitality. In another photograph from the issue, Luna poses in a silk floral Galanos sheath, more typical of his work in this period. Yet even here, Luna's glamorous elegance is exoticized and racialized by the caption, which describes "the tall strength and pride of movement of a Masai warrior: Donyale Luna, gauzed in silk." Outside of animal-print chiffon, it seems, Detroit's Peggy Ann Freeman's could be legible to *Harper's* audience only via a reference to timeless, premodern Africa. Together, these photographs and captions participate both in glamour and in a longer history of representing the black body that would have been familiar to white audiences.[146] In this one Avedon shoot from 1965, then, we can see the twin, imbricated discourses of primitivism and modernism.

While Galanos's animal-skin prints reference a longer history of racial primitivism, at the same time his work, and his favorite material—chiffon—represented the epitome of glamour for fashion audiences. Chiffon is an elegant, sheer silk weave with a soft drape and shimmering translucence, associated with both French evening gowns and intimate wear; knowledgeable American audiences associated the fabric with both French haute couture and with the glamour that France represented for 1960s audiences.[147] Galanos, one of the twentieth century's most prominent US-based designers, established his own label in 1952 in Los Angeles, after a period working as an apprentice designer

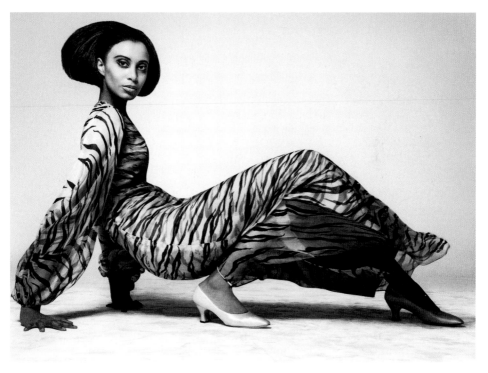

FIG. 5.7 Donyale Luna in James Galanos, February 9, 1965. Photograph by Richard Avedon. © The Richard Avedon Foundation. Published in *Harper's Bazaar*, vol. 98, issue 3041 (April 1965): 190.

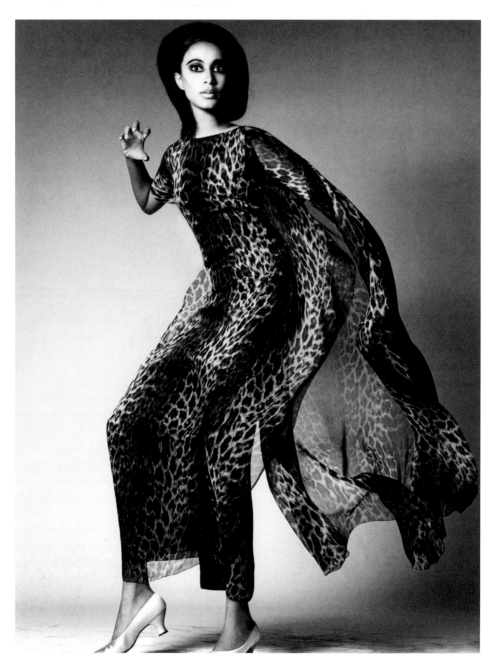

FIG. 5.8 Donyale Luna in James Galanos, February 9, 1965. Photograph by Richard Avedon. © The Richard Avedon Foundation. Published in *Harper's Bazaar*, vol. 98, issue 3041 (April 1965): 189.

to Paris couturier Robert Piguet. Based in Beverly Hills, Galanos designed personal wardrobes for a number of 1950s stars, including black entertainers Lena Horne, Diahann Carroll, Diana Ross, and Dorothy Dandridge, but he eventually focused his work on California-based society women, most famously the future First Lady Nancy Reagan.[148] In 1954, at the age of only twenty-nine, Galanos became the youngest designer ever to receive the prestigious Coty American Fashion Critics Award.[149] Galanos's designs are known for their exquisite craftsmanship, with construction techniques and finishing details that met the highest standards of French couture. Galanos worked in the finest fabrics available for his luxurious evening gowns and, in particular, his preferred chiffon.

Galanos aspired to glamour in his work, an enigmatic quality that epitomized style and is traced, historically, to the Hollywood star system for which Galanos also worked. His entrée to Hollywood was through his friendship with Hollywood costume designer Jean Louis, whom he had met in the mid-1940s; Galanos's first movie costume designs were for Rosalind Russell in the film *Never Wave at a WAC* (1953).[150] For the rest of his career, Galanos sought to imbue his work with the elegance, elite status, and workmanship that he associated with both the term "glamour" and the golden age of Hollywood. In 1999, in an interview with Robin Abarian for the *Los Angeles Times*, Galanos scoffed, "The stars look no better than the average person on the street today. You want to talk about the ' 40s? Those were movie stars whose whole thing was to look magnificent and glamorous. . . . People would just gape and reach out because it was something they needed in their lives."[151] "Gape and reach out": Galanos here references the materiality of glamour, its vital capacity to elicit the haptic.

Because of the racism directed toward Luna by American designers, Avedon turned to Bill Blass and Pauline Trigère to make new work for her to model. They used fabric made from the kinetic, optical designs of physicist Dr. Gerald Oster, whose work had recently opened at New York's Howard Wise Gallery.[152] Oster was a chemical engineer whose research concerned polymers, or plastics; he began his second career in op art after taking LSD, when he had been impressed by the dancing dots, lines, and spirals seen when one puts pressure on one's closed eyes, especially while tripping.[153] These purpose-made silk dresses indeed looked avant-garde, with their bold geometric patterns and layers of stripes and lines. In figure 5.9, Luna poses as an elegant figurehead, her long arms framing a sheath of striped organza, which billows behind her. The photograph connotes forward movement and modernity, elegance and glamour, simultaneously.

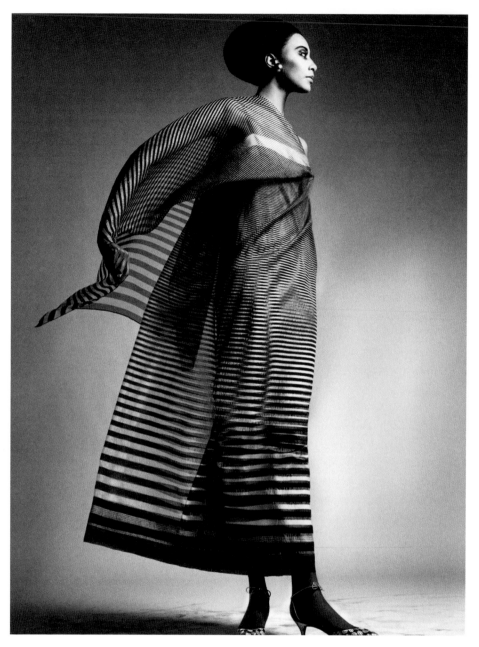

FIG. 5.9 Donyale Luna in a "simple and proud column of crepe, striped in black and white, loosely covered in striped organza which, touching the body, seems to break into shimmering waves," February 8, 1965. Dress by Pauline Trigère, with fabric based on the optical designs of physicist Dr. Gerald Oster. Photograph by Richard Avedon.
© The Richard Avedon Foundation. *Harper's*, vol. 98, issue 3041, April 1965, 192.

Clothing, as we see in these Avedon photographs, is a type of material perhaps unparalleled in its affective claims on the human. These silk sheathes—translucent, sheer, second skins—signal to Luna how to engage with the material, how to move her body, which gestures to deploy. Yet Luna also brought to this particular shoot her own embodied history as a model performing with things, and this somatic history came together with Avedon's usually minimalist stage directions to script Luna's performance as she transformed a finely crafted object—an expertly tailored silk garment—into a thing: an animated gown, rippling with vitality and coiled energy. As Robin Bernstein has argued, material culture can be a "scriptive thing," which "like a play script, broadly structures performance while simultaneously allowing for resistance and unleashing original, live variations that may not be individually predictable."[154] Things invite us to move according to a particular script; things—not just words—interpellate us in specific ways, combining narrative with history and materiality to structure specific gestures and movements. At the same time, Luna makes her own interpretive choices, working with her own affective engagement with the material, as she "dances with things," undoing the work of glamour as a white racial project. The dominant expectation, given the larger historical context of this particular fashion shoot, is one of racial primitivism; Luna and Avedon, however, construct and perform an oppositional black glamour.

By the World War II period, as we saw in chapter 3, glamour had become a technology not only of modern capitalism but also of whiteness itself. Glamour's whiteness was signaled, in Julian Carter's term, through race-evasive codes: "The ability to construct and teach white racial meanings *without appearing to do so.*"[155] By the mid-1960s, when Luna and Avedon began their collaboration, the imbrication of whiteness and glamour had become so intimate that it was nearly impossible for white audiences to conceptualize black glamour in the context of white print culture, and both Luna and Avedon struggled to develop a gestural vocabulary to connote it. Avedon, for one, continued his efforts after he had left *Harper's* for *Vogue* in early 1966. He requested Luna for one of his first photo shoots for *Vogue,* set in northern Japan, featuring furs. "I wanted the model to be Donyale Luna," Avedon told interviewer Doon Arbus in 1972, "because the thought of this tall, sort of this extenuated black girl who had this terrific sense of physical history about her ... there was no way of not being reminded of Egypt and not being reminded of Watusis and Africans, and no way of not being reminded of something that hadn't even happened yet."[156] In this one sentence, Avedon conjoins Africa, usually connected to the timeless

past in primitivist discourse, to the future, to modernity, to that which hasn't yet even happened.

But *Vogue* editor Diana Vreeland and former *Harper's Bazaar* art director Alexey Brodovitch, then working as a freelancer, resisted Avedon's choice, encouraging him to select the model Veruschka, with whom Avedon often collaborated. As a compromise, Vreeland encouraged Avedon to bring both Luna and Veruschka on the shoot, but as the day of departure drew near, Vreeland summoned Avedon to her red office at *Vogue* and flatly explained that Luna could not go on the trip. Avedon's twenty-seven-page photo essay starring Veruschka, titled "The Great Fur Caravan," eventually appeared in the October 16, 1966, issue, after Avedon had left *Harper's* for *Vogue*. Ironically, in 1966, *Vogue* named Donyale Luna "The Model of the Year."[157]

Andy's Queer Accessories

We can see how queer subjectivity and sensibility shaped some of Donyale Luna's fashion and art worlds in New York in the mid-1960s. Her extraordinary glamour, in which she transformed objects into things as part of capitalism's queer alchemy, unfolded in the context of one of New York's most important cultural scenes of the 1960s: the queer, art subculture organized around Andy Warhol. Luna pursued her love of theatre by attending productions featuring writers such as Lorraine Hansberry and LeRoi Jones, with actors such as James Earl Jones and Sammy Davis Jr. She was a regular at Sammy Davis Jr.'s all-night parties, and hung out with musicians such as Miles Davis.[158] She became a muse and model for the German-born artist Abdul Mati Klarwein, whose psychedelic paintings provided cover art for albums by Miles Davis, Jimi Hendrix, and Carlos Santana.

In the winter of 1965, around the same time that Avedon was photographing her for *Harper's*, Luna began hanging out with Andy Warhol and his newly established "Factory" on East 47th Street. Warhol's entire career exemplifies the queerness of the commodity. Of all twentieth-century cultural producers, Warhol used his nonnormative sexuality (not just same-sex desire but also voyeurism and fetishism) as the conduit through which he queerly interrogated the porous boundaries between the commodity and art, between objects and things. As a folk artist of capitalism, Warhol eschewed the art world's antipathy to the market and instead valorized mass production and the culture industries of Hollywood, fashion, and celebrity culture more generally. Even his name documents his intimate, intersubjective relationship to consumer culture and glamour: the name Warhol resulted from a misspelling of Warhola when one

of his illustrations for *Glamour* magazine was published in 1949—Warhol retained this misspelling from then on. Warhol's early career in New York brought him into intimate contact with the fashion and advertising industries, as he supported himself through commercial art, specializing in women's accessories, especially shoe illustrations—a niche that suited him perfectly, as he loved not only shoes but also feet. He entranced Madison Avenue's receptionists and art directors—especially the women—speaking in what his biographer described as a "fey whisper" and adopting a persona that was a mixture of "traumatized naivete and hipster innocence."[159] By the mid-1950s, according to Calvin Tomkins, Warhol had become the "most sought-after illustrator of women's accessories in New York," with his work appearing in the national women's and fashion magazines, including *Vogue* and *Harper's Bazaar*.[160]

As Gavin Butt and Jonathan Flatley have argued, Warhol's birth as a pop artist working with commodities such as Campbell's soup cans in the early 1960s can be seen as a response to his shaming as an effeminate gay man in the 1950s.[161] Warhol's approach to mass culture, including his fascination with models, doubled as a form of gay identification in the intensified homophobia of the McCarthy era.[162] Rather than butch up, as Noel Coward recommended to Cecil Beaton decades earlier, Warhol instead transformed his look to accentuate his swish signifiers: wearing silver wigs slightly askew; exaggerating his dancer's walk and limp wrists; changing his voice to produce inflected, whispered, monosyllabic, and usually nonsensical utterances. Warhol parodied himself, and the stereotypes of gay femininity, before anyone else had the chance. Butt convincingly shows how Warhol made himself into an avant-garde artist through a reworking and exaggeration of these abject homosexual signifiers, a journey from working-class fairy to upper-strata dandy.

Warhol, who worshipped at the altar of glamour and fame, hosted many models at the Factory and elsewhere, including Jean Shrimpton, Twiggy, Verushka, Penelope Tree, Ivy Nicholson, and Donyale Luna. At the Factory, Luna's spectacular femininity mapped onto Warhol's love of excess and artifice in the production of gender; her outrageous proportions, invented persona, and outsider elegance made Luna an obvious queer fellow traveler. Indeed, we might think of Warhol's glamorous models, including Luna, as his queer accessories. In Warhol's Factory, the materiality of silk, Galanos's preferred fabric, acquired new meanings. In Avedon's studio, Luna used her lithe body and long limbs to invigorate Galanos's silk sheaths with both glamour and atavistic intensity (fig. 5.8). Here, silk screens her body in multiple layers; Luna's body is an aesthetic contact zone that, through silk, provides an affective excessiveness—a sense of allure, vitality, or desire—that is one of glamour's key technologies.

At the Factory on East 47th Street, Warhol had also discovered silk. In 1962, Warhol began photo-silk-screening, starting with male stars; but with Marilyn Monroe's overdose on August 2, Warhol shifted to silk-screening female glamour. Silk-screening was faster and easier than painting, and also removed the obligation of the artist's hand; after June 1963, it was Warhol's assistant Gerard Malanga who physically did the work, coaxing the ink through the screen, made of silk, to the canvas below. Wayne Koestenbaum ties Warhol's screen-printing to his screen tests of the same period, emphasizing how both media introduced distance between Warhol and the viewer.[163] Silk screens are literally nets, or meshes, composed of a material associated with high-end women's wear; as Koestenbaum observes, "His beloved silkscreens were structures of enchainment and enchantment."[164] Glamour as a technology of modernity requires both intimacy—here, provided by silk as the mediator linking the body to the world—and distance, whether the distance of the screen or the magazine page.

Luna also participated in Warhol's *Screen Tests* series, and in late 1965 appeared in Warhol's *Camp*, a queer and camp send-up of the late-night variety show.[165] The show referred directly to Susan Sontag's 1964 "Notes on Camp," which had focused, in part, on Warhol's queer scene, referred to in the film, and in Sontag's essay, as "The 'In' Crowd." Sontag memorably defined "Camp" (which she capitalized in her essay) against what she called a "natural mode of sensibility."[166] "Indeed," she wrote, "the essence of Camp is its love of the unnatural: of artifice and exaggeration."[167] The word, she argued, described a sensibility, a private code, and a badge of identity all at once. For Sontag, artifice and the nonnatural were central to this urban, subcultural sensibility: "All Camp objects, and persons, contain a large element of artifice. Nothing in nature can be campy."[168] For this reason, Warhol loved Luna, whose femininity and performance as self were as artfully constructed as that of drag queen Mario Montez, whose performance of "bad" femininity also appeared in the film, and whose drag exemplified another defining characteristic of camp—"the exaggerated, the 'off,' the things-being-what-they-are-not."[169] Luna played "herself" in Warhol's film, modeling and dancing at the film's close. As part of Warhol's camp circle, Luna became an emblem of artifice—the camp antithesis to the natural—while at the same time performing white constructions of the natural—racial primitivism—through Galanos's gowns; in this way, Luna exemplified modernity's ambivalent relationship to racial difference. Later, when in Europe, Luna told *Time* magazine that she was happy to leave New York, which was a site of "bad things," which she did not mean in a camp sense.[170] "People were on drugs or hung up on pot," she said. In one of the few explicit,

mainstream references to the scene's gay milieu, Luna noted one of the reasons she was interested in leaving was that in New York "there was homosexuality and lesbianism and people who liked to hurt."[171]

Warhol saw and appreciated the artifice that Luna embodied as an ethereal model with an invented past, and even race. Within Warhol's queer art world, Luna was a star because of her exaggerated femininity, her posing, her artifice. And while fashion photographers were in the business of producing such artifice on film, the "fact" of Luna's blackness remained incontrovertible within the racist economy of the fashion world; race, and racism, rendered her beauty and glamorous femininity invisible to most fashion brokers. Avedon's work with Luna was controversial: reportedly, advertisers in southern states pulled their advertising; some subscribers cancelled; and publisher William Randolph Hearst was unhappy.[172] In the wake of this reaction, *Harper's* barred Avedon from photographing Luna again for the magazine. Soon after, Avedon left *Harper's* after his decades-long career at the magazine; he moved to *Vogue*, where he continued to work through the remainder of his life in fashion. Meanwhile, Luna decamped to the United Kingdom, where David Bailey photographed her for the cover of British *Vogue* in March 1966—the first non-white model whose photograph was featured on the cover of a major fashion magazine.[173] By April 1966 Luna's career had taken off in Europe, with a role in Fellini's *Satyricon* (1969) and photographs in *Paris Match*, Britain's *Queen*, the British, French, and American editions of *Vogue*, among other magazines; *Time* argued that she was "unquestionably the hottest model in Europe at the moment." Sadly, Luna died of a heroin overdose in Italy in 1979, at the beginning of the industry's drug-use zenith.[174]

In the context of black nationalism, the celebration of African heritage, and the art's emphasis on surface (from Warhol to Pollock) in the 1960s, black models themselves coproduced and reworked the meanings of both blackness and "Africanness" in these images, often tying primitivist tropes to emblems of modernity. For example, Elizabeth of Toro, a Ugandan educated in law at Cambridge and relocated to New York, modeled for Irving Penn for *Vogue* in 1969. In a *Life* feature of the same year, Elizabeth had been photographed "exotically at home in her Sutton Place apartment" (fig. 5.10).[175] Two zebra skins and several zebra pillows energize the image with their strong lines. Elizabeth sits, barefoot, long legs apart, upon an African tribal drum, wearing a very short knit dress that exposes much of her dark skin, including shoulders, arms, and legs. Behind her, two bongo drums sit below an Andy Warhol silk-screen of Marilyn Monroe. The zebra skins and the Warhol print are not props; this is how Elizabeth had chosen to decorate her own apartment. As Anna Cheng has

FIG. 5.10 Elizabeth of Toro, "Black Is Busting Out All Over: Black Models Take Center Stage." *Life*, October 17, 1969, 39. Photograph by Yale Joel.

suggested in her work on Josephine Baker and modern surface, skin as surface staged the crosscurrents of the modern and the primitive, bringing together and holding in tension the dichotomies of modernity: whiteness and its racialized others; human and machine; organic and inorganic; barbarism and civilization. As Cheng quotes Warhol, whose portrait of celebrity surface femininity overlooks the animal skins in this portrait of Elizabeth, "If you want to know all about Warhol, just look at the surface."[176] Modern primitivism, in other words, can be a complex dialectic between the primitive and the modern, between an "authentic" blackness and glamour, one of modernity's key technologies; like other aspects of the modeling industry, these contradictions are coproduced and held in tension by the models themselves, who use them to lay claim to the elegance, glamour, and sophistication that has been, historically, racialized as white within nonblack interpretive communities.

Over the course of this chapter, I've described mid-1970s feminism's uneasy relationship to both mainstream beauty culture and technology, as feminists celebrated (nontrans) women's biological differences from men while at the same time creating an alternative, countercultural movement designed to re-valorize women's "differences" in the context of patriarchy. The grounding of second-wave feminism in essentialist notions of female biology proved especially problematic for transsexual women, some of whom found themselves to be targets of second-wave feminist transphobia. Although some of these developments with the history of feminism appear far removed from the politics of modeling, I would like to suggest that they are not. The battles over the presence of trans women within the women's movement were staged through competing definitions of nature and the natural, a larger cultural discourse that shaped both second-wave feminism and the modeling industry in the 1970s. Unfortunately for trans women, including trans models, the feminist critique of the presence of trans women within the women's movement won out over the vociferous expressions of feminist solidarity with trans women that also marked this period. While the look of advertising shifted during the 1970s to accommodate feminist critiques of the media's representation of women, often by representing glamorous models in the confident, gendered poses of liberated femininity, the modeling industry stopped short of (knowingly) hiring models whose body history exemplified the crossing of gender lines celebrated within the ads.

The tensions within the women's movement over the place of trans women broke open in the early 1970s. In 1972, the San Francisco based lesbian rights group the Daughters of Bilitis (DOB) split over the issue of whether or not trans women were "really" women, and eventually expelled their vice president, an out transsexual woman. In voting to exclude transsexual women, some DOB members described them as "only synthetic women," drawing on the nature/technology distinction so prominent during the era.[177] In response to this transphobia, the entire staff of *Sisters* magazine, an older DOB monthly, resigned their positions and membership in protest.[178] Robin Morgan, who we remember from her role in the Miss America Pageant protest of 1968, played a central role in developing the 1970s' antitranssexual, feminist position based on essentialist notions of female biology at the 1973 West Coast Lesbian Conference, held in Los Angeles. Toward the end of her keynote speech, Morgan denounced folk singer Beth Elliott, a well-known feminist, activist, and transsexual woman, who had been invited by conference organizers to perform the

previous day. In her speech, Morgan referred to Elliott as a "transsexual male" and used male pronouns throughout, calling Elliott "an opportunist, an infiltrator, and a destroyer—with the mentality of a rapist."[179] According to the *Advocate*, members of the Transsexual Action Organization, a trans rights organization founded by Angela Douglas, promptly hexed Morgan.[180]

Elliott herself responded to Morgan's antitrans vitriol with a very moving essay in *The Lesbian Tide*, in which she lamented the increasing tone of Inquisitional self-righteousness at the conference, in which "everyone seemed to feel she had the right true gospel of liberation and everyone else was a Threat To The Movement."[181] Elliott discussed her transsexuality through an essay in the form of a dream in which she was on trial before Pope Robin for daring to call herself a woman and a lesbian. Within the dream, Elliott sought to complicate Robin's simplistic account of the relationship between "biology" and sex: her testimony drew on contemporary medical science concerning the role of hormones in shaping gender identity, which Elliott was careful to distinguish from biological sex and feminist theory critiquing sex role conditioning, among other strategies to complicate Morgan's essentialist standpoint. But Elliott knew she fought a losing battle: "YOUR BIOLOGY IS YOUR DESTINY," Elliott had Morgan thunder within the dream. In response to this declaration, Elliott questions what Morgan (and by extension, other antitranssexual feminists) means by "biology": "What? I don't get that. Look. The doctors are saying I am a woman with a defective body, for all practical purposes. . . . *That's* my biology."[182]

While Elliott sought a more nuanced understanding of sex, one that took hormones, social conditioning, and gender identity into consideration, antitranssexual feminists such as Morgan were unwilling to redefine sex. The antitranssexual position within one strain of radical feminism became widely known later in the decade through the publication of two books that were heavily circulated within middle-class, white feminist circles: feminist theologian Mary Daly's *Gyn/Ecology* (1975) and her student Janice Raymond's *The Transsexual Empire: The Making of the She-Male* (1979). Both books saw the transsexual as a human-machine hybrid, a Frankenstein that invaded women-only space, "raping" women through the technological appropriation of "natural" womanhood. Transsexuality represented one of phallocentric technology's most pernicious forms, a male desire to create synthetic women: as Daly argued in 1975, "Transsexualism is an example of . . . the projected manufacture by men of artificial wombs, of cyborgs which will be part flesh, part robot, of clones."[183] Within this biologically essentialist vein of feminist critique, both models and

transsexuals were Frankensteinian monsters, bringing together technology, artifice, and industry in the production of manufactured femininity.

Raymond's book was a polemic against the male-dominated medicine, using transsexuality as the case study.[184] In Raymond's view, transsexuality was an "invention of men" originally developed "for men"; "it should not be surprising that men," she wrote, "who have literally and figuratively, constructed women for centuries [a reference, in part, to beauty culture] are now 'perfecting' the man-made women out of their own flesh."[185] For both scholars, transsexual women were synthetic, man-made technologies, not "real women"; like the cyborg housewives in the 1975 film *The Stepford Wives* or the human-machine Plastic-Girly-Symbols posing in their bathing suits and evening wear at the 1968 Miss America Pageant, transsexual women were manufactured stereotypes of normative femininity produced to please men. In discussing the feminist controversies over transsexual women within the movement, Raymond revisited Morgan's rape accusation from 1973, also echoed in Daly's work in 1975, writing, "All transsexuals rape women's bodies by reducing the *real* female form to an artifact, appropriating this body for themselves."[186] For antitranssexual feminists, the category "real" was reserved for nontrans women; it was an immutable, ontological antonym for the artificial. The rhetoric of realness, artifice, and gendered violence is a clear stepchild of not only Morgan's 1973 attack on Beth Elliott, but also her 1968 critique of the Miss America pageant.

Raymond's writing on transsexuals as rapists can be found in her chapter on transsexual women in the feminist movement, in which one of her key examples was that of Sandy Stone, an out transsexual woman employed by feminist collective Olivia Records as a sound engineer. This phobic episode moment is well known within trans history. But in revisiting this moment, I want to draw readers' attention to a larger historical context: the important intellectual relationship between Stone and her mentor Donna Haraway in this period. Together, Stone and Haraway reconfigured feminist politics away from essentialist notions of gender toward one that eschewed binaries and simplistic notions of "nature"; they developed a profoundly influential feminist epistemology that celebrated the human-machine nexus, the Frankenstein/cyborg figure so denigrated by Morgan, Daly, and Raymond. In reshaping the intellectual and political foundations of feminist thought, Stone and Haraway laid one of the key cornerstones for both a trans-positive feminist politics and, eventually, as popular and commercial culture played catchup with shifting feminist epistemologies, the modeling industry's eventual willingness to work with out trans models.

In the summer of 1977, feminists wrote an "Open Letter to Olivia" to *Sister: West Coast Feminist Newspaper*, which published it along with the Olivia collective's response. The open letter critiqued Olivia Records for not only employing Sandy Stone, whom the letter writers did not regard as female, but also for failing to "out" Stone to the feminist community. In response, the Olivia collective published a defense of Stone, a brief trans-positive primer on transsexuality, and a critique of the Morgan-Daly-Raymond feminist position that transsexual women somehow continued to enjoy male privilege. On the contrary, the collective argued, "because Sandy decided to give up completely and permanently her male identity and live as a woman and a lesbian, she is now faced with the same kinds of oppression that other women and lesbians face."[187] Although Olivia Records was embroiled in controversy and negative publicity for some time, Stone remembers, "To the best of my knowledge, there was never anyone within Olivia who wanted to oust me."[188] As Joanne Meyerowitz has discussed in relationship to antitranssexual feminist scholar Janice Raymond, feminists such as those criticizing Olivia Records saw biology as self-evident, and one's "biological" history as a boy or a girl determined whether or not one was "really" a woman, regardless of how one presented gender (e.g., butch, ultra feminine, etc.).[189]

These radical feminist debates took place during a time in which popular culture, advertising, and the modeling industry were all reconceptualizing the meanings of normative gender and sex, all in response to the political transformation unfolding in the wake of the women's movement. This was a period, after all, in which male student radicals, both black and white, wore their hair long; college-educated lesbians turned to androgyny as style; and middle-class white girls were encouraged to climb trees and to otherwise "be free to be . . . you and me," to quote Marlo Thomas's best-selling record of 1972.[190] But while feminists, mainstream culture, and the modeling industry proved willing to broaden understandings of femininity through the crossing of gender lines, most cultural brokers, certainly within the advertising and modeling industries, drew the line at crossing sex.

The advertising industry capitalized on the second-wave women's movement, in the process expanding definitions of normative femininity within photographic modeling and advertising. Advertising, like second-wave feminism in general, proved willing to enlarge women's gender prerogatives to include masculine signifiers as a means of representing women's liberation. As early as 1967, the Leo Burnett agency began developing their advertising campaign for Philip Morris's new thin cigarette, renaming it Virginia Slims, with the catch phrase "You've Come a Long Way, Baby." In 1970, even Naomi Sims became

one of the "Virginia Slims Girls," as the models were called (see fig. 5.4).[191] In 1973, Revlon launched its Charlie perfume campaign to capitalize on the mainstreaming of feminism; this appropriation unfolded through a campaign that placed female masculinity in the mainstream of American commercial culture. Revlon launched the new fragrance in 1973 to appeal to the "liberated woman," with a male name and an ad campaign that featured its models not in dresses, but in pants. The original TV advertisement featured the lanky, blonde model Shelley Hack striding confidently—in a lemon-gold pantsuit—into a men-only club while jazz musician Bobby Short crooned the fragrance's theme song, "Kinda young, kinda now, Charlie / Kinda free, kinda wild, Charlie!" Wearing pants, gold tresses hidden under a cap, driving alone to a male club, sporting a man's name—these elements all crossed conventional gender lines in 1973; indeed, by post-1990s standards, Charlie is trans, although her more normative femininity is carefully recuperated by the ad's close.[192] Almost instantly, advertisements featuring lanky models crossing gender lines sprouted within the pages of commercial print culture. In figure 5.11, Naomi Sims strides confidently, smiling at the camera over her left shoulder, her right index finger pointed skyward as if to hail a cab. In striking contrast to her flowing dress in figure 5.4, here Sims models the fragrance's distinctive white pantsuit, a garment that had courted controversy throughout the twentieth century because the divided crotch was seen to be immodest for women; in 1973, in the context of federal Title IX education amendments of 1972, among other liberal feminist developments, the pantsuit was a sartorial statement of gender equality (fig. 5.11).

But while the modeling industry was willing to cross gender lines, it was not willing to cross the lines of sex. The transsexual women working in the industry in the 1970s were all stealth; discovery meant an end to their modeling career and the beginning of a second, usually unwanted, career in the tabloids or the burlesque club. At such a moment, the model's parasexuality became instantaneously transformed into a voyeuristic interest in the "fact" of sex, rather than the allure of implied sexuality. Tracey Gayle Norman, for example, is an African American trans woman and ball scene housemother who enjoyed a very successful career as a black female model in the 1970s, landing contracts not only with Clairol's Born Beautiful hair coloring product but also Ultra Sheen cosmetics and Avon skin care. As briefly discussed in the introduction, Norman was not out as trans in the modeling industry, for being out—she feared—meant losing her career (correctly, in her case). Norman's contract with Clairol lasted six years, and during this time, Clairol told Norman, it was the lines' strongest-selling product (fig. I.1).[193] Norman attributed her success, in part,

FIG. 5.11 Naomi Sims, in Charlie ad for Revlon. *Vogue*, August 1, 1976, 21.

to the fact that she looked like a younger version of Beverly Johnson, who later became the first African American model to appear on the cover of American *Vogue*, in July 1974. But when Norman was outed by a production assistant while on an *Essence* shoot in the late 1970s, her US modeling career ended. As Norman told *New York Magazine*, "I just felt so upset about it because it was my people and my community that did this to me. The black community and the gay community."[194] Soon after, she bought a one-way ticket to Paris, where she eventually landed work as a showroom model for Balenciaga, walking two shows a day.

Norman's success as a model was directly indebted to New York's working-class, queer, and trans of color world. Norman became involved in New York's drag ball scene in the 1960s, around the time she began taking hormones. Harlem's drag ball culture emerged in this decade as black and Latino gay men and trans women developed a queer and trans of color alternative to the mostly white gay drag balls that had been part of New York's gay culture since the 1930s.[195] Ball culture brought together gay men and trans women organized into queer kinship "houses," where the contestants would compete on the runway in categories such as "butch queen" or "realness."[196] Norman would go and watch, amazed at the beauties she'd see, until finally some friends pushed her onto the runway, and she began to walk as "Tracey from New Jersey." Sometimes, she chuckled in her interview on the Luna Show (which covers and historicizes the House and Ball community in New York), "it was that black bitch from New Jersey, Miss Tracey."[197] The first ball she walked in was organized and hosted by Paris Dupree, later featured in Livingston's documentary *Paris Is Burning*, at Harlem's Elks Lounge. Norman's immersion in the New York ball scene predated her modeling career, and her performances there directly influenced her later work as a model. In the 1980s, her professional modeling days behind her, Norman reconnected with the drag-ball community—partially as a way to make ends meet, as winners could earn prize money of one thousand dollars. She became a member of the House of Africa and, eventually, a house mother, whose job was (in part) to train and encourage her "children" (other members of the house) on the runway.

Tracey Norman's experience of antitranssexual feeling was typical of the modeling industry, mainstream culture, and some strands of second-wave feminist thought. But within feminism, at least, second-wave certainties concerning the nature/technology distinction began to shift toward the early 1980s, as feminist thought experienced a radical reorientation toward nature in the early 1980s with the publication of Donna Haraway's influential writing on feminism, nature, and technology. In 1983, Haraway began working on her

field-changing critique of biological essentialism, which the *Socialist Review* published as "A Manifesto for Cyborgs: Science, Technology, and Socialist Feminism in the 1980s" in 1985.[198] In this piece, the impact of which is hard to overstate within feminist thought, Haraway described cyborgs as "creatures simultaneously animal and machine, who populate worlds ambiguously natural and crafted."[199] She argued, in stark contrast to radical feminists such as Mary Daly, that all of us are "hybrids of machines and organism; in short, we are all cyborgs."[200] In the context of Ronald Reagan's America and the rise of military technology such as the Star Wars missile defense system, Haraway's essay explicitly critiqued Western (and feminist) dualisms of "mind/body, culture/nature, male/female."[201] Technology is here, Haraway argued, not outside of us, but in us: "Biological organisms have become biotic systems."[202] Haraway drew on contemporary developments in biotechnology, microelectronics, communications, and other new technologies to describe both a new informatics of domination and a radical new politics that refuses an antiscience metaphysics and the "maze of dualisms," such as nature/technology, that had marked recent feminist discourse. With an explicit reference to cultural feminism's celebration of the women's alternative ways of knowing, Haraway concluded her polemic by stating "I would rather be a cyborg than a goddess."[203]

Haraway's dramatic reorientation of feminist thought away from biological essentialism and toward the cyborg grew in dialogue with her PhD student, trans sound engineer Sandy Stone. Stone had moved to Santa Cruz, California, to transition in the early 1970s, and began working for Los Angeles–based Olivia Records in 1975. In 1978, as Stone became a target for lesbian feminists incensed that Olivia Records would knowingly include a trans woman in the group, and with Olivia facing an economically devastating boycott by antitranssexual feminists, Stone decided to leave. Moving back to Santa Cruz, Stone became friends with Haraway, who taught at University of California, Santa Cruz, and who was working on what became "A Manifesto for Cyborgs"; in 1987, Stone enrolled in the PhD program at University of California, Santa Cruz, with Haraway as her supervisor, and graduated in 1993.

In 1987, in close intellectual dialogue with Haraway, Stone published her own manifesto: "The *Empire* Strikes Back: A Posttranssexual Manifesto." This essay quickly emerged as one of the founding texts of trans studies; with a title directly referencing both Raymond and Haraway, as well as the second Star Wars novel and film, Stone responded to Raymond's antitranssexualism by critiquing biological essentialist notions of gender, as well as a medical approach to transsexuality that required trans people to produce gender normative narratives in order to access surgery and hormones. Like Raymond, Stone analyzed

the relationship between medical science and transsexuality; like Raymond, Stone drew on the radical feminist critique of the "phallocracy." Yet, unlike Raymond, Stone critiqued scientific and medical investment in the binary gender system that, she knew from her own personal experience at the Stanford Gender Identity clinic, barred most trans people's access to gender-affirming medical interventions. As Stone argued, "Under the binary phallocratic founding myth by which Western bodies and subjects are authorized, only one body per gendered subject is 'right.' All other bodies are wrong."[204] She concluded her essay with an impassioned call for a "re-envisioning of our lives," one where passing would no longer be the "essence of transsexualism."[205]

Stone's essay, in concert with the trans activism of Leslie Feinstein, Susan Stryker, and many others, helped reshape the meanings of gender and sex within feminism activism and theory. The binaries of the 1970s—nature/technology, female/male—unraveled in the wake of this trans-positive reconceptualization of feminist politics. While these shifts in thinking began in the alternative spaces of sexual and gender subcultures, including their scholarly manifestations, they have eventually reshaped queer, trans, and feminist popular culture. However, while Stone's call has transformed trans politics and activism, the challenges of being out and trans are multiplied when viewed through an intersectional lens. Black, working-class models such as Tracey Norman have had to contend with racial and class hierarchies, in addition to those based on sex, gender, and their embodied histories.[206]

THE STONE-HARAWAY RECONCEPTUALIZATION of the "natural" within feminist discourse found its parallel within some aspects of the modeling industry. As the 1970s ended and the 1980s began, cultural anxieties about the real, the natural, or the authentic appeared increasingly anachronistic. One clear marker of this transformation was the appearance of Teri Toye on New York's downtown arts scene. In 1983, Toye became fashion's first openly transsexual model when she began modeling for queer downtown artists Steven Meisel and Stephen Sprouse; all three of them burst into the mainstream fashion world in 1984, when Sprouse's clothing designs electrified the New York fashion world. Toye had moved to New York from Des Moines to enroll at Parsons School of Design in the late 1970s. After transitioning, she dropped out of Parsons and became part of the vibrant East Village arts scene of the early 1980s, a world that included trans artist Greer Lankton (who made a Toye doll), photographer Nan Goldin (who photographed Toye's wedding in 1987), and others.

Toye met fashion photographer Steven Meisel while jumping on a sofa during a party at musician (and queer impresario) Gabriel Rotello's loft.[207] At the time, Meisel was at the beginning of his career in fashion photography; he was still some years off from making the careers of 1980s supermodels such as Christy Turlington, Naomi Campbell, and Linda Evangelista. As Meisel was getting his start, the modeling industry was rapidly changing in the wake of John Casablancas's success in infiltrating the New York market; even Roy Cohn, the Ford Agency's lawyer, was unsuccessful in stopping Casablancas's Elite Models from poaching the Fords' talent.[208] The competition among the top modeling agencies reshaped the industry as high-end models began shifting rapidly between agencies, demanding and receiving higher prices for their work, and behaving more as independent contractors than loyal employees. In the mid-late 1980s, working out of his Park Avenue apartment, "the Clinic," Meisel created the Trinity—Christy Turlington, Linda Evangelista, and Naomi Campbell—by orchestrating their looks, photographing them together, and imbuing his supermodel entourage with a downtown hipness that added value to their brand.[209] Meisel's roots are in the queer and trans downtown New York art scene, and this history shapes his work. As Meisel told journalist Michael Gross in 1992, his work has always had a "queer sensibility," as he has sought out "more effeminate-looking men, more masculine-looking women, and drag queens" in an effort to show the wide variety of people.[210] Sprouse's eclectic, downtown work was an instant hit when it debuted in 1984: his aesthetic combined pop art, punk, and graffiti with couture, all set to a soundtrack of Siouxsie and the Banshees, and staged at the East Village club The Ritz.[211] Toye, Sprouse's muse at this time, was the star of the show that featured fifty models, 150 outfits, a video screen, strobe lights, and black lights (fig. 5.12).[212] The trio—Sprouse, Meisel, and Toye—were all over the New York fashion scene in 1983–84, with Toye and Meisel announcing a mock engagement at the opening of the club they helped make famous, the Limelight, home to the "Club Kids." Toye's modeling career flourished; she was represented by Click modeling, and walked for Gaultier, Thierry Mugler, and Chanel, among others. In 1987 she married art dealer Patrick Fox and they moved back to Iowa, where she has been working all these years in real estate and heritage preservation.

Toye's work with Stephen Sprouse suggests how irrelevant the "natural" had become by the 1980s. The show that put both Toye and Sprouse on the fashion map in 1984 drew its inspiration from the gritty and graffitied streetscapes of New York's East Village, home to street kids, drug addicts, and artists in a city only just recovering from bankruptcy. Sprouse's clothing brought this urban landscape to high fashion, writing graffiti-influenced words across his

urban landscape to high fashion — "natural" felt outmoded

FIG. 5.12 Teri Toye in red Sprouse dress. Photo courtesy of Teri Toye and Mauricio Padilha.

clothes—and even his models' faces—moments before their turn on the runway. His Day-Glo color palette of electric orange and radioactive greens spoke not of "nature" but the riotous colors of midnight tagging. In the local context of urban decay and the national context of Reagan's buildup of military technologies, with the AIDS crisis unfolding in gay communities such as the Lower East Side and elsewhere, the 1970s embrace of the natural seemed, by 1984, ancient history.

Teri Toye, like Donyale Luna, Tracey Norman, and other models I've discussed in this chapter, performed a spectacular femininity, a performance of gender produced for visual and affective consumption. In the long 1970s, this performative gender modeling found its inspiration in discourses of the natural, the real, and the authentic. In the process, black and Asian models navigated and reworked the industry's racialized expectations that nonwhite models were closer to nature, to the exotic and the primitive, than their white peers. Like all models, their work is a biopolitical production, in which the repetition of corporeal practices produces their own gender, of course, but also that of their audience as they watch, reflect, and purchase. The affective labor in producing gender, or the spectacular femininity of the runway or photographic model, might seem to be most clearly recognized in the careers of trans models such as Tracey Norman or Teri Toye. But such an argument would require understanding the spectacular femininities of nontrans models, such as Donyale Luna, as somehow "natural." Rather, in bringing both trans and nontrans models together in a discussion about the discourses of the "natural" in the long 1970s, I seek to underscore the affective labor underneath the production of *all* glamorous femininities.

As I was drafting this epilogue, model Tracey Norman of 1970s fame got a call from Proctor and Gamble's ad agency, New York–based Grey Advertising, asking her to meet with a mystery client. The client was Clairol. In the face of negative publicity over Clairol's treatment of Norman thirty years earlier, generated in the wake of Jada Yuan and Aaron Wong's cover story for *New York Magazine*'s fashion vertical *The Cut* in December 2015, Clairol deftly turned the page on the company's transphobic history. Clairol wanted the now sixty-three-year-old Norman back, as face of Clairol's new Nice 'N Easy "Color as Real as You Are" campaign. Norman accepted. Heather Carruthers, global Clairol associate brand director, focused on the brand's quality of naturalness, tying it to personal expression and an individual truth: the "Color as Real as You Are" campaign, she announced, "celebrates the confidence that comes from embracing what makes you unique and using natural color to express yourself freely."[1] In the three-minute documentary that accompanied Clairol's announcement, a simple, somber piano melody accompanies a visual story that traces Norman from the streetscapes of contemporary New York to the warm intimacy of her apartment, where she reflects on what she refers to as "her truth." When Clairol reached out to her, Norman explains, she felt that she was finally "being accepted for who I was, and they wanted me to come back as that person." The climax of the piece shows Norman raising her arms to the

New York skyline, exclaiming "Don't be afraid to live your truth . . . it's good to be back, and it's good to be me." As the video ends, strings join the piano and the melody shifts to a poignant minor key while Clairol's campaign tagline fills the screen: "Color as real as you are."[2]

Norman's return to Clairol takes place within a contemporary mediascape transformed by a new visibility of gender nonconforming and trans people, many of them people of color. Thirty years after Norman's career ended in the wake of her outing as a trans woman, times appear to have changed: decades of trans activism has prepared the ground for a new visibility of trans women of color in the American mainstream, from Laverne Cox's award-winning work on *Orange Is the New Black* to Janet Mock's best-selling memoir *Redefining Realness*.[3] In May 2014, *Time* featured Cox on the cover of the magazine, illustrating "The Transgender Tipping Point," a lead story on the changing status of trans people in the United States. In the wake of his highly successful 1992 dance club anthem *Supermodel of the World (You Better Work It)*, RuPaul, a professional drag queen, has since brought the artistry and antics of gender nonconforming queers of color to mainstream audiences through his reality TV show *RuPaul's Drag Race*, an autobiography, and a series of successful albums—one of the more recent of which is *Realness* (2015). Trans and queer gender nonconformity, it appears, is the "in" issue for mainstream media, even while the life chances of trans women of color remain the lowest of any social group, and while state legislatures debate and pass transphobic legislation, such as North Carolina's "Public Facilities Privacy and Security Act" (2016).

Within high-end modeling, out trans models have found a new level of acceptance. In 2015, Serbo-Croatian model Andreja Pejić relaunched her already successful career as an androgynous model after transitioning in 2014; she has since walked for Marc Jacobs and H&M, among others. In the same year, Hari Nef signed on as IMG's first openly trans model, and during New York's Fashion Week walked for Eckhaus Latta and Hood by Air; as of 2015, trans and gender nonbinary models even have their own agency, Trans Models, founded by trans Taiwan-born model Pêche Di and based in New York.[4] Brazilian-Italian trans woman Lea T began working as Givenchy creative director Riccardo Tisci's personal assistant in 2010, and soon emerged as the company's model-muse.[5] In 2014 she became the face of the US hair-care brand Redken—the first openly trans model for a cosmetics company; in the summer of 2016, she led the Brazilian team into the stadium during the Rio Olympics.[6]

But, as Naomi Sims described in the different but parallel context of the white fashion industry's "discovery" of black models in the late 1960s, "It's 'in' to use me and maybe some people do it when they don't really like me. But

even if they are prejudiced, they have to be tactful if they want a good picture."[7] Who knows how long the current industry fascination with trans models will last, or what impact this new visibility will have on the industry, those who pursue the fashion press, or buy the brands these models work for. The example of black modeling in the wake of the 1970s does not suggest a rosy future for trans models within the fashion industry. For example, despite the inroads that black models made in the industry forty years ago, in the shows during New York's Fashion Week in February 2008, there were no black models walking in the more than one hundred fashion presentations that week. As Constance White wrote for *Ebony* that year, "It's as if a sinister, velvet-gloved hand decided to ride back civil rights gains of the last four decades and ignore personal breakthroughs of women like Dorothea Towles."[8] As Ashley Mears reminds us, bookers and other industry cultural brokers are forever on the lookout for new trends, because the look that excites them is one of novelty and difference, especially in the editorial end of the business.[9] Modeling is a capitalist culture industry in which the most important focus is building brands and selling goods: if booking black or trans, or black trans, models will build the brand, excellent—until the next trend captivates the interest of industry insiders. A diversity of genders, sexualities, and races on the runway or magazine page, in other words, does not necessarily translate into sustained civil rights, economic stability, or improved life chances for the larger populations these models might represent.

I BEGAN THIS PROJECT many years ago when researching the history of the body in relationship to US corporate and visual culture.[10] At the time, I was interested in understanding the rationalization of the body under advanced capitalism: captivated by the mechanical dreamscapes of Tiller Girls and Busby Berkeley musicals, I wondered how this Taylorist aesthetic shaped the emerging modeling industry. But over time, I became more interested in the visual and body politics of those both central to, as well as in a nonnormative relationship with, the modeling industry. While a Frankfurt School–inspired analytic approach is an excellent choice for some aspects of the industry, and indeed one that Caroline Evans has admirably pursued in her excellent study in early twentieth-century fashion shows, I became concerned that such an approach would flatten the complexities of black models' relationship to racism and commodity culture, or to gay men's fashion photography in shaping the discourse of modern glamour, to cite just two of my emerging sites of inquiry.[11] As my project shifted away from a Taylorist analytic toward one shaped by in-

tersectional theories of gender and sexuality, my archival and analytic focus shifted to the queer approach these pages exemplify.

In this project I have sought to historicize a new form of modern sexuality central to consumer capitalism. Over the course of the twentieth century, sexuality and sexual appeal have emerged as crucially important sites for capitalist depredation, as advertisers and marketers have turned to the display of the human body to sell goods. Yes, representation through advertising is important to understanding this history, as we know from numerous excellent histories in this field. Building on this important scholarship, however, my questions throughout this project have been somewhat different: who does the work of representation, and how is this embodied labor central to both the history of capitalism and the history of sexuality? Models' bodies and commercialized affects have coproduced a new form of sexuality, one central to modern capitalism. That sexuality is one that is publicly visible, closely managed, strategically deployed, sexual without being erotic, and perfectly legal. It is the sexuality of consumer capitalism, in which models coproduce sexual feelings as a central requirement of the job description. This form of mobile, sexualized, and commercialized feeling is a form of sexual capital, originally developed by working-class women engaging in new forms of sexualized, commercial exchange in the growing urban spaces of the early twentieth century. By the end of the century, this form of commercialized, erotic appeal—sometimes, though not always, called "glamour"—had become ubiquitous in global commercial culture.

This emerging form of sexualized affect became a site of body politics for black models, gay men, trans women, and other cultural producers whose sexuality, race, or gender placed them in a nonnormative, or queer, relation to the modeling industry's reigning norms concerning beauty, whiteness, and heterosexuality. From Baron de Meyer to Tracey Norman, queer and trans people have always played key roles in the modeling industry, though it is only within the last few decades that sexual and gender differences have become visible in an industry ceaselessly in search of the new. The whitestream industry's parallel history of black modeling, from Irvin C. Miller's *Brownskin Models* through Naomi Sims, shows how black models have been required to navigate the shoals of racial violence when shaping a corporeal discourse of sexualized affect; their various solutions to the problem of black sexuality in the public sphere were a form of body politics in the context of white racism. None of these figures—elite gay men, working-class white women, trans women, or black models—fit comfortably into the dominant discourses of the fashion and photographic modeling industries as they developed over the course of the twentieth century.

Queer figures all, at odds with the industries' white and heteronormative norms, they have nonetheless shaped the contours of modern capitalism and its multiple strategies of consumer enticement. Their work, pursued in photographic studios, on runways, and in showrooms since the early twentieth century, offers one of many chapters in capitalism's queer history.

INTRODUCTION

1 Ford, *Liberated Threads*, 103. I discuss this history in more detail in chapter 5.

2 "Caroline R. Jones, 59, Founder of Black-Run Ad Companies," *New York Times*, July 8, 2001; Chambers, *Madison Avenue*, 218.

3 "The Opportunity for Clairol within the Black Community," marketing proposal dated November 14, 1969, Caroline Jones Series 3, Subseries 3, Box 25, Folder 3, Caroline R. Jones Collection, Archives Center, National Museum of American History. My thanks to Dan Guadagnolo for sharing this source with me, part of his dissertation research on niche marketing in the post-45 era.

4 "Opportunity for Clairol."

5 On this history of natural hair, see Kelley, "Nap Time"; Walker, *Style and Status*; Gill, *Beauty Shop Politics*; Ford, *Liberated Threads*.

6 Marchand, *Advertising the American Dream*.

7 "Clairol . . . Is Beautiful," silk scarf ad copy, February 12, 1970, Caroline Jones Series 3, Subseries 3, Box 25, Folder 3, Caroline R. Jones Collection, Archives Center, National Museum of American History.

8 Marchand, *Advertising the American Dream*; McGovern, *Sold American*; for a fuller discussion of the business of black hair care products in this period, see chapter 5.

9 Gross, *Model*, 250.

10 Interview with Tracey Africa, *The Luna Show*, episode 100, YouTube, October 19, 2009, https://www.youtube.com/watch?v=ZGWhRQSzqzk.

11 Livingstone, *Paris Is Burning* (1991); Hilderbrand, *Paris Is Burning: A Queer Film Classic;* Michael Cunningham, "The Slap of Love," *Open City* 6, 1996, http://opencity.org/archive/issue-6/the-slap-of-love; on balls in the 1930s, see Chauncey, *Gay New York*. For a contemporaneous film about drag culture of the late 1960s, see *The Queen*, dir. Frank Simon (New York City: Grove Press, 1968).

12 For a history of the term "trans" as an umbrella category to describe gender nonnormative people, see Valentine, *Imagining Transgender*.

13 The material about Norman is drawn from Africa interview, and from Yuan and Wong, "First Black Trans Model." Many thanks to Aaron Wong for discussing with me his research, which appeared in this *New York Magazine* article. After Yuan and Wong published their piece, Susan Taylor finally returned their calls to dispute

Norman's version of this story; see Jada Yuan, "Susan Taylor Says She Wouldn't Have Outed Tracey Africa," *Cut*, December 27, 2015, http://nymag.com/thecut/2015/12 /susan-taylor-tracey-africa.html.

14 Lears, *Fables of Abundance*; Baldwin, *Chicago's New Negroes*; Blaszczyk, *Imagining Consumers*; Leach, *Land of Desire*. For cultural intermediaries, see also Bourdieu, "Cultural Goodwill"; and Negus, "Work of Cultural Intermediaries."

15 Notable exceptions include Benson, *Counter Cultures*; S. Ross, *Working-Class Hollywood*; and the emergent scholarship on the labor economy of Walmart, such as Moreton, *To Serve God*; Lichtenstein, *Retail Revolution*.

16 J. B. Kennedy, "Model Maids," *Collier's* 85 (February 8, 1930): 61.

17 On the history of minority sexual communities, see, for example, D'Emilio and Freedman, "Introduction"; Chauncey, *Gay New York*; Stein, *City of Sisterly and Brotherly Loves*. On the history of sexual categories, see Meyerowitz, *How Sex Changed*; Hennessey, *Profit and Pleasure*; Terry, *American Obsession*; Canaday, *Straight State*. On the history of prostitution and "wide open" sexual subcultures, see Rosen, *Lost Sisterhood*; Gilfoyle, *City of Eros*; Clement, *Love for Sale*; Mumford, *Interzones*; Boyd, *Wide Open Town*; Sides, *Erotic City*.

18 P. Bailey, "Parasexuality and Glamour," 148.

19 P. Bailey, "Parasexuality and Glamour," 148

20 P. Bailey, "Parasexuality and Glamour," 148.

21 These overviews, however, have been very helpful in setting out the mainstream narrative through which I've been able to situate my more idiosyncratic analysis. See, for example, Gross, *Model*; Keenan, *Women We Wanted to Look Like*; Quick, *Catwalking*; Koda and Yohannan, *Model as Muse*. For black models, see Summers, *Skin Deep*.

22 C. Cohen, "Punks, Bulldaggers, and Welfare Queens."

23 V. Steele, *Queer History of Fashion*.

24 Sayers, "Etymology of *Queer.*"

25 Anzaldúa, "To(o) Queer the Writer," 264.

26 Stryker, "Queer Theory's Evil Twin," 214.

27 Scott, *Theory of Advertising*; quote from Marchand, *Advertising the American Dream*, 69.

28 Barry, *Femininity in Flight, 4*; see also Yano, *Airborne Dreams*; Vantoch, *Jet Sex*; and Tiemeyer, *Plane Queer*.

29 Joanne Entwistle and Elizabeth Wissinger, "Keeping Up Appearances: Aesthetic Labour and Identity in the Fashion Model Industries of London and New York," *Sociological Review* 54 (2006): 773–93; Joanne Entwistle, *The Aesthetic Economy of Fashion: Markets and Value in Clothing and Modeling* (London: Berg, 2009); Wissinger, "Always on Display."

30 Brown and Phu, *Feeling Photography*.

31 Hochschild, *Managed Heart*; Hardt, "Affective Labor."

32 Ahmed, "Affective Economies," 117; see also Ahmed, *Cultural Politics of Emotion*.

33 Wissinger, *This Year's Model*, 12; see also Wissinger and Slater, "Models as Brands," 16.

34 Mears, *Pricing Beauty*, 6.

35 Clough and Halley, *Affective Turn*.

36 Cvetkovich, *Archive of Feelings*.

37 Cvetkovich, *Archive of Feelings*; Love, *Feeling Backward*; Judith Halberstam, *Queer Time and Place*; Jack Halberstam, *Queer Art of Failure*; Muñoz, "Feeling Brown"; Vogel, *Scene of Harlem Cabaret*.

38 K. Stewart, *Ordinary Affects*.

39 Massumi, "Autonomy of Affect," 90; for a critique of Massumi, see Leys, "Turn to Affect."

40 Hennessey, *Profit and Pleasure*.

41 D'Emilio, "Capitalism and Gay Identity"; see also Weeks, *Coming Out: Homosexual Politics in Britain*; Foucault, *History of Sexuality*, vol. 1; Clark, "Commodity Lesbianism"; and Pellegrini, "Consuming Lifestyle."

42 On homonormativity and homonationalism, see Duggan, "New Homonormativity" and *The Twilight of Equality*; Puar, "Mapping U.S. Homonormativities" and *Terrorist Assemblages*. On the hegemony of US gay and lesbian identities, see Manalansan, "In the Shadows of Stonewall"; and El-Tayeb, "Gays." On the development of gay and lesbian markets, see Chasin, *Selling Out*; and Sender, *Business, Not Politics*.

43 D. Johnson, "Physique Pioneers"; Tiemeyer, *Plane Queer*; Frank, *Out in the Union*; Bengry, "Courting the Pink Pound."

44 Karl Marx, *Capital: A Critique of Political Economy*, vol. 1, trans. Ben Fowkes (New York: Penguin, 1981), 163.

45 Muñoz, "Ephemera as Evidence."

46 Foucault, *Discipline and Punish*; Bederman, *Manliness and Civilization*; Jennifer Terry and J. Urda, eds., *Deviant Bodies* (1995); Ott, Serlin, and Minh, *Artificial Parts, Practical Lives*; Eliot Gorn, "Re-Membering John Dillinger," in Cook et al., *The Cultural Turn in US History*; John Kasson, *Houdini, Tarzan, and the Perfect Man*.

47 See the July 18, 1885, entries for negative series numbers 937–42, as Muybridge described them in his workbooks. Eadweard Muybridge, Lab Notebook Number 2, May 2–August 4, 1885, International Museum of Photography, George Eastman House, Rochester, NY. See also Braun, "Muybridge le Magnifique."

48 Muybridge Notebooks, Notebook 3, negs. 1322–540, September15–October 28, 1885, International Museum of Photography, George Eastman House, Rochester, New York.

49 Muybridge Notebooks, Notebook 3, negs. 1322–540, September 15–October 28, 1885, 13.

50 Muybridge Notebooks, Notebook 2, negs. 524–1084, May 2–August 4, 1885; Brown, "Racializing the Virile Body"; Braun, "Leaving Traces."

51 See Spencer, "Some Notes"; D. Green, "Classified Subjects"; E. Edwards, "Photographic Types"; Roberts, "Taxonomy"; E. Edwards, *Raw Histories*; S. Smith, *Photography on the Color Line,* 49–50.

52 Brown, "Racializing the Virile Body."

53 For a discussion of perspectival seeing and Albrecht Dürer's use of the grid for drawing the female form, see Wolf, "Confessions of a Closet Ekphrastic."

54 Lamprey, "Method"; see also E. Edwards, "Ordering Others," 56.

55 L. F. Rondinella, "More about Muybridge's Work," quoting Muybridge's "Descriptive Zoopraxography" (1893) (July 1929), in Eadweard Muybridge Papers, UPT 50 M993, Box 2 Folder 6, University of Pennsylvania Archives.

56 "Important Project," newspaper clipping, March 22, 1884, and "Local Affairs," newspaper clipping, March 22, 1884, John C. Sims clipping books, vol. 1, University of Pennsylvania Archives.

57 Putney, *Muscular Christianity,* 23–24; H. Green, *Fit for America,* 181–216.

58 Roosevelt, *Strenuous Life;* see also Bederman, *Manliness and Civilization;* Rotundo, *American Manhood;* and H. Green, *Fit for America,* 219–58. On eugenics as a response in this period, see de la Peña, *Body Electric;* Cogdell, *Eugenic Design.*

59 J. Carter, *Heart of Whiteness;* Creadick, *Perfectly Average,* 9–12.

60 Igo, *Averaged American,* 55.

61 Serlin, *Replaceable You.*

62 J. Carter, *Heart of Whiteness,* 2.

ONE. Containing Sexuality

1 Waller, *Invention of the Model,* 37–57; Dawkins, *Nude,* 86–115.

2 Du Maurier, *Trilby.*

3 Waller, *Invention of the Model,* xiv; Dawkins, *Nude,* 86–115.

4 Bosworth, *Substitute Model; Model's Redemption.*

5 C. Evans, "Enchanted Spectacle."

6 De Marly, *History of Haute Couture,* 16; C. Evans, "Enchanted Spectacle," 272.

7 Wissinger, *This Year's Model,* 64.

8 Wissinger, *This Year's Model,* 65; C. Evans, "Enchanted Spectacle," 278.

9 C. Evans, *Mechanical Smile,* 186–87.

10 Colette, "Mannequins," 158.

11 Poiret, *King of Fashion,* 147.

12 Poiret, *King of Fashion,* 149–50.

13 De Marly, *History of Haute Couture,* 103–4, as quoted in Wissinger, *This Year's Model,* 64.

14 Helen B. Lowry, "Rude Intrusion of Facts into Fashion," *New York Times,* August 1, 1920, 46.

15 "Selling 'Stouts' in the Showroom: 'Team Work' on the Part of Model and Salesman Often Wins Over the Buyer," *New York Times,* November 26, 1916, E8.

16 "Almost Perfect," 22.

17 "Almost Perfect," 22.

18 See Peiss, *Hope in a Jar,* 61–133.

19 "Almost Perfect," 150.

20 J. B. Kennedy, "Model Maids," *Collier's* 85 (February 8, 1930): 61.

21 Peiss, "Charity Girls"; Peiss, *Cheap Amusements,* 110–13; Clement, *Love For Sale,* 212–39.

22 "Almost Perfect," 150.

23 "Almost Perfect," 150.

24 "Almost Perfect," 150; Meyerowitz, *Women Adrift*; Peiss, *Hope in a Jar,* 61–133; Studlar, "Perils of Pleasure?"

25 Schweitzer, *When Broadway Was the Runway*; Leach, *Land of Desire*; C. Evans, *Mechanical Smile.*

26 "The Easter Show," *Dry Goods Economist*, March 17, 1906, 101.

27 C. Evans, *Mechanical Smile*, 77–79; see also Green, *Ready-to-Wear*, 116–18.

28 Leach, *Land of Desire,* 102; C. Evans, "Enchanted Spectacle," 283.

29 *Dry Goods Economist*, November 1910, 33.

30 Schweitzer, *When Broadway Was the Runway*, 182–87; Leach, *Land of Desire*, 102; *New York Times*, March 30, 1911, 7.

31 C. Evans, *Mechanical Smile*, 81.

32 "Fashion Show as Trade Promoters," *New York Times*, October 19, 1913, 10; "12,000 at Trade Fair on the Opening Day," *New York Times*, August 8, 1922, 25.

33 C. Evans, "Enchanted Spectacle"; Schweitzer, *When Broadway Was the Runway.*

34 "Five Cities Will Hold Fashion Shows," *Retail Dry Goods* 23, no. 1 (July, 1922): 44–45; "Dewees' Holds Fashion Show 75 Miles from Store," *Retail Dry Goods* 24, no. 12 (July 1923): 2.

35 "Yearn to Be Suit Models: Girls Besiege Garment Films, Though Hours Are Long and the Work Is Hard," *New York Times,* August 1, 1924, 2; see also Harris, "Rising Star," 50; and Eleanor N. Knowles, "Snappiest Girls in Town," 8, 41.

36 Lowry, "Rude Intrusion," 46.

37 Beaton and Buckland, *Magic Image*, 106.

38 For a wonderful study on masculinity, photography, and modernism, see Vettel-Becker, *Shooting from the Hip.*

39 The pun references both Maurice Maeterlinck's play *Pélléas et Mélisande* (1893) and Claude Debussy's opera *Pélléas et Mélisande* (1902), central artifacts of the European symbolists. See Seebohm, *Man Who Was Vogue*, 194.

40 Harker, *Linked Ring*, 157.

41 Pictorialism has an extensive historiography; as an introduction, see Doty, *Photo-Secession;* Homer, *Alfred Stieglitz*; Peterson, "American Arts and Crafts"; Bear, *Disillusioned*; and S. M. Smith, *At the Edge of Sight.*

42 E. Brown, *Corporate Eye*, 187–88.

43 Niven, *Steichen*, 513.

44 Quoted in Niven, *Steichen*, 231.

45 Hoffman, "Baron Adolph de Meyer"; Hall-Duncan, *History of Fashion Photography*, 35.

46 Julian, "De Meyer," 36.

47 For Nast's biography, see Seebohm, *Man Who Was Vogue*; for useful insights into the changing nature of magazine publishing in these years, see Scanlon, *Inarticulate Longings*; and Garvey, *Adman in the Parlor.*

48 Seebohm, *Man Who Was Vogue*, 76; my discussion of *Vogue*'s transformation in this paragraph is drawn from chapter 5.

49 Leach, *Land of Desire.*

50 Schweitzer, "Accessible Feelings, Modern Looks," 223–55.

51 R. Williams, *Long Revolution*, 48–49.

52 It's worth remembering that it was F. Holland Day, the queer pictorialist whose work rivaled Stieglitz's, who published both Oscar Wilde and Aubrey Beardsley's *Yellow Book* in the United States.

53 Cécile Whiting, "Decorating."

54 George Platt Lynes to Glenway Wescott, February 1, 1945, Glenway Wescott Papers, correspondence from Box 69, Folder 1004, from George Platt Lynes to Monroe Wheeler and Glenway Wescott (1934–46), Beinecke Library, Yale University.

55 "Versatility Is the First Principle of Decoration," vol. 50, no. 3, *Vogue,* August 1, 1917, 46–47.

56 "camp, adj. and n.5," OED Online. June 2018. Oxford University Press. http://www.oed.com/view/Entry/26746?rskey=lSJkjj&result=6, accessed 2 August 2018; on the naming practices of these men, see Chauncey, *Gay New York*, 16.

57 Chauncey, *Gay New York*, 17.

58 Here my reading is shaped by José Esteban Muñoz, "Feeling Brown."

59 "Pearls and Tulle Spin Bridal Witcheries," *Vogue,* April 15, 1919, 43–45.

60 "Pearls and Tulle," 44.

61 Muñoz, "Feeling Brown," 69.

62 Miss Jeanne Eagels, *Vogue,* May 1, 1917, 54.

63 Dolan, "Performance"; Jameson, "Reification."

64 Johnston, *Real Fantasies,* 42.

65 Strand, "Photography and the New God"; Bochner, *American Lens*; Yochelson, "Clarence White."

66 William A. Ewing, "A Perfect Connection," in Brandow and Ewing, *Edward Steichen*, 30; see also Johnston, *Real Fantasies*, 42.

67 Seebohm, *Man Who Was Vogue,* 201.

68 E. Brown, "Rationalizing Consumption"; Yochelson, "Clarence White"; Bogart, *Artists*.

69 De Marly, *History of Haute Couture*, 86.

70 Marchand, *Advertising the American Dream*; Scanlon, *Inarticulate Longings*; Garvey, *The Adman in the Parlor*.

71 Marchand, *Advertising the American Dream*, 10–12; Fox, *The Mirror Makers*.

72 E. Brown, *Corporate Eye,* 172–83.

73 Watkins, *100 Greatest Advertisements*, 44–45.

74 J. Judson, "Illustrator Scouts the City to Get Suitable Models: Lejaren à Hiller Has Developed Universal Studio for Magazine Work and Card Indexes His Subjects' Faces," *Sun* (New York), November 4, 1917, 10.

75 R. G. Harrington, "The Photographic Portrait Study," *Printers Ink Monthly*, vol. 5, no. 6 Nov. 1922, 106.

76 "Using the Camera to Illustrate Fiction: Models Pose for Photographs Showing Scenes in the Story—How Two Artists Originated the Plan," *New York Times Magazine*, January 6, 1918, 13; see also E. Brown, *Corporate Eye*, 196.

77 "Using the Camera to Illustrate Fiction," 13.

78 Report on representatives' meeting held June 14, 1927, page 4, JWT Staff Meetings, 1927–1929, Box 1, Folder 1, Hartman Center for Sales, Marketing, and Advertising History, JWT Collection, Special Collections Library, Duke University.

79 Peiss, *Hope in a Jar*, 114. See also Peiss, "Making Faces."

80 Powers, *Power Girls*, 20–21; "John R. Powers Dies; Led Modeling Agency," *New York Times*, July 22, 1977, 15; see also Wissinger, *This Year's Model*, 117.

81 Powers, *Power Girls*, 22–23; Leach, *Land of Desire*, 308.

82 Information about Babs Shanton's work with Lucky Strike, including the ad, comes from "Stanford Research into the Impact of Tobacco Advertising," Stanford School of Medicine, accessed March 13, 2017. http://tobacco.stanford.edu/tobacco_main /images.php?token2=fm_st009.php&token1=fm_img2677.php.

83 *John Robert Powers Annual* 8, no. 2 (1932): 16.

84 This paragraph is drawn from my review of the Powers books held at the New York Public Library. See *John Powers Annual*, vol. 6 (John Robert Powers Publications, New York, 1930) and *John Powers Annual*, vol. 8 (John Robert Powers Publications, New York, 1932).

85 Marchand, *Advertising the American Dream*, 149; see also the opening editorial in *Commercial Photographer* 5, no. 4 (1930): 190–91; Charles, "Future of Photography."

86 James S. Yates, "Copy from an Art Director's Standpoint," J. Walter Thompson (hereafter JWT) Staff Meeting, May 5, 1931, JWT Staff Meetings, Box 3, Folder 7, 1930–1931, JWT Collection, Special Collections Library, Duke University.

87 Yates, "Copy from an Art Director's Standpoint."

88 Yates, "Copy from an Art Director's Standpoint."

89 "Creative Staff Meeting Minutes," October 26, 1932, JWT Staff Meetings, Box 5, Folder 6, 1932–1933, JWT Collection, Special Collections Library, Duke University; for more on Steichen's work for JWT on the Jergens campaign, see Johnston, *Real Fantasies,* 135–44.

90 Earle Clark, "The Federal Trade Commission and the Tainted Testimonial," JWT Staff Meetings, Box 4, Folder 3, 1931–1932, JWT Collection, Special Collections Library, Duke University; see also Moskowitz and Schweitzer, "Introduction," 9.

91 "Movie 'Stills' Crash Advertising Pages," 45; see also R. Young, "Human-Interest Illustrations"; Henle, "Realism in Advertising to Women."

92 Martin, "Photography in Advertising," 190; Wormald, "Making Photographs"; "Look Pleasant, Peas!" *Literary Digest* 112 (April 2, 1932): 33–34.

93 Quoted in Creative Staff meeting minutes, JWT Staff Meetings, Creative Meetings, Box 5, Folder 10, February 15, 1933, JWT Collection, Special Collections Library, Duke University.

94 Creative Staff meeting minutes, JWT Staff Meetings. For a description of Hiller's cinematic studio capacity during these years, see "The New Cover: Lejaren à Hiller Designs Cover Art for the *Literary Digest*," *Literary Digest* 123 (March 20, 1937): 23–24.

95 Creative Staff meeting minutes, JWT Staff Meetings.

96 Creative Staff meeting minutes, JWT Staff Meetings.

97 Creative Staff meeting minutes, JWT Staff Meetings.

98 Witherington, "How Advertising Photographs Are Made," 510; see also "Photographs Tell the Truth," advertisement for the Photography Association of America, appearing in *Commercial Photographer* 4, no. 10 (1929): 517; Quackenbush, "Setting That Enhances the Product."

99 Mahaffey, "Helping," 459.

100 MacKall, "Merchandising with a Camera," 246.

101 K. Ross, *Theory and Practice of Photography*, 13; see also Owen, "Pictorial Advertising."

102 Abel, "Making the Thing Desirable," 108.

103 Abel, "Making the Thing Desirable," 21–22; W. Stewart, "And the Ship Sank."

104 Sugrue, "Model Jobs," 80.

105 Stapely and Sharpe, *Photography in the Modern Advertisement,* 17; "Dramatic Photography in Advertising."

106 Larned, "Drama of the Human Face," 10; see also Wormald, "Your Model."

107 Sugrue, "Model Jobs," 82.

108 Powers, *Power Girls*, 23.

109 Powers, *Power Girls*, 23.

110 Powers, *Power Girls*, 24.

111 Powers, *Power Girls*, 26.

112 Powers, *Power Girls*, 27.

113 Powers, *Power Girls*, 26.

114 Powers, *Power Girls*, 26.

115 Powers, *Power Girls*, 25; see also "Model Man," *Newsweek* 18 (November 3, 1941): 60–61.

116 Gross, *Model*, 37.

117 Powers, *Power Girls*, 45.

118 Gross, *Model,* 64.

119 Sugrue, "Model Jobs," 46; see also "John Powers in Advertising Agency," *Literary Digest* 124 (July 31, 1937): 23; Louise Paine Benjamin, "Model Behavior," *Ladies' Home Journal* 54 (May 1937): 32–33; "Artists' Models: Some Accomplish Gracious Living on Fees of $5 an Hour," *Literary Digest* 122 (September 19, 1936): 24; "Powers Model," *New Yorker* 16 (September 14, 1940): 26–33.

120 Maurice Zolotow, "Case History of a Model," *Saturday Evening Post* 215 (August 29, 1942): 20–21, 66, 68–69.

121 John Robert Powers, *Current Biography, 1945*, vol. 6 (New York: H. W. Wilson, 1985), 478–79; Gross, *Model*, 61; Conover, *Cover Girls*, 44–45; Gilbert Millstein, "The Model Business," *Life*, March 25, 1946, 110–14; "License Is Denied to Model Agency," *New York Times*, May 27, 1959, 21; "Conover Troubles Unravel in Court," *New York Times*, May 28, 1959, 22; and "Approval Withheld on Conover License," *New York Times*, June 26, 1959, 52. During this troubled time, ex-wife and former model Candy Jones left Conover, claiming he was either bisexual or homosexual; she also claimed that she was a victim of the CIA's mind-control program in the 1960s (see Bain, *Control of Candy Jones*).

122 Conover, *Cover Girls*, 42; "Harry S. Conover, 53, Is Dead; Ran Model Agency 20 Years," *New York Times*, July 25, 1965, 68.

123 McLeod, *The Powers Girls*; Vidor, *Cover Girl*.

124 Peiss, *Cheap Amusements*; Ullman, *Sex Seen*; Boyd, *Wide-Open Town*; Fields, *Intimate Affair*; D'Emilio and Freedman, *Intimate Matters*, 202–38; Clement, *Love for Sale*.

TWO. Race, Sexuality, and the 1920s Stage Model

1 NAACP, "Head Here Criticizes Show," *Baltimore Afro-American*, December 12, 1925, 5.

2 Quoted in NAACP, "Head Here Criticizes Show," 5.

3 For fuller discussion of the history of women's dressmaking and the rise of the ready-to-wear industry for both men and women in the United States during this period, see Gamber, *Female Economy*; and N. Green, *Ready-to-Wear*.

4 Duff Gordon, *Discretions and Indiscretions*, 75. For a discussion of Duff Gordon's work in relationship to theatricality, see Kaplan and Stowell, *Theatre and Fashion*, 5–7, 115–21; Roach, *It*, 94.

5 "The Paris Fashion Show Has Brought a New Epoch," *New York Times*, November 28, 1915, X2. For an excellent discussion of the theatrical fashion show, and Lucile's role in founding it, see Schweitzer, *When Broadway Was the Runway*, 178–220.

6 Duff Gordon, *Discretions and Indiscretions*, 75.

7 Duff Gordon, *Discretions and Indiscretions*, 75.

8 Duff Gordon, *Discretions and Indiscretions*, 75.

9 Farley, "Alias Dinarzade," 76.

10 Farley, "Alias Dinarzade," 149; for the New York crowd, see "The Whistler of Dress: Lady Duff-Gordon Opens a Studio in New York to Make Dressmaking an Art," *Dry Goods* 10, no. 3 (1910): 98.

11 Farley, "Alias Dinarzade," 149.

12 Farley, "Alias Dinarzade," 80; see also Mendes and de la Haye, *Lucile, Ltd.*, 186.

13 Duff Gordon, *Discretions and Indiscretions*, 70.

14 Etherington-Smith and Pilcher, *"It" Girls*, 73.

15 Etherington-Smith and Pilcher, *"It" Girls*, 70.

16 Farley, "Alias Dinarzade," 66.

17 Bederman, *Manliness and Civilization*; J. Carter, *Heart of Whiteness*.

18 Todd, "Principles of Posture"; Georgen, *Delsarte System of Physical Culture*; see also Yosifon and Stearns, "Rise and Fall of American Posture"; and Gordon, "Educating the Eye."

19 J. Brown, *Babylon Girls*, 132.

20 J. Brown, *Babylon Girls*, 132.

21 For a discussion of these boisterous performance styles in relationship to ethnic, gender, and racial formation in the early twentieth century, see Glenn, *Female Spectacle*; Ullman, *Sex Seen*, 45–71; Kibler, *Rank Ladies*, 111–42; Mizejewski, *Ziegfeld Girl*, 109–35; Sotiropoulos, *Staging Race*; and J. Brown, *Babylon Girls*. For blackface minstrelsy, see Lott, *Love and Theft*; Lhamon Jr., *Raisin' Cain*; and Toll, *Blacking Up*.

22 *New York Times*, February 27, 1910, C3; Etherington-Smith and Pilcher, "*It" Girls*, 128; Duff Gordon, *Discretions and Indiscretions*, 147–48; C. Evans, *Mechanical Smile*, 82.

23 Kaplan and Stowell, *Theatre and Fashion*, 5.

24 Etherington-Smith and Pilcher, "*It" Girls*, 196–97.

25 Etherington-Smith and Pilcher, "*It" Girls,* 178; Duff Gordon, *Discretions and Indiscretions*, 268, 289–90.

26 Clippings folder for Dinarzade, Billy Rose Theatre Division, New York Public Library; Robinson Locke, Series 2, Vol. 278, 226, Billy Rose Theatre Division, New York Public Library; clippings folder for *Ziegfeld Follies* of 1917, Billy Rose Theatre Division, New York Public Library.

27 Farley, "Alias Dinarzade," 59.

28 C. Evans, "Jean Patou's American Mannequins"; C. Evans, *Mechanical Smile*, 125–29; see also Troy, *Couture Culture*.

29 "Dolores," Robinson Locke scrapbooks, Series 3, Vol. 368, 191–205, Billy Rose Theater Division, New York Public Library; for a reference to Dolores's "somewhat Cockney sister," see clipping from *Town Topics*, March 17, 1921, Robinson Locke scrapbooks, Series 3, Vol. 368, 203; for a brief discussion of the "Episode of Chiffon," see Berry, *Screen Style*, 54.

30 The claims concerning Dolores's height vary from five feet six to six feet. Suffice it to say, however, she was the tallest of the Ziegfeld showgirls when on stage, and was uniformly described as "statuesque."

31 Program for *Ziegfeld Midnight Frolic*, June 15, 1917, "Ziegfeld Midnight Frolic 1915–29," Microfilm, Billy Rose Theater Division, New York Public Library.

32 "New 'Frolic' an Achievement in Color, Harmony, and Fun," *New York Herald*, October 4, 1919; "The Ziegfeld Feast," *New York Evening Mail*, October 4, 1919; see also Mendes and de la Haye, *Lucile, Ltd.*

33 Brown, "De Meyer at Vogue."

34 "An April Shower of Musical Comedy Stars," *Vanity Fair* 10, no. 3 (May 1918): 48.

35 Glenn, *Female Spectacle*, 163. A related overhead ramp appeared in the Shuberts' *Passing Show of 1912*, when the chorus girls, dressed as members of a harem, entered the scene on a ramp built over the heads of the audience, at center stage. See B. N. Cohen, "Dance Direction of Ned Wayburn," 152.

36 B. N. Cohen, "Dance Direction of Ned Wayburn," 154.

37 Mizejewski, *Ziegfeld Girl*, 109–35; Jacobson, *Whiteness of a Different Color* and *Barbarian Virtues*.

38 For examples concerning Lucile mannequins, see program, *Ziegfeld Follies of 1917*, clippings folder for *Ziegfeld Follies* of 1917, Billy Rose Theatre Division, New York Public Library; clippings file for Dolores, Robinson Locke Collection, vol. 127, 195–216, in particular, full-page portrait of Dolores as Banu Ozrah, *Town and Country*, December 1, 1919, 201.

39 Glenn, *Female Spectacle*, 96; see also Walkowitz, "Vision of Salomé." For the role of orientalism in US women's middle-class domesticity, see Hoganson, "Cosmopolitan Domesticity," as well as her later *Consumers' Imperium*, 87–90.

40 Leach, *Land of Desire*.

41 B. N. Cohen, "Dance Direction of Ned Wayburn," 151–53. Cohen's reconstruction of the Ziegfeld Walk is based on interviews with former Follies performers, as well as floor plans for Follies productions in the Joseph Urban Papers, Rare Book and Manuscript Library, Columbia University. See also Mizejewski, *Ziegfeld Girl*, 97.

42 Marlis Schweitzer cites Robert Baral's suggestion that the pelvic thrust was borrowed from Irene Castle's popular dance style. See Schweitzer, *When Broadway Was the Runway*, 200 and Baral, *Revue*, 61.

43 Matthis, "Sketch for a Metapsychology of Affect"; Massumi, "Autonomy of Affect."

44 Ahmed, "Affective Economies," 117.

45 J. Brown, *Babylon Girls*, 164–66.

46 Sampson, *Blacks in Blackface*; J. Brown, *Babylon Girls*, 157, 170.

47 Mizejewski, *Ziegfeld Girl*, 8; see also Dinerstein, *Swinging the Machine*, 190.

48 See "Ziegfeld Revue for Nine O'Clock Glows with Girls," *New York Sun-Herald*, March 9, 1920.

49 Dinerstein, *Swinging the Machine*, 188.

50 See, for example, "New Frolic Is Gorgeous," *New York Times*, October 4, 1919.

51 Bederman, *Manliness and Civilization*; J. Carter, *Heart of Whiteness*; Jacobson, *Whiteness of a Different Color*; and Jacobson, *Barbarian Virtues*.

52 For the relationship between the Broadway stage and the department stores in this period, see Schweitzer, *When Broadway Was the Runway*.

53 "Irvin C. Miller's Brown Skin Models," *Chicago Defender*, November 21, 1925, 6.

54 For discussions of the role of respectability in relationship to historical discourses of black racial uplift, see Higginbotham, "Politics of Respectability"; White, *Too Heavy a Load*, 110–41; Wolcott, *Remaking Respectability*; Summers, *Manliness and Its Discontents*.

55 Locke, "New Negro," 50.

56 For recent work in this area, see Baldwin, *Chicago's New Negroes*; Vogel, *Scene of Harlem Cabaret*; Heap, *Slumming*, 189–230; and Chapman, *Prove It on Me*.

57 Haidarali, "Polishing Brown Diamonds"; see also E. Brown, "Black Models."

58 Floyd J. Calvin, "Irvin C. Miller Writes on Problems of the Theatre," *Pittsburgh Courier*, February 12, 1927, A2; Earl Calloway, "Brownskin Models Began Here," *Chicago Defender*, June 7, 1975, A2; Woll, *Dictionary of Black Theatre*, 232.

59 "Fisk Graduate Now Ranks as One of Race's Best Producers," *Pittsburgh Courier*, November 6, 1926, 8. For the history of the Charleston, see Woll, *Black Musical Theatre*, 89–90; Sampson, *Blacks in Blackface*, 110.

60 "'Shuffle Along' Premier," *New York Times*, May 23, 1921, 20; "'Put and Take' Is Lively," *New York Times*, August 24, 1921, 19.

61 Quoted in Woll, *Black Musical Theatre*, 78.

62 Quoted in Woll, *Black Musical Theatre*, 78.

63 Quoted in Woll, *Black Musical Theatre*, 78.

64 Miller, *Slaves to Fashion*, 199.

65 Woll, *Dictionary of Black Theatre*, 131; and Woll, *Black Musical Theatre*, 78.

66 Woll, *Black Musical Theatre*, 81.

67 "Brown-Skin Artists and Models," *Chicago Defender*, October 17, 1925, 1; "Irvin C. Miller Sues for 1/4 Million," *Philadelphia Tribune,* September 24, 1946, 12. Miller's show was influenced by the popular Shubert production *Artists and Models*, which opened in 1923.

68 Mrs. Helen Mack, "Newark N.J.," *Pittsburgh Courier*, October 24, 1925, 15; no author "Brownskin Models Bring Record Crowds," *Pittsburgh Courier*, April 3, 1926, 13; no author "Blanche Remains Pleasing to the Eye," *Pittsburgh Courier*, February 26, 1927, 6; Salem Tutt Whitney, "Brownskin Models Break Records; 'Great Day' Closes," *Chicago Defender*, November 23, 1929, 6.

69 "Brownskins' Draw Is High," *Chicago Defender*, March 27, 1943, 19.

70 Quoted in John Saunders, "Sepia Theatre's 'Glamour Gals' Fundamentally the Same Today as Yesteryear—Irvin Miller," *Philadelphia Tribune*, December 28, 1939, 20.

71 "Models Show Top Promise," *New Journal and Guide*, September 22, 1945, A7; Rob Roy, "The Brownskin Models,' Like Old Man River, Just Keep a Rollin,'" *Chicago Defender*, February 18, 1950, 20; Hilda See, "'Brownskin Models,' Again in Show Form, Due Soon," *Chicago Defender,* December 11, 1954, 6; Rob Roy, "'Brownskin Models' is Back—Better Some Say," *Chicago Defender,* March 19, 1955, 7.

72 "Irvin C. Miller's 1944 Brownskin Models Show to Feature Razaf, Higginbotham Tunes," *New York Amsterdam News*, September 11, 1943, 13A.

73 For more about Bee Freeman, who was also a civil rights activist in the interwar period, see Michelle Finn's excellent dissertation in progress from the University of Rochester, especially her chapter "Bee Freeman: The 'Brown-Skin Vamp' as a Modern Race Woman." Finn, "Modern Necessity," 102–60.

74 Sampson, *Blacks in Blackface*, 167–68.

75 Cameo of Miller in program for Brownskin Models, "Programs" Folder 1/5, Lily Yuen Collection, Schomburg Center for Research in Black Culture, New York Public Library; Irvin Miller's 'Brownskin Models' Unique Departure from Ye Musical Comedies," *Pittsburgh Courier*, December 12, 1925, 10; "Brownskin Models Scores Hit at Elmore," *Pittsburgh Courier*, December 1, 1928, 17.

76 Hilda See, "Brownskin Models, Again in Show Form, Due Soon," *Chicago Defender* December 11, 1954, 6.

77 See, "Brownskin Models," Cotton Club showgirls were required to be at least 5'6" in height, with a skin complexion "nothing darker than an olive tint"; an exception to this rule was Lucille Wilson, who was hired in 1932. See Haskins, *Cotton Club*, 75–76.

78 Review, Scrapbook 1926–1930, Folder 6, Lily Yuen Collection, Schomburg Center for Research in Black Culture, New York Public Library.

79 Review, Scrapbook 1926–1930, Folder 6, Lily Yuen Collection, Schomburg Center for Research in Black Culture, New York Public Library.

80 Classic works on the Harlem Renaissance include J. W. Johnson, *Black Manhattan*; Douglas, *Terrible Honesty*, especially 73–107; Lewis, *When Harlem Was in Vogue*; and Huggins, *Harlem Renaissance*.

81 The transformation of Aaron Douglas's work from regional modernist to neoprimitivist is one example during this period: see Earle, "Harlem, Modernism, and Beyond"; and Goeser, *Picturing the New Negro*. On the relationship between primitivism and modernism more generally, see Torgovnick, *Gone Primitive*.

82 Hall, "Encoding/Decoding."

83 Quoted in Lillian Johnson, "Blanche Thompson Mixes Beauty, Brains, and Work," *Afro-American*, February 5, 1938, 11.

84 "A Brownskin Model of 1927," *Pittsburgh Courier*, September 25, 1926, 1; L. Johnson, "Blanche Thompson," 11; "Years Deal Lightly with Models' Star," *New Journal and Guide*, February 25, 1939, 16; Billy Rowe, "Question: Integration or Self-Segregation," *New York Amsterdam News*, June 13, 1987, 20.

85 For one of many references to Miller's show as "glorifying the brownskin girl," see "Irvin Miller's 'Brownskin Models' Unique Departure from Ye Musical Comedies," *Pittsburgh Courier* December 12, 1925, 10.

86 John Saunders, "Sepia Theatre's 'Glamour Gals' Fundamentally the Same Today as Yesteryear—Irvin Miller," *Philadelphia Tribune*, December 28, 1939, 20.

87 Haidarali, "The Vampingest Vamp."

88 "Chorus Plays Big Part in Broadway Hits," *Chicago Defender*, March 24, 1934, 5; "Blanche Thompson Near Death in Auto Crash," *Pittsburgh Courier*, August 7, 1937, 20; "Years Deal Lightly with Models' Star," *New Journal and Guide*, February 25, 1939, 16.

89 "They Must Be 'High Yaller,'" *New York Amsterdam News*, June 15, 1940, 13.

90 "They Must Be 'High Yaller,'" 13. For recent work about Josephine Baker, see Cheng, *Josephine Baker*; Guterl, *Mother of the World*.

91 "They Must Be 'High Yaller,'" 13.

92 "They Must Be 'High Yaller,'" 13.

93 Quoted in "They Must Be 'High Yaller,'" 13.

94 L. Johnson, "Blanche Thompson," 11; Wilbur Thin, "No Legs in New Broadway Show," *Afro-American*, June 20, 1931, 20.

95 "Miller Glorifying the Brownskin Girl in his Latest Show," *Pittsburgh Courier*, December 12, 1925, 10.

96 "Miller Glorifying the Brownskin Girl," 10.

97 Thin, "No Legs in New Broadway Show," 20.

98 "New 'Brownskin Models' to Be Gorgeous Show," *Afro-American*, June 20, 1931, 9.

99 "New 'Brownskin Models' to Be Gorgeous Show," 9.

100 Baldwin, *Chicago's New Negroes*; Phillips, *Alabama North*; Grossman, *Land of Hope*, 123–60.

101 Carby, "Policing the Black Woman's Body," 738–55; see also Craig, *Ain't I a Beauty Queen?*

102 NAACP, "Head Here Criticizes Show," 5.

103 P. Bailey, "Parasexuality and Glamour," 148.

104 Warner, *Fear of A Queer Planet*, xvii.

105 Foucault, *History of Sexuality*, 1:24.

THREE. Queering Interwar Fashion

1 Brandow and Ewing, *Edward Steichen: In High Fashion;* Johnston, *Real Fantasies.*

2 Some of these alternative histories include the role of small cameras, movement, and location shooting through the work of Martin Munkácsi and others; one includes the important role of women photographers in fashion, particularly Toni Frissell and Louise Dahl-Wolfe. For more about these photographers, see Honnef et al., *Martin Munkácsi;* Goldberg and Richardson, *Louise Dahl-Wolfe;* Stafford, *Toni Frissell.*

3 I'm using multiple definitions of the term "queer" in this chapter. One is the old-fashioned meaning, from the seventeenth century up through the early twentieth: "queer" as in out of alignment, odd, or strange. This understanding has nothing to do with sexual practices or identities, and is (in my mind) clearly related to the older understandings of "glamour" as a charm that causes the eye to see things differently. A second meaning concerns male sexuality from the early twentieth century through the Stonewall era, when "queer" was a derogatory term for gay men; in the 1930s and 1940s, some figures in Lynes's circle, such as Lincoln Kirstein, self-identified as queer. A third meaning, emerging in the 1990s and still in place today, sees "queer" as an umbrella term that references nonnormative sexuality but that critiques stable identify formations such as "gay," "lesbian," "straight," and so on. This understanding, though presentist, also describes Lynes, who had more complex sexual allegiances than the word "gay" would suggest. And finally, a current academic understanding of the term, drawn from queer theory, uses "queer" mainly as a verb, to signify, simply, an intervention into normativity in its multiple, overlapping, iterations. It is worth stating that our current vocabulary remains inadequate to the task of understanding pre-Stonewall nonnormative sexualities, which historians continue to research and address.

4 Fraser is quoted in Warner, "Publics and Counter Publics," 85; for a fuller discussion of Warner's argument, see Warner, *Publics and Counter Publics.*

5 Roland Barthes, *Camera Lucida: Reflections on Photography,* trans. Richard Howard (New York: Hill and Wang, 1981), 6.

6 Butler, "Is Kinship Always Heterosexual?"; see also Weston, *Families We Choose.*

7 Wissinger, *This Year's Model,* 11

8 Wissinger, *This Year's Model,* 11; see also Mears, *Pricing Beauty;* Entwistle and Slater, "Models as Brands."

9 Gundle and Castelli, *Glamour System,* 3. See also Rose et al., *Glamour.*

10 P. Bailey, "Parasexuality and Glamour," 148–72.

11 P. Bailey, "Parasexuality and Glamour," 152.

12 Ahmed, "Affective Economies"; see also Ahmed, *Cultural Politics of Emotion.*

13 P. Bailey, "Parasexuality and Glamour."

14 Thrift, "Understanding the Material Practices."

15 Thrift, "Understanding the Material Practices," 297.

16 Stoker, *Dracula;* Dijkstra, *Evil Sisters;* Bailie, "Blood Ties"; Auerbach, *Our Vampires, Ourselves.*

17 Willis-Tropea, "Hollywood Glamour," 21.

18 Gundle, "Hollywood Glamour," 97. See also Gundle and Casteli, *Glamour System*, 69–72.

19 Leff, *Dame in the Kimono*; Couvares, *Movie Censorship*; Black, *Catholic Crusade*.

20 Willis-Tropea, "Hollywood Glamour."

21 Willis-Tropea, "Hollywood Glamour," 93.

22 Kobal, *Art*; Dance and Robertson, *Ruth Harriet Louise*.

23 Willis-Tropea, "Hollywood Glamour," 132–33.

24 Quoted in Willis-Tropea, "Hollywood Glamour," 115–16.

25 Wilson, "Note on Glamour," 98; Simmel, "Fashion."

26 Quoted in Vickers, *Cecil Beaton*, 23.

27 Cecil Beaton, *Photobiography*, 39.

28 Quoted in Beaton, *Photobiography*, 39–40; for more about Dorothy Todd, see L. Cohen, *All We Know*.

29 Beaton, *Photobiography*, 75; see also Albrecht, *Cecil Beaton*, 10–33.

30 Beaton, *Photobiography*, 50.

31 Beaton, *Photobiography*, 50.

32 Quoted in Beaton, *Wandering Years*, 187; see also Garner and Mellor, *Cecil Beaton;* Mellor, "Beaton's Beauties."

33 Quoted in Vickers, *Cecil Beaton*, 41. I hesitate to use the word "gay" to describe Beaton since, although he desired men sexually throughout his life (and indeed had sex with some of them), he had deep affective attachments with women as well, some of which were sexual—as with his much-written-about affair with Greta Garbo, who was also involved with Mercedes de Acosta at the time. See Souhami, *Greta and Cecil*; Vickers, *Loving Garbo*; Vickers, *Unexpurgated Beaton*; L. Cohen, *All We Know*.

34 Beaton, *Photobiography*, 30–32.

35 Beaton, *Photobiography*, 30–32; for other assessments of de Meyer's work by Beaton, see Beaton, *Glass of Fashion*, 81–82.

36 Beaton, *Glass of Fashion*, 91; see also Beaton, *Photobiography*, 97.

37 Halperin, *How to Be Gay*, 13.

38 Newton, *Mother Camp*; Cleto, "Introduction"; Sontag, "Notes on Camp"; Tinkom, *Working Like a Homosexual*; Crimp, *"Our Kind of Movie."*

39 Beaton, *Photobiography*, 66.

40 Du Bois, *Souls of Black Folk*, 38.

41 George Hoyningen-Huene, interviewed by Elizabeth Dixon, Mr. Hoyningen-Huene's home in Los Angeles, "George Hoyningen-Huene Photographer: Completed under the Auspices of the Oral History Program University of California Los Angeles 1967," *Open Library Internet Archives,* Record, April 1965, 1–44; December 16, 2013, 10; https://archive.org/stream/georgehoyningenhoohoyn.

42 Hoyningen-Huene interview, 11.

43 Hoyningen-Huene interview, 11.

44 This overview drawn from Ewing, *Photographic Art of Hoyningen-Huene*, 13–24.

45 Hoyningen-Huene interview, 12.

46 For more about Horst, also a critical figure in this queer interwar fashion world, see Pepper, *Horst Portraits*.

47 Hoyningen-Huene interview, 20.

48 Ewing, *Photographic Art of Hoyningen-Huene*, 30.

49 Bergman, *Camp Grounds*; Newton, *Mother Camp*; Sontag, "Notes on Camp"; Cleto, "Introduction."

50 Halperin, *How to Be Gay*, 253.

51 Pepper, *Horst Portraits*, 13; see also Hoyningen-Huene interview, 17.

52 Beaton, *Photobiography*, 246.

53 Ewing, *Photographic Art of Hoyningen-Huene*, 8; Lawford, *Horst*, 89.

54 Lawford, *Horst*, 89.

55 Hoyningen-Huene interview, 12.

56 Hoyningen-Huene interview, 12.

57 Hoyningen-Huene interview, 12.

58 Beaton, *Photobiography*, 48; see also Garner, "Instinct for Style."

59 Pepper, *Horst Portraits*, 18; see also Ewing, *Photographic Art of Hoyningen-Huene*, 108.

60 Quoted in Rowlands, *Dash of Darling*, 176.

61 Crump, "American Years," 271.

62 These are Kirstein's words, quoted in Duberman, *Worlds of Lincoln Kirstein*, 21–22.

63 This paragraph drawn from Leddick, *Intimate Companions*; Pohorilenko, *Photographer George Platt Lynes*; Rosco, *Glenway Wescott Personally*.

64 Glenway Wescott to George Platt Lynes, September 26, 1947, Wescott Papers, Box 71, Folder 1035, Beinecke Library, Yale University.

65 Wescott to Lynes, September 26, 1947.

66 On the nudes, see Crump, "Iconography of Desire"; W. Thompson, "Sex, Lies, and Photographs"; Haas, *George Platt Lynes*.

67 George Platt Lynes, "The Camera Knows When a Woman Is in Love," *Bachelor*, April 1937, 82.

68 "The Private Life of a Portrait Photographer," *Minicam Photography* 5 no. 2 (October 1941): 26–33, 97–100.

69 Quoted in "Private Life of a Portrait Photographer," 29.

70 Quoted in "Private Life of a Portrait Photographer," 32.

71 Quoted in "Private Life of a Portrait Photographer," 33.

72 Leddick, *Intimate Companions,* 30–55.

73 Pohorilenko, "Expatriate Years," 91.

74 Quoted in Leddick, *Intimate Companions*, 88.

75 Lynes, "Camera."

76 Lynes, "Camera," 82.

77 Steward, *Bad Boys and Tough Tattoos*; Spring, *Secret Historian*.

78 George Platt Lynes to Monroe Wheeler, January 18, 1948, Glenway Wescott Papers, Box 70, Folder 1010, Beinecke Library, Yale University.

79 Turner, *Backward Glances*, 9.

80 Turner, *Backward Glances*, 10.

81 Gavin Brown, "Ceramics, Clothing and Other Bodies: Affective Geographies of Homoerotic Cruising Encounters," *Social and Cultural Geography* 9, no. 8 (December 2008): 921.

82 Brown, "Ceramics, Clothing and Other Bodies," 921.

83 Lynes, "Camera," 82.

84 Chauncey, "Policed," 15; see also Chauncey, *Gay New York*, 142–47. See also Kaiser, *Gay Metropolis*, 12–13.

85 Chauncey, "Policed," 18.

86 Bérubé, *Coming Out Under Fire*, 100.

87 Chauncey, "Policed," 21.

88 Chauncey, *Gay New York,* 351.

89 Bérubé, *Coming Out Under Fire*, 109.

90 See, for example, Lynes's journal entries for November, 1942, George Platt Lynes Diaries and Memorabilia, Box 1, Beinecke Library, Yale University.

91 Unpublished typescript by Samuel Steward about George Platt Lynes, pg. 2, George Platt Lynes folder, Samuel Steward Papers, Box 1, Beinecke Library, Yale University.

92 Unpublished Steward typescript, 2.

93 Unpublished Steward typescript, 2.

94 Samuel Steward to George Platt Lynes, October 18, 1953, Samuel Steward Papers, Box 1, Beinecke Library, Yale University.

95 Samuel Steward to George Platt Lynes, December 23, [no year], Samuel Steward Papers, Box 1, Beinecke Library, Yale University.

96 George Platt Lynes to Samuel Steward, St Patrick's Day 1953, Box 3, Samuel Steward Papers, Beinecke Library, Yale University.

97 George Platt Lynes to Samuel Steward, September 10, 1953, Box 3, Samuel Steward Papers, Beinecke Library, Yale University.

98 George Platt Lynes to Samuel Steward, May 12, 1953, Box 3, Samuel Steward Papers, Beinecke Library, Yale University.

99 George Platt Lynes to Samuel Steward, October 30, 1952, Box 3, Samuel Steward Papers, Beinecke Library, Yale University.

100 Samuel Steward to George Platt Lynes, November 16, 1952, Box 3, Samuel Steward Papers, Beinecke Library, Yale University.

101 Donald Windham describes being photographed by Lynes in 1942 while visiting his studio with his Coast Guard companion Fred Melton; the set was part of his fashion work, and Lynes used his draping skills to adapt Melton's uniform to Windham's body, and to retouch the image to remove crooked teeth and other imperfections. As Windham observed, "The manipulating technique of the fashion world" was in full evidence during his session. Windham, "Which Urges and Reasonably So the Attraction of Some for Others," 7.

102 Double page advertisement for Carolyn Modes, *Vogue,* January 15, 1938, 12–13.

103 Kennedy and Davis, *Boots of Leather.*

104 J. Carter, "Of Mother Love." Carter begins his essay with a quote from Kennedy and Davis, *Boots of Leather.*

105 Mears, *Pricing Beauty*; Wissinger, "Always on Display"; Wissinger, "Modelling a Way of Life"; Etherington-Smith and Pilcher, *"It" Girls.*

106 Entwistle and Slater, "Models as Brands."

107 Entwistle and Slater, "Models as Brands," 25.

108 Wissinger, *This Year's Model*, 10; Mears, *Pricing Beauty*, 71–120.

109 Thrift, "Understanding the Material Practices."

110 Condé Nast to Miss Daves, Office Memorandum, January 27, 1941, Condé Nast Papers, MC 001, Box 19, Folder 23, Vogue Studio Models, 1935–1942, Condé Nast Archives, New York City; Mr. Patcevitch to Mrs. Chase, Office Memorandum, March 3, 1938, Condé Nast Papers, MC 001, Box 19, Folder 23, Vogue Studio Models, 1935–1942, Condé Nast Archives, New York City.

111 Ruth Ford to her brother Charles Henri and to her mother, July 5, [1935], Charles Henri Ford Collection, Box 13, Folder 4, Harry Ransom Center, University of Texas at Austin; Charles Henri Ford to Ruth Ford, August 26, 1935, Charles Henri Ford Collection, Box 7, Folder 9, Harry Ransom Center, University of Texas at Austin; Charles Henri Ford to Ruth Ford, October 6, 1935, Charles Henri Ford Collection, Box 7, Folder 9, Harry Ransom Center, University of Texas at Austin; Charles Henri Ford to Ruth Ford, October 16, 1935, Charles Henri Ford Collection, Box 7, Folder 9, Harry Ransom Center, University of Texas at Austin; Ruth Ford to her parents, [1937], Charles Henri Ford Collection, Box 18, Folder 4, Harry Ransom Center, University of Texas at Austin.

112 Crump, "American Years," 287.

113 Leddick, *Intimate Companions*, 19.

114 Ford and Tyler, *Young and the Evil*.

115 Ruth Ford to her parents, [1937].

116 Roach, *It*, 117; Thrift, "Understanding the Material Practices," 306.

117 Halperin, *How to Be Gay*, 362.

118 Charles Henri Ford to Ruth Ford, August 26, 1935; see also example Charles Henri Ford to Ruth Ford, October 16, 1935; emphasis in original.

119 Cecil Beaton to Charles Henri Ford and Pavel Tchelitchew, ca. August 1935 (exact date unknown), Charles Henri Ford Collection, Box 7, Folder 9, Harry Ransom Center, University of Texas at Austin.

120 Ruth Ford to Charles Henri Ford and Gertrude Ford, July 5, 1935, Charles Henri Ford Collection, Box 13, Folder 4, Harry Ransom Center, University of Texas at Austin.

121 Charles Henri Ford to Ruth Ford, August 26, 1935.

122 Charles Henri Ford to Ruth Ford, October 6, 1935.

123 Charles Henri Ford to Ruth Ford, October 6, 1935, postscript dated October 7, 1935, Charles Henri Ford Collection, Box 7, Folder 9, Harry Ransom Center, University of Texas at Austin.

124 Charles Henri Ford to Ruth Ford, October 6, 1935, postscript dated October 7, 1935.

125 Charles Henri Ford to sister Ruth Ford from Paris, October 8, 1935, Charles Henri Ford Collection, Box 7, Folder 9, Harry Ransom Center, University of Texas at Austin; emphasis in original.

126 Ruth Ford to Gertrude Ford, March 1, 1937, Box 17, Folder 4, Charles Henri Ford Collection, Box 7, Folder 9, Harry Ransom Center, University of Texas at Austin.

127 Rosco, *Glenway Wescott Personally*.

128 George Platt Lynes to Perry Ruston, December 29, 1947, Glenway Wescott Papers, Box 70, Folder 1009, Beinecke Library, Yale University; see also Crump, "Photography as Agency," 144.

129 George Platt Lynes to Monroe Wheeler, December 6, 1947, Glenway Wescott Papers, Box 70, Folder 1009, Beinecke Library, Yale University.

130 Contrast, for example, Penn's portrait of Mrs. André Embiricos (*Vogue*, July 1948, 43) with Lynes's full-page portrait for Henri Bendel (*Vogue*, August 1948, 1).

131 Leddick, *Intimate Companions*, 254.

132 Bettel-Vecker, *Shooting from the Hip*; but see Stevens and Aronson, *Avedon: Something Personal*.

133 Rosco, *Glenway Wescott Personally*, 123.

134 George Platt Lynes folder, Samuel Steward Papers, Box 1, Beinecke Library, Yale University.

135 Glenway Wescott to Alfred Kinsey, January 2, 1950, and May 22, 1951, Glenway Wescott Papers, Box 61, Folder 885, Beinecke Library, Yale University.

136 Spring, *The Secret Historian*.

137 D'Emilio, *Sexual Politics*; D. Johnson, *Lavender Scare*; Friedman, "Smearing of Joe McCarthy"; van den Oever, *Mama's Boy*; and Loftin, *Masked Voices*.

138 George Platt Lynes to Monroe Wheeler, May 1, 1952, Glenway Wescott Papers, Box 70, Folder 1012, Beinecke Library, Yale University.

FOUR. Black Models

1 Chambers, *Madison Avenue*, 133–34.

2 "Gains in Ads Made by Minority Groups," *New York Times*, January 16, 1965, 22.

3 Brenna Greer, *Represented*; Charles McGovern, *Sold American*; and Lizabeth Cohen, *Consumers' Republic*.

4 Ruffins, "Reflecting on Ethnic Imagery."

5 The term "Uncle Tom" comes from Harriet Beecher Stowe's *Uncle Tom's Cabin* (1851), the work that more than any other helped crystallize Northern antislavery feeling in the antebellum period. Stowe's character was meant to embody the gentleness and capacity for forgiveness central to the perfect Christian character; over time, the term became synonymous with white representations of black docility and subservience. See Frederickson, *Black Image*, 110–11.

6 "A Statue? Arabs? That's Mr. Hunter from Zululand! Ad Men's Favorite Dusky Model a Good Actor," *New York Post*, November 30, 1935, clipping in Maurice Hunter Scrapbooks, Schomburg Center for Research in Black Culture, New York Public Library; Maurice Hunter, "I Pose . . ." *Design Magazine*, January 1951, in Maurice Hunter Scrapbooks, Schomburg Center for Research in Black Culture, New York Public Library; Mel Heimer, "Men's Whirl," *Social Whirl*, December 27, 1954, in Maurice Hunter Scrapbooks, Schomburg Center for Research in Black Culture, New York Public Library.

7 Maurice Hunter Scrapbooks, Schomburg Center for Research in Black Culture, New York Public Library; These scrapbooks also provide numerous examples of the illustrated fiction for which he posed. For a history of African stereotypes in

Western popular culture and the relationship of these stereotypes to European and US imperialisms, see Pieterse, *White on Black,* especially 113–22 on the cannibal, 124–31 on the "black moor" as servant, and 152–55 for the US stereotypes of Uncle Tom and Aunt Jemima.

8 "Talk of the Town," *New Yorker,* November 16 1935, article in Maurice Hunter Collection, Schomburg Center for Research in Black Culture, New York Public Library.

9 "The Man in the Ads: Maurice Hunter Pops Up on Billboards All over U.S.," *Ebony,* 1947, 35–38, article in Folder 1, Maurice Hunter Collection, Schomburg Center for Research in Black Culture, New York Public Library.

10 Obituary, *New York Times,* March 4, 1966, Maurice Hunter Collection, Schomburg Center for Research in Black Culture, New York Public Library.

11 For the ads, see Maurice Hunter Scrapbooks, Schomburg Center for Research in Black Culture, New York Public Library; for the obituary, see *New York Times,* March 4, 1966; for the Pennsylvania Railroad mural, designed by Raymond Loewy, see Drix Duryea, "The Biggest Heads in the World," *Popular Photography*, February 1944, 40–41, 92–93.

12 Quoted in *Musical Advance*, May 1943, clipping, Maurice Hunter Scrapbooks, Schomburg Center for Research in Black Culture, New York Public Library.

13 "Talk of the Town," *New Yorker*, November 16, 1935, in Maurice Hunter Scrapbooks, Schomburg Center for Research in Black Culture, New York Public Library; see also his model publicity material in the scrapbooks.

14 Quoted in card from Godwin, Scrapbook 3, Maurice Hunter Scrapbooks, Schomburg Center for Research in Black Culture, New York Public Library.

15 For a history of protest against Aunt Jemima stereotypes, see Manring, *Slave in a Box*; and McElya, *Clinging to Mammy*, esp. 116–69; for a discussion of the NAACP protests against *The Birth of a Nation*, see Stokes, *D. W. Griffith's "The Birth of a Nation."* Although television offered more varied roles for black actors, J. Fred Mac-Donald describes the persistence of the Uncle Tom and Aunt Jemima stereotypes in his *Blacks and White TV*, 22–24.

16 Quoted in Frieda Wyandt, "I Became a Model to Help My Race, Says Negro Made Famous by Artists," *New York Evening Graphic,* magazine section, April 16, 1926, 6, Maurice Hunter Scrapbooks, Schomburg Center for Research in Black Culture, New York Public Library.

17 Virginia Girvin Collection, Folder: "1930s Playbills," Schomburg Center for Research in Black Culture, New York Public Library.

18 "My Poor but Happy Life," autobiographical typescript, Box 1, Folder 2, Virginia Girvin Collection, Schomburg Center for Research in Black Culture, New York Public Library.

19 Manring, *Slave in a Box*, 75.

20 White, *Ar'n't I a Woman?*, 27–61; Manring, *Slave in a Box;* McElya, *Clinging to Mammy*; Kern-Foxworth, *Aunt Jemima*; Bogle, *Toms, Coons, Mulattoes, Mammies, and Bucks.*

21 White, *Ar'n't I a Woman?*, 58.

22 See chapter 3 of Manring, *Slave in a Box.*

23 McElya, *Clinging to Mammy*, 6, 162.

24 Quoted in Kern-Foxworth, *Aunt Jemima*, 82–83.

25 Kern-Foxworth, *Aunt Jemima*, 82–83.

26 Kern-Foxworth, *Aunt Jemima*, 82–83. See also Manring, *Slave in a Box*, 157.

27 Smith, *Photography on the Color Line*; White and White, *Stylin'*; hooks, "In Our Glory."

28 The contemporaneous term for African Americans was "negro"; the term "black" did not become part of common usage until the late 1960s. For this reason, I often use the term "Negro," or "Negro market" in much of this chapter.

29 Du Bois, *Souls of Black Folk*.

30 Phillips, *Alabama North*; Grossman, *Land of Hope*; Baldwin, *Chicago's New Negroes*; Courbold, *Becoming African Americans*.

31 Weems, *Desegregating the Dollar*; Chambers, *Madison Avenue*, 20–44; Walker, *Style and Status;* Greer, *Represented*.

32 Sullivan, "Negro Market Today," 68–69.

33 Sullivan, "Negro Market Today," 68–69.

34 P. Edwards, *Southern Urban Negro*.

35 See, for example, Claude H. Hall's regular feature in *Printer's Ink* in the early 1960s, "The Negro Market." For a brief discussion of this history of cultivating the black consumer, see Halter, *Shopping for Identity*, 43; see also Newman, "Forgotten Fifteen Million."

36 E. Steele, "Some Aspects of the Negro Market"; see also Lizabeth Cohen, *Consumers' Republic*, 323; and Dates, "Advertising."

37 Alexis, "Pathways to the Negro Market."

38 For reporting on these studies, see Felicia Anthenelli, "Negro Market," *Wall Street Journal*, February 23, 1952, 1; "See Negro Market of $30 Billion," *Chicago Defender*, July 24, 1954, 21; "Abramson Lauds Negro Market Gains," *Chicago Defender*, July 25, 1953, 4; "Wall Street Feature Cites Importance of Negro Business," *Atlanta Daily World*, January 17, 1954, 4; Albert Barnett, "Big Business Courts Negro Market: Indolent South Finally Wakes Up," *Chicago Defender*, February 6, 1954, 9; for additional studies, see J. T. Johnson, *Potential Negro Market*.

39 See, for example, Sullivan, "Handful of Advertisers"; Alexis, "Pathways to the Negro Market"; "The Negro Market: An Appraisal"; "The Negro Market"; "Fourteen Million Negro Consumers."

40 Weems, *Desegregating the Dollar*, 54.

41 "The Forgotten 15,000,000 . . . Three Years Later," *Sponsor* 6 (July 28, 1952): 76–77, cited in Alexis, "Pathways to the Negro Market," 114–27, 121.

42 "The Forgotten 15,000,000," 76–77. The rhetoric of poor black self-esteem was popularized through the racial preference research of psychologists Kenneth and Mamie Clark, whose early 1940s studies of doll preferences among Negro children became important evidence for the Supreme Court's *Brown v. Board of Education of Topeka* (1954) decision to end segregation in schools.

43 John H. Johnson, "Why Negroes Buy Cadillacs," *Ebony*, September 1946, 34, cited in Chambers, *Madison Avenue*, 44. See also Strasser, *Satisfaction Guaranteed;* Albert

Barnett, "Negro Business a 12 Billion Dollar Market," *Chicago Defender*, February 5, 1949, 7.

44 Chambers, *Madison Avenue*, 43; on Johnson and *Ebony*, see also A. Green, *Selling the Race* and Greer, *Represented*.

45 "Smiley" ad, *Ebony*, March 1947, 3; Chambers, *Madison Avenue*, 43; Weems, *Desegregating the Dollar*, 73; Johnson, *Succeeding against the Odds*.

46 Johnson, *Succeeding against the Odds*, 230.

47 *Ebony and Jet Magazines Present,* studies no. 1 and no. 2; J. H. Johnson, "Does Your Sales Force Know?; for sales films, see Chambers, *Madison Avenue*, 43. For David J. Sullivan's important work going between black consumers and white trade press, see Sullivan, "Don't Do This" and "The American Negro."

48 Manring, *Slave in a Box*, 156.

49 *Ebony and Jet Magazines Present*, study no. 1.

50 Sullivan, "Don't Do This," 47.

51 Sullivan, "Don't Do This," 47; see also Weems, *Desegregating the Dollar*, 32–34; Chambers, *Madison Avenue*, 69–74.

52 See, for example, Cheddle, "Politics of the First"; an exception is Laila Haidarali, "Polishing Brown Diamonds," whose work ties modeling to the emergence of the "brownskin" ideal of African American femininity.

53 Some of these other agencies in the 1946–1950 period, in the New York area alone, included Sepia Art Models, based in Harlem, which provided Negro models for Ivel furs and ran an annual "If I Were a Model" contest, ca. 1947–50; the Thelma May models; the Hat Box models; the Gynlo models; and the Newark-based Belle Meade School of Charm and Modeling. In 1950, *Ebony* reported Negro modeling agencies in New York, Chicago, Cleveland, and Los Angeles. See "Ivel Seeks Model in Glamour Test," *New York Amsterdam News*, August 30, 1947, 19; *New York Amsterdam News*, October 11, 1947, 2; "Ivel Furs Third Contest Begins," *New York Amsterdam News,* November 8, 1947, 21; Gerru Major, "Fashionettes," *New York Amsterdam News*, April 8, 1950, 23; "Model Schools: Racket or Business," *Ebony,* September 1950, 73–77; for the Belle Meade School, see Summers, *Black and Beautiful*, 25.

54 "New Advertising Agency to Service Negro Market," *New Journal and Guide*, January 31, 1948, 3.

55 "New Advertising Agency to Service Negro Market," *New Journal and Guide*, January 31, 1948, 3; see also Jason Chambers, *Madison Avenue*, 74–77.

56 "First Negro Model Agency"; "Brandford Models: Rated with the Best," clipping from *COLOR*, n.d., Barbara Mae Watson Papers, Box 9, Folder 10, New York Public Library, Schomburg Center for Research in Black Culture; "Tan Model Agency May Change Ads," *Pittsburgh Courier*, October 19, 1946, 1.

57 "Negro Model Agency Opens in New York," *Philadelphia Tribune*, August 10, 1946, 3.

58 "Barbara Watson's Brown Skin Models: Judge's Daughter Has Idea, Makes It Work," *Chicago Defender*, February 20, 1954, 12; see also Smith and Phelps, *Notable Black American Women*, 691–93.

59 "J. S. Watson, N.Y. Judge, Dies at 59," *Chicago Defender*, May 17, 1952, 1; "Career Woman at Home," *New York Age*, March 5, 1947, clipping in Barbara Mae Watson

Papers, Box 9, Folder 10, New York Public Library, Schomburg Center for Research in Black Culture; "Barbara Watson's Brown Skin Models," 12.

60 Barbara Mae Watson Papers, New York Public Library, Schomburg Center for Research in Black Culture.

61 Quoted in Ophelia DeVore, "Figure, Voice, Make-Up, Breeding, Lead to Charm," *New York Amsterdam News*, September 5, 1953, 10.

62 DeVore, "Figure, Voice," 10; Sones, "The Secret to Inner Beauty"; Summer, *Black and Beautiful*, 25–38; Haidarali, "Polishing Brown Diamonds," 10.

63 Quoted in "Ed Brandford: The Guy Who Created Brandford Models," *Labor Vanguard*, clipping, n.d., Barbara Mae Watson Papers, Box 9, Folder 10, New York Public Library, Schomburg Center for Research in Black Culture.

64 Quoted in "No Uncle Toms or Aunt Jemimas," *Afro-American*, November 30, 1946, clipping, Box 9, Folder 10, Barbara Mae Watson Papers, New York Public Library, Schomburg Center for Research in Black Culture.

65 Quoted in "Harlem's First Professional Glamour Girls," newspaper clipping, Box 9, Folder 10, Barbara Mae Watson Papers, New York Public Library, Schomburg Center for Research in Black Culture; "Tan Model Agency May Change Ads," *Pittsburgh Courier*, October 19, 1946, 11.

66 Quoted in "Glamour Inc.: All about Negro Models," *New York Post*, June 16, 1955, 4, Box 10, Barbara Mae Watson Papers, New York Public Library, Schomburg Center for Research in Black Culture.

67 "Glamour Inc.: All about Negro Models," *New York Post*, June 16, 1955, 4, Box 10, Barbara Mae Watson Papers, New York Public Library, Schomburg Center for Research in Black Culture.

68 Quoted in "Harlem's First Professional Glamour Girls," newspaper clipping, Box 9, Folder 10, Barbara Mae Watson Papers, New York Public Library, Schomburg Center for Research in Black Culture; "Modeling Agency Opens in N'York at Hotel Astor," *Atlanta Daily World*, August 17, 1946, 1.

69 Higginbotham, *Righteous Discontent*; White and White, *Stylin'*; Wolcott, *Remaking Respectability*.

70 Lacey, *Model Woman,* 83–84.

71 Leigh, *Girl Who Had Everything*, 65–66.

72 Leigh, *Girl Who Had Everything*, 65–66; "Family-Style Model Agency," *Life,* October 4, 1948, 63–66.

73 Carter Henderson, "Comely Ladies, Manly Males Give Industry Touch of High Fashion," *Wall Street Journal*, January 18, 1957, 1; Elizabeth Harrison, "Noted Model Agent Always Seeks Bony Faces with Well-Spaced Eyes," *New York Times*, January 5, 1956, 28; Bernadette Carey, "Modeling Business Looks Good," *New York Times*, December 21, 1966, 57; Lacey, *Model Woman*, 100–104.

74 Lizabeth Cohen, *Consumer's Republic*; Horowitz, *Anxieties of Affluence;* McGovern, *Sold American*; A. Green, *Selling the Race*.

75 "Speaking of Pictures," *Life*, January 5, 1953, 2; Thomas Frank, *The Conquest of Cool: Business Culture, Counterculture, and the Rise of Hip Consumerism* (Chicago, IL: University of Chicago Press, 1997); see also Robert A. Sobieszek, *The*

Art of Persuasion: A History of Fashion Photography (New York: H.N. Abrams, 1988), 96.

76 Lacey, *Model Woman*, 92. Lambert also went on to found the Council of Fashion Designers of America in 1962.

77 See the Council of Fashion Designers of America, Inc, website, http://cfda.com /about/history, accessed June 20, 2016.

78 Lacey, *Model Woman*, 91.

79 Alexandra Palmer, *Dior: A New Look, a New Enterprise, 1947–57* (London: V+A, 2009), 48–49; for more on how this piracy worked before the war, see Elizabeth Hawes, *Fashion Is Spinach* (New York: Random House, 1938).

80 Gross, *Model*, 77–78.

81 William F. Stapp, "Penn as Portraitist," in *Irving Penn: Master Images,* 86; Merry A. Foresta, "Irving Penn: The Passion of Certainties," in *Irving Penn: Master Images*, 2. See also John Szarkowski, *Irving Penn* (New York: Museum of Modern Art, 1984).

82 Parks, *To Smile in Autumn: A Memoir*, 25.

83 Vettel-Becker, *Shooting from the Hip*, 88. I am indebted, in this paragraph, to Vettel-Becker's wonderful analysis of postwar photography and the female model.

84 This photograph appeared for the first time in "Speaking of Pictures . . . America's Most Photographed Models Pose for a Portrait," *Life*, May 12, 1947, 14–15; it was used again in "Penn's People," *Life*, November 14, 1960, 103.

85 "Speaking of Pictures," 14–15.

86 "Lisa Fonssagrives: Do Illusions Sell Refrigerators?" *Time* September 19, 1949, 90.

87 D. Johnson, *Lavender Scare*; May, *Homeward Bound*; Meyerowitz, *Not June Cleaver*; Gilbert, *Men in the Middle*; Canaday, *Straight State*; Meyerowitz, *How Sex Changed*; Serlin, *Replaceable You*.

88 "Three Day Sessions Make Fashion History," *Pittsburgh Courier*, July 4, 1953, 10.

89 "First Towles Reunion Was a Huge Success," *Los Angeles Sentinel,* July 30, 1981, C1; "Lois Towles, Concert Pianist and College Music Instructor," *New York Times*, March 25, 1983, B5.

90 San Diego obit.

91 "Sues Model for Divorce," *Pittsburgh Courier*, September 23, 1950, 5; A. Clayton Powell, Jr., "Powell Finds Bias Popping Up in Paris," *New York Amsterdam News*, December 8, 1951, 1; Dorothea Towles, "Dorothea and Dior, for Izzy," *Pittsburgh Courier*, August 15, 1953, 22.

92 Floyd Snelson, "Glamorous Dorothea Towles Returns from European Trip," *Atlanta Daily World*, April 10, 1952, 3.

93 "Dorothea Towles' Show to be Fabulous Affair, Hundreds Await Saturday Night," *Los Angeles Sentinel*, May 22, 1952, C3; see also "Model to Edit Beauty Column," *Daily Defender* (Chicago) March 2, 1959, A15; "Dorothea Towles Arrives for Show," *Los Angeles Sentinel,* April 28, 1960, B1.

94 "Dorothea Towles, Model, Weds New York Attorney," *Daily Defender* (Chicago) July 15, 1963, 15; "Modeling and Charm," *New York Amsterdam News*, June 29, 1963, 13.

95 Snelson, "Glamorous Dorothea Towles Returns"; "Fashions for Freedom Featured Our Heroines," *New York Amsterdam News*, July 4, 1964, 21.

96 "U.S. Negro Girl Wins Cannes Beauty Contest," *New York Times,* May 9, 1960, 33; Sones, "Secret to Inner Beauty," 28; Summers, *Black Is Beautiful*, 27; for more about the relationship between France and the United States in the context of the Cannes film festival, see Schwartz, *It's So French*.

97 Malia McAndrew, "Selling Black Beauty: African American Modeling Agencies and Charm Schools in Postwar America," *OAH Magazine of History*, January 2010, 30.

98 "Trio of Beauties Back from Conquests Abroad," *Daily Defender*, July 7, 1960, A20.

99 Stovall, *Paris Noir*.

100 Inez Kaiser, "Top American Designer Hires First Negro Model," *Atlanta Daily World*, July 23, 1961, 4; "Beverly Valdes Breaks Barrier in New York's Modeling Field," *Afro-American*, July 1, 1961, 10; Art Peters, "Light, Bright, Near-White Models Crack Color Bar," *Philadelphia Tribune*, September 8, 1962, 3; for the *Look* magazine reference, see "The Day Dawns Bright for the Negro Model," *Philadelphia Tribune*, September 10, 1963, 2.

101 "Day Dawns Bright," 2.

102 Janice Cheddle seeks to disrupt the fashion history narrative of a heroic Richard Avedon single-handedly breaking the color line in "The Politics of the First."

103 "Model Mothers," *Life*, May 22, 1944, 65–70; for a similar article, with nearly identical references to Powers, see Betty Hannah Hoffman, "The Model Mother," *Ladies' Home Journal*, October 1945, 159–62, 174–75.

104 "Model Mothers," *Life*, May 22, 1944, 65–70.

105 "Notions about Models," *Life*, May 12, 1947, 16.

106 For a wonderful history of glamour in the 1920s–1940s era, see Willis-Tropea, "Hollywood Glamour."

107 Buszek, *Pin-up Grrrls*, 209.

108 May, *Homeward Bound*; for a critique and complication of May's argument, see Meyerowitz, *Not June Cleaver*. See also Vettel-Becker, *Shooting From the Hip*, ch. 4.

109 Buszek, *Pin-Up Grrrls*, 236.

110 Greer, "Image Matters," 151; see also Haidarali, "Polishing Brown Diamonds," 15–21.

111 Craig, *Ain't I A Beauty Queen?*; see also Kinloch, "Beauty, Femininity, and Black Bodies."

112 For a discussion of the relationship between discourses of racial progress and the work of African American beauty culturalists during Jim Crow, see Peiss, *Hope in a Jar,* 203–38; Gill, "First Thing"; Walker, *Style and Status*.

113 Higginbotham, *Righteous Discontent*, 187.

114 Higginbotham, *Righteous Discontent*, 187.

115 White and White, *Stylin',* 192; see also Gill, "First Thing."

116 McGuire, *At the Dark End of the Street*.

117 Ford, *Liberated Threads*, 69–71. For additional work on the politics of respectability, see Wolcott, *Remaking Respectability*; and L. Thompson, *Beyond the Black Lady*.

118 Harris, a graduate of Bennett College in North Carolina, also pursued graduate work at Columbia; she had an active career as a singer and actress. In 1963 she married her second husband, John Carter, a Guyanese barrister who was knighted by Queen Elizabeth in 1966. Carter was Guyana's ambassador to many counties during his career, including the United States, Canada, and England. Smith and Phelps, *Notable Black American Women*, 87.

119 "Is It True What They Say about Models?" *Ebony*, November 1951, 60–64.

120 For other coverage of Sara Lou Harris, see "Ebony's Girls," *Ebony*, November 1950, 23–24; and "New Beauties vs. Old," *Ebony,* March 1954, 50. See also "Model Schools: Racket or Business," *Ebony,* September 1950, 73–77, for a similar themed article that also includes a discussion of Sara Lou Harris.

121 *Jet* cover, "Glamour Queen of the Disc Jockeys," Barbara Mae Watson Papers, Box 9, Folder 9, New York Public Library, Schomburg Center for Research in Black Culture.

122 Reichert, *Erotic History of Advertising*; West, *Kodak*; Kitch, *Girl on the Magazine Cover*.

123 Dorothea Towles, "Sex Pots' Have No Business Trying to Model," Pittsburgh Courier, July 7, 1956, pg. 1.

124 Dorothea Towles, "Sex Pots' Have No Business Trying to Model," Pittsburgh Courier, July 7, 1956, pg. 1.

125 Dorothea Towles, "Sex Pots' Have No Business Trying to Model," Pittsburgh Courier, July 7, 1956, pg. 1.

126 Frazier, *Black Bourgeoisie*.

FIVE. Constructing Femininity

1 Quant, *Quant by Quant*, 73.

2 Quant, *Quant by Quant*, 73.

3 Quant, *Quant by Quant*, 74.

4 Keenan, *Women*, 127.

5 Jean Shrimpton, "The Truth about Modeling," *Ladies' Home Journal* 82 (August 1965): 66.

6 Shrimpton, "Truth about Modeling," 66.

7 Craik, *Face of Fashion*, 107; see also Hall-Duncan, *History of Fashion Photography*, 161. The other two photographers of the so-called Terrible Three were Terence Donovan and Brian Duffy.

8 Craik, *Face of Fashion*, 108.

9 Eugene M. Hanson, "Finding Photographic Faces," US *Camera* 24 (August 1961): 68.

10 Hanson, "Finding Photographic Faces," 69.

11 Hanson, "Finding Photographic Faces," 69; see also Richard Musch, "Model's Day," *Popular Photography* 59 (July 1966): 82–83, 119–20.

12 Quoted in P. Gowland, "Hold It—That's the Pose," *Popular Photography* 58 (May 1966): 103.

13 Gowland, "Hold It—That's the Pose," 76.

14 Ochoa, *Queen for a Day*, 203.

15 See for example, "The Direct Approach," *US Camera* 27 (May 1964): 50.

16 Butler, "Imitation and Gender Insubordination," 317.

17 Mock, *Redefining Realness*, xviii; emphasis in source.

18 Mary Ann Zimmerman / Robin Gorman to Kris Thomas, "Breck 'Good Will,'" memo, November 5, 1990, Breck Collection, Box 1, Folder 13, Archives Center, National Museum of American History (hereafter given as NMAH); Kris Thomas to Mary Ann Zimmerman / Robin Gorman, "Importance of Beauty PR Re: The Breck Message," November 20 1990, Breck Collection, Box 1, Folder 13, Archives Center, NMAH.

19 Zimmerman/Gorman to Thomas, "Breck 'Good Will,'" memo.

20 Butler, "Imitation and Gender Insubordination," 313; see also Butler, *Gender Trouble*.

21 Peggy Cullen, "History of Breck Advertising," typescript 1964, Breck Collection, Box 1, Folder 1, Archives Center, NMAH. I've drawn the historical overview concerning Breck from this document as well as the articles gathered to celebrate the company's fiftieth anniversary in the *Breck Gold Box*, July–August 1958, Breck Collection, Box 1, Folder 2, Archives Center, NMAH.

22 "Photo Gallery," Jean Ivory Stephens, n.d., Breck Collection, Box 2, Folder 31, Archives Center, NMAH.

23 Memo "Notes on Breck Pastels," from Sally Dickson Associates, August 30, 1971, Breck Collection, Box 1, Folder 1, Archives Center, NMAH; "Who Are the Girls in the Breck Pastel Paintings?," *Breck Gold Box* 14, no. 3 (May–June 1959): 16–19, Breck Collection, Box 1, Folder 2, Archives Center, NMAH.

24 Carol Ryan, interviewed by the author, July 7, 2011, via telephone.

25 "Do Fashion Ads Need Tricks?," 48; see also Gloria Emerson, "47 Models Going to Russia Are Survivors of a Rugged Competition," *New York Times*, July 15, 1959, 32.

26 "Who Is the Girl in the Breck Portrait" ad, *Seventeen* (December 1963), with correspondence between the Dial Corporation and model Cheryl Bates Lord, Breck Collection, Box 3, Folder 2, Archives Center, NMAH.

27 "Who Is the Girl in the Breck Portrait" ad. See also "Secretary Becomes Breck Girl," in *Cyanamid News* 11, no. 9 (July 1967): 1, in Breck Collection, Archives Center, Box 3, folder 6, NMAH.

28 Pitzulo, *Bachelors and Bunnies*; see also Fraterrigo, *Playboy*.

29 See chapter 4 of Ehrenreich, *Hearts of Men*; Preciado, *Pornotopia*; Watts, *Mr. Playboy*.

30 Breck memo, October 14, 1977, Breck Collection, Box 1, Folder 6, Archives Center, NMAH.

31 Blair Sabol, "Forever Breck," *New York Times,* June 14, 1992, n.p., clipping in Breck Collection, Box 3, Folder 32, Archives Center, NMAH. The first black Breck Girl was Donna Alexander, who won New Jersey's Junior Miss in 1974 and who modeled for Breck in ads that appeared in issues of *Glamour* and *Mademoiselle* in January 1975, and in issues of *Seventeen* and *Teen* in March 1975. For more about Alexander, see Breck Collection, Box 9, Archives Center, NMAH.

32 Students for a Democratic Society, *Port Huron Statement*; see also Kazin, *American Dreamers;* Isserman*, If I Had a Hammer*; Hale, "Romance of Rebellion"; Binkley, *Getting Loose.*

33 Women's Liberation, "No More Miss America," *New York Free Press,* September 5, 1968, 2, Robin Morgan Papers, Sally Bingham Center for Women's History and Culture, Duke University, available online at http://library.duke.edu/digitalcollections /wlmpc_maddco4036/. "No More Miss America" was written by Robin Morgan under the name "Women's Liberation."

34 Letter from Robin Morgan to Richard S. Jackson, Mayor of Atlantic City, August 29, 1968, Robin Morgan Papers, Sally Bingham Center for Women's History and Culture, Duke University, available online at http://contentdm.lib.duke.edu /cdm/compoundobject/collection/p15957coll6/id/14/rec/2. See also Morgan, "Women Disrupt." For more about Flo Kennedy, see Chambers, *Madison Avenue*; and Guadagnolo, "Segmenting America."

35 Robin Morgan, "The Oldest Front: On Freedom for Women," *Liberation: An Independent Monthly* 13, no. 5 (October 1968): 34; see also letter from Robin Morgan to Richard S. Jackson, Mayor of Atlantic City, August 29, 1968, Robin Morgan Papers, Sally Bingham Center for Women's History and Culture, Duke University, available online at http://contentdm.lib.duke.edu/cdm/compoundobject/collection /p15957coll6/id/14/rec/2.

36 "No More Miss America Press Release," Robin Morgan Papers, Sally Bingham Center for Women's History and Culture, Duke University, available online at http://contentdm.lib.duke.edu/cdm/singleitem/collection/p15957coll6/id/125 /rec/4.

37 Morgan, "Oldest Front," 34.

38 Protest songs for the Miss America Protest, September 7, 1968, Robin Morgan Papers, Sally Bingham Center for Women's History and Culture, Duke University, available online at http://contentdm.lib.duke.edu/cdm/compoundobject /collection/p15957coll6/id/20/rec/2.

39 Press release and open letter inviting women to attend the Miss America protest, August 22, 1968, Robin Morgan Papers, Sally Bingham Center for Women's History and Culture, Duke University, available online at http://contentdm.lib.duke.edu /cdm/compoundobject/collection/p15957coll6/id/23/rec/2.

40 Meikle, *American Plastic*, 2.

41 Quote from Detroit Artists Workshop's "White Panther Manifesto" (1968), quoted in Meikle, *American Plastic,* 260.

42 Meikle, *American Plastic,* 260.

43 "Negro Girls Sought to Enter Contest for Miss America," *New York Times*, August 15, 1968, clipping in Robin Morgan Papers, Sally Bingham Center for Women's History and Culture, Duke University, available online at http://contentdm.lib.duke.edu /cdm/singleitem/collection/p15957coll6/id/106/rec/1.

44 Quoted in Matelski, "(Big) and Black Is Beautiful."

45 Charlotte Curtis and Judy Klemesrud, "Along With Miss America, There's Now Miss Black America," *New York Times,* September 9, 1968, clipping in Robin Morgan

Papers, Sally Bingham Center for Women's History and Culture, Duke University, available online at http://contentdm.lib.duke.edu/cdm/singleitem/collection /p15957coll6/id/121/rec/1.

46 Hite, *Hite Report*.

47 Densmore, "Temptation," 207.

48 "Advertising: Women's Lib to Give Awards," *New York Times*, August 26, 1971, 63.

49 Thom, *Inside Ms.*, 211.

50 Lyons and Rosenblatt, "Body Hair, the Last Frontier."

51 Quoted in Scanlon, *Bad Girls Go Everywhere*, 176.

52 For a brief discussion of this activism, see Rosen, *World Split Open*, 162–63.

53 Hite, *Hite Report*, 84.

54 Hite, *Hite Report*, 93.

55 Hite, *Hite Report*, 94.

56 Hite, *Hite Report*, 94.

57 For Hite's research and writing during the 1970s, see her bestselling book *The Hite Report* (1976).

58 Midge Kovacs, "Women: Correcting the Myths," *New York Times*, August 26, 1972, 25.

59 Bronstein, *Battling Pornography*, 188–99; Strub, *Perversion for Profit*, 230–31; Griffin, *Pornography and Silence*.

60 B. Williams, "Retreat to Cultural Feminism," 65.

61 B. Williams, "Retreat to Cultural Feminism," 65.

62 Jane Alpert, "MotherRight: A New Feminist Theory," *Ms.*, August 1973, 92; Rich, *Of Woman Born*; Daly, *Gyn/Ecology*.

63 See especially Echols, *Daring to Be Bad*, 243–86; Gerherdt, *Desiring Revolution*, 149–82; Hesford, *Feeling Women's Liberation*, 222–23; S. Evans, *Born for Liberty*, 294; Enke, *Finding the Movement*, 217–51; and Fraser, "Feminism's Two Legacies."

64 Firestone, *Dialectic of Sex*, 206.

65 Griffin, *Woman and Nature*, 226.

66 Stone, "*Empire* Strikes Back." For the sometimes-fraught relationship between cis and trans women within second-wave feminism, see Stryker, *Transgender History*, 113–20.

67 "Models' Convention to be Held in Detroit," *Atlanta Daily World*, June 3, 1958, 2; "Models Look Forward to Foxes Meet," *Daily Defender,* April 30, 1959, 16; "Little Foxes Attract Top Models to 2nd Glamour Confab in Detroit," *Chicago Defender,* July 25, 1959, 14; "Negro Models to Meet in Detroit," *Atlanta Daily World*, July 14, 1960, 8; "Sixth Annual National Confab in Philadelphia," *Los Angeles Sentinel,* August 6, 1964, C5; "Black Modeling Group Stresses Improvement," *Los Angeles Sentinel*, July 31, 1969, A12.

68 The Mayor's Committee on Job Advancement, Preliminary Report on Advertising Practices, in Robert F. Wagner Papers, Mayor's Commission on Job Advancement, New York City Municipal Archives, Box 152, folder 2126.

69 "March on Madison," *Newsweek,* September 9, 1963, 68; "Employment," *Ebony,* January 1963, 87; "Have Black Models Really Made It?" *Ebony,* May 1970, 160; Chambers, *Madison Avenue*, 133–34.

70 Peter Bart, "Advertising: Negro Models Getting TV Work," *New York Times,* September 7, 1962, 44; Peter Bart, "Advertising: Use of Negro Models Widening," *New York Times,* June 13, 1963, 35; Peter Bart, "Advertising: Colgate to Use Negro Models," *New York Times,* August 23, 1963, 30.

71 Summers, *Black Is Beautiful*, 34.

72 "Dark Glamour," *Newsweek*, September 3, 1962, 69; "Swirl of Bright Hues," *Life*, June 29, 1962, 84–86; "Negro Models—A Band of Beautiful Pioneers," *Life*, June 29, 1962, 87–88; Marilyn Bender, "Negro Role in Modeling is Growing," *New York Times,* September 5, 1963, 24.

73 Jeannette Reid to Naomi Sims, 1975, Naomi Sims Collection, Box 5, Schomberg Center for Research in Black Culture, New York Public Library.

74 Ms. Monterey Lane to Naomi Sims, October 27, 1973, Naomi Sims Collection, Box 5, Schomberg Center for Research in Black Culture, New York Public Library.

75 R. Lydia Greene to Naomi Sims, October 19, 1975, Naomi Sims Collection, Box 5, Schomberg Center for Research in Black Culture, New York Public Library.

76 Eric Wilson, "Naomi Sims, 61, Pioneering Black Cover Girl, Is Dead," *New York Times*, August 3, 2009, A21; head-shot of Sims photograph for McCall Publishing Company, February 1976, in the Naomi Sims Portrait Collection, Schomberg Center for Research in Black Culture, New York Public Library.

77 Biographical details are drawn from Wilson, "Naomi Sims, 61," A21; Michael Sokolove, "Sims Cover Girl Elegant Beauty Cloaked a Complicated Life," *New York Times*, December 27, 2009, SM18; Bernadine Morris, "Naomi Sims: The Model Who Electrifies," *New York Times*, June 24, 1969, 34; "Black Look in Beauty," *Time*, April 11, 1969, 72.

78 Marjene Busby, "New Life for a Top Model," *Kansas City Star*, June 22, 1975, clipping, in Box 6, Duplicate Clippings, Naomi Sims Collection, Box 5, Schomberg Center for Research in Black Culture, New York Public Library.

79 Quoted in Gross, *Model*, 234.

80 Laurie Johnston, "Wilhelmina, High Fashion Model and Agency Owner, Is Dead at 40," *New York Times,* March 3, 1980, D11.

81 Quoted in S. G. Carter, "Naomi Sims," 4; Dell'Orefice quoted in Lacey, *Model Woman*, 177.

82 Wilhelmina Model Book, Spring 1972, Naomi Sims Collection, Box 5, Wilhelmina Receipts Folder, Schomberg Center for Research in Black Culture, New York Public Library.

83 Naomi Sims to Eileen Ford, May 4, 1972, Naomi Sims Collection, Box 6, Ford Contracts Folder, Schomberg Center for Research in Black Culture, New York Public Library.

84 Jo Ahern Zill, "Black Beauty," *Look* 33 (January 7, 1969): 72; see also Marylin Bender, "Black Models Find They Have Friends in the White World," *New York Times*, December 18, 1968, 40.

85 Quoted in Bernadine Morris, "Naomi Sims: Model Who Electrifies," 34.

86 "Naomi," *Ladies' Home Journal,* November 1968, 145.

87 See Torgovnick, *Gone Primitive*.

88 Michael Sokolove, "Sims Cover Girl Elegant Beauty Cloaked a Complicated Life," *New York Times*, December 27, 2009, SM18; Marjene Busby, "New Life for a Top Model," *Kansas City Star,* June 22, 1975, clipping, in Box 6, Duplicate Clippings, Naomi Sims Collection, Box 5, Schomberg Center for Research in Black Culture, New York Public Library.

89 Morris, "Naomi Sims: Model Who Electrifies," 34.

90 Ford, *Liberated Threads*, 56–57.

91 Quant, *Quant by Quant*, 74–75; see also Sheridan, *Fashion, Media, Promotion*, 154–55.

92 Givhan, *Battle of Versailles,* 208–10. For the relationship between voguing and queer and trans of color urban culture in the 1980s, see Livingston, *Paris Is Burning.*

93 André Leon Talley, "The Ten Top Black Models," *Ebony*, July 1980, 125.

94 All Blair and Burrows quotes from "Those Sleek Black Beauties," *Newsweek,* May 5, 1975, 68.

95 Clive Barnes, "A New Fashion Energy," *Vogue,* December 1978, 274.

96 Barnes, "New Fashion Energy," 274.

97 For a history of the global politics of soul style, see Ford, *Liberated Threads*; and C. Young, *Soul Power.*

98 Quoted in Angela Taylor, "Designing Hairpieces for Blacks: Shop Talk," *New York Times,* May 31, 1973, 46.

99 Taylor, "Designing Hairpieces," 46.

100 "Smoother Styles Are Replacing Afro Looks," *Kansas City Star,* clipping ca. 1975, Duplicate Clippings, Naomi Sims Collection, Box 6, Schomberg Center for Research in Black Culture, New York Public Library.

101 "Smoother Styles"; see also "Naomi Sims: Model to Super-Businesswoman," Millinery and Wig Research, March 26, 1975, clipping, Naomi Sims Collection, Box 6, Schomberg Center for Research in Black Culture, New York Public Library.

102 Kelley, "Nap Time: Historicizing the Afro," 341; Jones and Jones, *All about the Natural*; Mercer, "Black Hair/Style Politics"; Rooks, *Hair Raising.*

103 Walker, *Style and Status*, 171; Craig, *Ain't I a Beauty Queen?*, 42–43.

104 Kelley, "Nap Time," 344.

105 Quoted in Gill, *Beauty Shop Politics*, 122.

106 Ford, *Liberated Threads*, 104–5.

107 Quoted in Kelley, "Nap Time," 346; see also Ford, *Liberated Threads*, 79.

108 Marcia Turnier, interview by the author, December 8, 2012, New York City. All information about Turnier, including the quotations below, is from this interview.

109 Orvell, *Real Thing.*

110 Jacobson, *Roots Too.*

111 Students for a Democratic Society, *Port Huron Statement*; see also Haselstein, Gross, and Snyder-Körber, *Pathos of Authenticity.*

112 Hale, "Romance of Rebellion," 78; see also Hale's *Nation of Outsiders*, especially chapter 3.

113 Meikle, *American Plastic,* 3.

114 Halter, *Shopping for Identity.* For reflections on the commodification of ethnic, sexual, and racial identities since the 1970s, see also Comaroff and Comaroff,

Ethnicity Inc.; Chasin, *Selling Out*; Sender, *Business, Not Politics*; Davilo, *Latinos, Inc.*

115 For foundational discussions of orientalism and primitivism in Western culture, see Said, *Orientalism*; and Torgovnick, *Gone Primitive*.

116 Alex Haley's *Roots: The Saga of an American Family* premiered on television in 1977. The novel was published in 1976.

117 Kedakai Lipton, interview with author, December 8, 2012, New York City. All Lipton quotes are from this interview.

118 "Naomi," *Ladies' Home Journal,* November 1968, 115.

119 Emerson, "Talented Beauty," 40.

120 Emerson, "Talented Beauty," 40.

121 Lacey, *Model Woman*, 168.

122 Cook, "They Made It on Looks," 26.

123 "Five Beauties Steal the Show," *Life*, September 23, 1960, 92; Liaut, *Cover Girls and Super Models*, 153–56.

124 "Model Is a Commuter on an International Level," *New York Times*, January 8, 1965, 24.

125 "The Girls Who Put Paris Across," *Life*, March 1, 1968, 32.

126 This sketch of Luna is indebted to Richard Powell's excellent work in *Cutting a Figure*, 88.

127 Powell, *Cutting a Figure*, 88–89.

128 "The Blaze of Spain," *Harper's Bazaar,* January 1965, 107–28; "New Proportions '65," *Harper's Bazaar,* January 1965, 132–37.

129 These are Avedon's words, drawn from Sara Blair's interviews with Avedon, in her excellent *Harlem Crossroads*, 182 and 174.

130 Paul Roth, "Preface."

131 Leigh, *Girl Who Had Everything*, 75.

132 Mary Panzer, "States of Emergency," in *Avedon: Murals and Portraits* (New York: Harry N. Abrams, 2012), 13–14.

133 Quoted in Roth, "Family Tree," 241.

134 Avedon and Baldwin, *Nothing Personal*.

135 Avedon and Baldwin, *Nothing Personal*.

136 Avedon and Baldwin, *Nothing Personal*; Blair, *Harlem Crossroads*, 192–238.

137 Blair, *Harlem Crossroads*, 192.

138 Blair, *Harlem Crossroads*, 13.

139 Carol Squiers, "Let's Call It Fashion," 183.

140 Carol Bjorkman, "Features: Carol," *Women's Wear Daily* 111, no. 91 (November 8, 1965): 16.

141 "Frug that Fat Away: The Death of the Diet," *Harper's Bazaar*, April 1965, 188–89.

142 "The New Botticelli Girl," *Harper's Bazaar*, April 1965, 211.

143 Doon Arbus, interview with Richard Avedon, March 17, 1972, sides 1 and 2, typed transcript "Dick on Luna," p. 10, Richard Avedon Foundation, New York.

144 Arbus interview, 14.

145 Arbus interview, 10. See also Cheddie, "Politics of the First," 61–82.

146 Arbus interview, 14.

147 Kristin Hoganson, *Consumers' Imperium*; Schwartz, *It's So French!*

148 Coffey-Webb and Rosenbaum, "James Galanos," 68.

149 Coffey-Webb and Rosenbaum, "James Galanos," 68.

150 Coffey-Webb and Rosenbaum, "James Galanos," 68.

151 Robin Abarian, "Galanos Cuts Loose: The Designer Says Goodbye to the Last of the Glamourous Gowns That Made Him a Legend," *Los Angeles Times*, September 12, 1999; see also Bernadine Morris, "Galanos and Scaasi: A Vivid Spring, a Master of Chiffon," *New York Times*, February 28, 1989.

152 "Not to Be Missed," *Harper's Bazaar*, February 1965, 3.

153 "Psychedelic Art," *LIFE*, September 9, 1966, 66.

154 Bernstein, *Dances with Things*, 69.

155 J. Carter, *Heart of Whiteness*, 2.

156 Arbus interview. All quotes from this paragraph are from this interview.

157 Koda and Yohanna, *Model as Muse*, 91.

158 Powell, *Cutting a Figure*, 90.

159 Bokris, *Warhol*, 52.

160 Bokris, *Warhol*, 69.

161 Butt, *Between You and Me,* 117; Flatley, "Warhol Gives Good Face." Butt is working closely with Victor Bokris's biography, *Warhol*.

162 D. Johnson, *Lavender Scare*.

163 Koestenbaum, *Andy Warhol*, 60–61.

164 Koestenbaum, *Andy Warhol*, 63.

165 Powell, *Cutting a Figure*, 97.

166 Sontag, "Notes on Camp," 275.

167 Sontag, "Notes on Camp," 275.

168 Sontag, "Notes on Camp," 279.

169 Sontag, "Notes on Camp," 279.

170 "The Luna Year," *TIME*, April 1, 1966, 47.

171 "Luna Year," 47.

172 Ben Arongundade, "The Tragic Tale of Donyale Luna," Telegraph.co.uk, November 11, 2012, Avedon Foundation, http://www.avedonfoundation.org/about/.

173 Button, "Vogue Timelines," 283.

174 Gross, *Model*, 343; see also Lacey, *Model Woman*, 231–33.

175 "Black Is Busting Out All Over: Black Models Take Center Stage," *Life*, October 17, 1969, 34–41.

176 Cheng, *Second Skin*, 10; on the central role of primitivism in producing modernity, see also Lemke, *Primitivist Modernism*.

177 Jeanne Cordova, "Daughters of Bilitis Vote No to TS women," *Lesbian Tide* 2, no. 5 (1972): 21.

178 Cordova, "Daughters of Bilitis," 21; see also "Transsexual Ban Splits DOB Unit," *Advocate*, January 3, 1973, 14.

179 Robin Morgan, "Keynote Address," *Lesbian Tide* 2, no. 10/11 (1973): 32; for additional coverage, see Pichulina Hampi, *Advocate*, May 9, 1973, 4.

180 "Transsexuals Hex Robin Morgan," *Advocate*, July 18, 1973, 21.

181 Beth Elliott, "Of Infidels and Inquisitions," *Lesbian Tide* 2, no. 10/11 (1973): 15–26.

182 Elliott, "Of Infidels and Inquisitions," 26.

183 Daly, *Gyn/Ecology*, 71.

184 Raymond, *Transsexual Empire*.

185 Raymond, *Transsexual Empire*, xiv–xv.

186 Daly, *Gyn/Ecology*, 104; emphasis mine.

187 As quoted in Marti Abernathey, "Transphobic Radical Hate Didn't Start with Brennan: The Sandy Stone-Olivia Records Controversy," *Transadvocate,* August 24, 2011, http://www.transadvocate.com/transphobic-radical-hate-didnt-start-with-brennan-the-sandy-stone-olivia-records-controversy_n_4112.htm; see also Meyerowitz, *How Sex Changed,* 260–61; and Stryker, *Transgender History*, 105.

188 Gabriel, "Interview with the Transsexual Vampire," 18.

189 Meyerowitz, *How Sex Changed*, 262.

190 Rotskoff and Lovett, *When We Were Free to Be*.

191 Virginia Slims Folder, Naomi Sims Collection, Box 5, Schomberg Center for Research in Black Culture, New York Public Library.

192 For this history of "trans" as an umbrella category in the 1990s, see Valentine, *Imagining Transgender*.

193 Yuan and Wong, "First Black Trans Model."

194 Interview with Tracey Africa, *Luna Show*, episode 100, YouTube, October 19, 2009, https://www.youtube.com/watch?v=ZGWhRQSzqzk.

195 Michael Cunningham, "The Slap of Love," *Open City* 6, http://opencity.org/archive/issue-6/the-slap-of-love; see also Chauncey, *Gay New York*.

196 For a review of the literature on voguing, see Hilderbrand, *Paris Is Burning*.

197 Africa interview. See also Yuan and Wong, "First Black Trans Model," Many thanks to the Luna Show and to the unnamed interviewer who spoke with Tracey about her work.

198 Haraway, *"Manifesto for Cyborgs."*

199 Haraway, *"Manifesto for Cyborgs,"* 66.

200 Haraway, *"Manifesto for Cyborgs,"* 66.

201 Haraway, *"Manifesto for Cyborgs,"* 97.

202 Haraway, *"Manifesto for Cyborgs,"* 97.

203 Haraway, *"Manifesto for Cyborgs,"* 101.

204 I am referencing the version of the essay published as Stone *"Empire* Strikes Back," 231.

205 Stone, *"Empire* Strikes Back," 232.

206 See also Mock, *Redefining Realness*.

207 Michael Gross, "Steven Meisel: Madonna's Magician," *New York Magazine*, October 12, 1992, 31.

208 Lacey, *Model Woman*, 136; see also Gross, *Model*, 434.

209 Koda and Yohannan, *Model as Muse*, 136; D. Bailey, *David Bailey*, 28–29.

210 D. Bailey, *David Bailey*, 28–29.

211 Leah Chernikoff, "See Rare Footage of Stephen Sprouse's First Punk Fashion Show," *Fashionista*, May 2, 2013, http://fashionista.com/2013/05/see-rare-footage-of-stephen-sprouses-first-punk-fashion-show.

212 Padiha and Padiha, *Stephen Sprouse*.

EPILOGUE

1 Monloss, "Clairol"; Hoby, "Tracey Norman"; "She's Back, and She's Every Bit Her Real Self," Clairol.com, accessed August 24, 2016, http://clairol.com/en-us/beauty-school/tracey-africa-norman.

2 "She's Back."

3 Jada Yuan, "Tracey Africa Norman"; Hoby, "Tracey Norman"; Monloss, "Clairol."

4 "Meet Hari Nef: Model, Actress, Activist, and the First Trans Woman Signed to IMG Worldwide," *Vogue*, accessed August 25, 2016, http://www.vogue.com/13273361/hari-nef-transgender-model-img-interview/.

5 Tom Phillips, "Lea T and the Loneliness of the Fashion World's First Transsexual Supermodel," *Guardian*, August 1, 2010, https://www.theguardian.com/lifeandstyle/2010/aug/01/fashion-transgender.

6 Alyssa Vingant Klein, "Transgender Model Lea T Lands Big Redken Contract," Fashionista.com, November 4, 2014, http://fashionista.com/2014/11/lea-t-redken-campaign.

7 Quoted in Bernadine Morris, "Naomi Sims: The Model Who Electrifies," *New York Times*, June 24, 1969, 34.

8 Constance C. R. White, "Black Out: What Has Happened to the Black Models?," *Ebony*, September 2008, 98; see also Vicki Woods, "Is Fashion Racist?," *Vogue*, July 2008.

9 Mears, *Pricing Beauty*, 151.

10 Brown, *Corporate Eye*.

11 C. Evans, *Mechanical Smile*.

Abel, Charles. "Making the Thing Desirable." *Commercial Photographer* 2, no. 3 (1926): 106–9.

Ahmed, Sara. "Affective Economies." *Social Text* 22, no. 2 (2004): 117–39.

Ahmed, Sara. *The Cultural Politics of Emotion.* London: Routledge, 2004.

Albrecht, Donald. *Cecil Beaton: The New York Years.* New York: Skira Rizzoli, 2011.

Alexis, Marcus. "Pathways to the Negro Market." *Journal of Negro Education* 28, no. 2 (1959): 114–27.

Anzaldúa, Gloria E. "To(o) Queer the Writer: Loca, Escritoria, y Chicana." In *Living Chicana Theory*, edited by Carla Trujilla, 263–76. Berkeley, CA: Third Woman Press, 1998.

Auerbach, Nina. *Our Vampires, Ourselves.* Chicago, IL: University of Chicago Press, 2012.

Avedon, Richard, and James Baldwin. *Nothing Personal.* New York: Dell Publishing, 1964.

Bailey, David, with James Sherwood. *David Bailey: Models Close Up.* London: Channel Four Books, 1998.

Bailey, Peter. "Parasexuality and Glamour: The Victorian Barmaid as Cultural Prototype." *Gender and History* 2, no. 2 (June 1990): 148–72.

Bailie, Helen T. "Blood Ties: The Vampire Lover in the Popular Romance." *Journal of American Culture* 34, no. 2 (2011): 141–48.

Bain, Donald. *The Control of Candy Jones.* New York: Harper Collins, 1967.

Baldwin, Davarian. *Chicago's New Negroes: Modernity, the Great Migration, and Black Urban Life.* Chapel Hill: University of North Carolina Press, 2007.

Baral, Robert. *Revue: A Nostalgic Reprise of the Great Broadway Period.* New York: Fleet Publishing, 1962.

Barry, Kathleen. *Femininity in Flight: A History of Flight Attendants.* Durham, NC: Duke University Press, 2007.

Bear, Jordan. *Disillusioned: Victorian Photography and the Discerning Subject.* Philadelphia: Penn State University Press, 2015.

Beaton, Cecil. *The Glass of Fashion.* New York: Doubleday, 1954.

Beaton, Cecil. *Photobiography.* London: Odhams Press, 1951.

Beaton, Cecil. *The Wandering Years: Diaries, 1922–1939*. London: Weidenfeld and Nicolson, 1961.

Beaton, Cecil, and Gail Buckland. *The Magic Image: The Genius of Photography*. London: Pavilion Books, 1975.

Bederman, Gail. *Manliness and Civilization: A Cultural History of Gender and Race in the United States, 1880–1917*. Chicago, IL: University of Chicago Press, 1995.

Bender, Marylin. "Black Models Find They Have Friends in the White World." *New York Times* December 18, 1968, 40.

Bengry, Justin. "Courting the Pink Pound: *Men Only* and the Queer Consumer, 1935–1939." *History Workshop Journal* 68 (2009): 122–48.

Benson, Susan Porter. *Counter Cultures: Saleswomen, Managers, and Customers in American Department Stores, 1890–1940*. Urbana: University of Illinois Press, 1986.

Bergman, David. *Camp Grounds: Style and Homosexuality*. Amherst: University of Massachusetts Press, 1993.

Berry, Sarah. *Screen Style: Fashion and Femininity in 1930s Hollywood*. Minneapolis: University of Minnesota Press, 2000.

Bérubé, Allan. *Coming Out Under Fire: The History of Gay Men and Women in World War Two*. New York: Free Press, 1990.

Bettel-Vecker, Patricia. *Shooting from the Hip: Photography, Masculinity, and Postwar America*. Minneapolis: University of Minnesota Press, 2005.

Binkley, Sam. *Getting Loose: Lifestyle Consumption in the 1970s*. Durham, NC: Duke University Press, 2007.

Black, Gregory D. *The Catholic Crusade against the Movies, 1940–1975*. New York: Cambridge University Press, 1998.

Blair, Sara. *Harlem Crossroads: Black Writers and the Photograph in the Twentieth Century*. Princeton, NJ: Princeton University Press, 2007.

Blaszczyk, Regina Lee. *Imagining Consumers: Design and Innovation from Wedgwood to Corning*. Baltimore, MD: Johns Hopkins University Press, 2000.

Bochner, Jay. *An American Lens: Scenes from Alfred Stieglitz's New York Secession*. Boston, MA: MIT Press, 1995.

Bogart, Michele. *Artists, Advertising, and the Borders of Art, 1890–1960*. Chicago, IL: University of Chicago, 1995.

Bogle, Donald. *Toms, Coons, Mulattoes, Mammies, and Bucks; an Interpretive History of Blacks in American Films*. New York: Viking Press, 1973.

Bokris, Victor. *Warhol*. London: Penguin, 1989.

Bosworth, Howard, dir. *The Substitute Model*. Los Angeles, CA: Selig Polyscope, 1912.

Bourdieu, Pierre. "Cultural Goodwill." In *Distinction: A Social Critique of the Judgment of Taste*, 318–71. London: Routledge, 1984.

Boyd, Nan A. *Wide Open Town: A History of Queer San Francisco to 1965*. Berkeley: University of California Press, 2005.

Brandow, Todd, and William Ewing. *Edward Steichen: In High Fashion: The Condé Nast Years, 1923–1937*. New York: Norton, 2008.

Braun, Marta. "Chronophotography: Leaving Traces." In *Moving Pictures: American Art and Early Film, 1890–1910*, edited by Nancy Mowll Mathews with Charles Musser, 95–99. Williamstown, MA: Williams College, 2005.

Braun, Marta. "Muybridge le Magnifique." *Études Photographiques* 10 (November 2002): 34–50.

Bronstein, Carolyn. *Battling Pornography: The American Feminist Anti-Pornography Movement, 1976–1986*. New York: Cambridge University Press, 2011.

Brown, Elspeth H. "Black Models and the Invention of the U.S. 'Negro Market,' 1945–1960." In *Inside Marketing,* edited by Detlev Zwick and Julien Cayla, 185–211. Oxford: Oxford University Press, 2011.

Brown, Elspeth H. *The Corporate Eye: Photography and the Rationalization of American Commercial Culture, 1884–1929*. Baltimore, MD: Johns Hopkins University Press, 2005.

Brown, Elspeth H. "From Artist's Model to the 'Natural Girl': Containing Sexuality in Early Twentieth-Century Modelling." In *Fashion Models: Modeling as Image, Text, and Industry*, edited by Joanne Entwistle and Elizabeth Wissinger, 37–55. London: Berg, 2012.

Brown, Elspeth H. "Rationalizing Consumption: Photography and Commercial Illustration, 1913–1919." *Enterprise and Society* 1, no. 4 (2000): 715–38.

Brown, Elspeth H. "Racializing the Virile Body: Eadweard Muybridge's Locomotion Studies, 1883–1887." *Gender and History* 17, no. 3 (2005): 1–30.

Brown, Elspeth H. "De Meyer at *Vogue*: Commercializing Queer Affect in First World War-era Fashion Photography." *Photography and Culture* 2 no. 3 (2009): 253–73.

Brown, Elspeth H., and Thy Phu. "Introduction." In *Feeling Photography,* edited by Elspeth Brown and Thy Phu, 1–28. Durham, NC: Duke University Press, 2014.

Brown, Jayna. *Babylon Girls: Black Women Performers and the Shaping of the Modern*. Durham, NC: Duke University Press, 2008.

Butler, Judith. *Gender Trouble*. New York: Routledge, 1990.

Butler, Judith. "Imitation and Gender Insubordination." In *The Gay and Lesbian Studies Reader,* edited by Henry Abelove et al., 307–20. New York: Routledge, 1993.

Butler, Judith. "Is Kinship Always Heterosexual?" *differences* 15, no. 1 (2002): 14–44.

Buszek, Maria Elena. *Pin-up Grrrls: Feminism, Sexuality, Popular Culture*. Durham, NC: Duke University Press, 2006.

Butt, Gavin. *Between You and Me: Queer Disclosures in the New York Art World*. Durham, NC: Duke University Press, 2005.

Button, Janine. "Vogue Timelines." *Fashion Theory* 10, no. 1/2 (2006): 279–88.

Canaday, Margot. *The Straight State: Sexuality and Citizenship in Twentieth-Century America*. Princeton, NJ: Princeton University Press, 2009.

Carby, Hazel V. "Policing the Black Woman's Body in the Urban Context." *Critical Inquiry* 18, no. 4 (1992): 738–55.

Carter, Julian. "Of Mother Love: History, Queer Theory, and Nonlesbian Identity." *Journal of the History of Sexuality* 14, nos. 1–2 (2005): 107–38.

Carter, Julian. *The Heart of Whiteness: Normal Sexuality and Race in America, 1880–1940*. Durham, NC: Duke University Press, 2007.

Carter, Shawn Grain. "Naomi Sims: America's First Black Cover Model." Master's thesis, Fashion Institute of Technology, 2009.

Chambers, Jason. *Madison Avenue and the Color Line: African Americans in the Advertising Industry.* Philadelphia: University of Pennsylvania Press, 2008.

Chapman, Erin D. *Prove It on Me: New Negroes, Sex, and Popular Culture in the 1920s.* New York: Oxford University Press, 2012.

Charles, David. "The Future of Photography in America." *Commercial Photographer* 4, no. 6 (1929): 282–84.

Chase, Edna. *Always in Vogue.* London: Victor Gollancz, 1954.

Chasin, Alexandra. *Selling Out: The Gay and Lesbian Movement Goes to Market.* New York: Palgrave, 2000.

Chauncey, George. *Gay New York: Gender, Urban Culture, and the Making of the Gay Male World, 1890–1940.* New York: Basic Books, 1994.

Chauncey, George. "The Policed: Gay Men's Strategies of Everyday Resistance in Times Square." In *Creating a Place for Ourselves: Lesbian, Gay, and Bisexual Community Histories,* edited by Brett Breemyn, 9–25. New York: Routledge, 1997.

Cheddie, Janice. "The Politics of the First: The Emergence of the Black Model in the Civil Rights Era." *Fashion Theory* 6, no. 1 (2002): 61–82.

Cheng, Anne. *Second Skin: Josephine Baker and the Modern Surface.* New York: Oxford University Press, 2011.

Clement, Elizabeth A. *Love for Sale: Courting, Treating, and Prostitution in New York City, 1900–1945.* Chapel Hill: University of North Carolina Press, 2006.

Cleto, Fabio. "Introduction: Queering the Camp." In *Camp: Queer Aesthetics and the Performing Subject: A Reader,* edited by Fabio Cleto, 1–43. Edinburgh, UK: Edinburgh University Press, 1999.

Clough, Patricia T., and Jean Halley. *Affective Turn: Theorizing the Social.* Durham, NC: Duke University Press Books, 2007.

Coffey-Webb, Louise, and Sandra L. Rosenbaum, "James Galanos." *Dress* 32, no. 1 (2005): 66–74.

Cogdell, Christina. *Eugenic Design: Streamlining America in the 1930s.* Philadelphia: University of Pennsylvania Press, 2004.

Cohen, Barbara Naomi. "The Dance Direction of Ned Wayburn." PhD diss., New York University, 1980.

Cohen, Cathy J. "Punks, Bulldaggers, and Welfare Queens: The Radical Potential of Queer Politics?" *GLQ: A Journal of Lesbian and Gay Studies* 3 (1997): 437–65.

Cohen, Lisa. *All We Know: Three Lives.* New York: Farrar, Straus and Giroux, 2012.

Cohen, Lizabeth. *A Consumers' Republic: The Politics of Mass Consumption in Postwar America.* New York: Vintage, 2004.

Colette. "Mannequins." 1925. *Vogue,* May 1960, 158, 230.

Comaroff, John L., and Jean Comaroff. *Ethnicity Inc.* Chicago, IL: University of Chicago Press, 2007.

Conover, Carole. *Cover Girls: The Story of Harry Conover.* Englewood Cliffs, NJ: Prentice Hall, 1978.

Courbold, Clare. *Becoming African Americans: Black Public Life in Harlem, 1919–1939*. Cambridge, MA: Harvard University Press, 2009.

Couvares, Francis G., ed. *Movie Censorship and American Culture*. Amherst: University of Massachusetts Press, 2006.

Craig, Maxine Leeds. *Ain't I a Beauty Queen? Black Women, Beauty, and the Politics of Race*. New York: Oxford University Press, 2002.

Craik, Jennifer. *The Face of Fashion*. London: Routledge, 1994.

Creadick, Anna G. *Perfectly Average: The Pursuit of Normality in Postwar America*. Amherst: University of Massachusetts Press, 2010.

Crimp, Douglas. *"Our Kind of Movie": The Films of Andy Warhol*. Cambridge, MA: MIT Press, 2012.

Crump, James. "The American Years, 1933–1943." In *When We Were Three: The Travel Albums of George Platt Lynes, Monroe Wheeler, and Glenway Wescott, 1925–1935*. Santa Fe, NM: Arena Editions, 1998.

Crump, James. "Iconography of Desire: George Platt Lynes and Gay Male Visual Culture in Postwar New York." In *George Platt Lynes: Photographs from the Kinsey Institute*, 149- 56. Boston, MA: Little, Brown, 1993.

Crump, James. "Photography as Agency: George Platt Lynes and the Avant-Garde." In *George Platt Lynes: Photographs from the Kinsey Institute*, 137–48. Boston, MA: Little, Brown 1993.

Cvetkovich, Ann. *An Archive of Feelings: Trauma, Sexuality, and Lesbian Public Cultures*. Durham, NC: Duke University Press, 2003.

Cvetkovich, Ann. "Public Feelings." *South Atlantic Quarterly* 106, no. 3 (2007): 459–68.

Daly, Mary. *Gyn/Ecology: The Metaethics of Radical Feminism*. Boston, MA: Beacon Press, 1978.

Danae, Clark. "Commodity Lesbianism." *Camera Obscura: A Journal of Feminism, Culture, and Media Studies* 25–26, no. 25 (1991): 186–201.

Dance, Robert, and Bruce Robertson. *Ruth Harriet Louise and Hollywood Glamour Photography*. Berkeley: University of California Press, 2002.

Dates, Janette L. "Advertising." In *Split Image: African Americans in the Mass Media*, edited by Janette L. Dates and William Barlow, 421–54. Washington, DC: Howard University Press, 1990.

Davilo, Arlene. *Latinos, Inc: The Marketing of a People*. Berkeley: University of California Press, 2001.

Dawkins, Heather. *The Nude in French Art and Culture, 1870–1910*. Cambridge, MA: Cambridge University Press, 2002.

de la Peña, Carolyn Thomas. *The Body Electric: How Strange Machines Built the Modern American*. New York: NYU Press, 2003.

de Marly, Diana. *The History of Haute Couture, 1850–1950*. London: B. T. Batsford, 1980.

D'Emilio, John. "Capitalism and Gay Identity." In *Powers of Desire: The Politics of Sexuality*, edited by Ann Snitow, Christine Stansell, and Sharon Thompson, 100–113. Boston, MA: Monthly Review Press, 1983.

D'Emilio, John. *Sexual Politics, Sexual Community: The Making of a Homosexual Minority in the United States, 1940–1970*. Chicago, IL: University of Chicago Press, 1983.

D'Emilio, John, and Estelle B. Freedman. *Intimate Matters: A History of Sexuality in America.* 3rd ed. Chicago, IL: University of Chicago Press, 2012.

D'Emilio, John, and Estelle B. Freedman. "Introduction." In *Coming Out Under Fire,* by Allan Bérubé, vii–xiv. Chapel Hill: University of North Carolina Press, 2010.

Densmore, Dana. "On the Temptation to Be a Beautiful Object." In *Female Liberation: History and Current Politics*, edited by Roberta Salpert. 203–207. New York: Knopf, 1972.

Dijkstra, Bram. *Evil Sisters: The Threat of Female Sexuality in Twentieth-Century Culture.* New York: Henry Holt, 1998.

Dinerstein, Joel. *Swinging the Machine: Modernity, Technology, and African American Culture between the World Wars.* Amherst: University of Massachusetts Press, 2003.

"Do Fashion Ads Need Tricks? No, Just Love." *Printers' Ink,* March 23, 1962, 48.

Dolan, Jill. "Performance, Utopia, and the Utopian Performative." *Theatre Journal* 53 (2001): 455–79.

Doty, Robert. *Photo-Secession: Stieglitz and the Fine-Art Movement in Photography.* New York: Dover, 1978.

Douglas, Ann. *Terrible Honesty: Mongrel Manhattan in the 1920s.* New York: Farrar, Straus and Giroux, 1995.

Doyle, Jennifer, Jonathan Flatley, and José Esteban Muñoz, *Pop Out: Queer Warhol.* Durham, NC: Duke University Press, 1996.

"Dramatic Photography in Advertising." *Commercial Photographer* 5, no. 12 (1930): 623–27.

Duberman, Martin. *The Worlds of Lincoln Kirstein.* New York: Knopf, 2007.

Du Bois, W. E. B. *The Souls of Black Folk.* 1903. Edited with an introduction by David W. Blight and Robert Gooding-Williams. New York: Bedford/St. Martin's, 1997.

Duff Gordon, Lady ("Lucile"). *Discretions and Indiscretions.* New York: Frederick A. Stokes, 1932.

Duggan, Lisa. "The New Homonormativity: The Sexual Politics of Neoliberalism." In *Materializing Democracy: Toward a Revitalized Cultural Politics*, edited by Russ Castronovo and Dana D. Nelson, 188–207. Durham, NC: Duke University Press, 2002.

Duggan, Lisa. *The Twilight of Equality: Neoliberalism, Cultural Politics, and the Attack on Democracy.* Boston, MA: Beacon Press, 2004.

du Maurier, George. *Trilby.* 1894. Hertfordshire, UK: Wordsworth Editions, 1995.

Earle, Susan. "Harlem, Modernism, and Beyond: Aaron Douglas and His Role in Art/History." In *Aaron Douglas: African American Modernist,* edited by Susan Earle, 5–52. New Haven, CT: Yale University Press, 2008.

Ebony and Jet Magazines Present the Urban Negro Market for Liquors, Wines, and Beers. Study no. 1. New York: Johnson Publishing, 1953.

Ebony and Jet Magazines Present the Urban Negro Market for Liquors, Wines, and Beers. Study no. 2. New York: Johnson Publishing, 1954.

Echols, Alice. *Daring to Be Bad: Radical Feminism in America, 1967–1975.* Minneapolis: University of Minnesota Press, 1987.

"Editorial." *Commercial Photographer* 5, no. 4 (1930): 190–91.

Edwards, Elizabeth. "Ordering Others: Photography, Anthropologies, and Taxonomies." In *Invisible Light: Photography and Classification in Art, Science, and the Everyday,* edited by Chrissie Iles and Russell Roberts, 54–68. Oxford: Museum of Modern Art, 1998.

Edwards, Elizabeth. "Photographic Types: The Pursuit of Visual Method." *Visual Anthropology* 3 (1990): 235–58.

Edwards, Elizabeth. *Raw Histories: Photographs, Anthropology, and Museums.* London: Berg, 2001.

Edwards, Paul K. *The Southern Urban Negro as Consumer.* 1932. New York: Prentice Hall, 1981.

Ehrenreich, Barbara. *The Hearts of Men.* New York: Penguin, 1987.

El-Tayeb, Fatima. "'Gays Who Cannot Properly Be Gay': Queer Muslims in the Neoliberal European City." *European Journal of Women's Studies* 19 no. 1 (2012): 79–95.

Enstad, Nan. *Ladies of Love, Girls of Adventure Working Women, Popular Culture, and Labor Politics at the Turn of the Twentieth Century.* New York: Columbia, 1999.

Enke, Finn. *Finding the Movement: Sexuality, Contested Space, and Feminist Activism.* Durham: Duke University Press, 2007.

Entwistle, Joanne, and Don Slater. "Models as Brands: Critical Thinking about Bodies and Images." In *Fashioning Models: Image, Text, and Industry,* edited by Joanne Entwistle and Elizabeth Wissinger, 15–36. London: Berg, 2012.

Etherington-Smith, Meredith, and Jeremy Pilcher. *The "It" Girls: Lucy, Lady Duff Gordon, the Couturière "Lucile," and Elinor Glyn, Romantic Novelist.* London: H. Hamilton, 1986.

Evans, Caroline. "The Enchanted Spectacle." *Fashion Theory* 5, no. 3 (2001): 271–310.

Evans, Caroline. "Jean Patou's American Mannequins: Early Fashion Shows and Modernism." *Modernism/Modernity* 15, no. 2 (2008): 243–63.

Evans, Caroline. *The Mechanical Smile: Modernism and the First Fashion Shows in France and America, 1900–1929.* New Haven, CT: Yale University Press, 2013.

Evans, Caroline. "Multiple, Movement, Model, Mode: The Mannequin Parade, 1900–1929." In *Fashion and Modernity,* edited by Christopher Brewer and Caroline Evans, 125–46. London: Berg, 2005.

Evans, Sara. *Born for Liberty: A History of Women in America.* New York: Free Press, 1989.

Ewing, William A. *The Photographic Art of Hoyningen-Huene.* London: Thames and Hudson, 1986.

Ewing, William A., and Todd Brandow. *Edward Steichen in High Fashion: The Condé Nast Years, 1923–1937.* New York: W. W. Norton, 2008.

Farley, Lillian. "Alias Dinarzade: A Chronicle of the '20s." Unpublished manuscript. Last modified 1980.

Fields, Jill. *An Intimate Affair: Women, Lingerie, and Sexuality.* Berkeley: University of California Press, 2007.

Finn, Michelle R. "A Modern Necessity: Feminism, Popular Culture, and American Womanhood, 1920–1948." PhD diss., University of Rochester, 2012.

Firestone, Shulamith. *The Dialectic of Sex: The Case for Feminist Revolution*. New York: William Morrow, 1970.

"First Negro Model Agency Opened in New York." *Printers' Ink*, August 9, 1946.

Flatley, Jonathan. "Warhol Gives Good Face: Publicity and the Politics of Prosopopoeia." In *Pop Out: Queer Warhol*, edited by Jennifer Doyle, Jonathan Flatley, and José Esteban Munoz, 101–33. Durham, NC: Duke University Press, 1996.

Ford, Tanisha C. *Liberated Threads: Black Women, Style, and the Global Politics of Soul*. Chapel Hill: University of North Carolina Press, 2012.

Ford, Charles Henri, and Parker Tyler. *The Young and the Evil*. Paris: Obelisk Press, 1933.

Foresta, Merry A. "Irving Penn: The Passion of Certainties." In *Irving Penn: Master Images: The Collections of the National Museum of American Art and the National Portrait Gallery*, edited by Merry A. Foresta and William F. Stapp, 1–13. Washington D.C.: Smithsonian, 1994.

Foucault, Michel. *The History of Sexuality*. Vol. 1, *An Introduction*. Translated by Robert Hurley. New York: Pantheon Books, 1990 [1978].

Foucault, Michel. *Discipline and Punish: The Birth of the Prison*. Translated by Alan Sheridan. New York: Pantheon Books, 1977.

"Fourteen Million Negro Consumers." *Management Review* 36 (June 1947): 338.

Fox, S. *The Mirror Makers: A History of American Advertising and Its Creators*. New York: William Morrow, 1984.

Frank, Miriam. *Out in the Union: A Labor History of Queer America*. Philadelphia, PA: Temple University Press, 2014.

Fraser, Nancy. "Feminism's Two Legacies: A Tale of Ambivalence." *South Atlantic Quarterly* 114, no. 4 (2015): 699–712.

Fraterrigo, Elizabeth. *Playboy and the Making of the Good Life in Modern America*. Oxford: Oxford University Press, 2009.

Frazier, E. Franklin. *Black Bourgeoisie*. New York: Free Press, 1957.

Frederickson, George M. *The Black Image in the White Mind: The Debate on Afro-American Character and Destiny, 1817–1914*. New York: Harper and Row, 1971.

Friedman, Andrea. "The Smearing of Joe McCarthy: The Lavender Scare, Gossip, and Cold War Politics." *American Quarterly* 57, no. 4 (2005): 1105–29.

Gabriel, Davina Anne. "Interview with the Transsexual Vampire: Sandy Stone's Dark Gift." *TransSisters: The Journal of Transsexual Feminism* 8 (1993): 15–27.

Gamber, Wendy. *The Female Economy: The Millinery and Dressmaking Trades, 1860–1930*. Urbana: University of Illinois Press, 1997.

Garner, Philippe. "An Instinct for Style." In *Cecil Beaton*, edited by Philippe Garner and David Allan Mellor, 67–68. New York: Stewart, Tabori, and Chang, 1994.

Garner, Philippe, and David Alan Mellor, eds. *Cecil Beaton*. New York: Stewart, Tabori, and Chang, 1994.

Garvey, Ellen Gruber. *The Adman in the Parlor: Magazines and the Gendering of Consumer Culture, 1880s–1910*. New York: Oxford, 1996.

Gerherdt, Jane. *Desiring Revolution: Second-Wave Feminism and the Rewriting of American Sexual Thought, 1920–1982*. New York: Columbia University Press, 2011.

Gilfoyle, Timothy J. *City of Eros: New York City, Prostitution, and the Commercialization of Sex, 1790–1920.* New York: W. W. Norton, 1994.

Gill, Tiffany M. *Beauty Shop Politics: African American Women's Activism in the Beauty Industry.* Chicago: University of Illinois Press, 2010.

Gill, Tiffany M. "'The First Thing Every Negro Girl Does': Black Beauty Culture, Racial Politics, and the Construction of Modern Black Womanhood, 1905–1925." In *Cultures of Commerce: Representation and American Business Culture, 1877–1960,* edited by Elspeth H. Brown, Catherine Gudis, and Marina Moskowitz, 143–70. New York: Palgrave Macmillan, 2006.

Givhan, Robin. *The Battle of Versailles.* New York: Flatiron Books, 2015.

Georgen, Eleanor. *The Delsarte System of Physical Culture.* New York: Butterick, 1893.

Gilbert, James. *Men in the Middle: Searching for Masculinity in the 1950s.* Chicago: University of Chicago Press, 2005.

Glenn, Susan A. *Female Spectacle: The Theatrical Roots of Modern Feminism.* Cambridge, MA: Harvard University Press, 2000.

Goeser, Caroline. *Picturing the New Negro: Harlem Renaissance Print Culture and Modern Black Identity.* Lawrence: University of Kansas Press, 2007.

Goldberg, Vicki, and Nan Richardson. *Louise Dahl-Wolfe.* New York: Harry N. Abrams, 2000.

Gordon, Carma R. "Educating the Eye: Body Mechanics and Streamlining in the United States, 1925–1950." *American Quarterly* 58, no. 3 (2006): 839–68.

Gorn, Eliot. "Re-Membering John Dillinger" In *The Cultural Turn in US History,* edited by Jay Cook, Lawrence Glickman, and Michael O'Malley, 153–85. Chicago: University of Chicago Press, 2008.

Green, Adam. *Selling the Race: Culture, Community, and Black Chicago, 1940–1955.* Chicago, IL: University of Chicago Press, 2007.

Green, David. "Classified Subjects." *Ten/8 Photographic Journal* no. 14 (1984): 30–37.

Green, Harvey. *Fit for America: Fitness, Sport, and American Society.* New York: Pantheon Books, 1986.

Green, Nancy L. *Ready-to-Wear and Ready-to-Work: A Century of Industry and Immigrants in Paris and New York.* Durham, NC: Duke University Press, 1997.

Greer, Brenna. "Image Matters: Black Representation Politics and Civil Rights Work in the Mid-Twentieth Century United States." PhD diss., University of Wisconsin–Madison 2011.

Greer, Brenna. *Represented: The Black Imagemakers Who Reimagined African American Citizenship.* University of Pennsylvania Press, 2019.

Griffin, Susan. *Pornography and Silence.* New York: Harper and Row, 1981.

Griffin, Susan. *Woman and Nature: The Roaring inside Her.* New York: Harper Colophon, 1980.

Gross, Michael. *Model: The Ugly Business of Beautiful Women.* 1995; repr., New York: Harper's Perennial, 2003.

Grossman, James R. *Land of Hope: Chicago, Black Southerners, and the Great Migration.* Chicago, IL: University of Chicago Press, 1989.

Guadagnolo, Dan. "Segmenting America: Consumption and Niche Marketing in the Postwar United States." PhD diss., University of Wisconsin–Madison, forthcoming.

Gundle, Stephen. "Hollywood Glamour and Mass Consumption in Post-War Italy." *Journal of Cold War Studies* 4, no. 3 (2002): 95–118.

Gundle, Stephen, and Clino T. Castelli. *The Glamour System.* London: Palgrave Macmillan, 2006.

Guterl, Matthew. *Mother of the World: Josephine Baker and the Rainbow Tribe.* Cambridge, MA: Harvard University Press, 2014.

Haas, Steven, ed. *George Platt Lynes: The Male Nudes.* New York: Rizzoli, 2011.

Haidarali, Laila. "Polishing Brown Diamonds: African American Women, Popular Magazines, and the Advent of Modeling in Early Postwar America." *Journal of Women's History* 17, no. 1 (2005): 10–37.

Haidarali, Laila. "The Vampingest Vamp Is a Brownskin": Colour, Sex, Beauty and African American Womanhood, 1920–1954." PhD diss., York University, 2007.

Halberstam, Judith. *In a Queer Time and Place: Transgender Bodies, Subcultural Lives.* New York: New York University Press, 2005.

Halberstam, Jack. *The Queer Art of Failure.* Durham, NC: Duke University Press, 2011.

Hale, Grace Elizabeth. *A Nation of Outsiders: How the White Middle Class Fell in Love with Rebellion in Post-War America.* New York: Oxford University Press, 2010.

Hale, Grace Elizabeth. "The Romance of Rebellion." In *The Port Huron Statement: Sources and Legacies of the New Left's Manifesto,* edited by Richard Flacks and Nelson Lichtenstein, 65–80. Philadelphia: University of Pennsylvania Press, 2015.

Hall, Stuart. "Encoding/Decoding." In *The Cultural Studies Reader,* edited by Simon During, 90–103. New York: Routledge, 1993.

Hall-Duncan, Nancy. *The History of Fashion Photography.* New York: International Museum of Photography / Alpine Book Company, 1979.

Halperin, David M. *How to Be Gay.* Cambridge, MA: Harvard University Press, 2012.

Halter, Marilyn. *Shopping for Identity: The Marketing of Ethnicity.* New York: Schocken Books, 2000.

Haraway, Donna. "*A Manifesto for Cyborgs*: Science, Technology, and Socialist Feminism in the 1980s." *Socialist Review* 15, no. 2 (1985): 65–107.

Hardt, Michael. "Affective Labor." *boundary 2* 26, no. 2 (1999): 89–100.

Harker, Margaret F. *Linked Ring.* London: William Heinemann, 1979.

Harris, Muriel. "The Rising Star of the Paris Mannequin." *New York Times,* July 23, 1923, 50.

Haselstein, Ulla, Andrew Gross, and Maryann Snyder-Körber. *The Pathos of Authenticity: American Passions of the Real.* Heidelberg, Germany: Universitatsverlag Winter, 2010.

Haskins, Jim. *The Cotton Club.* New York: Random House, 1977.

Heap, Chad. *Slumming: Sexual and Racial Encounters in American Nightlife, 1885–1940.* Chicago, IL: University of Chicago Press, 2009.

Henle, James. "Realism in Advertising to Women." *Printer's Ink* 5, no. 2 (1922): 33–34.

Hennessey, Rosemary. *Profit and Pleasure: Sexual Identities in Late Capitalism.* New York: Routledge, 2000.

Hesford, Victoria. *Feeling Women's Liberation.* Durham, NC: Duke University Press, 2013.

Higginbotham, Evelyn Brooks. *Righteous Discontent: The Women's Movement in the Black Baptist Church*. Cambridge, MA: Harvard University Press, 1993.

Hilderbrand, Lucas. *Paris Is Burning: A Queer Film Classic*. Vancouver, BC: Arsenal Pulp Press, 2013.

Hite, Shere. *The Hite Report: A Nationwide Study of Female Sexuality*. New York: Macmillan, 1976.

Hite, Shere. *The Hite Report on Shere Hite: Daughter in Exile*. London: Arcadia, 1999.

Hoby, Hermione. "How Tracey Norman, America's First Black Trans Model, Returned to the Limelight." *Guardian*, August 21, 2016. https://www.theguardian.com/society/2016/aug/21/tracey-norman-black-trans-model-face-of-clairol.

Hochschild, Arlie R. *The Managed Heart: Commercialization of Human Feeling*. Berkeley: University of California Press, 1983.

Hoffman, Katherine. "Baron Adolph de Meyer." In *Encyclopedia of Nineteenth-Century Photography*, edited by John Hannavy, 395–96. Vol. 1, A-I, index. New York: Routledge, 2007.

Hoganson, Kristin L. *Consumers' Imperium: The Global Production of American Domesticity, 1865–1920*. Chapel Hill: University of North Carolina Press, 2007.

Hoganson, Kristin L. "Cosmopolitan Domesticity: Importing the American Dream, 1865–1920." *American Historical Review* 107, no. 1 (2002): 55–83.

Homer, William Innes. *Alfred Stieglitz and the Photo-Secession*. Boston, MA: Little Brown, 1983.

Honnef, Klaus, Enno Kaufhold, Richard Avedon, and F. C. Gundlach. *Martin Munkácsi*. London: Thames & Hudson, 2006.

hooks, bell. "In Our Glory: Photography and Black Life." In *Picturing Us: African American Identity in Photography*, edited by Deborah Willis, 54–64. New York: New Press, 1994.

Horowitz, Daniel. *The Anxieties of Affluence*. Amherst: University of Massachusetts Press, 2005.

Huggins, Nathan. *Harlem Renaissance*. New York: Oxford University Press, 1971.

Igo, Sarah E. *The Averaged American: Surveys, Citizens, and the Making of a Mass Public*. Cambridge, MA: Harvard University Press, 2007.

"Integrated Ads." *Commonweal* 78 (May 24, 1963): 236.

Isserman, Maurice. *If I Had a Hammer . . . The Death of the Old Left and the Birth of the New Left*. New York: Basic Books, 1987.

Jacobson, Matthew Frye. *Barbarian Virtues: The United States Encounters Foreign Peoples at Home and Abroad, 1876–1917*. New York: Hill and Wang, 2000.

Jacobson, Matthew Frye. *Roots Too: White Ethnic Revival in Post-Civil Rights America*. Boston, MA: Harvard University Press, 2009.

Jacobson, Matthew Frye. *Whiteness of a Different Color: European Immigrants and the Alchemy of Race*. Cambridge, MA: Harvard University Press, 1998.

Jameson, Fredric. "Reification and Utopia in Mass Culture." *Social Text* 1 (1979): 130–48.

Johnson, David K. *The Lavender Scare: The Cold War Persecution of Gays and Lesbians in the Federal Government*. Chicago, IL: University of Chicago Press, 2004.

Johnson, David K. "Physique Pioneers: The Politics of 1960s Gay Consumer Culture." *Journal of Social History* 43, no. 4 (2010): 867–92.

Johnson, James Weldon. *Black Manhattan*. New York: Knopf, 1930.

Johnson, John H. "Does Your Sales Force Know How to Sell the Negro Trade? Some Dos and Don'ts." *Advertising Age* 23 (March 17, 1952): 73–74.

Johnson, John H., with Lerone Bennett, Jr. *Succeeding Against the Odds*. New York: Amistad, 1989.

Johnson, Joseph T. *The Potential Negro Market*. New York: Pageant Press, 1952.

Johnston, Patricia. *Real Fantasies: Edward Steichen's Advertising Photography*. Berkeley: University of California Press, 1997.

Jones, Lois Liberty, and John Henry Jones. *All about the Natural*. New York: Clairol, 1971.

Julian, Philippe. "De Meyer." In *De Meyer*, edited by Robert Brandau, 10–46. New York: Knopf, 1976.

Kaiser, Charles. *The Gay Metropolis, 1940–1996*. New York: Harcourt Brace, 1997.

Kaplan, Joel L., and Sheila Stowell. *Theatre and Fashion: Oscar Wilde to the Suffragettes*. London: Cambridge University Press, 1994.

Kasson, John. *Houdini, Tarzan, and the Perfect Man: The White Male Body and the Challenge of Modernity in America*. New York: Hill and Wang, 2002.

Kazin, Michael. *American Dreamers: How the Left Change a Nation*. New York: Vintage, 2012.

Keenan, Brigid. *The Women We Wanted to Look Like*. London: Macmillan, 1977.

Kelley, Robin D. G. "Nap Time: Historicizing the Afro." *Fashion Theory* 1, no. 4, 1997: 339–52.

Kennedy, Elizabeth Lapovsky, and Madeline Davis. *Boots of Leather, Slippers of Gold: The History of a Lesbian Community*. New York: Routledge, 1993.

Kern-Foxworth, Marilyn. *Aunt Jemima, Uncle Ben, and Rastus: Blacks in Advertising Yesterday, Today, and Tomorrow*. Westport, CT: Greenwood Press, 1994.

Kibler, M. Alison. *Rank Ladies: Gender and Cultural Hierarchy in American Vaudeville*. Chapel Hill: University of North Carolina Press, 1999.

Kinloch, Valerie Felita. "Beauty, Femininity, and Black Bodies: Challenging the Paradigms of Race in the Miss America Pageant." In *"There She Is, Miss America": The Politics of Sex, Beauty, and Race in America's Most Famous Pageant*, edited by Elwood Watson and Darcy Martin, 93–109. New York: Palgrave Macmillan, 2004.

Kitch, Carolyn L. *The Girl on the Magazine Cover: The Origins of Visual Stereotypes in American Mass Media*. Chapel Hill: University of North Carolina Press, 2001.

Knowles, Eleanor N. "The Snappiest Girls in Town." *Collier's*, August 7, 1926, 8, 41.

Kobal, John. *The Art of the Great Hollywood Portrait Photographers*. London: Allan Lane, 1980.

Koda, Harold, and Kohle Yohannan. *Model as Muse: Embodying Fashion*. New York: Metropolitan Museum of Art, 2009.

Koestenbaum, Wayne. *Andy Warhol: A Biography*. Open Road Media, 2015.

Lacey, Robert. *Model Woman: Eileen Ford and the Business of Beauty*. New York: Harper Collins, 2015.

Lamprey, J. "On a Method of Measuring Human Form for Students of Ethnology." *Journal of the Ethnological Society*, 1869, N.S. 1, 84–85.

Larned, W. Livingston. "The Drama of the Human Face." *Commercial Photographer* 8, no. 1 (1932): 8–12.

Lawford, Valentine. *Horst: His Work and His World*. New York: Knopf, 1984.

Leach, William. *Land of Desire: Merchants, Power, and the Rise of a New American Culture*. New York: Pantheon, 1993.

Lears, T. J. Jackson. *Fables of Abundance: A Cultural History of Advertising in America*. New York: Basic Books, 1994.

Leddick, David. *Intimate Companions: A Triography of George Platt Lynes, Paul Cadmus, Lincoln Kirstein, and Their Circle*. New York: St. Martin's Press, 2000.

Leff, Leonard J. *The Dame in the Kimono: Hollywood, Censorship, and the Production Code*. Lexington: University Press of Kentucky, 2001.

Leigh, Dorian, with Laura Hobe. *The Girl Who Had Everything: The Story of the "Fire and Ice Girl."* Garden City, NY: Doubleday, 1980.

Lemke, Sieglinde. *Primitivist Modernism: Black Culture and the Origins of Transatlantic Modernism*. London: Oxford University Press, 1998.

Lewis, David Levering. *When Harlem Was in Vogue*. New York: Vintage, 1981.

Leys, Ruth. "The Turn to Affect: A Critique." *Critical Inquiry* 37 (2011): 434–72.

Lhamon, W. T., Jr. *Raisin' Cain: Blackface Performance from Jim Crow to Hip Hop*. Cambridge, MA: Harvard University Press, 1998.

Liaut, Jean Noel. *Cover Girls and Super Models, 1945–1965*. Translated by Robin Buss. London: Marion Boyars, 1996.

Lichtenstein, Nelson. *Retail Revolution: How Wal-Mart Remade American Business, Transformed the Global Economy, and Put Politics in Every Store*. New York: Metropolitan Books, 2009.

Livingston, Jennie, dir. *Paris Is Burning*. Los Angeles, CA: Miramax, 1991.

Locke, Alain. "The New Negro." In *The New Negro: Voices of the Harlem Renaissance*, 3–17. New York: Simon and Schuster, 1992.

Loftin, Craig M. *Masked Voices: Gay Men and Lesbians in Cold War America*. Albany: State University of New York Press, 2012.

Lott, Eric. *Love and Theft: Blackface Minstrelsy and the American Working Class*. New York: Oxford University Press, 1993.

Love, Heather. *Feeling Backward: Loss and the Politics of Queer History*. Cambridge, MA: Harvard University Press, 2007.

Lyons, Harriet, and Rebecca W. Rosenblatt. "Body Hair, the Last Frontier." In *The First Ms. Reader,* edited by Francine Klagsbrun, 145–49. New York: Warner, 1973.

MacDonald, J. Fred. *Blacks and White TV: Afro-Americans in Television since 1948*. Chicago, IL: Nelson-Hall Publishers, 1983.

MacKall, Lawton. "Merchandising with a Camera." *Commercial Photographer* 5, no. 5 (1930): 246–50.

Mahaffey, Perry L. "Helping the Advertising, Publicity, and Sales Promotion Departments by Photography." *Commercial Photographer* 5, no. 9 (1930): 458–66.

Manalansan, Martin, IV. "In the Shadows of Stonewall: Examining Gay Transnational Politics and the Diasporic Dilemma." *GLQ: Gay and Lesbian Quarterly* 2 (1995): 425–38.

Manring, M. M. *Slave in a Box: The Strange Career of Aunt Jemima.* Charlottesville: University Press of Virginia, 1998.

Marchand, Roland. *Advertising the American Dream: Making Way for Modernity, 1920–1940.* Berkeley: University of California Press, 1985.

Martin, Earle. "Photography in Advertising." *The American Annual of Photography* 44 (1930), 190–91.

Massumi, Brian. "Autonomy of Affect." *Cultural Critique* 31 (1995): 83–109.

Massumi, Brian. *Parables of the Virtual: Movement, Affect, Sensation.* Durham, NC: Duke University Press, 2002.

Matelski, Elizabeth. "(Big) and Black Is Beautiful: Body Image and Expanded Beauty Ideals in the African-American Community, 1945–1968." *Essays in History* (2012): 3–20.

Matthis, Irene. "Sketch for a Metapsychology of Affect." *International Journal of Psychoanalysis* 81 (2000): 215–27.

May, Elaine Tyler. *Homeward Bound: American Families in the Cold War Era.* New York: Basic Books, 1988.

McAndrew, Malia. "Selling Black Beauty: African American Modeling Agencies and Charm Schools in Postwar America." *OAH Magazine of History* January 2010, 28–32.

McElya, Micki. *Clinging to Mammy: The Faithful Slave in Twentieth-Century America.* Cambridge, MA: Harvard University Press, 2007.

McEntee, Ann Marie. "Feathers, Finials, and Frou-Frou: Florenz Ziegfeld's Exoticized Follies Girls." In *Art, Glitter, and Glitz: Mainstream Playwrights and Popular Theatre in 1920s America,* edited by Arthur Gewirtz and James L. Kolb, 177–8. Westport, CT: Praeger, 2004.

McGovern, Charles F. *Sold American: Consumption and Citizenship, 1890–1945.* Chapel Hill, NC: University of North Carolina Press, 2006.

McGuire, Danielle L. *At the Dark End of the Street: Black Women, Rape, and Resistance: A New History of the Civil Rights Movement from Rosa Parks to the Rise of Black Power.* New York: Alred A. Knopf, 2010.

McLeod, Norman Z., dir. *The Powers Girls.* Los Angeles, CA: General Service Studios, 1943.

Mears, Ashley. *Pricing Beauty: The Making of a Fashion Model.* Berkeley: University of California Press, 2011.

Meikle, Jeffrey L. *American Plastic: A Cultural History.* New Brunswick, NJ: Rutgers University Press, 1995.

Mellor, David Alan. "Beaton's Beauties." In *Cecil Beaton,* edited by Philippe Garner and David Alan Mellor, 12–24. New York: Stewart, Tabori, and Chang.

Mendes, Valerie D., and Amy de la Haye. *Lucile, Ltd.: London, Paris, New York, and Chicago, 1890s–1930s.* London: V&A Publishing, 2009.

Mercer, Kobena. "Black Hair/Style Politics." In *Out There: Marginalization and Contemporary Cultures,* edited by Russell Ferguson, Martha Gever, Trinh T. Minh-ha, and Cornel West, 247–64. New York: New Museum of Contemporary Art / Cambridge, MA: MIT Press, 1990.

Meyerowitz, Joanne J. *How Sex Changed: A History of Transsexuality in the United States.* Cambridge, MA: Harvard University Press, 2004.

Meyerowitz, Joanne, ed. *Not June Cleaver: Women and Gender in Postwar America.* Philadelphia, PA: Temple University Press, 1994.

Meyerowitz, Joanne J. *Women Adrift: Independent Wage Earners in Chicago, 1880–1930.* Chicago, IL: University of Chicago Press, 1991.

Miller, Monica L. *Slaves to Fashion: Black Dandyism and the Styling of Black Diasporic Identity.* Durham, NC: Duke University Press, 2009.

Mizejewski, Linda. *Ziegfeld Girl: Image and Icon in Culture and Cinema.* Durham, NC: Duke University Press, 1999.

Mock, Janet. *Redefining Realness: My Path to Womanhood, Identity, Love, and So Much More.* New York: Atria Books, 2014.

The Model's Redemption. New York: Independent Moving Pictures Co. of America, 1910.

Monloss, Kristina. "Clairol Brings Back the First Black Transgender Fashion Model in Its Lovely New Campaign." *Adweek,* August 16, 2016. http://www.adweek.com/news /advertising-branding/clairol-brings-back-first-black-transgender-fashion-model-its -lovely-new-campaign-172987.

Moreton, Bethany. *To Serve God and Wal-Mart: The Making of Christian Free Enterprise.* Cambridge, MA: Harvard University Press, 2009.

Morgan, Robin. "Women Disrupt the Miss America Pageant." In *Going Too Far: The Personal Chronicles of a Feminist,* 64–65. New York: Random House, 1977.

Moskowitz, Marina, and Marlis Schweitzer. Introduction to *Testimonial Advertising in the American Marketplace,* edited by Marlis Schweitzer and Marina Moskowitz, 1–22. New York: Palgrave, 2009.

"Movie 'Stills' Crash Advertising Pages." *Commercial Photographer* 9, no. 2 (1933): 45–46.

Mumford, Kevin J. *Interzones: Black/White Sex Districts in Chicago and New York in the Early Twentieth Century.* New York: Columbia University Press, 1997.

Muñoz, José Esteban. "Feeling Brown: Ethnicity and Affect in Ricardo Bracho's *The Sweetest Hangover (and Other STDs)*." *Theatre Journal* 52 (2000): 67–79.

Muñoz, José Esteban. "Ephemera as Evidence: Introductory Notes to Queer Acts." *Women and Performace: A Journal of Feminist Theory* 8, Issue 2 (1996): 5–16.

"The Negro Market." *Tide* 26 (July 1952): 47.

"The Negro Market: An Appraisal." *Tide* 21 (March 1947): 15.

Negus, Keith. "The Work of Cultural Intermediaries and the Enduring Distance between Production and Consumption." *Cultural Studies* 16, no. 4 (2002): 501–15.

Newman, Kathy M. "The Forgotten Fifteen Million: Black Radio, The 'Negro Market,' and the Civil Rights Movement." *Radical History Review* 76 (2000): 115–35.

Newton, Esther. *Mother Camp: Female Impersonators in America.* Englewood Cliffs, NJ: Prentice-Hall, 1972.

Niven, Penelope. *Steichen.* New York: Clarkson Potter, 1997.

Ochoa, Marcia. *Queen for a Day: Transformistas, Beauty Queens, and the Performance of Femininity in Venezuela.* Durham, NC: Duke University Press, 2014.

O'Dwyer, Jack. "Minority Groups Might Get More Ad Notice." *Printers' Ink* 282, no. 4 (January 35, 1963): 10.

Orvell, Miles. *The Real Thing: Imitation and Authenticity in American Culture, 1880– 1940.* Chapel Hill: University of North Carolina Press, 1990.

Ott, Katherine, David Serlin and Stephen Mihm. *Artificial Parts, Practical Lives: Modern Histories of Prosthetics.* New York: NYU Press, 2002.

Owen, N. Courtney. "Pictorial Advertising." *Photo-Era* 54 (1925): 76–78.

Padiha, Roger, and Mauricio Padiha. *Stephen Sprouse.* New York: Rizzoli, 2009.

Peiss, Kathy. "'Charity Girls' and City Pleasures: Historical Notes on Working-Class Sexuality, 1880–1920." In *Passion and Power: Sexuality in History*, edited by Kathy Peiss et al., 57–70. Philadelphia, PA: Temple University Press, 1987.

Peiss, Kathy. *Cheap Amusements: Working Women and Leisure in Turn-of-the-Century New York.* Philadelphia, PA: Temple University Press, 1986.

Peiss, Kathy. *Hope in a Jar: The Making of America's Beauty Culture.* New York: Henry Holdt, 1998.

Peiss, Kathy. "Making Faces: The Cosmetics Industry and the Cultural Construction of Gender." *Genders* 7 (1990): 143–69.

Pellegrini, Ann. "Consuming Lifestyle: Commodity Capitalism and Transformations in Gay Identity." In Arnaldo Cruz-Malave and Martin F. Manalansan IV, editors, *Queer Globalizations: Citizenship and the Afterlife of Colonialism* New York: New York University Press, 2002: 134–48.

Pepper, Terence. *Horst Portraits: Paris, London, New York.* London: National Portrait Gallery, 2001.

Peterson, Christian A. "American Arts and Crafts: The Photograph Beautiful, 1895–1915." *History of Photography* 16, no. 3 (1992): 189–232.

Phillips, Kimberly L. *Alabama North: African-American Migrants, Community, and Working-Class Activism in Cleveland, 1915–1945.* Urbana: University of Illinois Press, 1999.

Pieterse, Jan Nederveen. *White on Black: Images of Africa and Blacks in Western Popular Culture.* New Haven, CT: Yale University Press, 1992.

Pitzulo, Carrie. *Bachelors and Bunnies: The Sexual Politics of Playboy.* Chicago, IL: University of Chicago Press, 2011.

Pohorilenko, Anatole. "The Expatriate Years, 1926–1934." In *When We Were Three: The Travel Albums of George Platt Lynes, Monroe Wheeler, and Glenway Wescott, 1925–1935.* Santa Fe, NM: Arena Editions, 1998.

Pohorilenko, Anatole. *The Photographer George Platt Lynes: Known and Unknown.* New York: John Stevenson Gallery, 2004.

Poiret, Paul. *King of Fashion: The Autobiography of Paul Poiret.* Translated by Stephen Haden Guest. Philadelphia, PA: J. B. Lippincott, 1931.

Powell, Richard. *Cutting a Figure: Fashioning Black Portraiture.* Chicago: University of Chicago Press, 2008.

Powers, John Robert. *The Power Girls: The Story of Models and Modeling and the Natural Steps by Which Attractive Girls Are Created.* New York: E. P. Dutton, 1941.

Preciado, Beatriz. *Pornotopia: An Essay on Playboy's Architecture and Biopolitics.* New York: Zone Books, 2014.

Puar, Jasbir K. "Mapping U.S. Homonormativities." *Gender, Place and Culture* 13, no. 1 (2006):

Puar, Jasbir K. *Terrorist Assemblages: Homonationalism in Queer Times.* Durham, NC: Duke University Press, 2007.

Putney, Clifford. *Muscular Christianity: Manhood and Sports in Protestant America, 1880–1920*. Cambridge, MA: Harvard University Press, 2001.

Quackenbush, Edgar. "The Setting That Enhances the Product." *Commercial Photographer* 2, no. 7 (1927): 300–304.

Quant, Mary. *Quant by Quant*. London: Victoria and Albert Publishing, 2012.

Quick, Harriet. *Catwalking: A History of the Fashion Model*. London: Hamlyn, 1997.

Raymond, Janice. *The Transsexual Empire: The Making of the She-Male*. Boston, MA: Beacon Press, 1979.

Reichert, Tom. *The Erotic History of Advertising*. Amherst, MA: Prometheus Books, 2003.

Rich, Adrienne. *Of Woman Born*. New York: W. W. Norton, 1976.

Roach, Joseph. *It*. Ann Arbor: University of Michigan Press, 2007.

Roberts, Russell. "Taxonomy: Some Notes towards the Histories of Photography and Classification." In *Invisible Light: Photography and Classification in Art, Science, and the Everyday*, edited by Chrissie Iles and Russell Roberts, 9–52. Oxford: Museum of Modern Art, 1998.

Rooks, Noliwe M. *Hair Raising: Beauty, Culture, and African American Women*. New Brunswick, NJ: Rutgers University Press, 1996.

Roosevelt, Theodore. *The Strenuous Life: Essays and Addresses*. New York: Century, 1901.

Rosco, Jerry. *Glenway Wescott Personally: A Biography*. Madison: University of Wisconsin Press, 2002.

Rose, Joseph, et al. *Glamour: Fashion and Industrial Design and Architecture*. New Haven, CT: Yale University Press, 2004.

Rosen, Ruth. *The Lost Sisterhood: Prostitution in America, 1900–1918*. Baltimore, MD: Johns Hopkins University Press, 1982.

Rosen, Ruth. *The World Split Open: How the Modern Women's Movement Changed America*. New York: Penguin, 2000.

Ross, Kip. *The Theory and Practice of Photography: Illustrative Advertising Photography*. New York: New York Institute of Photography / Universal Photographers, ca. 1930s.

Ross, Stephen J. *Working-Class Hollywood: Silent Cinema and the Shaping of Class in America*. Princeton, NJ: Princeton University Press, 1998.

Roth, Paul. "Family Tree: Richard Avedon, Politics, and Power, 1969–1976." In *Richard Avedon: Portraits of Power*, 241–76. London: Thames and Hudson, 2008.

Roth, Paul. Preface to *Richard Avedon: Portraits of Power*. London: Thames and Hudson, 2008.

Rotskoff, Lori, and Laura L. Lovett. *When We Were Free to Be: Looking Back at a Children's Classic and the Difference It Made*. Chapel Hill: University of North Carolina Press, 2012.

Rotundo, E. Anthony. *American Manhood: Transformations in Masculinity from the Revolution to the Modern Era*. New York: Basic Books, 1993.

Rowlands, Penelope. *A Dash of Darling: Carmel Snow and Her Life in Fashion, Art, and Letters*. New York: Atria Books, 2006.

Ruffins, Fath Davis. "Reflecting on Ethnic Imagery in the Landscape of Commerce." In *Getting and Spending: European and American Consumer Societies in the Twentieth*

Century, edited by Susan Strasser, Charles McGovern, and Matthias Judt, 379–406. Washington, DC: German Historical Institute, 1998.

Said, Edward. *Orientalism.* New York: Pantheon Books, 1979.

Sampson, Henry T. *Blacks in Blackface: A Sourcebook on Early Black Musical Shows.* Metuchen, NJ: The Scarecrow Press, 1980.

Sayers, William. "The Etymology of *Queer.*" *American Notes and Queries* 18, no. 2 (2005): 15–18.

Scanlon, Jennifer. *Bad Girls Go Everywhere: The Life of Helen Gurley Brown.* New York: Oxford University Press, 2009.

Scanlon, Jennifer. *Inarticulate Longings: The Ladies' Home Journal, Gender, and the Promises of Consumer Culture.* New York: Routledge, 1995.

Schwartz, Vanessa. *It's So French: Hollywood, Paris, and the Making of Cosmopolitan Film Culture.* Chicago, IL: University of Chicago Press, 2007.

Schweitzer, Marlis. "Accessible Feelings, Modern Looks: Irene Castle, Ira L. Hill, and Broadway's Affective Economy." In *Feeling Photography,* edited by Elspeth H. Brown and Thy Phu, 223–55. Durham, NC: Duke University Press, 2014.

Schweitzer, Marlis. *When Broadway Was the Runway: Theatre, Fashion, and American Culture.* Philadelphia: University of Pennsylvania Press, 2009.

Scott, Walter Dill. *Theory of Advertising.* 1903. New York: Garland, 1985.

Seebohm, Caroline. *The Man Who Was Vogue.* New York: Viking Press, 1982.

Sender, Katherine. *Business, Not Politics: The Making of the Gay Market.* New York: Columbia University Press, 2004.

Serlin, David. *Replaceable You: Engineering the Body in Postwar America.* Chicago, IL: University of Chicago Press, 2004.

Sheridan, Jayne. *Fashion, Media, Promotion: The New Black Magic.* Chichester, UK: Wiley, 2013.

Sides, Josh. *Erotic City: Sexual Revolutions and the Making of Modern San Francisco.* New York: Oxford University Press, 2009.

Simmel, Georg. "Fashion." In *Individuality and Social Forms,* edited by D. Levine. London: University of Chicago Press, 1941.

Smith, Jessie Carney, and Shirelle Phelps. *Notable Black American Women.* Vol. 2. Detroit, MI: Gale Research, 1992–2003.

Smith, Shawn Michelle. *Photography on the Color Line: W. E. B. Du Bois, Race, and Visual Culture.* Durham, NC: Duke University Press, 2004.

Smith, Shawn Michelle. *At the Edge of Sight.* Durham, NC: Duke University Press, 2013.

Sones, Melissa. "The Secret to Inner Beauty." *American Legacy* 9, no. 3 (2003): 20–32.

Sontag, Susan. "Notes on Camp." In *Against Interpretation,* 275–92. New York: Farrar, Straus and Giroux, 1961.

Sotiropoulos, Karen. *Staging Race: Black Performers in Turn-of-the-Century America.* Cambridge, MA: Harvard University Press, 2006.

Souhami, Diana. *Greta and Cecil.* New York: Phoenix Press, 2001.

Spring, Justin. *The Secret Historian: The Life and Times of Samuel Steward, Tattoo Artist, Professor, and Sexual Renegade.* New York: Farrar, Straus and Giroux, 2010.

Spencer, Frank. "Some Notes on the Attempt to Apply Photography to Anthropometry during the Second Half of the Nineteenth Century." In *Anthropology and Photography, 1860–1920*, edited by Elizabeth Edwards, 99–107. New Haven, CT: Yale University Press, 1992.

Squiers, Carol. "'Let's Call It Fashion': Richard Avedon at Harper's Bazaar." In *Avedon Fashion, 1944–2000*, edited by Carol Squiers, Vince Aletti, et al., 156–99. New York: Abrams, 2009.

Stafford, Sidney F. *Toni Frissell: Photographs, 1933–1967.* New York: Doubleday in association with the Library of Congress, 1994.

Stapely, Gordon, and Leonard Sharpe. *Photography in the Modern Advertisement.* London: Chapman and Hall, 1937.

Stapp, William F. "Penn as Portraitist." In *Irving Penn Master Images: The Collections of the National Museum of American Art and the National Portrait Gallery,* edited by Merry A. Foresta and William F. Stapp, 85–91. Washington D.C.: Smithsonian, 1994.

Steele, Edgar A. "Some Aspects of the Negro Market." *Journal of Marketing* 11, no. 4 (1947): 399–401.

Steele, Valerie, ed. *A Queer History of Fashion: From the Closet to the Catwalk.* New Haven, CT: Yale University Press 2013.

Stein, Marc. *City of Sisterly and Brotherly Loves: Lesbian and Gay Philadelphia, 1945–1972.* Chicago, IL: University of Chicago Press, 2000.

Stevens, Norma, and Stephen M.L Aronson. *Avedon: Something Personal.* New York: Spigel & Grau, 2017.

Steward, Samuel. *Bad Boys and Tough Tattoos: A Social History of the Tattoo with Gangs, Sailors, and Street-Corner Punks 1950–1965.* Routledge, 1990.

Stewart, Kathleen. *Ordinary Affects.* Durham, NC: Duke University Press, 2007.

Stewart, Wert. "And the Ship Sank—in a Bath Tub!" *Commercial Photographer* 5, no. 4 (1930): 190–93.

Stine, Whitney. *50 Years of Photographing Hollywood: The Hurrell Style.* New York: Greenwich House, distributed by Crown Publishers, 1983.

Stoker, Bram. *Dracula.* New York: Grosset and Dunlap, 1897.

Stokes, Melvyn. *D. W. Griffith's "The Birth of a Nation": A History of "The Most Controversial Motion Picture of All Time."* New York: Oxford University Press, 2007.

Stone, Sandy. "The *Empire* Strikes Back: A Posttranssexual Manifesto." In *The Transgender Studies Reader,* edited by Susan Stryker and Stephen Whittle, 221–35. New York: Routledge, 2006.

Stovall, Tyler. *Paris Noir: African Americans in the City of Light.* Boston, MA: Houghton Mifflin, 1996.

Strand, Paul. "Photography and the New God." 1917. In *Classic Essays on Photography,* edited by Alan Trachtenberg, 144–51. New Haven, CT: Leetes Island Books, 1980.

Strasser, Susan. *Satisfaction Guaranteed: The Making of the American Mass Market.* New York: Pantheon, 1989.

Strub, Whitney. *Perversion for Profit: The Politics of Pornography and the Rise of the New Right.* New York: Columbia University Press, 2011.

Stryker, Susan. *Transgender History*. Berkeley, CA: Seal Press, 2008.

Stryker, Susan. "Transgender Studies: Queer Theory's Evil Twin." *GLQ: A Journal of Lesbian and Gay Studies* 10, no. 2 (2004): 212–15.

Students for a Democratic Society (US). *The Port Huron Statement*. 1962. Chicago, IL: C. H. Kerr, 1990.

Studlar, Gaylyn. "The Perils of Pleasure? Fan Magazine Discourse as Women's Commodified Culture in the 1920s." In *Silent Film*, edited by Richard Abel, 263–98. New Brunswick, NJ: Rutgers University Press, 1996.

Sugrue, Thomas. "Model Jobs." *American Magazine*, April 1937, 80.

Sullivan, David J. "The American Negro—an 'Export Market' at Home!" *Printer's Ink* 208 (1944): 46–50.

Sullivan, David J. "Don't Do This—If You Want to Sell Your Product to Negroes!" *Sales Management* 52 (1943): 46–50.

Sullivan, David J. "The Negro Market Today and Postwar." *Journal of Marketing* 10, no. 1 (1945): 68–69.

Sullivan, David J. "Why a Handful of Advertisers Dominate the Negro Markets." *Sales Management* 65 (September 1950): 154–60.

Summers, Barbara. *Black and Beautiful: How Women of Color Changed the Fashion Industry*. New York: Amistad Press, 2001.

Summers, Barbara. *Skin Deep: The Story of Black Models in America and Abroad*. New York: Amistad, 1998.

Summers, Martin. *Manliness and Its Discontents: The Black Middle Class and the Transformation of Masculinity, 1900–1930*. Chapel Hill: University of North Carolina Press, 2004.

Szarkowski, John. *Irving Penn*. New York: Museum of Modern Art, 1984.

Terry, Jennifer. *An American Obsession: Science, Medicine, and Homosexuality in Modern Society*. Chicago, IL: University of Chicago Press, 1999.

Terry, Jennifer and Jacqueline Urda. *Deviant Bodies*. Bloomington: Indiana University Press, 1995.

Thom, Mary. *Inside Ms: 25 Years of the Magazine and the Feminist Movement*. New York: Harry Holt, 1997.

Thompson, Lisa. *Beyond the Black Lady: Sexuality and the New African American Middle Class*. Urbana-Champaign: University of Illinois Press, 2012.

Thompson, William R. "Sex, Lies, and Photographs: Letters from George Platt Lynes." Master's thesis, Rice University, 1996.

Thrift, Nigel. "Understanding the Material Practices of Glamour." In *The Affect Theory Reader*, edited by Melissa Gregg and Gregory J. Seigworth, 289–308. Durham, NC: Duke University Press, 2010.

Tiemeyer, Phil. *Plane Queer: Labor, Sexuality, and AIDS in the History of Male Flight Attendants*. Berkeley: University of California Press, 2013.

Tinkom, Matthew. *Working Like a Homosexual: Camp, Capital, and Cinema*. Durham, NC: Duke University Press, 2002.

Todd, Mabel Elsworth. "Principles of Posture." 1920. In *Early Writings, 1920–1934*, 45–49. New York: Dance Horizons, 1977.

Toll, Robert. *Blacking Up: The Minstrel Show in Nineteenth-Century America*. New York: Oxford University Press, 1974.

Torgovnick, Marianna. *Gone Primitive: Savage Intellects, Modern Lives*. Chicago, IL: University of Chicago Press, 1990.

Troy, Nancy J. *Couture Culture: A Study in Modern Art and Fashion*. Cambridge, MA: MIT Press, 2003.

Turner, Mark W. *Backward Glances: Cruising the Queer Streets of New York and London*. London: Reaktion Books, 2003.

Ullman, Sharon R. *Sex Seen: The Emergence of Modern Sexuality in America*. Berkeley: University of California Press, 1997.

Valentine, David. *Imagining Transgender: An Ethnography of a Category*. Durham, NC: Duke University Press, 2007.

van den Oever, Roel. *Mama's Boy: Momism and Homophobia in Postwar American Culture*. London: Palgrave MacMillan, 2012.

Vantoch, Victoria. *The Jet Sex: Airline Stewardesses and the Making of an American Icon*. Philadelphia: University of Pennsylvania Press, 2013.

Vettel-Becker, Patricia. *Shooting from the Hip: Photography, Masculinity, and Postwar America*. Minneapolis: University of Minnesota Press, 2005.

Vickers, Hugh. *Cecil Beaton: The Authorized Biography*. London: Weidenfeld & Nicolson, 1983.

Vickers, Hugh. *Loving Garbo: The Story of Greta Garbo, Cecil Beaton, and Mercedes de Acosta*. London: J. Cape, 1994.

Vickers, Hugh. *The Unexpurgated Beaton: The Cecil Beaton Diaries as He Wrote Them*. New York: Alfred A. Knopf, 2003.

Vidor, Charles, dir. *Cover Girl*. Los Angeles, CA: Columbia Pictures, 1944.

Vogel, Shane. *The Scene of Harlem Cabaret: Race, Sexuality, Performance*. Chicago, IL: University of Chicago Press, 2009.

Walker, Susannah. *Style and Status: Selling Beauty to African American Women, 1920–1975*. Louisville: University Press of Kentucky, 2007.

Walkowitz, Judith. "The 'Vision of Salome': Cosmopolitanism and Erotic Dancing in Central London, 1908–1918." *American Historical Review* 108, no. 2 (2003): 337–76.

Waller, Susan. *The Invention of the Model: Artists and Models in Paris, 1830–1870*. London: Ashgate, 2006.

Warner, Michael. Ed. *Fear of a Queer Planet: Queer Politics and Social Theory*. Minneapolis: University of Minnesota Press, 1993.

Warner, Michael. "Publics and Counter Publics." *Public Culture* 14, no. 1 (2002): 49–90.

Warner, Michael. *Publics and Counter Publics*. New York: Zone Books, 2002.

Watkins, Julian L. *The 100 Greatest Advertisements*. New York: Dover, 1959.

Watts, Steven. *Mr. Playboy: Hugh Hefner and the American Dream*. New York: Wiley, 2009.

Weeks, Jeffrey. *Coming Out: Homosexual Politics in Britain*. London: Quartet Books, 1977.

Weems, Robert E., Jr. *Desegregating the Dollar: African American Consumerism in the Twentieth Century*. New York: New York University Press, 1998.

Weinstein, Hal. "How an Agency Builds a Brand: The Virginia Slims Story." Papers from the AAAA Region Conventions of 1969. Last accessed June 21, 2018. http://industrydocuments.library.ucsf.edu/tobacco/docs/jmnb0122.

West, Nancy Martha. *Kodak and the Lens of Nostalgia*. Charlottesville: University Press of Virginia, 2000.

Weston, Kath. *Families We Choose: Lesbians, Gays, and Kinship*. New York: Columbia University Press, 1991.

White, Deborah Gray. *Ar'n't I a Woman? Female Slaves in the Plantation South*. New York: Norton, 1995.

White, Deborah Gray. *Too Heavy a Load: Black Women in Defense of Themselves, 1894–1994*. New York: Norton, 1999.

White, Shane, and Graham White. *Stylin': African American Expressive Culture from Its Beginnings to the Zoot Suit*. Ithaca, NY: Cornell University Press, 1998.

Whiting, Cécile. "Decorating with Stettheimer and the Boys." *American Art* 14, no. 1 (2000): 25–49.

Williams, Brooke. "The Retreat to Cultural Feminism." In *Feminist Revolution*, 65–68. New Paltz, NY: Redstockings, 1975.

Williams, Raymond L. *The Long Revolution*. Westport, CT: Greenwood Press, 1961.

Willis-Tropea, Liz. "Hollywood Glamour: Sex, Power, and Photography, 1925–1939." PhD diss., University of California, Los Angeles, 2008.

Wilson, Elizabeth. "A Note on Glamour." *Fashion Theory* 11, no. 1 (2007): 95–108.

Windham, Donald. "Which Urges and Reasonably So the Attraction of Some for Others," *Yale Review* 86, no. 4 (Oct 1998): 18–31.

Wissinger, Elizabeth. "Always on Display: Affective Production in the Modeling Industry." In *The Affective Turn: Theorizing the Social,* edited by Patricia Clough and Jean Halley, 231–60. Durham, NC: Duke University Press, 2007.

Wissinger, Elizabeth. "Modelling a Way of Life: Immaterial and Affective Labour in the Fashion Modeling Industry." *Ephemera* 7, no. 1 (2007): 250–69.

Wissinger, Elizabeth. *This Year's Model: Fashion, Media, and the Making of Glamour*. New York: New York University Press, 2015.

Witherington, K. "How Advertising Photographs Are Made." *Commercial Photographer* 5, no. 10 (1930): 510–15.

Wolcott, Victoria. *Remaking Respectability: African American Women in Interwar Detroit*. Chapel Hill: University of North Carolina Press, 2001.

Wolf, Bryan. "Confessions of a Closet Ekphrastic: Literature, Painting and Other Unnatural Relations." *Yale Journal of Criticism* 3 (1990): 181–203.

Woll, Allen. *Black Musical Theatre: From Coontown to Dreamgirls*. Baton Rouge: Louisiana State University Press, 1989.

Woll, Allen. *Dictionary of Black Theatre*. Westport, CT: Greenwood Press, 1983.

Wormald, Charles. "Has Your Model the Right Expression?" *Commercial Photographer* 8, no. 7 (1933): 201–2.

Wormald, Charles. "Making Photographs That Have Advertising Appeal." *Commercial Photographer* 1, no. 11 (1926): 389–92.

Yano, Christine R. *Airborne Dreams: Nisei Stewardesses and Pan American World Airways*. Durham, NC: Duke University Press, 2011.

Yochelson, Bonnie. "Clarence White: Peaceful Warrior." In *Pictorialism into Modernism*, edited by Marianne Fulton, 111–14. New York: Rizzoli, 1996.

Yosifon, David, and Peter N. Stearns. "The Rise and Fall of American Posture." *American Historical Review* 103, no. 4 (1998): 1057–95.

Young, Cynthia A. *Soul Power: Culture, Radicalism, and the Making of a U.S. Third World Left*. Durham, NC: Duke University Press, 2006.

Young, Ralph. "Human-Interest Illustrations." *American Photography* 22, no. 1 (1928): 6–10.

Yuan, Jada. "Tracey Africa Norman Is Back as the Face of Clairol." *New York Magazine*. August 15, 2016. http://nymag.com/thecut/2016/08/tracey-africa-norman-is-back-on-a-box-of-clairol.html.

Yuan, Jada, and Ada Wong, "The First Black Trans Model Had Her Face on a Box of Clairol." *New York Magazine,* December 14, 2015. http://nymag.com/thecut/2015/12/tracey-africa-transgender-model-c-v-r.html.

Zill, Jo Ahern. "Black Beauty." *Look* 33 (January 7, 1969): 70–75.